500 CAMERAS

170 Years of Photographic Innovation

This book is dedicated to my father, Harry Gustavson.

Sterling Signature
NEW YORK

An Imprint of Sterling Publishing
387 Park Avenue South
New York, NY 10016

Book and cover design by Stewart A. Williams
All camera photos by Barbara Puorro Galasso

All cameras are from the George Eastman House Technology Collection. Camera IDs contain
the item's introduction dates; dates for many are preceded by "circa" as most cameras have a
production range. When the museum's collection does not contain the first model, a later date
is established by serial number or by research in secondary sources.

ISBN 978-1-4027-8086-8

Distributed in Canada by Sterling Publishing
c/o Canadian Manda Group, 165 Dufferin Street
Toronto, Ontario, Canada M6K 3H6
Distributed in the United Kingdom by GMC Distribution Services
Castle Place, 166 High Street, Lewes, East Sussex, England BN7 1XU
Distributed in Australia by Capricorn Link (Australia) Pty. Ltd.
P.O. Box 704, Windsor, NSW 2756, Australia

For information about custom editions, special sales, and premium and corporate purchases,
please contact Sterling Special Sales at 800-805-5489 or specialsales@sterlingpublishing.com.

Printed in China

2 4 6 8 10 9 7 5 3 1

www.sterlingpublishing.com

GEORGE EASTMAN HOUSE

500 CAMERAS

170 YEARS *of* PHOTOGRAPHIC INNOVATION

Todd Gustavson

Sterling Signature
NEW YORK

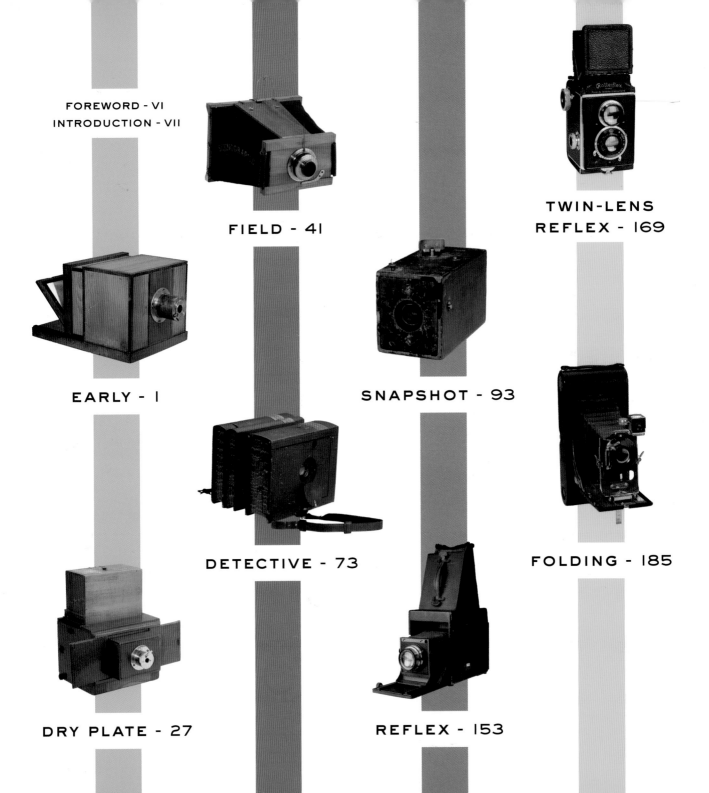

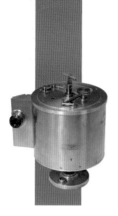
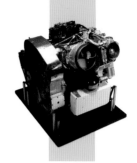
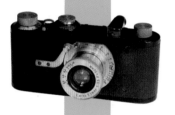
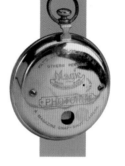
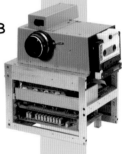
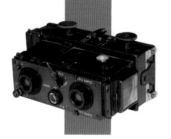
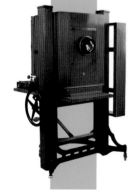

FOREWORD
Anthony Bannon
The Ron and Donna Fielding Director, George Eastman House

Collections manage time. Collections have been gathered before it was too late. They bear messages carried through time. They talk about where they have been, deep within their archeology of knowledge. If we listen, they can direct our activities and help administer our growth.

In coming together one at a time, collected objects become something different. A collection carries a new message. A collection speaks in a louder voice, its objects now in concert with others.

Collections ask a lot of us. They ask to be named, organized, given a place, valued, interpreted, shared. We may not forget that they are palpable and fugitive, like fruit, with texture, color, dimension, and fragility. And they nourish us. But we must care for them, say their names, and notice what they consign.

A collection has moment. It seizes that moment and declares its importance. More humbly, it also asks that we simply pay attention, take notice, and even celebrate its existence. Thereby collections make a mark; they leave a trace. They carry with them time, and it adds up. A collection signals where it has been and how it has been used.

We know that through collections we can touch greatness—connect with the artisan, for example, who uniquely created a beautiful wooden view camera, or the inventor who freshly conceived the digital camera, or the designer who brilliantly devised a camera's ergonomic styling to make it work. These things come from the hands of greatness.

So we take responsibility for our collections with gratitude. The collector, whether individual or institutional, engages with the object to recognize the light of its value and hold the spark, to take on the responsibility of its meaning and make sense of it.

All this can be tricky, though. With museums, so much of the gathering is done through accidents of opportunity, though fortunately within the shaping structure of a self-conscious, principle-directed institution. As time passes, collections are smoothed out by curators with training and passion for their chosen fields.

Why, for example, does George Eastman House have so many more Leica cameras and accessories than Nikon, and so many more Nikon objects than Canon? The answer: It was just a matter of fortune—the gifts of several sources, and the wise curators who said "yes." The generous curiosity of curators stands against the horrible loss of knowledge, should they be intellectually stingy and look the other way, or worse, only select what they know best, allowing the objects to slip away.

The finest curators have the grit to collect what is unsettling or uncertain. They have the wisdom to discern the right thing to do. Luckily, the curators at George Eastman House have taken their time here seriously, left their brand, and taken pains to understand all that has passed before them, back to the beginning of camera time.

Another lucky thing for Eastman House is that Eastman Kodak Company had the presence to ground its leadership in the knowledge of those manufacturers who established the medium, and that Kodak executives had the prescience to establish the first museum of photography and film in George Eastman's old house. This endowed a legacy—that archeology of knowledge about photography and often its provenance.

The gathering of master photographic objects in this book is itself an assembly for history. And its selection by Eastman House Technology Curator Todd Gustavson—scholarly and passionate—is another accomplishment in the chain of collecting practice worthy of our appreciation.

INTRODUCTION
Todd Gustavson

With origins traced to the fourteenth century, the modern camera was one of several mechanical devices that transformed how we see the world and ourselves. And like its revolutionary counterparts, the telephone, the printing press, and the steam locomotive, this precision consumer device rendered the world new in sharp contrast to the old. It supported the emergence of a visual medium—photography—that would satisfy society's insatiable demand for a universal system of communication. It easily broke barriers of time and space, delving into the limitless prospects of merging the past, present, and future in single or sequences of captured images. It recognized no geographic boundaries, bringing into focus the mysteries of the vast celestial sky and divulging the invisible realm of microscopic organisms.

The camera is an enduring mechanical device with the power to transform. It occupies a central role in all facets of the social realm, from the personal to the public, the political to the economic, entertainment to the law. Few modern devices are acknowledged as being as far-reaching in its ubiquity of use and users, and in its distinctive ability to shape human perception, knowledge, and memory. A triumph of ideas and imagination, technology, and industry, the camera has the ability to instantly capture an entire scene with the press of a button—a relatively effortless feat compared to the act of drawing or painting. The camera's ready adaptability to combine with other technologies of communication and information—telephonic, televisual, computing—continues its vaulted status as a device of infinite possibility.

However, producing images was not always so easy. Both the camera and the photographic process have undergone extensive transformations. The word camera derives from the Greek καμάρα (kamára), meaning vaulted chamber. Photographic cameras evolved from the camera obscura (Latin for darkened chamber), a Renaissance drawing apparatus used by artists as an aid for correctly rendering perspective. Early cameras were box-like devices with an aperture at one end, and at the other, a frame holding sensitized materials that, when exposed to light, produced a photographic image. The simple box camera is the ancestor common to all photographic cameras, regardless of size or type, process or manufacturer, simple or complex, analog or digital.

Cameras contain numerous subsystems—the lens (or light-accepting portal), shutter, and light-sensitive material—that allow them to function. This is true of all cameras, from the earliest versions used by the inventors of the photographic process to the digital cameras of today. It has been the improvements to these systems, individually or in concert, that have driven camera advancement. The original system, introduced in 1839 by Louis-Jacques-Mandé Daguerre, required the photographer not only to compose and take the picture, but also to chemically sensitize and develop the image, demanding the knowledge and skills of both artist and scientist. Since then, countless individuals have sought solutions on how to improve the process in ease, portability, versatility, and transmittal.

Few consumer products have had such a long and diverse history. Alphonse Giroux was the first to produce cameras in quantity, and before long, other firms were building competitive products. In the more than one hundred seventy years since, hundreds of companies throughout the world have manufactured cameras. The George Eastman House database currently lists more than five hundred such firms from more than two dozen countries that have been involved in camera production.

Manufactured goods can be used as a barometer of economic health. High-tech products such as cameras illustrate the level of manufacturing technology possessed by a company or country, as the complexity of design and quality of components needed to build them is rather high. Cameras have become status symbols not only for their owners, but also for their manufacturers and countries of origin.

The earliest cameras were products of France and England, which not coincidentally were world leaders in producing manufactured goods at the time. Since then, manufacturing prowess worldwide can be tracked by following camera manufacturing. Eastman Kodak Company became a highly successful camera manufacturer in the early 1900s, a time when the United States was becoming a significant economic power. Camera manufacturing similarly stood out as a centerpiece of the Japanese post-World War II economic plan. And today, as China becomes a leading producer of high-tech goods, camera manufacturing is one of that country's well-established industries.

The five hundred cameras featured in this illustrated publication are selected highlights from the technology collection at George Eastman House International Museum of Photography and Film. Opened in 1949 in the home of George Eastman, founder of Eastman Kodak Company, the Museum was the first American institution whose specific mission was to collect, preserve, interpret, and display photography, motion pictures, and its related technology. In this objective the Museum had remarkable foresight. It brought new awareness to the visual media of photography and film, which had yet to attain the recognized aesthetic status of other visual arts. At the same time, the Museum acknowledged the cultural, technological, and industrial framework supporting its collected artifacts, including the camera.

Now, as then, the technology collection plays a critical role in supporting allied museum holdings while pronouncing its own unique properties as a collection of encyclopedic importance. It contains more than 20,000 artifacts, spanning the history of camera technology from its pre-history to today's integrated, handheld digital devices. In addition to cameras, the collection contains all the equipment necessary for photographic image making, as well as ephemera (film, chemistry, packaging, catalogues, etc.), and all manner of printed documentation related to the business, manufacturing, and marketing of the photographic and motion picture industries. Simply put, no other American collecting institution holds a related technology collection of such unparalleled scope and depth. Worldwide, few collections can compare in its size and historical gravity.

This book is a selected survey illustrating the breadth of the Eastman House's technology collection. Organized thematically and chronologically, these cameras, both rare and mundane, offer an insider's view into the collection, with its vast array of camera systems, applications, and processes. The cameras and accompanying text tell the interconnected story of technological invention and innovation, from its modern origins in the nineteenth century to its present-day digital manifestations.

EARLY

The photographic camera evolved from the camera obscura, a drawing device with roots dating to the late sixteenth century. Early cameras were of the sliding double-box design, fitted with simple achromatic lenses. But unlike these simple devices, the early photographic processes were rather complex, requiring the photographer to be both artist and chemist, as commercially manufactured sensitized photographic materials did not exist. Much like a meal, in which the flavor of the finished product depends on the skill of the chef, the quality of images created using these processes was completely depended on the expertise of the photographer. And much like becoming a fine chef, the best way to learn photography was to apprentice with a master.

Camera obscura *ca. 1820*

Unidentified manufacturer, France.
Gift of Eastman Kodak Company, ex-collection Gabriel Cromer. 1989:1341:0001.

For thousands of years humanity has understood that light passing through a small hole into a darkened chamber projects an inverted image of the outside scene upon the chamber's opposite wall. This is known as the camera obscura (or "dark chamber") phenomenon.

The writings of ancient philosophers Mo-Ti (470-390 BC) and Aristotle (384-322 BC) reference the device. In his *Kitab al-Manazir* (*Book of Optics*), Alhazen (965-1039 AD) compared human vision to the camera obscura. In the 1500s, it was observed that simple lenses improved the resolution and sharpness of images created by cameras obscura. Leonardo da Vinci's (1452-1519) twelve-volume set of writings and drawings, *Codex Atlanticus* (*Atlantic Codex*), contains a detailed description of the camera obscura. Giovanni Battista Della Porta (ca. 1535-1615), in his 1558 publication *Magiae Naturalis* (*Natural Magic*), may have been the first to publish images drawn with the aid of a camera obscura.

Further improvements to the camera obscura occurred in the late sixteenth and early seventeenth century. Friedrich Risner (ca. 1533-1580) suggested a portable version, and Johann Christoph Sturm (1635-1703) added the reflex mirror. Both these improvements made the camera obscura a tool easily used by artists as an aid to correctly render perspective. All photographic cameras descend from the reflex camera obscura.

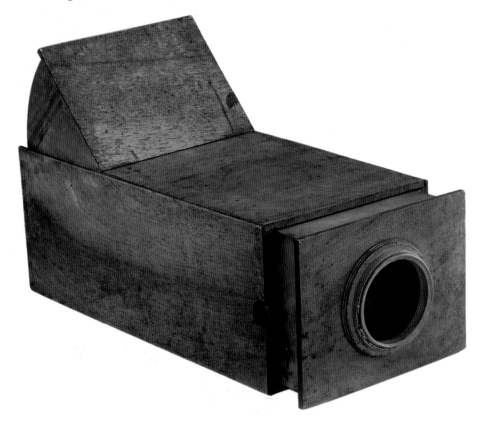

Giroux daguerreotype camera *1839*

Alphonse Giroux, Paris, France.
Gift of Eastman Kodak Company, ex-collection Gabriel Cromer. 1978:1371:0008.

The Giroux daguerreotype apparatus is photography's first camera manufactured in quantity. On June 22, 1839, L.-J.-M. Daguerre (1787-1851) and Isidore Niépce (1805-1868) (the son of Daguerre's deceased partner, Joseph Nicéphore Niépce) signed a contract with Alphonse Giroux (a relative of Daguerre's wife) granting him the rights to sell the materials and equipment required to produce daguerreotype images. Scientist and politician François Arago publicly announced the new daguerreotype process in a speech to a joint meeting of the French Academy of Fine Arts and the Academy of Sciences on August 19, 1839, and the first advertisement promoting the process appeared in the August 21 issue of *La Gazette de France*. Within three short weeks, Giroux met with popular success both in and outside of France; the first export of his company's cameras arrived in Berlin, Germany, on September 6, 1839.

The Giroux camera was an improved version of the apparatus used by Daguerre in his groundbreaking experiments in photography, now fitted with a landscape-type lens produced by Charles Chevalier, a renowned designer of optical systems for microscopes and other viewing devices. The camera is a fixed-bed, double-box camera with an attached 15-inch f/15 Chevalier lens, accompanied by a slightly smaller rear box that slides inside for picture focusing. It measures a robust 12 x 15 x 20 inches and produces an image of 6½ x 8½ inches, a size format known as a full- or whole-plate daguerreotype. It also houses a mirror held at a forty-five degree angle from the focusing glass on which an image is composed prior to loading and exposing a sensitized plate.

The Giroux was sold as an outfit consisting of a camera, lens, plate holder, iodine box for sensitizing daguerreotype plates, mercury box for chemical development, and an assortment of other items necessary to produce the unique, mirror-like images. In a nod to product marketing in an emergent and competitive industrial age, Giroux "branded" his outfit with trademark authority when he attached a plaque to his cameras inscribed with the statement: "No apparatus is guaranteed if it does not bear the signature of Mr. Daguerre and the seal of Mr. Giroux."

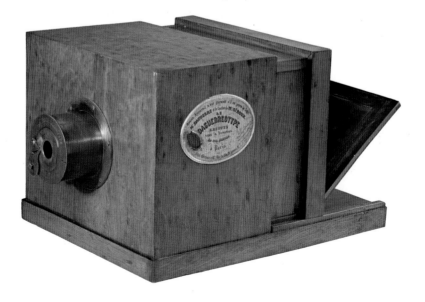

Full-plate daguerreotype camera <small>(OWNED BY S. A. BEMIS)</small> *1840*

Alphonse Giroux (attrib.), Paris, France.
Gift of Eastman Kodak Company. 1978:1792:0001.

Samuel A. Bemis (1793-1881), a Boston dentist and amateur daguerreotypist, bought one of the first cameras sold in the United States. Fortunately, he and his heirs saved not only the camera but also its receipt. While it is likely too late to return the camera, the receipt is useful as evidence of what is probably the earliest documented sale of an American daguerrean outfit. Thanks to the dentist's pack rat ways, we know that on April 15, 1840, he paid $76 to François Gouraud, Giroux's agent in the U.S., for a "daguerreotype apparatus," twelve whole plates at $2 each, and a freight charge of $1. The apparatus, which Gouraud advertised as consisting of sixty-two

items, included the camera, lens, plate holder, iodine box for sensitizing plates, mercury box for developing plates, holding box for unused plates, and a large wooden trunk to house the entire system. Quite large, the camera weighs about thirteen pounds and can produce full-plate images, 6½ x 8½ inches in size. Bemis made his first daguerreotype on April 19, 1840, from the window of his Boston office, and during the next several years went on to expose more than three hundred images, most of them in his beloved White Mountains of New Hampshire. The George Eastman House collection also contains a second Bemis camera and nineteen of his images.

Bellows camera (owned by Isidore Niépce) *ca. 1840*

Unidentified manufacturer, France.
Gift of Eastman Kodak Company, ex-collection Gabriel Cromer. 1974:0037:2113.

Thought to be the first to use a bellows, this quarter-plate camera was acquired in 1933 by Gabriel Cromer from J. Batenet, a childhood friend of Isidore Niépce (1805-1868). Isidore's father, Joseph Nicéphore Niépce (1765-1833), is credited as the first to apply the bellows to photographic instruments (though not cameras). He had earlier employed a similar device to induce air into what he called the "pyréolophore," an internal combustion engine he and his brother Claude built in 1807.

According to Cromer, Isidore had this camera constructed "at the earliest time of the Daguerreotype," using a bellows in place of the more typical double-box system of focusing. An additional feature is that the camera's base also functions as its carrying case. The front standard and bellows can be detached from the bed and stowed in a compartment in the base, enabling more convenient transport.

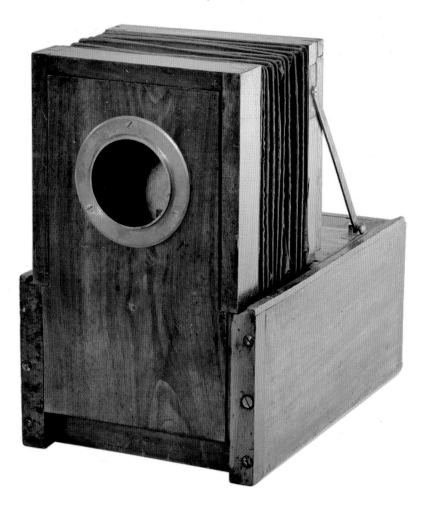

Chevalier half-plate camera *ca. 1841*

Charles Chevalier, Paris, France.
Gift of Eastman Kodak Company, ex-collection Gabriel Cromer. 1974:0037:2565.

S oon after Daguerre made his photographic process public, other manufacturers began producing cameras. Parisian optician Charles Chevalier (1804-1859), who made lenses for the experiments of both Joseph Nicéphore Niépce and Daguerre and provided the link that brought the men together, introduced a double-box camera with hinges added to the bed. This improvement allowed the bed to fold and nest at the back of the rear box, making the camera less cumbersome to transport. To further improve portability, Chevalier added a hinged brass handle to the camera's top. The camera was fitted with his Photographe à Verres Combinés à Foyer Variable, an empirically designed lens, which shortened exposure times from about fifteen minutes to three. At the front of the lens is a prism, which was used to laterally correct the otherwise reversed daguerreotype images.

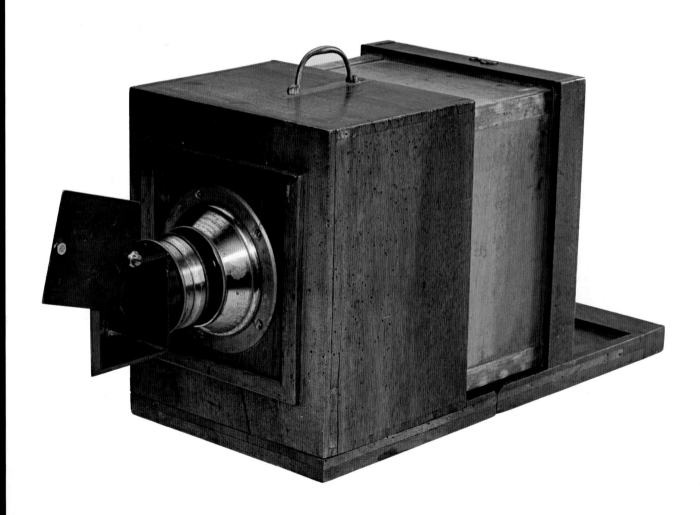

Novel Appareil Gaudin *ca. 1841*

N. P. Lerebours, Paris, France.

Gift of Eastman Kodak Company, ex-collection Gabriel Cromer. 1974:0028:3543.

Another early departure from Daguerre's Giroux camera design was the Nouvel Appareil Gaudin. Designed by Gaudin of Paris, France, the body of this sixth-plate (8 x 7 cm) camera is made of two brass tubes that slide within each other to adjust focus. The camera is built into its carrying case, which is large enough to transport the sensitizing and developing boxes as well as the rest of the items required to make daguerreotypes. On the top of the carrying case is a piece of black cloth that was raised and lowered over the lens, acting as a very simple shutter. The f/4 doublet lens was faster than that of the Giroux, which, when combined with the sixth-plate image size, made the camera suitable for portraiture. George Eastman House owns a portrait that, according to Gabriel Cromer, was made with a Gaudin camera. On front of the lens is mounted a wheel stop, a metal disc with three proportional holes used for controlling the amount of light exposing the plate.

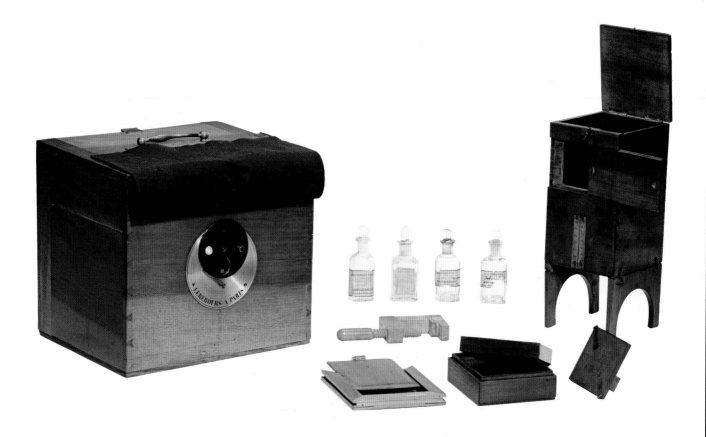

Richebourg daguerreotype outfit (QUARTER-PLATE) *ca. 1842*

A. Richebourg, Paris, France.
Gift of Eastman Kodak Company, ex-collection Gabriel Cromer. 1982:0237:0007.

Pierre-Ambroise Richebourg was apprenticed to optical instrument maker Vincent Chevalier, who supplied Daguerre with his experimental equipment. Following Chevalier's death in 1841, Richebourg took over the business of supplying cameras and lenses and expanded into giving lessons in daguerreotypy and producing portraits.

This quarter-plate Richebourg camera is of the fixed-bed double-box type, fitted with a landscape lens, with provision for a correcting mirror. It is shown with its sensitizing and developing boxes and a box for six plate holders, all of which fit into a wooden trunk bearing the Vincent Chevalier and Richebourg label inside the lid.

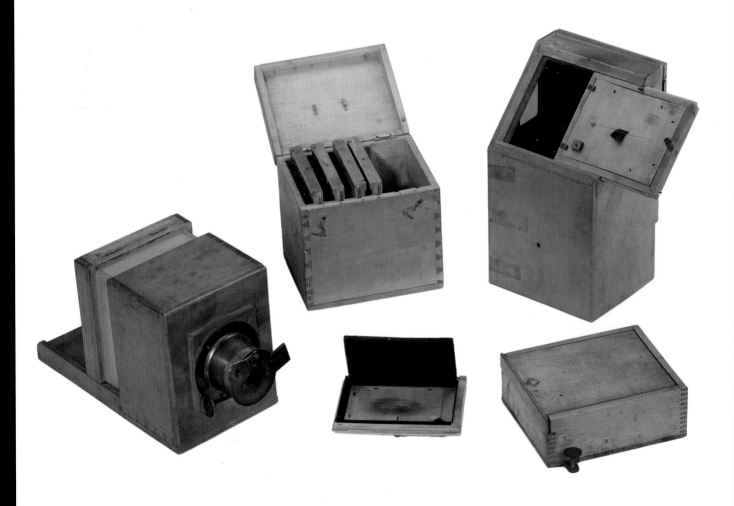

Plumbe daguerreotype camera *ca. 1842*

John Plumbe Jr., Boston, Massachusetts.
Gift of Eastman Kodak Company. 1974:0037:0093.

Dating from the early 1840s, the Plumbe daguerreotype camera is the oldest American-made camera in the George Eastman House collection. Of the double-box style, the Plumbe is similar in design to the Bemis camera, but it produced the smaller 3¼ x 2¾-inch images known as sixth plates. Unlike the Bemis, it was intended as a portrait camera. A label on the camera's back identifies it as a product of Plumbe's Daguerreotype Depot, United States Photographic Institute, Boston.

John Plumbe Jr. (1809-1857) was a civil engineer, early promoter of a transcontinental railroad, author, daguerreotypist, and publisher. He may have studied the daguerreotype process with François Gouraud in Boston, Massachusetts, in March 1840, though he certainly opened a studio in the city by late that fall. The next year, he established the United States Photographic Institute, also in Boston, and opened the first of branch galleries that he called "photographic depots." Plumbe continued to set up new studios and in 1843 opened one on Broadway in New York, a city that would soon be the center of his operations. The first American to create and franchise a chain of daguerreotype galleries, he had founded establishments in at least twenty-five towns and cities by the time of his bankruptcy in 1848. In addition to being a working daguerreotypist, "Professor" of the process, and franchiser, Plumbe also distributed daguerrean materials and equipment bearing his name.

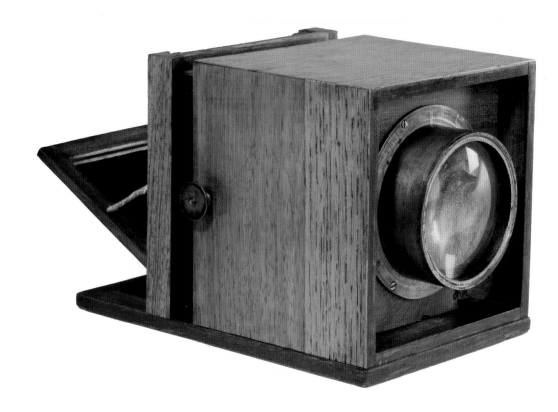

Grand Photographe *ca. 1843*

Charles Chevalier, Paris, France.
Gift of Eastman Kodak Company, ex-collection Gabriel Cromer. 1974:0028:3313.

About 1843, Charles Chevalier introduced a full-plate camera designed to be portable. The camera is of the double-box style, but the sides of the boxes are hinged. Removing the lens board at the front of the camera and the track for the plate holder at the rear allows the camera to collapse vertically from 11 inches to 3½ inches. The camera also features a rack-and-pinion focusing system; turning the large brass knob on the top of the camera adjusts the focus by moving the inner box toward and away from the lens.

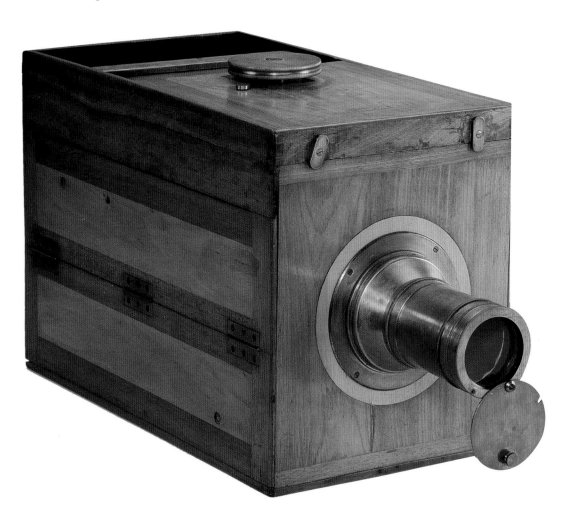

Quarter-plate French triple sliding-box camera *ca. 1845*

Unidentified manufacturer, France.

Gift of Eastman Kodak Company, ex-collection Gabriel Cromer. 1974:0037:2916.

This fixed-bed French quarter-plate daguerreotype camera employs an unusual three-box focusing system, instead of the traditional two-box design. The extra box allows the camera to telescope much like a bellows would, though there is no apparent technical advantage over the usual construction. Also unusual is the landscape lens, which is fitted with a pivoting aperture used to control the exposure.

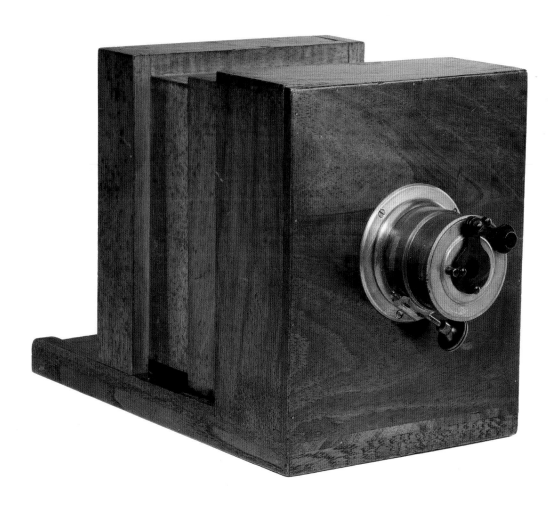

Bourquin camera *ca. 1845*

Bourquin, Paris, France.

Gift of Eastman Kodak Company, ex-collection Gabriel Cromer. 1977:0850:0007.

Judging from the way the ground glass and plate holder affix to the camera, the Bourquin dates from about 1845. It is a French-made single-box-style camera fitted with a Petzval-type portrait lens; the only means of focus is the lens's rack and pinion. Mounted on either side of the lens are dragons, which appear to support the lens but more likely were used to hold the attention of the subject, a sort of daguerrean-era version of "watch the birdie."

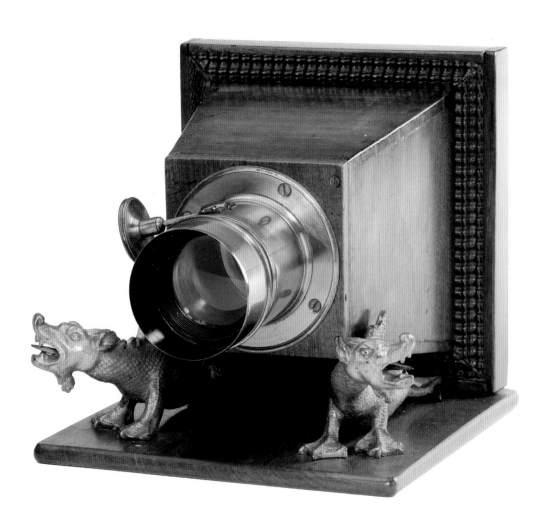

American-style daguerreotype camera *ca. 1848*

Unidentified manufacturer, United States.
Gift of 3M Foundation, ex-collection Louis Walton Sipley. 1977:0085:0004.

The style of simple box camera was produced by numerous U.S. manufacturers during the middle of the daguerreotype era, about 1845 to 1850, and is usually referred to as the American-style daguerreotype camera. The cameras came in three sizes for full, half, or quarter plates; this particular example is the quarter-plate size. The doors at the top of the camera allow access to the focusing glass and frame for the plate holder. Focusing is accomplished by the rack-and-pinion mechanism mounted on the lens, as there is no provision for focusing within the camera body.

The American-style cameras were most commonly used for portraiture and are usually fitted with Petzval portrait lenses. Introduced in 1841, Petzval lenses were about twenty times as fast as the landscape lens first used on the Giroux cameras, and they, along with more light-sensitive plates, allowed for shorter exposure times, making portraiture feasible.

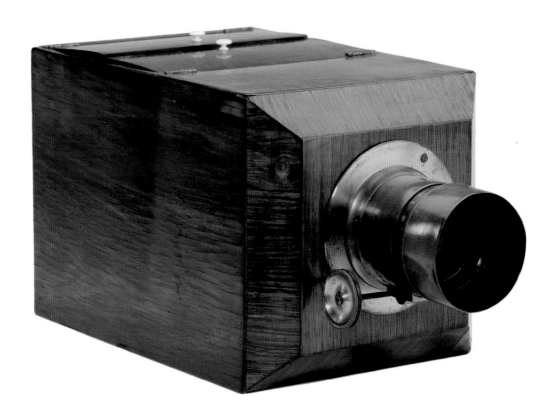

THE PHOTOGRAPHIC LENS
Martin Scott

In 1839, when photography was announced to the public, the first camera lenses were of the simplest possible construction: a single glass element. They had very little light-gathering power and were rife with image-degrading aberrations. Any spectacle-maker could turn out such a simple lens. With one of these, the photographing of a landscape in full sunlight required an exposure of a quarter hour. To sit absolutely motionless for a portrait under those conditions was beyond the endurance of most people. Yet the desire to have one's likeness made would be such a driving force in the growth of photography that it became a priority to shorten the time necessary for a portrait sitting.

Josef Petzval designed the first lens made specifically for photography in 1840. The famous Petzval Portrait Lens, along with advances in chemistry, reduced exposure times to mere seconds. Although not a lens for all applications, Petzval's was ideal for portraiture. It was an excellent example of a designer building a lens to a very specific application. His lens had good center-field sharpness, where the sitter's face would be imaged, and less sharpness elsewhere. In a portrait we always look to the face and pay little attention to the rest of the image. For architectural photography, in which all parts must be equally sharp and square buildings must be square, not bowed, such a lens would not do.

To design a lens for sharp imaging under all light conditions requires correction of the aberrations that plague simple lenses. This requires using multiple glass elements. Until the mid-twentieth century, designing such a complex lens demanded months of laborious calculations and six-figure accuracy. How did Petzval design his four-element lens so quickly, barely a year after photography was born? He conscripted a platoon of gunnery officers from the Bavarian Army, men whose professional training made them facile with computations involving logarithms and trigonometric functions. Today, that platoon is replaced with digital computers and clever software.

There is no universal photographic lens for all applications. The great variety of photographic lenses necessarily stems from the varying requirements of different applications, as well as from the need of manufacturers to avoid each other's patents. Early lens designers often made elaborate aesthetic claims for their portrait and landscape lenses, claims that might make today's lens designers smile—or wince. Lenses with

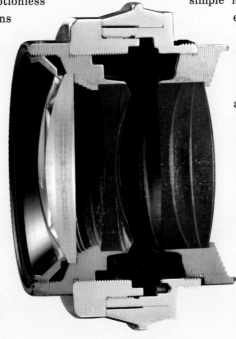

Ilex Anastigmat lens, sectioned, ca. 1910.
Ilex Optical Company, Rochester, New York.
1978:0410:0001.

intentionally uncorrected aberrations lent a dreamy, atmospheric quality to landscapes. Other lenses, designed with a limited ability to record fine detail, softened the wrinkles of aging dowagers. In the late nineteenth century portrait lenses could be amended with an attachment that made the sitter appear slimmer. Care was needed in fitting this to the camera, for if not mounted correctly, it would produce the opposite effect! In portraiture, flattery is more important than truth.

Today most camera lenses strive for some degree of broad application. This is the type supplied as the basic lens for professional cameras. The professional photographer will then select other lenses according to business needs: broad sweeping views, very distant scenes, minute objects, portraits, architecture, wildlife, low-light situations, or sports action.

Lenses for casual photographers today are usually integral to the camera, restricting any variation to within the built-in optics. Such lenses can zoom, that is, change their focal length, thus altering the angle of view and the size of things in the image. At the short focal length setting, they encompass a wide field of view; at the long setting, they depict a narrow field with an enlarged view of distant objects. Today, high-technology imaging has effectively hidden itself, turning photography into an almost thoughtless event, epitomized by the shrinking of the digital camera and its lens into but a single component of a multi-tasking cell phone.

Adapted from Martin L. Scott, Rudolf Kingslake: His Life and Professional Career in Optics *(Rochester, NY: University of Rochester Press, 2011).*

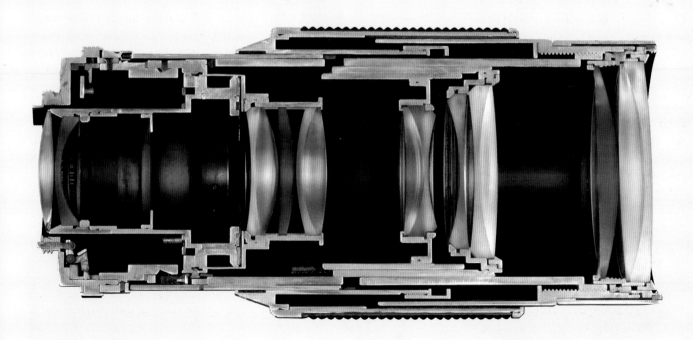

Vivitar Series 1 zoom lens, ca. 1975. Vivitar Corporation, Tokyo, Japan. Gift of Ponder and Best, Los Angeles, California. 1983:1421:0098.

Ninth-plate sliding box camera *ca. 1850*

Unidentified manufacturer, France.

Gift of Eastman Kodak Company, ex-collection Gabriel Cromer. 1995:2625:0001.

This is the smallest double-box camera in the George Eastman House collection. Fitted with a Hermagis landscape lens, it produced an unusually sized 1½ x 2-inch image. Accompanying the camera is a glass-lined iodizing box, the earliest style used to sensitize daguerreotype plates. A second accessory is a daylight magazine-loading plate box, suggesting the camera may have had a long working life, perhaps in an amateur's hands. The box would have allowed the camera to use dry plates, which appeared on the photographic scene nearly forty years after the camera was manufactured.

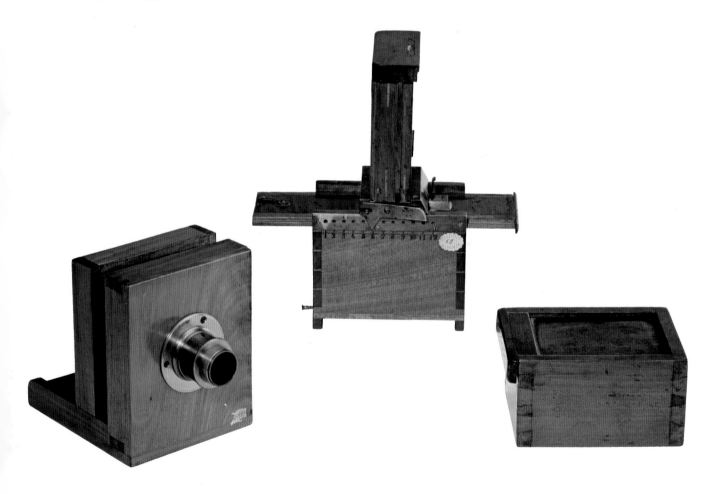

Lewis daguerreotype camera (QUARTER-PLATE) *ca. 1851*

W. & W. H. Lewis, New York, New York.
Gift of Robert Henry Head. 1974:0037:2887.

In 1851, W. & W. H. Lewis of New York City introduced a fixed-bed bellows camera that became one of the most popular with daguerrean studio photographers. Similar in appearance to the earlier American-style chamfered box camera, this style had the bellows inserted into the middle of the camera body. This was done to facilitate the copying of daguerreotypes, which, being unique objects, could be duplicated only as a second, in-camera copy of the original.

Initially a partnership of the father and son William and William H. Lewis, the firm changed hands several times while the basic style of its camera remained the same. Other known manufacturers of this type of camera include Gardner, Harrison & Company, Palmer & Longking, and H. J. Lewis, as well as unidentified makers. This particular camera is quarter-plate in size; others were made in half-plate and full-plate sizes.

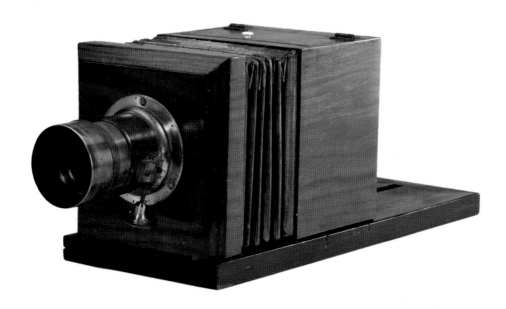

DAGUERREOTYPE
Mark Osterman

There are many ways to record the effect of light, photography being the most popular. The invention of photography was not really about creating an image with light, but rather, keeping that image. The actual invention might be set at different dates by those who can support their argument, but nearly all agree that the first practical system of making permanent images with light was introduced to a group of curious Parisians on January 7, 1839. The process was devised a few years earlier by Louis-Jacques-Mandé Daguerre (1787-1851), inventor and owner of a popular entertainment called the Diorama.

Fig. 82. **Salting the Paper.**

Salting the Paper, ca. 1863. Woodcut. From D. Van Monckoven, *A Popular Treatise on Photography*, London: Virtue Brothers & Co., 1863.

The daguerreotype was based on earlier important experiments by Daguerre's late partner, Joseph Nicéphore Niépce (1765-1833). Daguerre polished silver-plated copper plates and suspended them, silver side down, over dark purple flakes of iodine. The iodine-fumed silver surface became yellow, forming light-sensitive silver iodide. A special holder was then used to carry the sensitized plate to the camera, where the exposure was made by uncovering the lens.

In 1839, daguerreotype exposures were measured in minutes—around eighteen to twenty-five for a landscape, even on a sunny day. The invisible image was revealed by placing the plate over heated mercury until a picture was formed. A quick treatment in salt water and a final wash in clean water completed the process.

When Daguerre demonstrated his invention, most who bore witness didn't understand the concept and couldn't believe the result. Daguerre was limited only by the quality of the lenses available to him, and his process was nearly perfect. Every detail of the original subject was recorded in white frosty deposits on the mirror-like surface of the polished silver. However, the image was as delicate as the powdery scales on a moth's wing; the pictures could be wiped off by a single touch of the finger.

By 1840, better quality lenses, additional fuming with bromine and chlorine, and gilding with gold chloride made the process much more light sensitive and the resulting diaphanous pictures more durable. More important, these improvements meant that daguerreotypy could be used for commercial portraiture in a skylighted studio, thereby stimulating the evolution of daguerrean equipment and

Daguerre and Niépce de St. Victor, ca. 1845, by Albert Chéreau. Lithograph with applied color. From series *Les Grands Inventors, Anciens et Modernes*, by Alfred des Essart, ca. 1845. Gift of Eastman Kodak Company.

setting the process on a path that took it to the outermost limits of the civilized world.

PAPER NEGATIVES

At nearly the same time as Daguerre, English scholar William Henry Fox Talbot (1800-1877) was working on a completely different silver-based technique that was applied to paper. Talbot's *photogenic drawing* process produced a negative on paper that was sensitized with silver chloride. He placed objects on the sensitive paper, creating photograms, and then made images by exposing the sensitized material within small cameras. Exposure to sunlight printed a visible negative image on the paper. The resultant image was much less sensitive than the daguerreotype and not stable enough for display. In 1841, Talbot improved his original technique by switching to silver iodide, making his *calotype* process one hundred times more sensitive than before and better suited to exposures within a camera. He also perfected his fixing method.

Talbot's calotype technique allowed a photographer to make many positive photographic prints from one paper negative. Unfortunately, even the improved process was still not sensitive enough to be used in a studio, relegating it to landscape work and portraits taken outdoors. While the calotype and other paper negative processes were never to reach the commercial success of the daguerreotype, they laid the conceptual and chemical groundwork for the negative/positive photography, which only now has been superseded by digital imaging.

GLASS NEGATIVES

Negatives on glass were a natural step in the technical evolution of the negative. Like the calotype, the first glass negatives invented by Niépce de Saint Victor (1805-1870) in 1846 relied on the light-sensitive compound of silver iodide. Albumen (egg white) was used as a binder to make the chemicals adhere to the glass. The *niépceotype* process was capable of incredible resolution, even by today's standards, but the process was even less sensitive than the calotype, challenging experimenters to find a more suitable process for live subjects.

The *wet collodion* process, first published in 1851 by English calotypist Frederick Scott Archer (1813-1857), also had very high resolution and was capable of much faster exposures. It was based on the use of collodion, a nitrocellulose solution made by dissolving nitrated cotton in ether and alcohol into which was suspended potassium iodide. The process was so named because it was used wet, the glass plates being coated immediately before exposure and developed before the sensitive coating dried. Collodion containing potassium iodide was poured onto the plates and the clear film allowed to set before the iodized plates were then sensitized in a solution of silver nitrate. After processing, the negatives were varnished and used for printing on albumen or salted paper.

By the mid-1850s, improvements in the collodion and developer formulas made the process sensitive enough to use in a studio for commercial work. At the same time, direct positive variants of the collodion process such as the ambrotype and tintype, which were more sensitive and cheaper than the daguerreotype, were also becoming popular. Cameras manufactured at this time allowed use of the daguerreotype, calotype, niépceotype, and the collodion process variants with no significant design differences except the "shield" that held the sensitive paper or plate.

The wet collodion negative process was never more sensitive than the daguerreotype, but the possibility of offering multiple prints from one negative eventually became the standard of nineteenth- and twentieth-century portraiture. By the end of the 1850s most daguerreotype portrait studios had switched to using one of the three collodion variants. The collodion negative process was also used in various moist, dry, and emulsion variants but was eventually made obsolete for many purposes when silver-bromide gelatin emulsion technology became established in the mid-1880s. Collodion plates continued to be used in graphic arts applications until the 1950s.

Fɪɢ. 33. — Appareil de voyage américain développé et ouvert.

Appareil de Voyage Américain Développé et Onvert. (American field darkroom). Woodcut. From A. Liébert, *La Photographie en Amérique Traité Complet de Photographie Pratique*. Paris: En Vente Chez L'auteur A. Liébert, 1874.

GELATIN EMULSIONS

The first serious attempts in making silver-bromide gelatin emulsions were in the early 1870s by Richard Leach Maddox (1816-1902). The basics had been worked out well enough in 1880 to spawn a new industry producing negative plates good enough to compete with collodion technology. Factory-made gelatin emulsion plates were initially coated by hand. Hot emulsions were poured onto the plates that were chilled on slabs of leveled marble and then racked to dry in the dark. One of George Eastman's first contributions to the technical evolution of photography was to design reliable machines to automatically coat both plates and photographic paper.

Eastman's next innovation was to produce a flexible film and the device to move the film within the camera for successive exposures. William Walker and George Eastman introduced the Eastman-Walker roll film holder in October 1884 to transport Eastman's newly invented *American film*. The film was a length of paper initially coated with a layer of soluble gelatin and then a second layer of sensitive gelatin emulsion. Once exposed, the gelatin layer bearing the exposure was stripped from the paper, processed, and slid onto a sheet of glass for printing. This was the first film to be used in Eastman's famous Kodak camera of 1888.

Shortly thereafter the paper film backing of the American film was replaced with clear nitrocellulose plastic. The product worked very well, and there was no need for stripping off the negative record; prints could be exposed right through the flexible plastic backing. The democratization of photography owes much to the invention of *nitrate film*. Cameras and films became cheaper, and the average person could finally create his or her own photographic family archive, reducing dependence on professionals.

Nitrate film, however, proved to be dimensionally unstable in storage and was also extremely flammable. Safer plastics were invented in the early 1920s, and by the 1950s, they had completely replaced nitrate film. Flexible films in many different formats and gelatin emulsion glass plates continued to be manufactured throughout the twentieth century.

The Kodak Camera, ca. 1891. Woodcut. From *The British Journal Almanac and Daily Companion Advertisements*. London: H. Greenwood & Co., 1891.

The year 2010 marked the one hundred seventy-fifth anniversary of the invention of the first photographic negative by William Henry Fox Talbot. The negative used to be important; it was the basis of nearly all the photographic images we have created and celebrated in our own lifetime. With digital imaging eventually overtaking twentieth-century chemical photography, it is important to remember that every camera ever made still shares basic elements. All cameras are essentially dark chambers that allow light to enter from one end and contain the means to record that light on the other.

Mark Osterman, Process Historian, George Eastman House, International Museum of Photography and Film

Chambre Automatique De Bertsch *ca. 1860*

Adolphe Bertsch, Paris, France.
Gift of Eastman Kodak Company, ex-collection Gabriel Cromer. 1974:0028:3315.

Adolphe Bertsch's Chambre Automatique was a portable wet-plate kit consisting of a camera, darkroom, and the rest of the equipment and chemistry necessary to sensitize and process wet-plate images. The carrying case also served as the darkroom, complete with an amber glass safelight mounted in the lid; a wooden panel with a sleeve covered an opening at the box's hinged front to allow light-tight access. The term "Automatique" in the kit's name refers to the fixed-focus nature of the camera and lens. Images were composed within the black wire frame finder located on the camera's top.

This example is fitted with a four-inch lens with a small, fixed aperture, f/20, to achieve sharp focus for objects from about five feet and beyond. Bertsch produced these camera/kits in a variety of sizes and styles, for both landscape and portraiture, as well as stereo images. Enlargements were possible using the Megascope, Bertsch's solar enlarger.

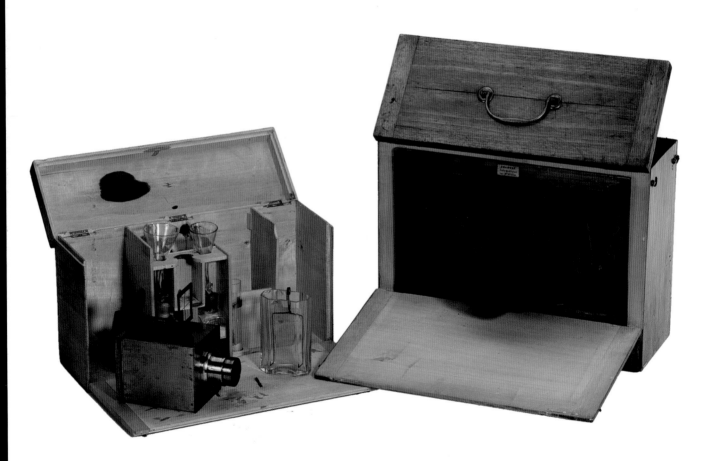

Wet-plate monorail view camera *ca. 1860*

Charles Chevalier (attrib.), Paris, France.
Gift of Eastman Kodak Company, ex-collection Gabriel Cromer. 1978:1371:0055.

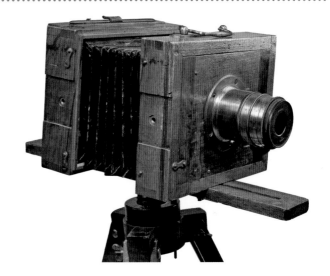

Chevalier's monorail camera, of about 1860, is the earliest camera of this style in the George Eastman House collection. As the name implies, the design made use of a monorail, employing a single beam to support both front and back standards of the camera and connecting them with a light-tight flexible leather bellows. This allowed maximum movements for perspective control. The monorail was an integrated part of the tripod, with both standards attached to the rail by thumbscrews. The fixed standards gave a rigidity to the camera that made for easier transport.

Sliding-box camera (OWNED BY M. B. BRADY STUDIO) *ca. 1860*

Nelson Wright (attrib.), New York, New York.
Gift of Graflex, Inc. 1974:0028:3261.

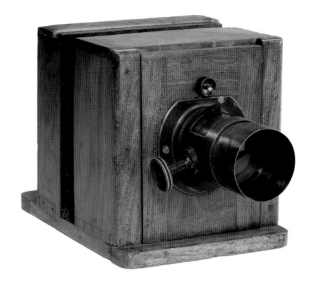

Fixed-bed double-box cameras date back to the original design specified by Daguerre. They were made in numerous sizes and remained popular into the 1860s. This quarter-plate (3¼ x 4¼-inch) version was made by Nelson Wright and is fitted with a C. C. Harrison Petzval-type portrait lens. Both manufacturers were acquired by Scovill Manufacturing Company, one of the oldest photographic manufacturing firms in the United States. The camera was found with an assortment of Mathew B. Brady (ca. 1823-1896) glass plates in Auburn, New York, hence the Brady Studio association.

Stanhope camera *ca. 1860*

René Prudent Dagron (attrib.), Paris, France. 1983:1421:0085.

The microscope plays a role in the production of two types of photography with confusingly similar names: photomicrography and microphotography. In a practice almost as old as photography itself, photomicrographs picture very small things that have been magnified, usually through a microscope. On the other hand, microphotographs are very small images that can be viewed only through magnification. The first examples of these also date to the infancy of the medium and were made by Englishman John Benjamin Dancer (1812-1887), though it would be another decade or so before he made any of a high technical quality. When Dancer shared his tiny images with Sir David Brewster, the Scottish scientist suggested using Lord Stanhope's magnifying lens as a simple way to view them.

René Prudent Dagron (1819-1900), a daguerreotypist by trade, designed and patented a camera system to mass produce microphotographs, or what he called "bijoux photographiques" (photographic jewels), more commonly know as Stanhopes. Dagron's method involved copying a photographic negative through a series of exposures that resulted in as many as 450 positive 2 x 2-mm images on a single plate.

The reducing camera's lens board had an arrangement of twenty-five very small lenses mounted in five rows and five columns. As the lens board was shifted vertically to reposition the array for each new exposure, the repeating back, which held a sensitized plate, was moved horizontally. The stability of the nearly six and one-half-pound solid brass apparatus permitted the precise movements needed to compactly fill a 4.5 x 8.5-cm wet-collodion plate with microscopic images. After processing, the images were cut out and affixed to a Stanhope lens, a glass cylinder with a refracting surface at one end, which could be mounted in a variety of ornamental objects.

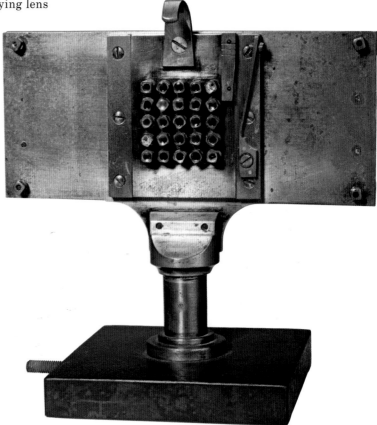

Folding tail-board camera (OWNED BY NADAR) *ca. 1860*

Unidentified manufacturer, France.
Gift of Eastman Kodak Company, ex-collection Gabriel Cromer. 1974:0028:3510.

According to the collector Gabriel Cromer, this camera belonged to the well-known French portrait photographer Nadar (Gaspard-Félix Tournachon, 1820-1910). The camera is a folding-bed 5 x 7-inch wet-plate bellows type, and it employs a bed-mounted rack-and-pinion focusing system. It was produced by an unidentified French manufacturer.

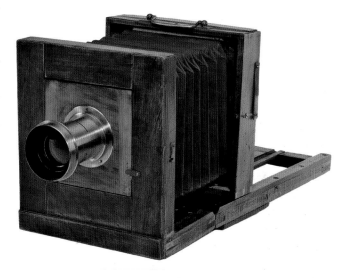

Lewis wet-plate camera *ca. 1862*

H. J. Lewis, New York, New York.
Gift of Polaroid Corporation. 1981:2814:0005.

Manufactured by H. J. Lewis of New York City and typical of Civil War-vintage studio equipment, this repeating back bellows camera produced two 3¼ x 4½-inch images on 4½ x 6½-inch wet plates. The large box at the back of the camera was used to index the plate holder. The camera's finish has a lovely patina, acquired from both age and heavy use, illustrating its workhorse status.

Manufacturer and camera were directly related to W. & W. H. Lewis and their daguerreotype camera. Genealogically, Henry James Lewis was the second son of William and younger brother to William H., while the camera is stylistically a direct descendant of the daguerreotype apparatus, even retaining the Lewis cast-iron bed locknut.

Thompson's Revolver Camera *ca. 1862*

A. Briois, Paris, France.

Gift of Eastman Kodak Company, ex-collection Gabriel Cromer. 1974:0037:0090.

One of the earliest handheld cameras, Thompson's Revolver produces four one-inch diameter images on a single three-inch diameter wet plate, making it among the first to yield multiple images on circular plates. It also is one of the first "inconspicuous" cameras, meaning it has an atypical appearance. Of course, someone carrying such a camera will surely be conspicuous in the usual sense. In use, the 40mm f/2 Petzval-type lens locks at the top of the camera for focusing and framing the image. Pressing the button located at the three o'clock position on the camera's drum-shaped body allows the lens to then slide down to the picture-taking position, trip the rotary shutter, and expose the plate. Afterward, the disc rotates ninety degrees for the next exposure.

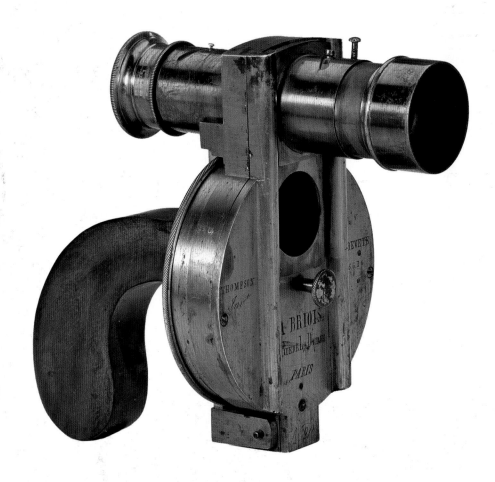

DRY PLATE

The introduction of commercially manufactured dry plates—silver gelatin emulsions on glass substrate—changed both photography and the photographic industry. Several companies, Cramer of St. Louis, Carbutt of Philadelphia, and Eastman of Rochester, introduced these plates in 1880, creating the sensitized materials industry. Dry plates created a new class of photographer, the amateur. Cameras designed to use the new media took advantage of the pre-prepared nature of the plates, differing from the preceding wet plates in appearance, function, and style. Cameras could now be fitted with quick-changing plate magazines, and as the speed of the plates increased, shutters became necessary to control faster exposures, which allowed cameras to be hand-held.

Tourograph No. 1 *ca. 1881*

Blair Tourograph & Dry Plate Company, Boston, Massachusetts.
Gift of H. Edward Bascom. 1974:0037:2469.

Designed for the challenges of landscape photography, the 1881 Blair Tourograph No. 1 was the first dry-plate camera manufactured in the U.S. The self-contained and portable apparatus was touted as "Photography in a Nut Shell." Sliding front doors protected the lens, and the 5 x 7-inch dry plates were stored within the camera body for transport. In use, an indexed magazine of twelve plates was held in the smaller box located above the camera. Opening a brass dark slide located under each plate allowed the plate to gravity drop into the gate for exposure. Afterwards, the photographer manipulated the exposed plate back into the magazine through a cloth sleeve located at the back of the camera, then closed the dark slide. This procedure was repeated until all plates were used. Its retail price was $30.

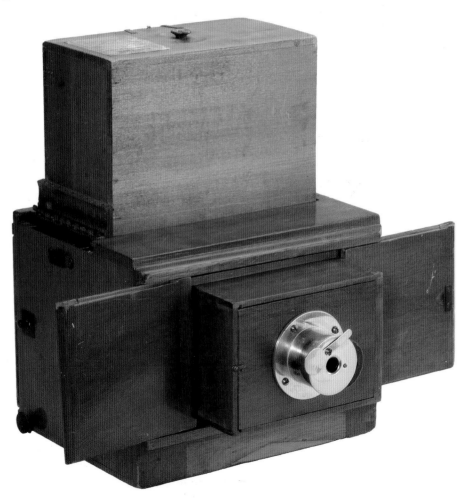

Box camera *ca. 1880*

L. Dowe, San Francisco, California. 1974:0028:3554.

This large wooden dry-plate camera bears little in the way of identification except for two brass parts stamped "L. Dowe, Maker." One Lewis Dowe was a California photographer active for at least fifteen years during the last quarter of the nineteenth century, about ten of them in San Francisco. Perhaps he made this camera. Although simple in appearance, it was well designed and constructed. Built mainly of mahogany, Dowe's camera was fitted with a periscopic lens from R. D. Gray of New York. A sliding box mount for the plate holder facilitated focusing. From the camera's top, the movable box was operated by a brass lever that had a pointed end and a small knob, which the photographer would lift and move to the proper setting. A tiny pin on the pointer would drop into one of ten holes on the brass distance scale. The shutter was a spring-powered guillotine type that could be set for different speeds by placing the spring end in one of the seven notches provided. Access to the shutter and the aperture wheel was by a hinged door on the front, and a pivoting paddle-shaped cover protected both the taking and finder lenses when the camera was not in use. The camera had a leather carrying strap but no tripod mount.

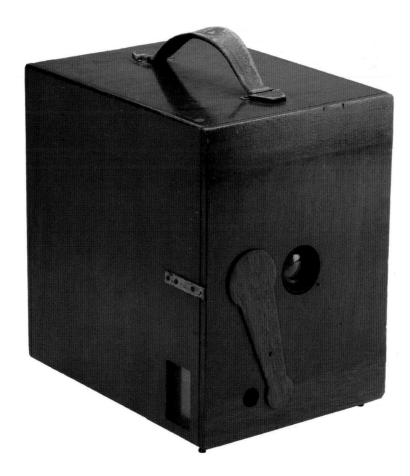

Walker's Pocket Camera *ca. 1881*

William H. Walker & Company, Rochester, New York.
Gift of George C. Clark. 1974:0037:1600.

"Photography made easy for everybody" was William H. Walker & Company's advertising slogan for Walker's Pocket Camera in 1881. The Rochester, New York firm sold the wooden box camera for $10, including a double holder for 2¾ x 3¼-inch plates. Although it's doubtful anyone had a pocket roomy enough to carry the camera, ease of operation was as claimed. A swiveling tripod mount allowed easy leveling. Slipping the gravity-powered shutter assembly from the 3½-inch f/7.7 achromatic meniscus lens allowed the subject to be viewed on the ground glass back. With the shutter replaced and set in the upper position, the viewing door was opened and the holder snapped in place. When the shutter release was pulled, the exposure was made.

Walker & Company sold all supplies needed for developing and printing the pictures. It was one of the few camera firms using the "American System" of manufacturing, where parts were made to standard dimensions and were interchangeable between units, a practice that drastically cut costs and increased profits. William Walker later worked for George Eastman on the roll holder that would make the Kodak possible and Walker's Pocket Camera obsolete.

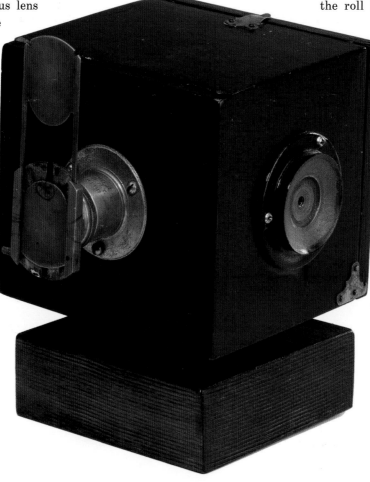

Herzog Amateur Camera (improved model) *ca. 1882*

August Herzog, New York, New York.
Gift of Eastman Kodak Company. 1982:0237:0010.

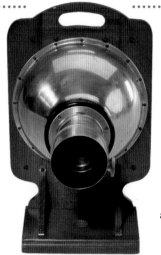

The Herzog Amateur Camera looks like anything but a picture-taking device. Its designer, August Herzog of New York, started business in the 1870s with his first Amateur camera. The wood and cardboard construction of that very simple dry-plate camera helped keep prices low enough for the average family budget. Although promoted as a children's toy, the Herzog Amateur was used by many adults due to its simplicity. In order to better serve that end of his market, Herzog redesigned the camera; this was the final version. Nickel-plated brass replaced cardboard, and the wood base was reinforced. The 3½ x 4½-inch dry plates were exposed to light fed through the Darlot 160mm f/4.5 Petzval-type lens. A knurled knob for the rack and pinion operated the sliding tube focus mount. Waterhouse stops could be inserted by the photographer, based on conditions. The plates of the day weren't sensitive enough to need a shutter, so the lens cap was removed to make the exposure. Herzog's patented plate holder allowed the media to be loaded in either a vertical or horizontal orientation.

Photo-Revolver de Poche *ca. 1882*

E. Enjalbert, Paris, France.
Gift of Eastman Kodak Company, ex-collection Gabriel Cromer. 1974:0084:0022.

The 1882 Photo-Revolver de Poche, made by E. Enjalbert in Paris, not only looked like a handgun, it was operated like one. Ammunition in the form of ten 20 x 20-mm dry plates was loaded in the cylinder, waiting to be exposed by the periscopic 70mm f/10 lens inside the nickel-plated brass barrel. The shutter release was, naturally, the pistol's trigger. After each picture, the shooter thumbed the hammer back, rotated the cylinder a half-turn, and listened for the click indicating the exposed plate had entered the storage chamber. Turning the cylinder back again placed a new plate in position behind the shutter. The Photo-Revolver de Poche had no viewfinder, but it did have a front sight to help you draw a bead on your target.

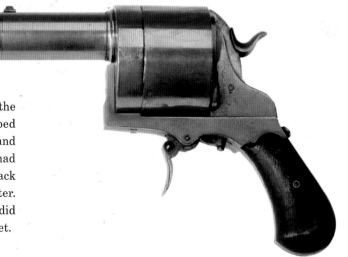

Instantograph (QUARTER-PLATE) *ca. 1882*

J. Lancaster & Son, Birmingham, England.
Gift of Elmer B. Cookson. 1974:0037:0132.

This early example of a quarter-plate Lancaster Instantograph of about 1882 shows the lens panel secured from below with thumbscrews through slots in the focusing slide. The arrangement was effective but prevented the camera from sitting level on a flat surface.

This changed in 1886 when the camera was redesigned as a folding model. It had a front-mounted rotary shutter that provided various instantaneous speeds by adjusting spring tension. A knob at the back turned a worm gear to focus. Well made and compact, it proved quite popular. In an advertisement from 1907, Lancaster claimed more than 150,000 had been manufactured. Its list price was £22.

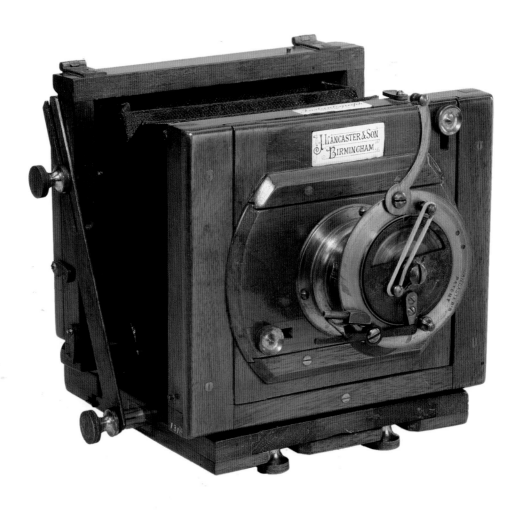

American Challenge Swivel-Bed Camera *ca. 1883*

Rochester Optical Company, Rochester, New York.
Gift of Eastman Kodak Company. 1997:0209:0001.

A very early monorail design, the American Challenge was a polished cherry wood camera atop a metal bed with an integral tripod head that swiveled. The square body could make 4 x 5-inch images in either horizontal or vertical positions. A sliding lens board allowed the lens to rise and fall, and the lens could be reversed for storage inside the camera body for transport. Rochester Optical Company claimed it to be one of the most compact cameras made. Fully collapsed, it was just over two inches thick. In 1883 the Challenge retailed for $20.

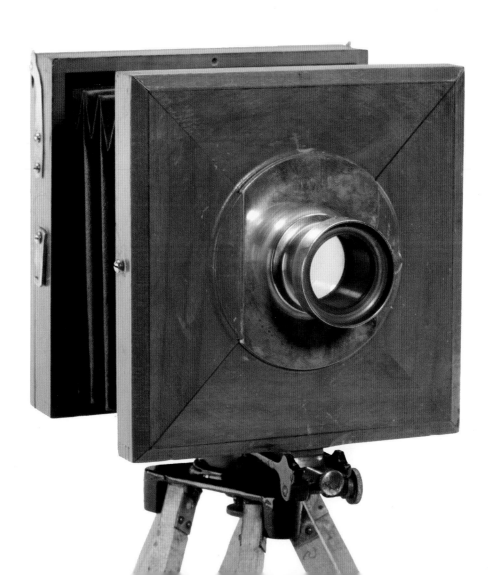

Anthony's Patent Novelette View Camera (4 x 5) *ca. 1884*

E. & H. T. Anthony & Company, New York, New York. 1974:0084:0028.

Anthony's Patent Novelette View Camera was designed for a quick change from a horizontal to vertical format. Keyhole slots in the back engaged screw heads in the bed so that a slight movement to the side released the back. Then the bellows pivoted on the front, allowing the back and bellows to rotate together and be secured with a second set of keyhole slots. The Novelette camera was also available in a special long bellows version for view, portrait, or copy work requiring closer focusing. This 4 x 5 camera cost $15.50 in 1891.

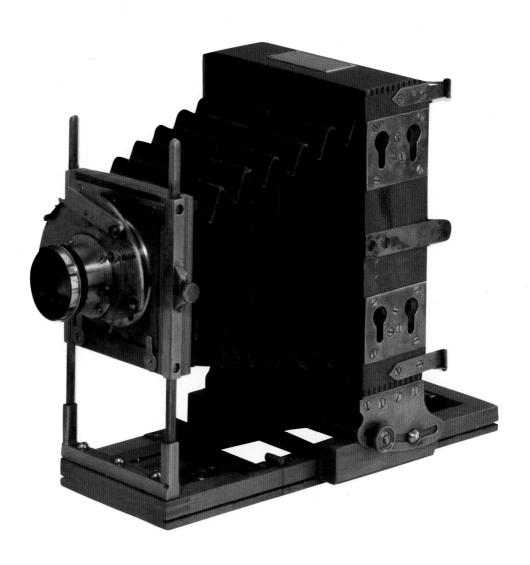

Patent Academy Camera No. 4 *ca. 1885*

Marion & Co., London, England.
Gift of Eastman Kodak Company. 1974:0037:2120.

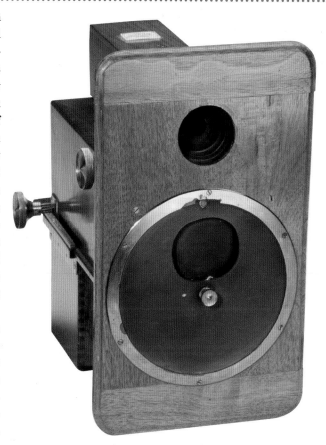

When gelatin dry plates replaced the wet-collodion process in the 1880s, it became possible to build magazines that could hold a quantity of plates, eliminating the need to remove each one after exposure. With its under-tray system, Marion & Company's Patent Academy cameras made loading and changing plates easier than ever before. The firm's No. 4 model was constructed of mahogany using exquisite English joinery and came with a wooden magazine that held twelve 4¼ x 3¼-inch dry plates, each in its own slot. Rotating a brass knob moved the tray while a rack-and-pinion mechanism lined up a fresh plate with a slot in the camera body. The plate was inserted by pulling a knob on the back and then turning the camera upside-down. Gravity dropped the plate into place. The photographer then released the knob and turned the camera right side up. The rotary shutter was set by turning another brass knob against the spring until it locked.

Focus was the job of still another brass knob and another rack-and-pinion gear set. A viewing lens atop the main box projected the image onto the ground glass screen, and the main or "acting" lens moved with the top viewer. When framing and focus were achieved, the shutter was tripped, and the plate exposed. The rear knob was again pulled, the camera inverted, and the plate returned to its allotted space in the tray. The process could be repeated until all twelve plates were exposed.

Using gravity to load and unload plates made the Academy series much less troublesome than cameras that used various linkages and transfer mechanisms to change plates. Academy magazine trays had to be loaded and unloaded in the darkroom, but the entire tray could be removed and replaced with a fresh one in daylight.

Flammang's Revolving Back Patent Camera *ca. 1885*

American Optical Division, Scovill Manufacturing Company, New York, New York.
Gift of Mr. and Mrs. C. S. Perkins. 1983:0904:0001.

Most of today's camera users are familiar with the terms "portrait" and "landscape" to describe the orientation of a rectangular picture format. Photographers using handheld cameras routinely hold them at ninety degrees, in a portrait orientation, to snap subjects that are taller than they are wide. Film cameras, especially the 35mm variety, were easy to turn ninety degrees for vertical-format shots. In the nineteenth century, however, things were different. Cameras were much larger then, and using them sideways wasn't so easy. One solution was invented by the E. & H. T. Anthony Company in the form of a camera back and bellows assembly that could rotate from horizontal to vertical. An even simpler method, in which only the plate holder rotated, was patented by Mathias Flammang. The latter design was adopted by Scovill Manufacturing's American Optical Division in New York for its Revolving Back view cameras, a series of dual-format equipment offered in fifteen different sizes, ranging from 4 x 5 inches to a 25 x 30-inch monster.

This 11 x 14-inch Flammang's Revolving Back Patent Camera listed for $70 in the Scovill catalog. Lenses and shutters could easily add another $100, and $30 more bought the Eastman-Walker holder for roll films. In 1888, this added up to a lot more than pocket change, and for that money the premium mahogany construction was expected. Metal parts were made of brass, with a sag-proof rubberized cloth bellows completing the package. Focus was achieved by means of a rack-and-pinion mechanism that moved the rear standard, which also had swing and tilt adjustments.

The Flammang back was also used on a few other Scovill cameras, and the feature was incorporated by several manufacturers in the century that followed, among them Graflex and Mamiya. Universal fit rotating backs were built in different sizes as well.

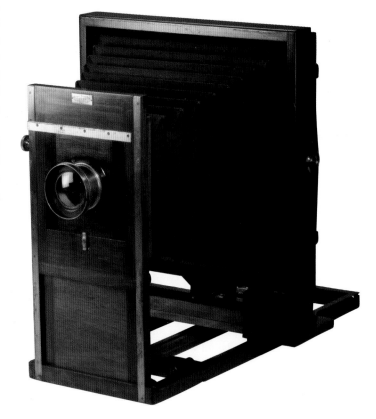

Waterbury View Camera _ca. 1885_

Scovill Manufacturing Company, New York, New York. 1974:0028:3467.

The 6½ x 8½-inch Scovill Waterbury Camera Outfit, introduced in 1885, included the camera, double plate holder, wooden carrying case, tripod, and a Waterbury lens with a set of stops. Manufactured in three sizes by the American Optical Company and made of polished blond mahogany, the camera had a fixed front standard and a folding rear bed made rigid with a patented latch. Movements were limited to a single rear swing and front rise. Introduced in 1888, the Prosch Duplex shutter was a later improvement. In 1885, the outfit cost $20; adding an Eastman-Walker roll-film holder brought the price to $44.

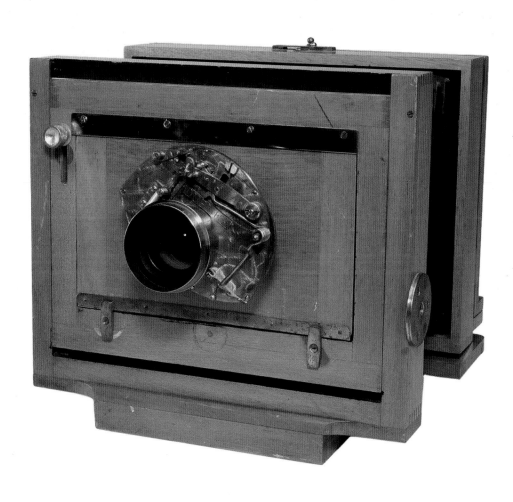

New Model Improved Camera *1888*

Rochester Optical Company, Rochester, New York.
Gift of 3M, ex-collection Louis Walton Sipley. 1977:0415:0200.

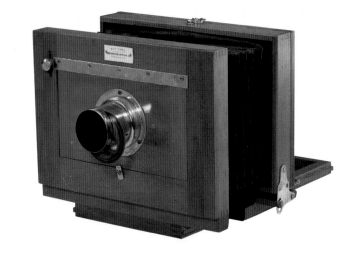

Produced in sizes from quarter plate (3¼ x 4¼ inches) to 8 x 10 inches, the Rochester Optical Company's New Model Improved Camera was intended for amateur photographers looking for a quality view camera at a reasonable price. The 1893 ROC catalog lists this full-plate (6½ x 8½-inch) version for $22, which included the Single View (landscape) lens, a double plate holder, tripod, and carrying case. The camera itself was a polished Honduras mahogany body with nickel-plated fittings, rack-and-pinion focusing, front rise, and rear swing. To put this into perspective, the firm's most expensive models, the Carlton and Universal View cameras, listed in the same catalog at more than twice the price, not including lenses.

Miniature Rochester Optical View with Tripod *1988*

Harvey Libowitz, Brooklyn, New York. 1988:0290:0001.

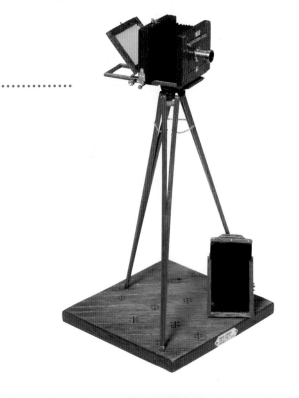

The tripod-mounted miniature version of the Rochester Optical Company's New Model View Camera was made by Harvey Libowitz of Brooklyn, New York. At 5¾ inches high, tripod included, it is not merely a doll house toy but a working 35mm camera. Made after an estimated fourteen hours of labor, using mahogany acquired from a vintage ROC plate holder, this little gem produced 18 x 24-mm, half-frame images on its tiny double holder. Close examination in this case literally using a magnifying glass reveals the amazing detail of the camera parts. The miniature is incredibly true to the original, complete with a hinged ground-glass panel, rising front panel (for perspective control), and a wheel stop equipped landscape lens mounted on a removable lens board.

Photake *ca. 1896*

Chicago Camera Company, Chicago, Illinois.
Gift of Eastman Kodak Company. 1974:0084:0070.

The Photake camera was manufactured starting in 1896 by the Chicago Camera Company. It had a four-inch diameter cylindrical metal body resembling a coffee can. Five dry plates were arranged around the inner circumference of the can, and by rotating the outer cover, which contained the lens, the photographer could expose the next plate. Advertised as "An ideal Christmas gift," the camera was packaged in a wooden box along with six dry plates and enough chemicals and paper to make twelve prints. It retailed for $2.50.

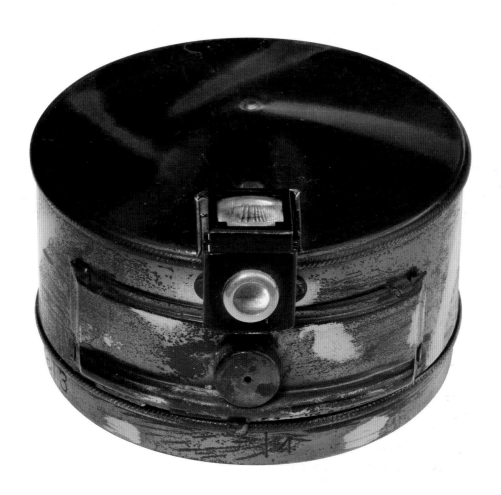

Le Sphinx *ca. 1900*

Guilleminot Roux & Cie, Paris, France.
Gift of Eastman Kodak Company. 1974:0037:2296.

In 1857, René Guilleminot established his Paris photographic supply business that became the place to go for materials used in wet-plate photography, and later for ready-made dry plates and films. Decades later, the company, then known as Guilleminot Roux & Cie, decided, as other manufacturers of photo materials had, that getting into the camera business seemed the next logical step. In 1900, it introduced a detective-style camera called Le Sphinx.

Basically a mahogany box, the apparatus was designed around the common 9 x 12-cm dry plate. It featured a magazine that could hold twelve plates in sheet brass holders, and a mechanical falling plate changer. Being a detective camera, its exposure controls were hidden behind a hinged panel that lifted for access to the aperture stop wheel, shutter spring winder, and the instant time selector. The lens focus was adjusted by turning the tiny brass pointer on the side of the box, which operated a rack and pinion that moved the lens fore and aft. The lens barrel itself was secured to its board by a three-lug bayonet mount, perhaps the first time this design was used in a camera.

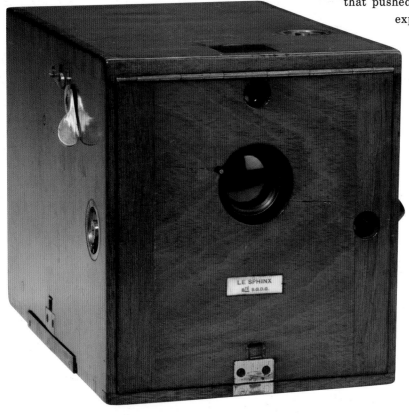

In use, Le Sphinx had a spring-loaded pressure plate that pushed the stack against a stop tab to await exposure when the sector shutter was tripped. Pressing the plate changer lever let the plate holder tip forward like a domino and drop the exposed plate into the lower chamber to make way for the next picture. Like most dry-plate magazine cameras, this one had to be unloaded and restocked with fresh media in a darkroom. By the time of its introduction, the market for roll-film cameras was on the rise, at the expense of the plate-camera business. Guilleminot soon abandoned camera production, but continued as a manufacturer of plates, films, and papers for almost another century. In 1995, the firm was sold to Bergger S.A. of Paris, which still makes black-and-white films, papers, and, increasingly, materials for printing digital images.

FIELD

Soon after Louis-Jacques-Mandé Daguerre (1787-1851) first demonstrated his image-making process with his large full-plate double box camera, various opticians and instrument makers began producing apparatus more convenient for field use. The bellows was likely first applied to a camera by Isidore Niépce (1805-1868), and later used on a fixed-bed portrait camera designed by W. & W. H. Lewis in the early 1850s. Both of these applications used straight bellows, which lightened the weight of the camera but did little to make the camera smaller when folded. In the late 1850s, Scottish photographer C. G. H. (Charles George Hood) Kinnear (1832-1894) patented a camera with a tapered bellows whose folds nested inside one another, creating a smaller device when folded.

Universal Improved Kinnear Camera (10 x 8) *ca. 1857*

W. W. Rouch & Company, London, England.
Gift of John Howard. 1974:0037:2100.

The pleated leather bellows was first used in cameras as a way to adjust the distance between the lens and the sensitized plate. In the 1850s it occurred to Scottish photographer Charles George Hood Kinnear (1832-1894) that designing a bellows with tapered sides would allow it to fold almost flat. A camera using Kinnear's patented bellows design could be folded into a much smaller package for storage or transport. Kinnear built his own cameras but also licensed his bellows to other firms, such as W. W. Rouch of London. Their 1857 Rouch Universal Improved Kinnear Camera was made in several sizes besides this 10 x 8-inch version. The Rouch's front standard was

rigidly attached to the baseboard, which was rabbeted so it could move freely in the grooved wooden guides on each side. Turning the brass crank below the rear of the mahogany body rotated a threaded rod that moved the base in or out for focusing. The lens was a Triple Achromatic made by J. H. Dahlmeyer, also of London. The Rouch was a handy field camera that didn't take up much space in the knapsack or buggy.

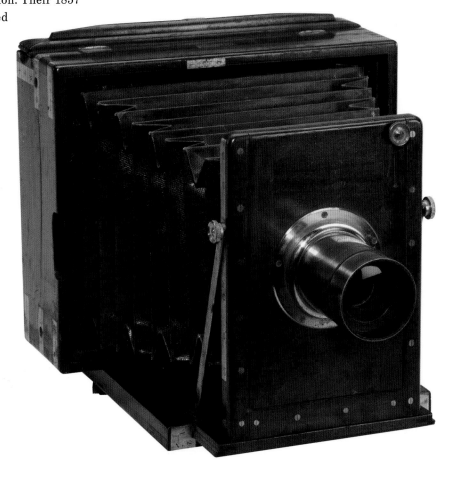

Scénographe *ca. 1874*

E. Deyrolle Fils, Paris, France.
Gift of Eastman Kodak Company, ex-collection Gabriel Cromer. 1974:0037:1970.

An early dry plate camera, the Scénographe was designed in 1874 to be the last word in lightweight portable cameras. E. Deyrolle Fils of Paris kept its bulk to a minimum by using thin brass sheet for the metal parts and a non-pleated cloth bag as a collapsible bellows. The folding finder and its plumb bob leveler were made of brass wire. Thin hardwood supports were used to keep the bellows taut when the camera was opened. The bottom bellows support had a tripod socket, for this camera was not for handheld use. The recently introduced gelatin dry plates were slow, making exposure times long, and only when supported on the tripod could the flimsy structure remain motionless long enough to take a blur-free 10 x 15-cm picture. As the name implies, the Scénographe was intended for scenic views and came appropriately fitted with a 180mm f/20 landscape lens. Exposures were controlled by the removal and replacement of a brass lens cap. The camera was priced at fifty francs.

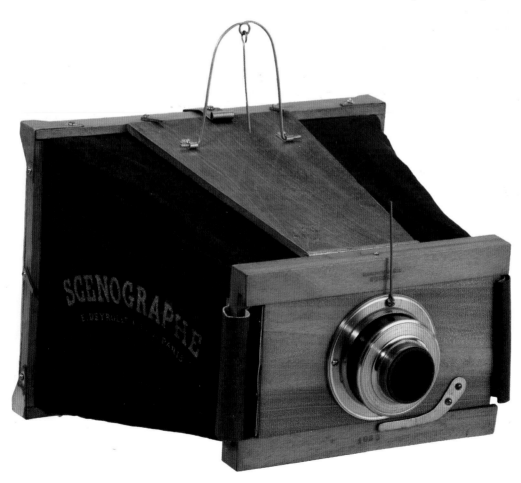

Compact Camera *1883*

G. F. E. Pearsall, Brooklyn, New York. 1974:0037:1048.

In early 1883, George Frank E. Pearsall patented and marketed the Compact Camera, considered to be the first American-made self-casing camera. This rare apparatus, of which fewer than a handful are known to exist, is a self-contained, box-like folding-bed camera with a top-mounted leather handle for easy transport. The front panel opens ninety degrees to become the bed and reveals two parallel rails used to guide the lens standard for focusing. The camera's back opens to disclose a bellows-like focusing hood and a patented silk, roller-blind screen used for image composition and focus, instead of the much heavier traditional ground glass.

Pearsall was a man who looked simultaneously backward and forward. While he claimed the largest photographic enterprise in the then-independent city of Brooklyn, New York, the photographer also made daguerreotype portraits, using a process that had peaked commercially in the mid-1850s. On the other hand, his seemingly straightforward design of a camera set the standard for the styling of folding dry-plate cameras over the next forty years. And it didn't end there. With its case that forms a protective shell for the bellows and lens during transport, the Compact's stylistic influence would extend beyond dry-plate apparatus. Its heirs include press cameras such as the Speed Graphic and its Japanese successor, the Toyo Graphic, made with the tooling of the final Speed Graphic after Graflex was dissolved in 1973. Today, Toyo and Wista continue to manufacture folding field cameras that borrow from the original design, so the line remains unbroken.

Of the known examples of the Compact Camera, this is the only one finished with black paint and is thought to be the first one made.

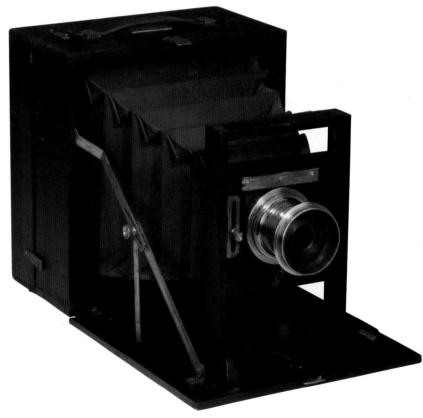

Lucidograph *1885*

Blair Camera Company, Boston, Massachusetts. 1974:0037:1832.

In the late 1870s Thomas Blair of Boston began manufacturing cameras intended for amateur photographers. His first camera, the Tourograph, was introduced in 1878 as a wet-plate camera. By 1881 it had evolved into a portable, dry-plate magazine camera, the first of its kind. This was followed by another innovative camera in 1884, which appeared in 1885 catalogs as the Lucidograph.

The Lucidograph took nearly two years to develop and is one of the earliest examples of an American-made, self-casing style camera to be offered after Pearsall's 1883 Compact Camera. Typical self-casing cameras had a bottom-hinged drop bed with built-in rails and focusing system, usually rack and pinion. In contrast, the Lucidograph had a side-hinged door, which, when opened, supported a separate set of rails and a rack-and-pinion focusing system. With this unusual arrangement, Blair created a camera that was extremely small for its format yet still allowed the rails, bellows, and front standard to pivot, providing a bit of front swing. The front standard, as on most cameras of this type, allowed for lens rise, though there were no perspective control movements at the back of the camera. Reversing the lens allowed, in this case, the 5 x 8-inch version to fold to a rather compressed 6½ x 9½ x 3½-inch size. Blair's price of $13.50, not including lens or tripod, was very reasonable for a camera of this size. As one might expect for a product bristling with novel features, Blair patented the Lucidograph; patent number 362,599 was granted May 10, 1887.

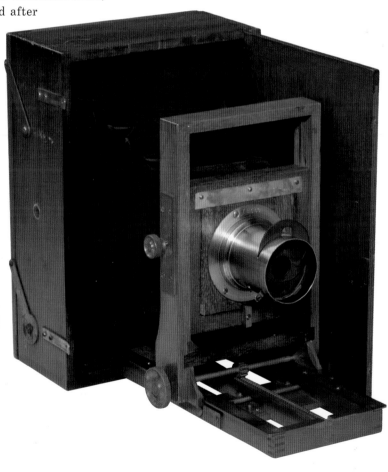

Folding field camera (9 x 12 cm) *1885*

Unidentified manufacturer, France.
Gift of Eastman Kodak Company. 1974:0037:1847.

Photo Velo full-plate tourist camera *1892*

Unidentified manufacturer, France.
Gift of Eastman Kodak Company, ex-collection Gabriel Cromer. 1981:1296:0005.

Vulga camera (13 x 18 cm) *ca. 1885*

Photographie Vulgarisatrice, Paris, France.
Gift of Eastman Kodak Company. 1974:0037:1982.

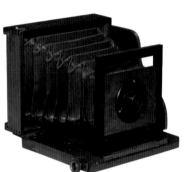

The popularity of the dry-plate process among amateur photographers created a ready market for folding tourist cameras. These three French models are similar to the 1874 Scénographe, an early portable dry-plate camera that was also of French manufacture. In contrast to their more fragile predecessor, these cameras were built with mahogany bodies and leather bellows. In common with the older model, all three had tripod sockets to accommodate the long exposures required for dry plates.

This 9 x 12-cm folding field camera of unknown manufacture (top right), which traveled at a thickness of just 2⅛ inches, used the rear panel to swing around and give support to the folding bed. A simple rotary with an external spring, the shutter presented three apertures and one speed (instant), with the ability to be half-cocked to a time position and for focusing. Since it had no scale markings, focus was on ground glass only.

The Photo Velo full-plate camera (left) had a unique folding feature. The lens board was retracted with the focus knob, then the brass rods were unscrewed and stored within the body.

The brass Darlot landscape lens mounted here had a selection of four apertures but no shutter and needed to be capped and uncapped for exposure.

The Vulga 13 x 18-cm field camera (below), made by Photographie Vulgarisatrice of Paris, was offered about 1885. Its unusual lens board support was a sturdy one formed by two folding wings. To fold the apparatus, the photographer had to release the wings from the lens board, which allowed the bellows to collapse within the body and the strut wings to fold down and be latched. A Vulga Rapide Extra Superieur f/8 lens with variable iris was paired with a rotary shutter with an exterior spring. Focus was again achieved on ground glass. Exterior hardware included two tripod mounts and a spirit level.

Eastman Interchangeable View Camera (5 x 7) *ca. 1887*

Eastman Dry Plate & Film Company, Rochester, New York.
Gift of Eastman Kodak Company. 1974:0037:1010.

Eastman's 1887 Interchangeable View Camera featured a back and bellows assembly that could be removed from the bed and front standard and exchanged for another size. Many different formats could be acquired at a total cost lower than a collection of individual cameras of each size. Well constructed from French polished mahogany and lacquered brass fittings, it offered double rear swing and double rising front movements. The smallest size, 4¼ x 5½ inches, was available for $26, while the largest, 20 x 24 inches, was priced at $100. The extra backs were $13 to $50.

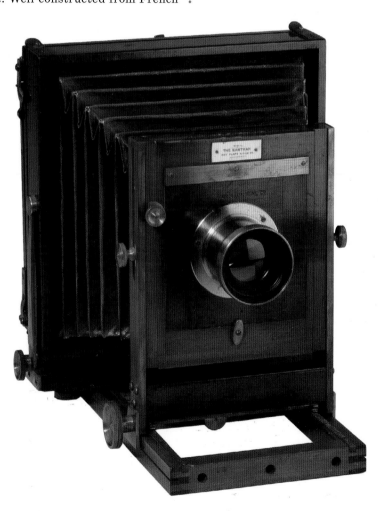

English Compact Reversible Back Camera *ca. 1888*

Blair Camera Company, Boston, Massachusetts. 1978:1371:0017.

. .

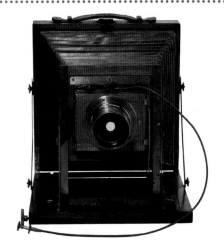

Named for a popular style, the full-plate (6½ x 8½-inch) Blair English Compact Reversible Back Camera folds into a thickness of only 3½ inches. Made in Boston, Massachusetts from 1888 to 1898, it was commercially available in a single swing version at a cost of $50; a double swing could be made to order. The bed hinges away from the rear standard, and the front standard folds up. The geared focusing track accommodates focus up to twenty inches. The Blair Rigid Extension allowed conversion to a larger size. A tripod top is built into the bed, with sockets for attaching the legs.

Improved Empire State View Camera *(14 x 17) ca. 1890*

Rochester Optical Company, Rochester, New York.

Gift of 3M Foundation, ex-collection Louis Walton Sipley. 1977:0415:0374.

. .

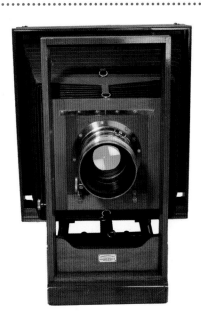

In the 1890s, the Rochester Optical Company made some very large view cameras, including this 14 x 17-inch Improved Empire State View, part of a line that included sizes up to 20 x 24 inches. Unlike the smaller models, this camera featured a fixed front standard and rear focus. Made of mahogany with polished brass fittings, it offered movements to satisfy professional photographic needs. The 1893 catalog shows two models: single and double swing, priced at $50 and $55 respectively (excluding lens).

Henry Clay *ca. 1891*

American Optical Division of Scovill & Adams, New York, New York.
Gift of Eastman Kodak Company. 1974:0037:1780.

Whether named for the pre-Civil War U.S. senator and statesman, or for Henry Clay Price, a Scovill & Adams employee who co-authored the firm's *How to Make Photographs*, this model was the first of the self-casing plate cameras to feature front standard perspective control movements of shift and swing. Cameras of this style, when closed, resemble a small valise, with the outer shell protecting the lens and other photographic "innards" from harm. They are considered the first true refinement of the design put forth by Frank Pearsall's pioneering Compact Camera.

The Henry Clay was designed to be either hand-held or tripod mounted, and thus was fitted with both a reflecting waist-level finder and a ground glass for composing images. Storage behind the ground glass provided space for one double plate holder or a mounted roll holder. Three versions of the camera were manufactured. Illustrated is the first, which is distinguished by its unusual sliding bed and is quite rare. The later versions used the more traditional hinged folding bed. In 1891, the 5 x 7 Henry Clay with lens, shutter, and double plate holder sold for $65, quite a sum for an amateur camera of the day.

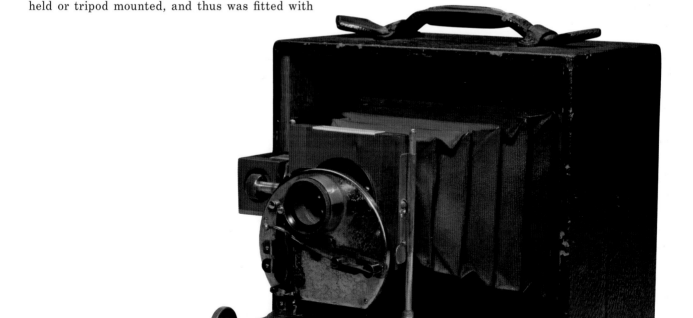

Irving View *1892*

American Optical Division of Scovill & Adams, New York, New York.
Gift of Eastman Kodak Company. 1997:2428:0001.

American Optical Company produced some of the highest quality cameras made in nineteenth-century New York City. As a division of Scovill Manufacturing, which acquired the firm in 1867, and then of Scovill & Adams after a merger in 1889, the American Optical name appeared on camera nameplates into the 1890s.

A fine example of New York camera design and craftsmanship, the Irving View was awarded the highest prize at the city's American Institute Fair. Made from polished mahogany, it is of the "self-casing" style, fitted with a square-cornered Kinnear-style tapered bellows and a reversible back for the taking of both horizontal and vertical photographs. Features included perspective control movements that were limited to front rise and rear tilt, and rack-and-pinion-adjusted focus that was, unlike most cameras of this type, controlled by a bed-mounted knob. The Irving View was sold in sizes from 4 x 5 to 20 x 24 inches. The pictured camera made 5 x 7-inch images and retailed for $33, without the lens.

This camera was never fitted with a lens; it was a pristine old-stock item acquired by Eastman Kodak Company's research laboratories as a study piece.

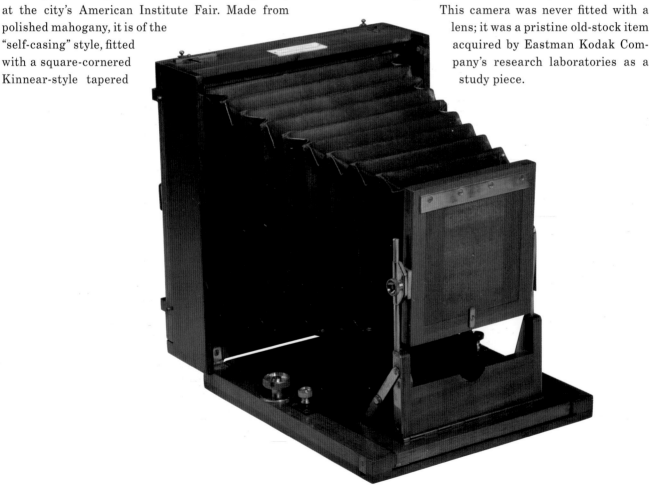

Optimus Long Focus Camera *ca. 1892*

Perken, Son & Rayment, London, England. 1974:0028:3086.

A traditional English pattern field camera, the Optimus Long Focus Camera was manufactured by Perken, Son & Rayment, London, from 1891 to 1899. Dating back to the 1860s, this style of camera, which always had a stationary front standard and a rear bellows extensible on a long tailboard, remained in production for more than one hundred years. Finished in brass-bound figured mahogany, this 10 x 8-inch camera has several well-planned features, including front rise and shift and rear swing movements, rack-and-pinion rear tilt, very strong outboard front struts for rigidity, and a hidden helical rack-and-pinion drive that controlled the tailboard. It also has a reversible back with a proprietary design book-style plate holder and a double-hinged dark slide landscape lens with a four-aperture wheel stop. The retail price was $227 in 1891.

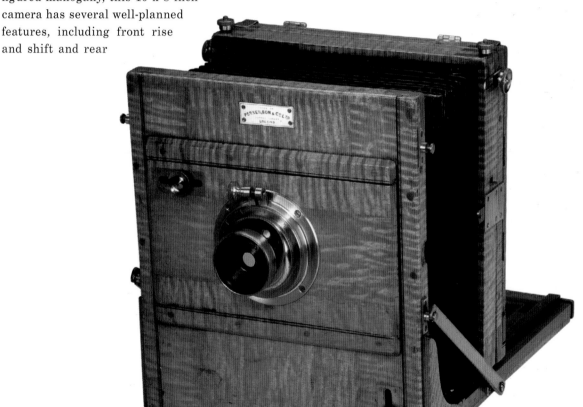

No. 4 Folding Kodak (Improved Model) *1893*

Eastman Kodak Company, Rochester, New York.
Gift of Eastman Kodak Company. 1974:0037:1513.

The No. 4 Folding Kodak (improved model) of 1893, manufactured by Frank Brownell for Eastman Kodak Company of Rochester, New York, embodied several improvements over Kodak's original model of 1890. A folding bellows camera with a drop front and a hinged top cover that gave access to the Eastman-Walker roll holder, it was capable of making forty-eight 4 x 5-inch exposures on Eastman transparent roll film. Improvements in the 1893 model included a new Bausch & Lomb iris shutter, the flexibility of using either roll film or plates, and a hinged baseboard that permitted drop front movements. The retail price was $60.

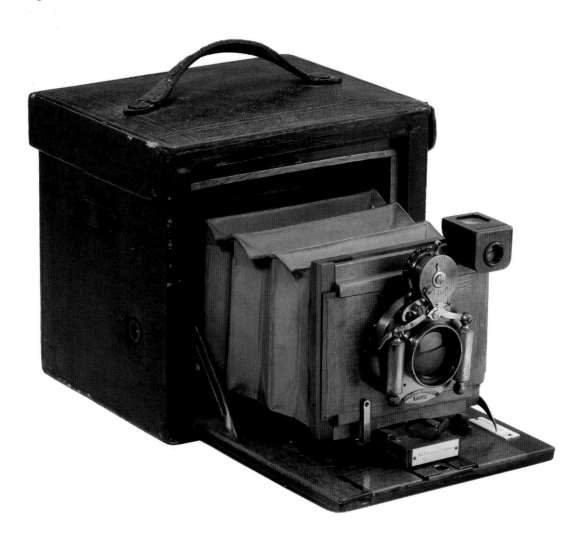

Folding strut camera *ca. 1895*

J. Audouin, Paris, France.
Gift of Eastman Kodak Company. 1974:0037:1823.

The invention of the dry plate removed a lot of drudgery and hocus-pocus from the photographic process. The idea of buying ready-to-shoot and safely storable media appealed to amateurs who found the wet-plate experience too labor intensive and cumbersome. By the late nineteenth century, dry plates and folding cameras could be carried in small satchels, purses, and bags that hung from the bicycle crossbar. The simplest folding cameras were of the flat-folding strut design. These were little more than a front panel with a lens, a larger rear panel for the plate, and a cloth or leather bag between them. Set-up was just a matter of swinging a pair of wire or wooden struts that were hinged to the rear panel and snapping them into slots on the front panel. This made the bag taut and provided the lens board with a very rigid support. Focusing a bellows camera usually involved shifting the board and lens back or forth while the bellows pleats took up any slack. With a strut camera, it simply meant moving an element within the lens.

Audouin's apparatus was made of hardwood and nickel-plated brass, with a black leather bag. Equipped with a simple wire frame finder to help aim the camera, it used a tube-within-a-tube lens to achieve focus and a thumbscrew to lock the lens in place. The shutter, a variation of the gravity-powered guillotine design, worked much like a crossbow, using a small spring to pull the hole in the shutter blade across the lens until the locking pawl caught a notch. When it was time to snap the photo, pushing the release lever let the spring tension slide the blade so light could reach the plate surface. Care had to be taken to prevent the stiff steel blade from hitting a finger during the cycle. Otherwise, operation was very simple, though the camera lacked any sort of adjustment for exposure time beyond locking it open and hoping the subject wouldn't move.

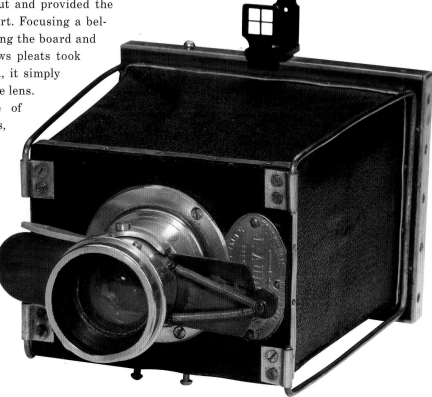

Alta Automatic *ca. 1896*

Reichenbach, Morey, & Will Company, Rochester, New York.
Gift of Eastman Kodak Company. 2002:0965:0001.

With its Alta Automatic, the Reichenbach, Morey, & Will Company of Rochester, New York, added a new twist to the folding cycle-type camera. Equipment of this style traditionally opened in a two-step process: open the camera and lock the bed in place, then slide the lens mounted on the front standard to the infinity position. However, this camera, with its unusual system of pivoting arms fixed permanently at the forward edge of the hinged bed, automatically located the lens at the infinity position upon opening. If necessary, the focus could then be adjusted using a rack-and-pinion mechanism.

The company's Alta Cameras catalog proudly proclaimed its apparatus to be "finished thoughout in the best possible manner and of best material," so that each instrument "becomes a living advertisment for us in the hands of the purchaser." Limiting its output to self-casing cycle-type cameras may have aided the manufacturer in offering products of such high quality and clever design.

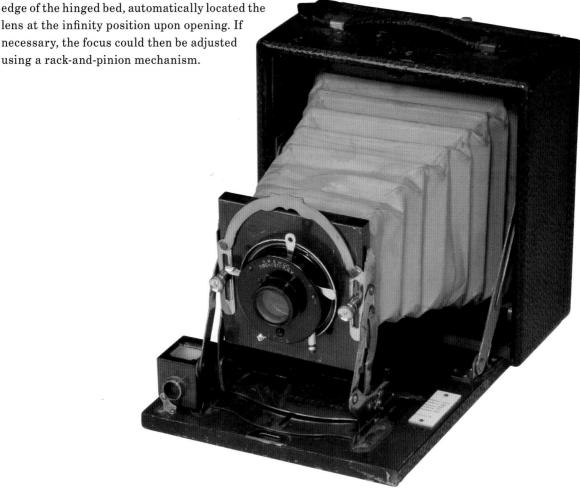

Rambler Tropical Field Camera *ca. 1898*

J. Lizars, Glasgow, Scotland. 1974:0028:3472.

The manufacture of cameras in the late 1800s took the skills of many craftsmen not needed in today's business—expert woodworkers to build teakwood or mahogany bodies and metalsmiths to construct standards, struts, and other brass parts. J. Lizars of Glasgow, Scotland, purveyors of optical, scientific, and photographic goods, took great pride in its line of Challenge hand cameras, such as this Rambler of 1898. Crafted of solid teakwood because of its resistance to heat and moisture, the Rambler was designed for field work. The lens board was adjustable for rise, shift, and tilt, and the "trap door" panel on the top of the body allowed the Russia leather bellows ample room for extreme rise settings. A Bausch & Lomb shutter controlled light through the lens to expose the 8 x 10.5-cm plates. Besides the fine cameras constructed at its Golden Acre Works in Glasgow, J. Lizars sold anything and everything a photographer needed, from a variety of manufacturers, including cameras from Goerz and Kodak, among others. Although no longer a photographic manufacturer, the firm remains in the optical business with a number of branches in Britain.

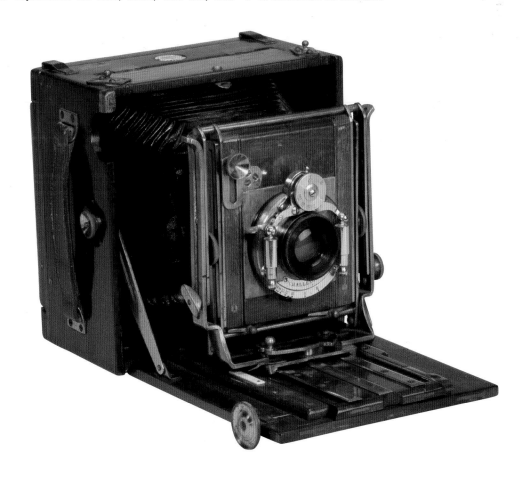

RB Cycle Graphic (4 x 5) *ca. 1900*

Folmer & Schwing Manufacturing Company, New York, New York.
Gift of Graflex, Inc. 1974:0037:1722.

Designed to collapse down to the smallest possible package, cycle cameras proved a popular carry-along with bicyclists. The RB Cycle Graphic, introduced in 1900 by Folmer & Schwing Manufacturing Company of New York, was the "embodiment of all that is perfect in a camera of cycle size." For viewers of old black-and-white movies, this camera may seem vaguely familiar. Picture it with an added rangefinder and a wire-frame finder protruding above the front lens board and you have the Speed Graphic, the legendary press camera and offspring of the Cycle Graphic.

Widely believed to have surpassed all other cycle cameras in terms of workmanship and materials, the RB Cycle Graphic featured extra strong wood panels, heavier gauge brass fittings, and red Russia leather bellows. The reversible back (RB) could be removed and repositioned for vertical or horizontal images. This 4 x 5-inch model, with a Graphic Rapid Rectilinear (RR) lens, sold for $40. Substituting a Goerz or Bausch & Lomb lens would more than double the price. The camera was also available in 5 x 7-, 6½ x 8½-, and 8 x 10-inch sizes.

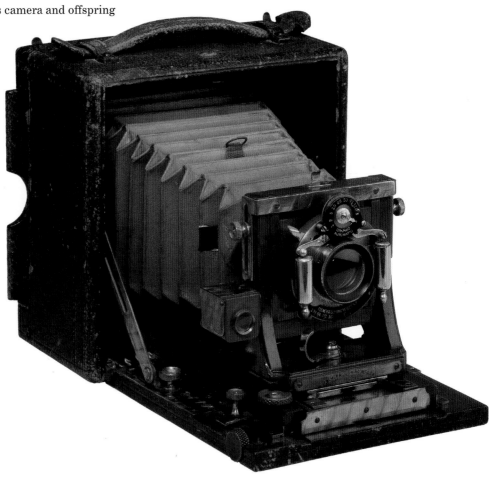

Xit *ca. 1900*

J. F. Shew & Company, London, England.
Gift of Kaye Weedon. 1978:1637:0001.

When James Shew opened the doors of his London wholesale store in 1849, the photographic business was only a decade old. Shew offered everything a photographer would need, including training courses. Taking note of what customers asked, he saw opportunity in inventing things that would solve their problems with the new medium. By the 1880s, Shew's catalog included his own line of cameras, designed for maximum portability without sacrificing performance.

The Xit series of folding cameras used a unique strut design patented earlier by Scottish inventor George Lowdon (ca. 1824–1912), resulting in a package that folded small enough to be carried in a coat pocket. The side-strut system was easy and fast to set up or fold, and provided the lens board a strong, rigid platform. The early cameras were all wood, while later editions, like this one, used aluminum to add strength and durability to the mahogany structure. The Xit was designed for plates or sheet films, but some models could be fitted with an Eastman-Walker roll holder for even greater versatility.

Shew & Company could deliver the Xit with any of several lenses from Zeiss, Goerz, or Ross, with Shew's own patented helical focus mount for rapid adjustment. The firm made its own single-speed shutter and also offered the multi-speed compound shutter as an option; later models were made with a focal-plane shutter. It wasn't long before competitors began to make inroads in the pocket camera market, and Shew & Company ceased production in 1920.

Snappa _ca. 1902_

Rochester Optical & Camera Company, Rochester, New York. 1974:0037:0135.

The technology of Eastman Kodak Company made photography available to people everywhere, without requiring any knowledge of optics, mechanics, or chemistry. That success spurred other camera makers to take the mystery out of the process. Rochester Optical and Camera Company had its roots back to about the same time that George Eastman was developing his business. The company wanted something that would appeal to amateurs, but with more sophistication than the simple box designs Kodak offered as "everyman's camera." The Snappa appeared in the Rochester Optical lineup in 1902, billed as the "crowning achievement of creative genius in camera construction."

Assuring potential buyers that if they chose a Snappa, "failure was impossible," Rochester Optical sought to achieve that goal in several ways. The very compact, 3¼ x 4¼-inch folding camera used the same construction materials found in professional equipment: hardwood, brass, aluminum, and red Russia leather lined with gossamer cloth for the bellows. Its lens and shutter were supplied by Bausch & Lomb, also of Rochester. The Snappa's greatest feature was a magazine with a push-pull, quick-change action that allowed twenty-four film shots (twelve with plates) in

rapid succession, and film packs that could be loaded and unloaded in daylight. All this could be purchased for just $25. For those who wanted an optics upgrade, optional lenses were available, up to the Zeiss Series VIIa, which boosted the price to $68.

The repeating shutter could be tripped by the fingertip lever or remotely with a rubber squeeze bulb that actuated tiny pneumatic cylinders. Rack-and-pinion focus, a rising front, and a two-position reflex viewer completed the package. Less than a year after announcing the Snappa, Rochester Optical and Camera Company, itself the product of a merger of several manufacturers, was bought by Eastman Kodak. The Snappa didn't make the cut.

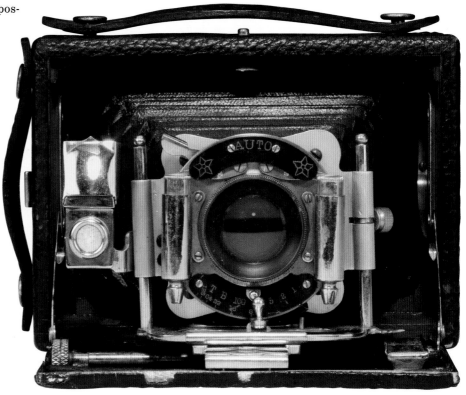

Acme field camera *ca. 1905*

W. Watson & Sons, Ltd. (attrib.), London, England. 1978:1657:0005.

This apparatus closely resembles the Acme field camera manufactured by W. Watson & Sons, Ltd., of London, though it bears the label of Westminster Photographic Exchange, Ltd., vendors of both new and secondhand equipment. It was likely made as a private label item for Westminster, which moved enough stock to warrant its own brand by selling from several London addresses and to overseas markets throughout the British Empire.

Watson's catalog description declares the Acme to be "the perfection of apparatus for tourist use, both as regards convenience and workmanship." While this statement may seem grandiose, a close inspection of the materials and craftsmanship on this traditional English-style field camera thoroughly supports the claim. Closed, the camera measures only 1 inch thick, making it very compact for a half-plate (4¼ x 6½ inches) view camera that offered front and rear swing as well as front rise perspective control movements.

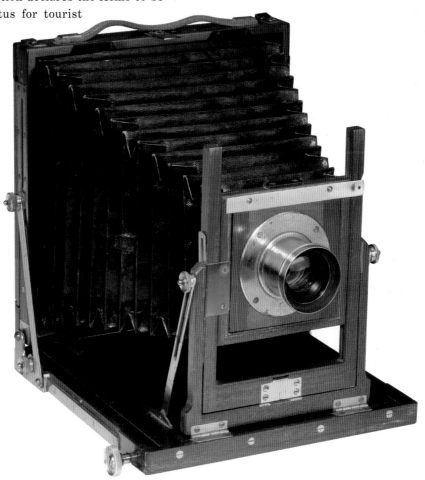

Century Model 46 *ca. 1905*

Century Camera Company, Rochester, New York.
Gift of Eastman Kodak Company. 1999:0160:0001.

The Century Model 46 was a beautiful 4 x 5-inch field camera made by the Century Camera Company of Rochester, New York. The company began manufacturing in 1900, but by 1903 it was purchased by George Eastman. The camera shown here in gorgeous condition with mahogany base, red leather bellows, revolving back, and brass fittings carries a name plate reading " Eastman Kodak Co., Succ'rs to CENTURY CAMERA CO." The first camera in which Century introduced the double section brass-bound telescopic bed, it has a Centar series II lens in a Century shutter. The original retail price was $32, but with a Bausch & Lomb or Zeiss lens the price more than doubled.

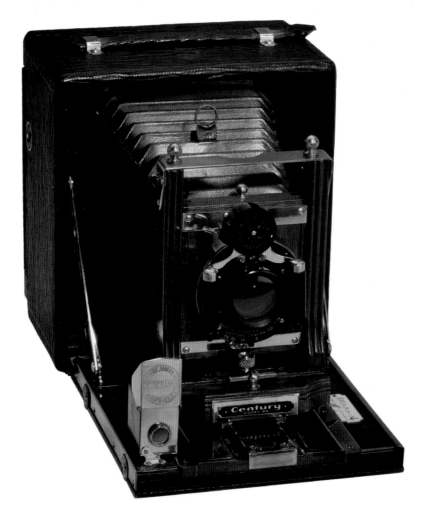

Chautauqua *1905*

Seneca Camera Company, Rochester, New York. 1974:0037:1761.

The Larkin Soap Company was founded in Buffalo, New York, by John D. Larkin in 1875. The business was soon joined by Elbert Hubbard, Larkin's brother-in-law and future partner, and a marketing genius who is remembered as the founder of the Roycroft community and movement. Larkin Soap used a variety of sales techniques and was especially known for offering numerous premiums to entice customers to purchase its products. The company applied the Chautauqua name to many of those premiums, including bicycles, chairs, desks, and other common household items, as well as this camera. The Chautauqua Institution, which is on a lake of the same name about seventy-five miles from Buffalo, and the educational movement it inspired were widely known across the country.

The Chautauqua was a version of the Seneca No. 2 folding cycle-type camera. Like the apparatus from which it was derived, the Chautauqua was a basic model with a Rapid Rectilinear lens mounted in a three-speed Uno shutter and offered front rise as the only camera movement. Both cameras initially were covered with fine black seal-grain leather with a polished mahogany interior and fitted with a red Russia leather bellows. Beginning about 1907, Seneca Camera Company switched the interiors to a black ebonized finish with a matching black leather bellows. According to the 1906 Larkin premium catalog, a Chautauqua camera could be yours for five Larkin Certificates, or free with a ten dollar purchase of Larkin products.

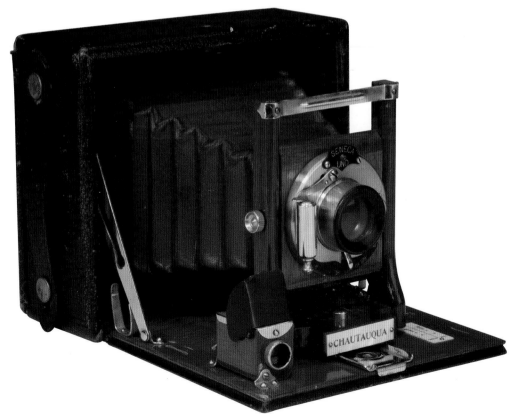

Premo View *ca. 1906*

Rochester Optical Division of Eastman Kodak Company, Rochester, New York.
Gift of Eastman Kodak Company. 1997:2434:0001.

Rochester Optical and Camera Company was formed in 1899 by the merger of five Rochester, New York-based companies: Monroe Camera, Ray Camera, Rochester Camera, Rochester Optical, and Western Camera. In 1903 Eastman Kodak Company acquired the company and continued to manufacture most of the previous companies' product lines, most notably the Poco and Premo cameras, produced under the nameplate Rochester Optical Division of Eastman Kodak Company.

Back in the 1890s, Rochester Optical Company produced numerous high-quality view cameras, including the Carlton Camera, named for one of the company founders, William F. Carlton. The Carlton was designed by one of the best camera repairmen of the day, Laben F. Deardorff, who some twenty years later would go on to build his own cameras of similar design. About 1906, the front standard of the Carlton was modified (the twin front standard bed locks were moved from the top of the uprights to the bottom center) with the resulting improved camera named the Premo View.

The Premo View retained the features of the earlier Carlton camera: double extension bellows with focusing rack and pinion on both front and rear extensions, allowing the camera to be centered on the tripod for all focal length lenses; vertical and horizontal swings coupled with an extreme front rise; and a reversible back. The Premo was made from the same high-quality, mahogany and brass materials, superbly fitted and hand polished and lacquered to a finish rivaling the best English cameras of the day. The illustrated example, fitted with an undrilled lens board, is a new old-stock camera acquired from Eastman Kodak Company.

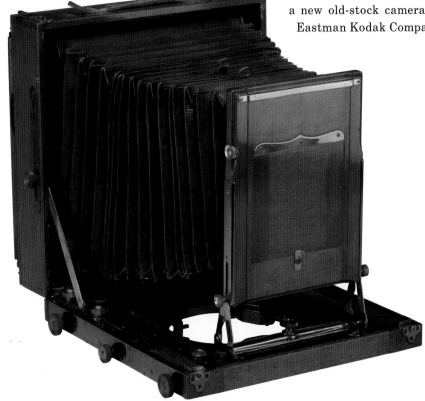

Sanderson De Luxe *ca. 1908*

Houghtons Ltd., London, England.
Gift of Arthur Sintzenich. 1974:0037:1619.

Frederick Sanderson was an English woodworker unhappy with the hand cameras available to him in the 1880s, so he decided to build his own. One source of his frustration was in making lens movements for perspective adjustments. His solution was so ingenious that he patented it and arranged to have his camera manufactured in quantity. The Sanderson lens board was mounted in slotted struts, allowing extreme upward movement. Large knurled knobs could be tightened easily while viewing through the rear ground glass. In addition, small levers on each side unlocked the lens board for tilting. This Sanderson De Luxe was made of Spanish mahogany and brass, with the body covered in black leather. It used either plates or film for 3¼ x 4¼-inch images. The Blitz Double Anastigmat 5-inch f/6.8 lens is mounted on a Koilos shutter. The price in a 1910 catalog was £13.

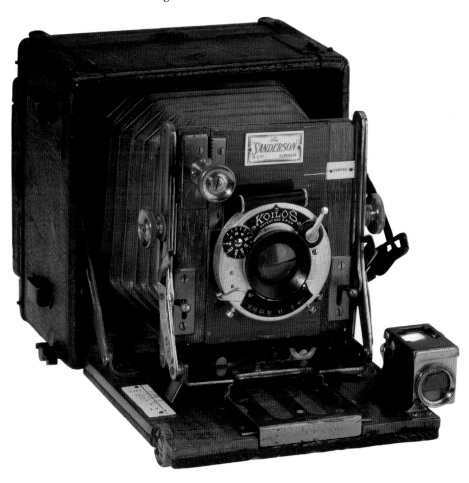

Eastman View No. 2D (OWNED BY ALFRED STIEGLITZ) *1921*

Eastman Kodak Company, Rochester, New York.
Gift of Georgia O'Keeffe. 1978:1371:0054.

Alfred Stieglitz (1864-1946) was instrumental in elevating photography to an art form. His gallery on Fifth Avenue in New York exhibited photographers' works along with paintings by modernists such as Picasso and Cézanne. For his own pictures, Stieglitz relied on equipment like the Eastman View No. 2D. From its beginning, the Kodak brand was associated with amateur photography, but Eastman Kodak Company also sold a lot of professional items. The 2D View and other cameras were added to its catalog through the acquisition of companies such as Rochester Optical, Century, and Graflex. Introduced in 1921, the Eastman View No. 2D remained in the lineup until 1950. The "D" in the model number denotes "Dark" finish, which allowed the use of less-expensive mahogany stock for the body. Stieglitz's 8 x 10-inch camera listed for under $50, much less than fancier brands, but he didn't skimp when fitting it with a lens. A Goerz Double Anastigmat of 14-inch focal length was chosen to pass light through a Packard-Ideal pneumatically operated shutter. Eastman offered a Graflex focal-plane shutter with the 2D View for an additional $41.

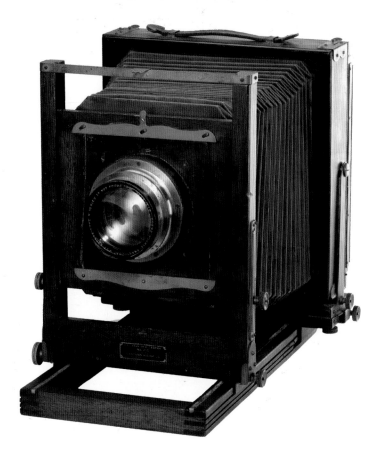

Deardorff Commercial Camera *1923*

L. F. Deardorff & Sons, Chicago, Illinois.
Gift of Eastman Kodak Company. 1997:2438:0001.

In 1923, L. F. Deardorff & Sons produced its first series of ten 8 x10-inch wooden view cameras, which were handmade—including the hardware—using recycled tools and materials. The mahogany for the woodwork came from tavern counters scrapped during Prohibition. Sold as the Deardorff Commercial Camera, it remained on the market with few alterations (the hardware was changed from brass to nickel plate in 1938; front swings were added in 1949) and became the professional workhorse view camera. As described in their 1935 catalog, it was "a definitely new camera specially designed and constructed to meet the demands of modern advertising." Some consider the Deardorff as the Harley-Davidson of view cameras, both being iconic products from small family-owned companies. The camera illustrated here is the second camera made from the first series; it has never been used.

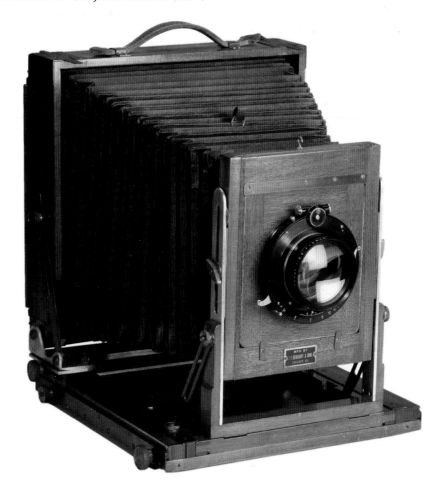

Technika *ca. 1930*

Linhof Präzisions Kamera Werke GmbH, Munich, Germany.
Gift of Graflex, Inc. 1974:0037:2436.

The Technika, introduced in 1936, was manufactured by Linhof of Munich, Germany. First in a series of Technika cameras, which were distinguished from the Standard series by the inclusion of an adjustable back for perspective control, it featured a heavy, sturdy construction of a leather-covered metal body with triple extension drop baseboard. While resembling a Graflex Speed Graphic, the Technika had the extra adjustability useful in architectural and scientific work.

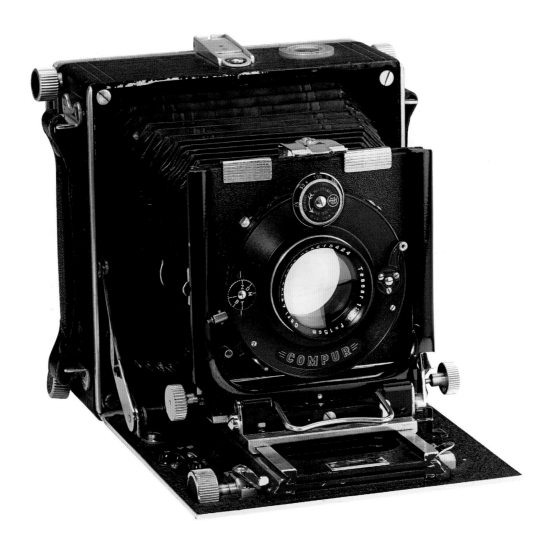

Eastman Commercial View (MAGNESIUM) *ca. 1937*

Eastman Kodak Company, Rochester, New York. 1989:0015:0001.

The Eastman Commercial View was the tried-and-true Eastman 2D View camera recast in magnesium, a lightweight and extremely strong metal now used primarily in aircraft construction. The magnesium construction made the camera much more durable than its mahogany sibling but ultimately led to its demise. After only a few years of production, a World War II shortage of the metal ended the run (planes were more important than cameras to the war effort). A clever accessory was a tongs-style lens board, which gave the fixed-front camera front tilt and swing movements of twenty degrees. This 8 x 10-inch model cost $175, excluding the 14-inch f/6.3 Commercial Ektar lens shown.

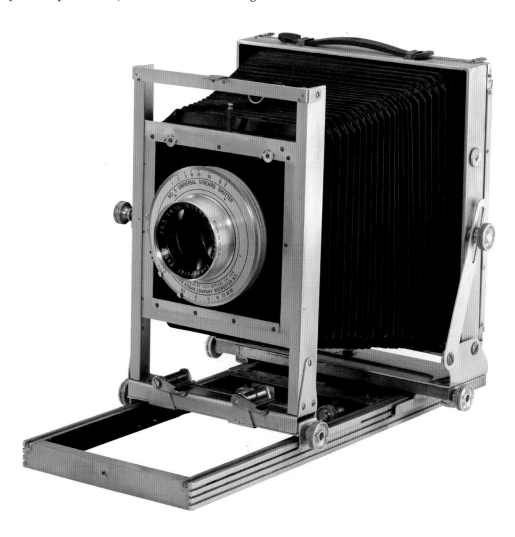

Teknar *1946*

Eastman Kodak Company, Rochester, New York.
Gift of Eastman Kodak Company. 1990:0128:0006.

Eastman Kodak Company designed the Teknar to be an American alternative to the German Linhof Technika line of precision field cameras. Constructed mainly of aluminum, it was a rugged camera intended for location work in harsh environs. Never taken beyond the experimental stage, the 1946 prototype had many features important to photographers, such as back adjustments for both focus and perspective correction and a lens board that could rise and tilt. Focusing was either by ground glass or

a coupled rangefinder that could be mounted atop the black leather-covered body. Also on top was a distance scale that could be set to match the lens being used. Image size was 6 x 9 cm both for sheets or No. 620 film, which was used when the roll holder was in place. A Kodak Flash Supermatic shutter with maximum speed of 1/400 second and a coated 80mm f/6.3 Kodak Wide Field Ektar lens is on this example, but markings on the bed rails show positions for six other lenses up to 338mm f/5.6.

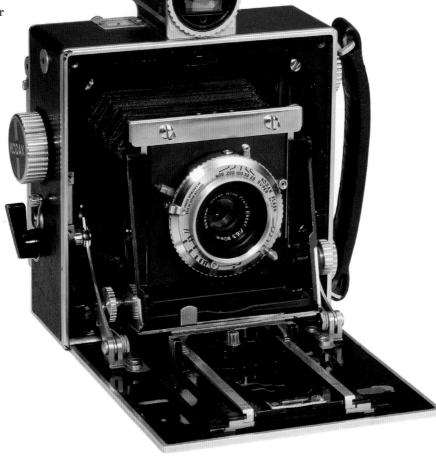

Super Technika IV *ca. 1956*

Linhof Präzisions Kamera Werke GmbH, Munich, West Germany.
Gift of James Sibley Watson Jr. 1981:0790:0046.

Another iconic camera of the twentieth century is the Linhof Super Technika IV. Manufactured by Linhof Präzisions Kamera Werke GmbH of Munich, West Germany, and introduced in 1956, the latest model in a line that began in 1936 was fitted with a larger lens board to accommodate larger modern lenses and shutters, an improved front standard design that allowed for tilt as well as swing, and a revolving back. Suitable as either a press or field camera, the Super Technika IV had nearly the same perspective control capability as many monorail view cameras, making it also popular for use in the studio. Neither lightweight nor cheap, the 4 x 5-inch model weighed about eight and a half pounds and listed for $499.50, without lens, at introduction.

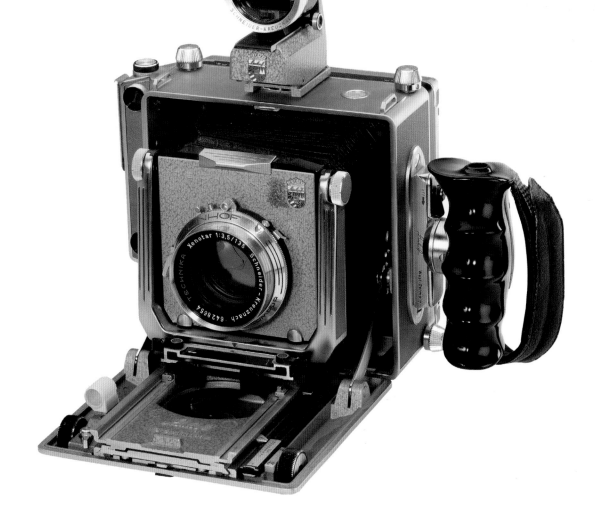

Universal Camera *ca. 1970*

Louis Gandolfi & Sons, London, England. 1974:0028:3058.

Born in London of Italian and Scottish parents, Louis Gandolfi founded his own camera manufacturing firm in 1885 at the age of twenty-one. By then he had spent almost half his life as a woodworker, beginning as an apprentice cabinetmaker at age twelve, then building cameras for Lejeune Perkins & Company at age eighteen. His London firm was a true family business, formed initially with his wife Caroline, and joined by sons Thomas, Frederick, and Arthur during the 1920s. The business gained a third generation with the addition of grandson Tom Jr. in the 1960s. Unlike the other English camera firms that produced traditional view cameras, the Gandolfis survived two world wars and the Great Depression, crafting handmade cameras until Arthur's death in 1993. The firm continues today under the stewardship of Edward Hill.

In its 1972 product catalog, Gandolfi described the Universal Camera as a well-known square-cornered bellows camera for professional, technical, and commercial photography. Well known indeed. First advertised in the 1899 British Journal Photographic Almanac, the Universal had been a staple in the company product line for nearly seventy-five years. Demand for the camera was relatively strong, typically requiring about a three-year wait for delivery. For those customers interested in old-world craftsmanship, Gandolfi, as the lone English firm producing brass-bound cameras from French-polished, seasoned Honduras mahogany, made the camera equivalent of a Rolls Royce automobile. A camera of this quality should be fitted with fine optics. On this example, the 180mm f/5.6 Nikkor-W lens mounted in a Copal No. 1 shutter more than fits the bill.

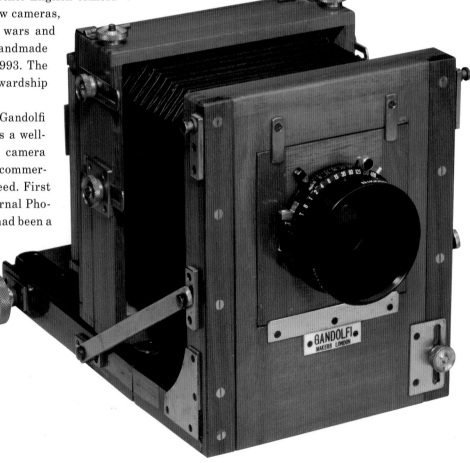

Gowland Pocket View *1982*

Calumet Photographic, Inc., Bensenville, Illinois.
Gift of Calumet Photographic, Inc. 1982:1752:0001.

The well-known glamour photographer Peter Gowland designed many of the cameras he used in his studio. The best known was the Gowlandflex, a large-format twin-lens reflex produced in sizes up to 8 x 10 inches. On the other end of the scale was the Gowland Pocket View, described by Calumet, manufacturer and distributor of the camera, as the "smallest, lightest 4 x 5-inch camera in the world." For photographers on the go who required the flexibility of the monorail-style camera, the Pocket View was the answer. Weighing in at less than two pounds and measuring a mere 8½ x 8½ x 3 inches when compressed, it conveniently fit into a backpack. Loosening the various cap screws with a 3/32 hex wrench (included with the camera) allowed for simple adjustments of various camera movements like front rise/swing and rear swing/tilt. Its cost of $199, not including lens, made it the lowest-priced view camera in the Calumet catalog.

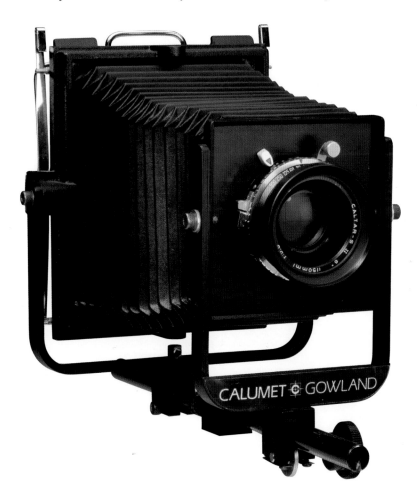

Field 4 x 5 *1983*

Wista Company, Ltd., Tokyo, Japan.
Gift of Wista Company, Ltd. 1983:0693:0001.

Formed in 1972 from the defunct Musashino Optics Company and its distributor, Rittreck Trading Company, Wista Company of Tokyo, Japan, is a manufacturer of large-format view cameras and studio equipment. Its view cameras incorporate traditional view camera design and movements with quality materials to produce handsome yet durable modern field cameras. The Field 4 x 5 used lacquered wood for the non-stressed camera parts—the back, bed frame, and lens standard—and lacquered brass and black anodized aluminum for the stressed moving parts. The rotating back is equipped with a Fresnel lens. This camera has a body of rosewood. Cherry and ebony were also available, so any choice meant the owner of one of these large-format beauties possessed a distinctive camera.

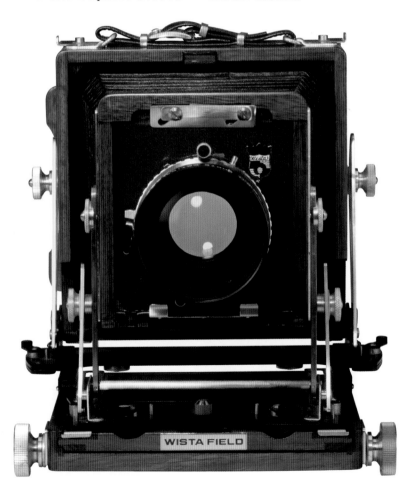

DETECTIVE

The detective camera, a name first applied by the British inventor Thomas Bolas (1848–1932) in 1881, includes a broad range of hand-held cameras usually associated with the introduction of commercially manufactured sensitized photographic materials. The genre includes box cameras, such as Eastman's original Kodak camera, as well as those that were cleverly disguised as personal accoutrements, such as books, parcels, or watches. While not exactly designed for espionage, detective cameras were intended to obtain candid photographs in a surreptitious manner. So-called spy cameras, while technically embraced in this definition, have been included in this book with the subminiature cameras due to their small size.

Photo-Binocular *ca. 1867*

Geymet & Alker, Paris, France.
Gift of Eastman Kodak Company, ex-collection Gabriel Cromer. 1974:0084:0015.

Manufactured by the French firm of Geymet & Alker in 1867, the Jumelle, which means binocular in French, is known as the Photo-Binocular camera in English. The entire camera is contained in one side of the binocular, while the other houses the viewfinder. A removable drum magazine holds fifty collodion dry plates, 4 x 4 cm each. By inverting the camera after exposure, the plate would be returned to the magazine and the dial rotated to drop another. The Photo-Binocular is sometimes called a detective camera because with the drum removed, the photographer appears to be looking through a pair of binoculars instead of operating a camera. The drum could be worn with a shoulder strap, making it look like a canteen.

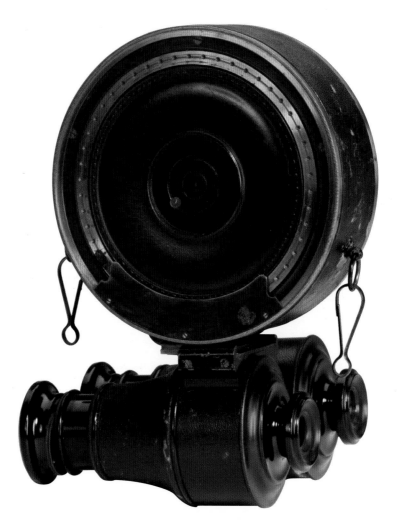

Schmid's Patent Detective Camera (IMPROVED MODEL) *ca. 1883*

E. & H. T. Anthony & Company, New York, New York.
Gift of Mrs. Lyle R. Berger. 1974:0037:1435.

Patented in 1883, Schmid's Patent Detective Camera was the first commercially produced handheld camera in the United States. Its small size, inconspicuous operation, and "instantaneous" exposures introduced the "detective camera" concept, which was applied to apparatus that could be operated without the knowledge of the person being photographed. The term wasn't given only to those cameras disguised as some other object. In fact, it was most often used to describe relatively small but normal-looking cameras that were capable of taking a picture quickly with little set-up necessary. Schmid's camera eliminated the need for a ground glass to focus by instead using a focusing register and pointer to set the estimated subject distance. A ground glass was used to calibrate the scale. This "second version" shows a hinged brass handle and has an Eastman-Walker roll holder, custom fitted to the 3½ x 4¼-inch size. The price in 1891 ranged from $55 to $77, depending on the lens included.

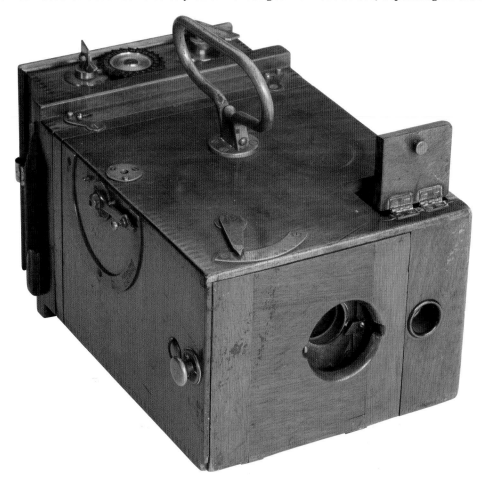

"America" detective camera ca. 1887

Rudolf Stirn, Berlin, Germany.
Gift of Eastman Kodak Company. 1974:0028:3317.

In 1885, the Eastman Dry Plate Company simultaneously introduced Eastman's American Film, a paper-backed stripping film that came in rolls, and a series of film holders known as Eastman-Walker roll holders. Adaptable to a number of different cameras, the roll holders were necessary because initially there was no camera made specifically for the new film. This would soon change. In March 1886, George Eastman and Franklin M. Cossitt applied for a U.S. patent for a detective camera that used the film. Later that year, in October, Robert D. Gray and Henry E. Stammers filed a patent application for a camera in which a roll holder was an integral, non-removable part. On the very day the Gray and Stammers patent was issued in 1887, Carl P. Stirn filed for a patent in Germany for the same invention. The two Americans invented the camera, but C. P. Stirn assumed responsibility for its further development and manufacture by his brother Rudolf in Berlin.

Debuting in 1887 as a detective camera known as the "America" detective camera, the mahogany box camera made twenty-five 2 7/8 x 4-inch exposures on Eastman's film. The Stirn apparatus had a unique form of image register that employed a spring-mounted lever whose end pointed to an engraved scale. As the film was wound with a key, the lever advanced to the next engraved marking with a snapping of the spring, thus indicating one full exposure had been advanced; this motion also cocked the fixed-speed shutter. The film frame was slightly curved to compensate for the curved field of the lens, a component that would frequently be used in later years on inexpensive cameras such as the Baby Brownie. Other features included a single reflecting waist-level finder, a 105mm f/17 lens, and a sector shutter. Introduced at a retail price of 50 marks, the America was warmly received. Previously, the Eastman-Walker roll holders alone had been priced at 50 to 75 marks.

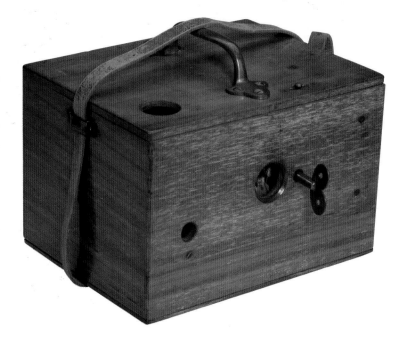

T. & W. Detective Camera (Owned by Alfred Stieglitz) *1887*

Tisdell & Whittlesey, New York, New York.
Gift of Georgia O'Keeffe. 1974:0037:1972.

In the 1880s, the term "detective camera" was used loosely by many makers for cameras that required little or no set-up to snap a quick picture. Sometimes the tag was applied to simple box cameras that could be used to photograph people unposed or in candid situations, and other times it labeled equipment that hid its real purpose of capturing the unaware on film. Either way, such cameras were soon the rage. True detective cameras were those configured to fool the unwary. With these devices, such as the Tisdell & Whittlesey Detective Camera made in New York, the photographer could aim and shoot without arousing much suspicion. The T & W looked like an ordinary box, perhaps one used to carry a camera, which it did. However, instead of needing to open the box and remove the camera, the "detective" sighted the subject with a viewer hidden under the carrying strap end. When the guilty party could be caught red-handed, a small panel on the side of the box was moved to uncover the lens, and the box lid opened just enough to cock the shutter. Pushing the lid closed tripped the shutter.

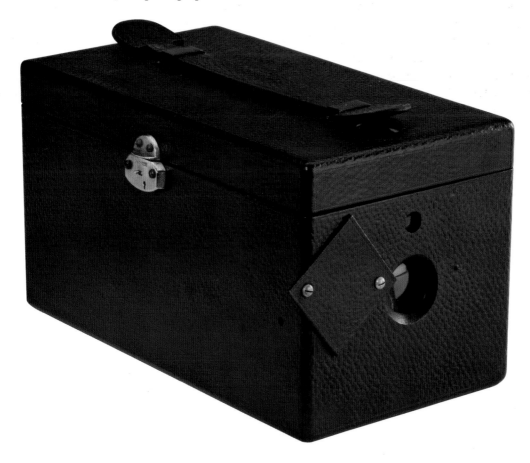

Concealed Vest Camera, No. 2 *1888*

C. P. Stirn, New York, New York. 1974:0037:2288.

Walking about with a hidden camera has long had its appeal. Judging by the sales figures for Stirn's Patent Concealed Vest Camera, in the 1880s there were plenty of surreptitious photographers willing to pay $20 for the seven-inch-diameter device. Although originally designed by American inventor R. D. Gray, Stirn purchased the rights, and the cameras were produced in Berlin, Germany. The camera was worn low on the chest, suspended by a neck cord. The lens and exposure advance knob protruded through buttonholes and the shutter was operated by pulling a string attached to a shaft near the bottom edge of the brass body. The circular dry plates were loaded into the camera by opening the clamshell rear door and inserting a six-exposure disc. This had to be done in a darkroom, as did the unloading. Included in the camera's price was a wooden storage box that had a threaded plate for tripod mounting. A small door on the box opened to reveal the lens and advance knob, and a hole was provided for the shutter string.

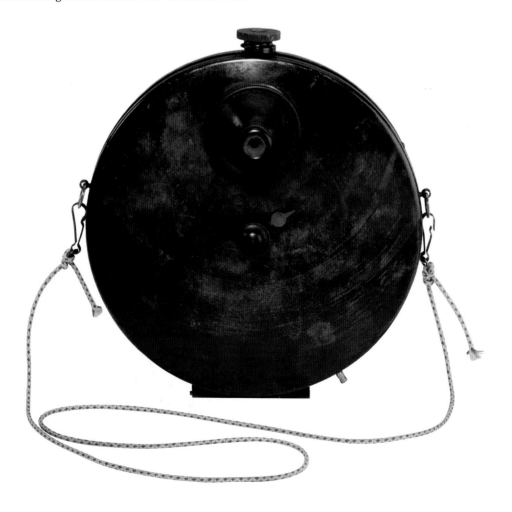

Express Détective Nadar Tropical *ca. 1888*

Paul Nadar, Paris, France.
Gift of Eastman Kodak Company, ex-collection Gabriel Cromer. 1974:0037:2905.

At first glance, the Express Détective Nadar Tropical didn't seem much different from any other "detective" cameras on the market in the 1880s. Closer examination revealed some unusual features. Though dry plates were still the photographic medium of choice for detective camera designers, Paul Nadar (1856-1939), son of the famed French portrait photographer, incorporated the American Eastman-Walker roll holder into the Express Détective. The holder used Eastman 3½-inch-wide film in forty-eight-exposure rolls. Focusing the 150mm f/6.8 Steinheil Gruppen Antiplanat lens by the somewhat outmoded sliding box-within-box method was improved by a rack-and-pinion mechanism. The shutter was a spring-loaded sector with speed controlled by varying the pressure of a friction shoe that rubbed against it as it turned. The camera was available in either a polished wood or leather-covered finish.

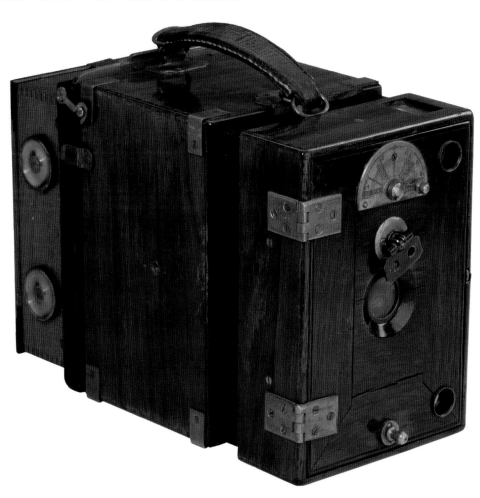

Photo-Livre *ca. 1888*

H. Mackenstein, Paris, France.
Gift of Eastman Kodak Company, ex-collection Gabriel Cromer. 1974:0037:1815.

Rudolf Krügener was a nineteenth-century German photographer with many camera-related patents to his credit. In 1888 he introduced his Taschenbuch, a box camera disguised as a small book. Book cameras weren't new, but Dr. Krügener's featured a clever mechanism for changing the 4 x 4-cm dry plates in the camera's built-in twenty-four-exposure magazine. The Taschenbuch was manufactured under different names for sale in various countries. This Photo-Livre version was made to be sold by Mackenstein of Paris. The 65mm f/12 lens was hidden in the "spine," and the shutter was actuated by pulling strings on either side of the camera. There was no viewfinder because using one to aim the camera would have revealed the ruse. Other manufacturers continued a tradition of the book camera, using roll films and even 110 Pocket Instamatic cartridges, so we may see a digital version one day.

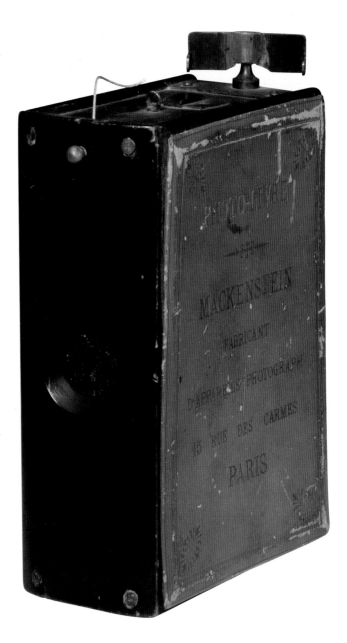

Escopette *ca. 1888*

E. V. Boissonas, Geneva, Switzerland.

Gift of Eastman Kodak Company, ex-collection Gabriel Cromer. 1974:0037:0014.

Eastman's 1888 Kodak introduced many people to photography and spurred the design of cameras built around Eastman roll films. Swiss inventor Albert Darier took advantage of the readily available Eastman 70mm-wide films with his Escopette, also in 1888. The handsome hardwood box with dovetail joinery housed a 110-exposure roll and the film winding mechanism, while a bottle-shaped metal nose contained the spherical shutter and Steinheil periscopic 90mm f/6 lens. The shutter speed was adjusted by a ridged wheel with ratchet stops that set the spring tighter with each click. A brass key under the ratchet set the shutter, so it could be tripped by the photographer's trigger finger as the camera was held by the pistol-grip handle. The handle became part of a tabletop stand when the two adjustable brass legs were pivoted open. Carrying on the firearm theme, the metal parts were lacquered or gun-blued. E. V. Boissonas manufactured the Darier design and priced the camera at 190 francs.

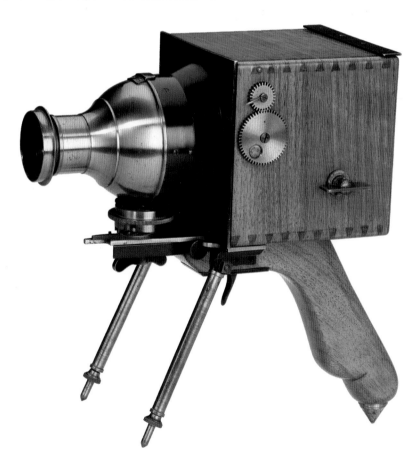

Tom Thumb Camera *ca. 1889*

Max Juruick, Jersey City, New Jersey.
Gift of Eastman Kodak Company. 1974:0037:2580.

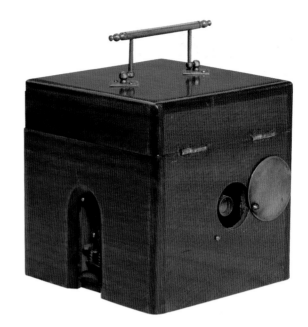

The Tom Thumb Camera falls into the category of detective cameras, its disguise being the finished wooden carrying case. It also could be removed from the case and used as a handheld camera. Invented by James Ford and manufactured by Max Juruick of Jersey City, New Jersey, in 1889, the early versions were labeled Ford's Tom Thumb Camera. It used dry plates and produced 2½-inch square images that could be made round by inserting a circular mask.

Demon Detective Camera No. 1 *ca. 1889*

American Camera Company, London, England.
Gift of Eastman Kodak Company,
ex-collection Gabriel Cromer. 1982:0237:0002.

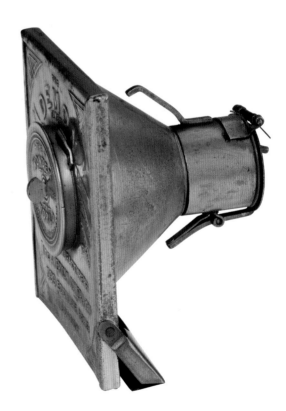

Invented in 1889 by Walter O'Reilly, the Demon Detective Camera No. 1 was manufactured for the American Camera Company of London, England. Stamped from nickel-plated brass, the back was quite decoratively embossed. Sitting at the end of the funnel-shaped front, the achromatic doublet lens and simple flap shutter made a single, circular, instantaneous exposure on a dry plate. There was no viewfinder to aid in aiming the camera. A hinged door at the bottom gave access for changing the plate. An advertisement announcing the larger No. 2 model claimed 100,000 of the smaller No. 1 model sold in twelve months. Its list price was five shillings, including plates and chemicals.

Photo-Cravate *1890*

Edmund & Leon Bloch, Paris, France.
Gift of Eastman Kodak Company, ex-collection Gabriel Cromer. 1974:0084:0050.

Designed by Edmund Bloch of Paris, the Photo-Cravate had a tiny camera concealed behind an innocent-looking piece of 1890s men's neckwear. The body of the all-brass camera was only seven millimeters thick, but it contained six 25-mm square dry plates in holders attached to a tiny conveyor chain. A small knob on the camera protruded through the tie like a shirt button and was turned to bring a fresh plate behind the 25mm f/16 lens, which was positioned on the necktie to resemble a stickpin jewel. Making an exposure meant squeezing and relaxing a rubber bulb with a tube that operated the pneumatic shutter. The savvy photographer would vary the exposure time according to the lighting conditions, holding the bulb longer to keep the shutter open. Known in English-speaking markets as the Detective Photo Scarf, the Photo-Cravate was priced at $21 in 1891, with replacement ties in various colors and patterns available separately.

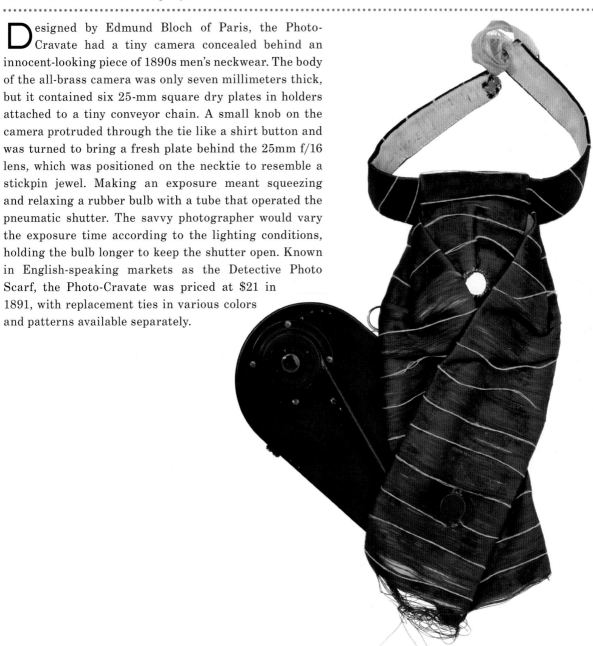

Antique Oak Detective Camera *ca. 1890*

Scovill & Adams Company, New York, New York.
Gift of Mr. and Mrs. C. S. Perkins. 1983:0904:0001.

Scovill & Adams made its first detective camera in 1886, a bellows design concealed inside a hinged-top case. A few years later, the firm introduced a series of Waterbury Detective cameras, which were simple-looking wooden boxes with quick-acting controls, advertised as requiring no skills to capture a photo of the "unsuspecting victim." All that was necessary was to sight the subject in one of the reflex viewfinders, turn the focus dial to the approximate distance from your prey, arm the shutter, and press the tiny brass release button atop the box. That was it. You had your candid shot, your evidence, and off you went to develop the plates.

The Antique Oak model was created to appeal to those who wanted a real detective camera but couldn't justify the Waterbury's $25 sticker price. The oak version met the same specifications, but used cheaper wood for the body and cost only $15. For an extra $2.50, you could have it covered in black leather. Either way, you got the Double Combination Instantaneous lens, rack-and-pinion focusing, tripod threads, and one 4 x 5-inch double dry-plate holder. The holders were accessible by opening the hinged door on the right side of the camera. To emphasize the bargain price of the Oak Detective, the company's catalog pointed out that the lens alone sold for $15, making the camera a virtual giveaway.

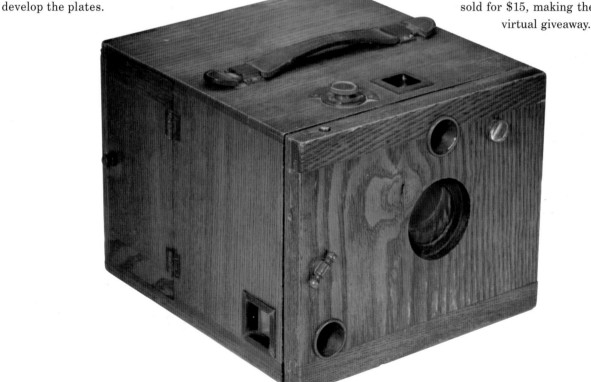

Scovill & Adams Company Book Camera *1892*

Scovill & Adams, New York, New York. 1974:0084:0053.

One of the rarest of all the detective cameras is the Scovill & Adams Company Book Camera of 1892. Disguised as a bundle of three schoolbooks, titled French, Latin, and Shadows, and secured by a leather carrying strap, its cover would be blown when put to photographic use. The multiple manipulations needed to prepare the camera for imaging required the group of books to be inverted, spines-up, in a most unnatural position. The retail price was $25.

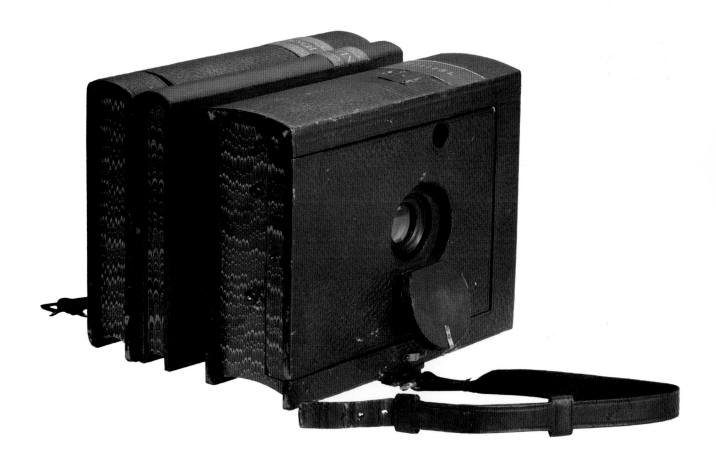

Velocigraphe *ca. 1892*

J. Fleury Hermagis, Paris, France.
Gift of Eastman Kodak Company. 1974:0084:0051.

The end of the wet-plate era meant photographers could spend less time preparing cumbersome media and more time taking pictures. When mass production made the dry plate widely available in the late nineteenth century, all a photographer needed for an outing was a good camera and a stack of fresh plates. However, since plate holders held only one or two plates and still needed to be loaded in the dark, many a Victorian shutterbug would take along a sackful. Yet even at this new level of convenience, photographers wanted something faster and easier. Designers responded by incorporating a plate magazine and changing mechanism inside the camera.

One popular changer system was the "falling-plate" design, which used a spring to push a plate stack against the film plane. After the exposure was made, an escapement released the spent plate, and gravity did the rest. When the last plate was exposed and dropped into the storage well, the camera was taken to the darkroom for unloading and refilling.

The Paris optician J. Fleury Hermagis also designed and built cameras. His Velocigraphe detective camera had a hardwood body that fit snugly into a black leather case and looked like a small valise. Its falling plate changer could hold a dozen 9 x 12-cm dry plates in the magazine. Sneaking a picture was as easy as dropping the front panel of the case, adjusting the helical mount Hermagis lens for distance, and tripping the shutter, which also performed the changing duties. With that, you had your picture and were ready to take another, much as you would with a motorized film advance on a point-and-shoot camera one hundred years later. Even though they worked well, plate changers were abandoned when roll film began dominating the market.

Hawk-Eye Detective Camera *ca. 1893*

Blair Camera Company, Boston, Massachusetts.
Gift of 3M, ex-collection Louis Walton Sipley. 1977:0415:0316.

With this model, Blair Camera Company combined the rugged construction of a hardwood box with the focus accuracy of a view camera. Inside the box was a bellows and a lens board that was adjustable by turning the brass knob on the rear panel. A removable cover revealed a ground glass for precise focus, and a hinged side door made it easy to quickly swap the ground glass and plate holder. The camera's self-capping shutter could be set to one of three speeds by twisting the brass winder on top of the camera. A small button next to the winder tripped the shutter. For time exposures, a button on the front opened the shutter while the one on top closed it. Reflex finders on adjacent sides allowed for both orientations of the rectangular picture format.

Roughly the size of a shoe box, the Hawk-Eye Detective Camera was designed for 4 x 5-inch plates or film sheets but had room to mount a roll-film holder loaded with enough stock to take one hundred pictures. When shooting roll film, the photographer could develop and print at home, using equipment and supplies purchased from Blair, or return the loaded roll holder to the factory. For $15, the firm processed the pictures and returned them along with fresh film in the holder.

The Hawk-Eye Detective Camera was priced at $15 alone, or $30 with loaded roll holder. It could be purchased with a better lens, such as a Darlot or Taylor-Hobson, for an extra $15 or $25, respectively. For $5 more, Blair covered it with black leather.

Photo-Étui-Jumelle *ca. 1893*

Franck-Valéry, Paris, France.
Gift of Eastman Kodak Company,
ex-collection Gabriel Cromer. 1974:0084:0060.

The Photo-Étui-Jumelle of 1893 was manufactured by Franck-Valéry of Paris. It was yet another example of the then-popular "detective" cameras. In this case, when folded, the camera was disguised as a pair of binoculars in a traditional binocular case. The sides of the camera were spread in a clamshell fashion to accept a plate. It was available in two plate sizes: 9 x 12 cm or 13 x 18 cm. The retail price was 180 Swiss francs.

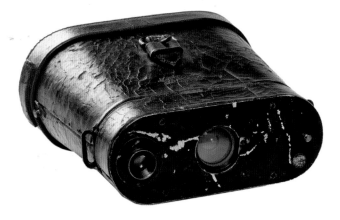

Kauffer Photo-Sac à Main *ca. 1895*

Charles Alibert, Paris, France.

Gift of Eastman Kodak Company, ex-collection Gabriel Cromer. 1974:0037:1549.

Though not really a detective camera, the Photo-Sac à Main was disguised, or at least housed, in a leather-covered wooden case resembling an elegant ladies handbag. Manufactured by Charles Alibert of Paris in 1895, the camera used a strut-mounted leather bellows concealed by overlapping front flaps whose elegant nickel-plated trim and stylish latch enhanced the guise. The bag's rear compartment was roomy enough for three double 9 x 12-cm dry plate holders, along with a ground glass back.

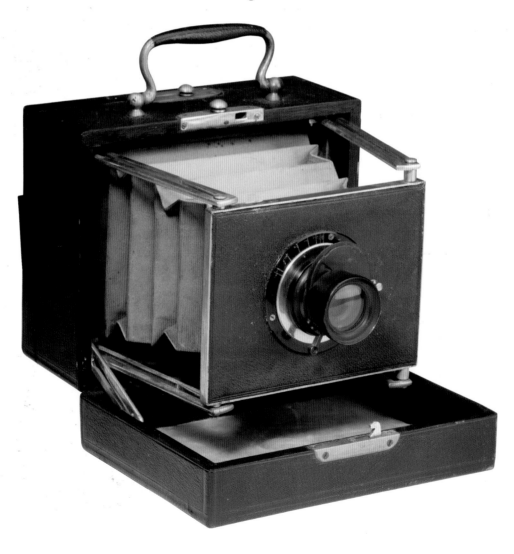

Pocket Kozy (ORIGINAL MODEL) *ca. 1897*

Kozy Camera Company, Boston, Massachusetts.
Gift of Eastman Kodak Company. 1995:0151:0001.

The Pocket Kozy camera, first introduced in 1897 by the Kozy Camera Company of Boston, was different from traditional self-casing, folding cameras. Instead of using the classic drop-bed design, Hiram A. Benedict created a novel camera that opened like a book, with red leather bellows fanning out like pages. Eventually there were three versions, but the camera shown here is the first model, and surely fewer than a handful survive today. The first model had a flat front and opened with the bellows facing the rear of the camera, with the lens and shutter located in the "spine" position. The second and third models placed the bellows to the side with the lens on the curved front. All versions made twelve or eighteen 3½ x 3½-inch exposures on roll film. In 1897 the camera sold for $10 and could be purchased on a payment plan. Benedict hoped to sell 100,000 units, though it is safe to assume that goal was not reached.

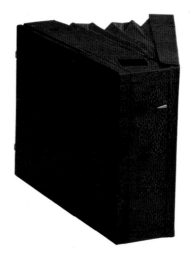

Deceptive Angle Graphic *ca. 1901*

Folmer & Schwing Manufacturing Company, New York, New York.
Gift of Graflex, Inc. 1974:0037:2326.

The Deceptive Angle Graphic was manufactured by Folmer & Schwing Manufacturing Company in New York City. At the time of its introduction in 1901, the public was fascinated by candid photography that used "detective" or "deceptive angle" cameras. It was designed to look like a stereo camera with a pair of fake lenses on the front while an obscure lens mounted on the side of the camera, ninety degrees to the photographer's perceived line of vision, took the actual pictures. The retail price, with Rapid Rectilinear lens, was $67 in 1904.

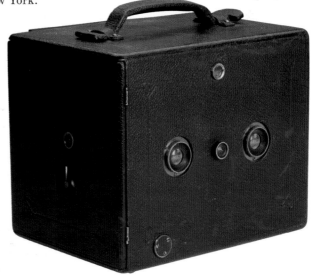

Ben Akiba *ca. 1903*

A. Lehmann, Berlin, Germany.
Gift of Eastman Kodak Company,
ex-collection Gabriel Cromer. 1974:0084:0086.

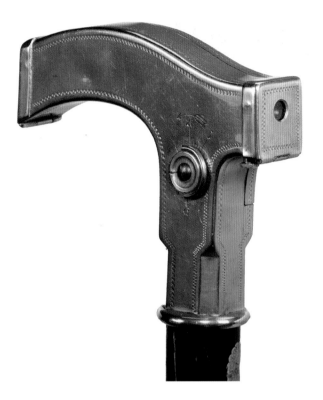

Cameras have been disguised in just about every type of fashionable accessory, from hats to handbags, with many seemingly more likely found among the wares of the haberdashery than the camera shop. In this case, the camera is hidden in the handle of a gentleman's walking stick. Patented by Emil Kronke and manufactured by A. Lehmann, both of Germany, the Ben Akiba produced twenty images, 1.3 x 2.5 cm in size, on roll film. Given the small image size and the emulsion of the time, the quality of the images produced was not very good, relegating the cane camera to the novelty category. On the other hand, it may have been the turn-of-last-century answer to that age-old question: what to give the dapper gent who has everything?

Expo Police Camera *ca. 1911*

Expo Camera Corporation, New York, New York. 1974:0037:2068.

Manufactured by the Expo Camera Corporation of New York City from 1911 to 1924, the Expo Police Camera is an example of the "detective" cameras popular at the time. About the size of a box of kitchen matches, it was an all-metal box camera with a cloth focal-plane shutter. It produced twelve ¾ x 1¹/₁₆-inch images on special roll-film cassettes. Many consider it a milestone subminiature camera, the precursor of all the "matchbox" cameras. Its original retail price was $5.

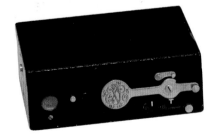

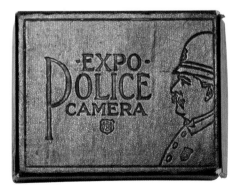

Vest Pocket Ensign (MOUNTED IN HANDBAG) *ca. 1925*

Houghton-Butcher, Ltd., London, England.
Gift of Eastman Kodak Company. 1974:0037:1671.

Concealed and disguised cameras have always intrigued people. Designers loved dreaming up clever ways to incorporate photographic devices into everyday items. "Purse cameras" first appeared in the nineteenth century with bulky dry-plate apparatus in big Victorian-era handbags. By the time Samuel Aspis of London patented his "Combination of Hand Bag . . . and Collapsible Photographic Camera" in 1928, roll-film vest pocket cameras were at the height of their popularity. Aspis designed his version around an ordinary Ensign Vest Pocket, which folded flat enough to mount inside a special leather clutch purse. To take photos, the purse flap was flipped over and a mirror panel unsnapped. The camera faceplate had to be pulled out to lock the struts, and it was then ready to begin filling up the roll of 127 film with pictures. Metal brackets riveted to the purse held the camera securely. The Aspis purse camera wasn't intended for surreptitious photography, but rather as a convenient way to always have a camera ready to use. And one would assume the fashion-conscious dame of the time would have shoes and earrings to match the Ensign clutch.

Erac Mercury *ca. 1938*

E.R.A.C. Selling Company, Ltd., London, England.
Gift of Jerry Friedman. 2004:0957:0001.

Cameras disguised as other objects have taken many forms since the invention of photography. Being able to sneak a photograph without being noticed has appealed even to those who aren't in the espionage business. So-called detective cameras have been cleverly hidden in satchels, books, and even under a man's shirt, with the lens doubling as his tie pin. However, it's hard to imagine a camera like the Erac Mercury being used in such a stealthy manner. Who would not be alarmed when being "shot at" by this? Perhaps the Erac was conceived not as a spy camera but as a novelty item that happened to take pictures. In any case, the snub-nose shape of the pistol camera would likely fool only those unfamiliar with handguns.

Inside the Erac Mercury's boxy housing was a complete, British-made subminiature camera. This camera, the Merlin, was a sturdy, all-metal design with a single-speed shutter and fixed-focus lens. It used special roll films to make 18-mm square negatives. The pistol housing consisted of two halves that contained both camera and a trigger mechanism, which had to serve as shutter release and film advance, once the halves were fastened together. A gear-and-ratchet pawl mechanism tripped the shutter when the trigger was squeezed, then wound the film to the next frame on the return stroke. Keeping track of the shots was left to the photographer, as the Merlin's red exposure window couldn't be seen until the pistol halves were separated. Disassembly was also necessary to change films. The Erac Mercury sold for about $3.75 in 1938.

SNAPSHOT

Snapshot, originally a hunting term referring to a shot taken without careful aim, was first applied to photography by English scientist Sir John Herschel (1792-1871) in the 1860s. Nearly twenty years later, after numerous improvements had been made to cameras, lenses, shutters, and sensitized materials, Herschel's vision of spontaneous photography became possible.

The foundation for snapshot photography was established by the Eastman Dry Plate and Film Company in 1888 with the introduction of the Kodak camera and the accompanying photo-finishing industry. A few years later, the $1.00 Brownie firmly reinforced the point-and-shoot segment of the camera market, which over the next hundred years proved to be a staple of the photographic industry.

Pistolgraph *1859*

Thomas Skaife, London, England.

Gift of Eastman Kodak Company, ex-collection Gabriel Cromer. 1974:0084:0007.

Thomas Skaife's Pistolgraph, the first camera to incorporate a mechanical shutter, was capable of instantaneous photography. Its small image size, coupled with a fast f/2.2 Petzval-type lens and a rubber-band-actuated double-flap shutter with an estimated speed of 1/10 second, allowed one to photograph some moving subjects. Somewhat resembling a small pistol, the camera mounted to the top of a wooden box which also doubled as its storage case with a ball-and-socket mechanism. At the camera's rear was a rectangular compartment used to both hold and sensitize a one-inch square wet plate.

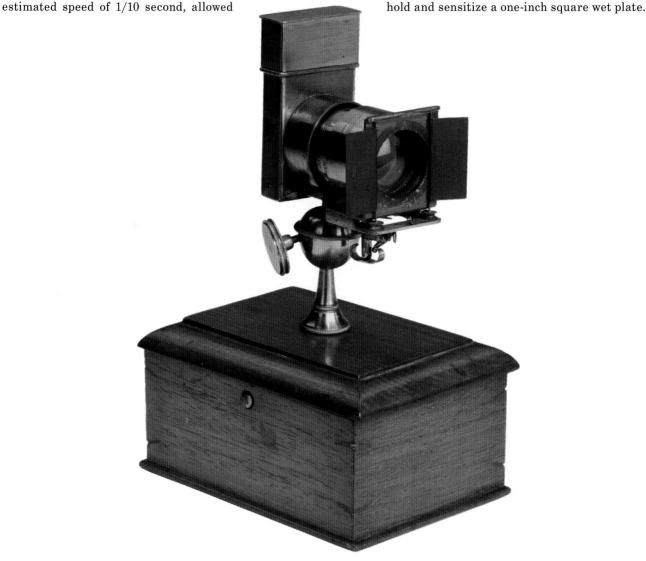

Stebbing's Automatic Camera *ca. 1883*

E. Stebbing, Paris, France. 1974:0037:1501.

Stebbing's Automatic Camera, the first camera with an integral roll holder, was invented and manufactured in 1883 by Professor E. Stebbing of Paris. Stebbing used the word "automatic" in the name of his all-wood box camera to indicate that it required no focus. "Focusing is useless," he said. "It is controlled with too much care."

The camera produced sixty to eighty 6-cm square exposures on roll film or gelatino-bromide paper, and it could also produce single exposures on dry plates. The Stebbing's Automatic had several interesting features, including an audible click when enough film had been advanced for the next exposure, as well as a moveable pressure plate to precisely place the film in the exposure plane. The pressure plate action pierced the film to mark where it later should be cut for development. The concept had great promise and seemed to offer simplicity and ease of use, but the film proved troublesome, requiring lengthy drying time and suffering dimensional instability. This, coupled with the introduction of Eastman's roll film and the Eastman-Walker roll holder, which adapted to almost any camera, caused the demise of the $12 camera after only a few years.

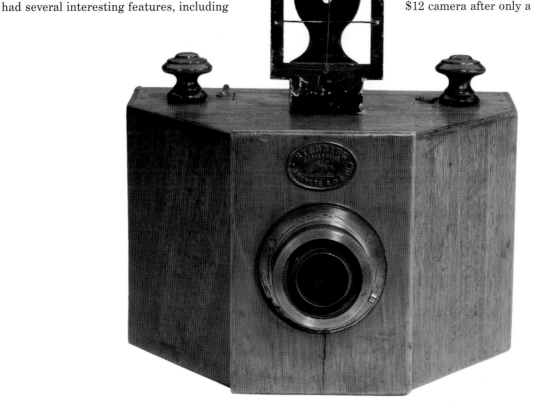

Kodak Camera (BARREL SHUTTER) *1888*

Eastman Dry Plate & Film Company, Rochester, New York.
Gift of Eastman Kodak Company. 1990:0128:0001.

In 1888, the world first learned to say Kodak, which originally was the name of this handheld box camera rather than an entire company. The camera was manufactured by Frank Brownell of Rochester, New York, for Eastman Dry Plate & Film Company, also of Rochester. The name was coined by George Eastman, who is said to have favored the letter "K" and wanted something memorable and pronounceable in multiple languages.

Expensive for the time, the purchase of a Kodak at $25 included a factory-loaded roll of sensitized film, enough for one hundred 2½-inch circular images. After exposure, the still-loaded camera was returned to Rochester, where the film was developed, prints made, and a new roll inserted, all for $10. This ease of use was such a key selling point that Eastman soon promoted sales with his slogan, "You press the button, we do the rest."

An early "point-and-shoot" camera, the Kodak revolutionized the photographic market with its simplicity of use and freedom from the mess of darkroom chemistry. The first successful camera to use roll film, it stood for convenience. Looking to build on this reputation, over several months in late 1889 George Eastman introduced a modified version of the original Kodak, now designated the No. 1, and three fresh models bearing the Kodak name, all loaded with the new Eastman's Transparent film.

Those first Kodaks marked the beginning of photography as a tool and pastime for the common person. Even more important than their sales figures was the major role they played in establishing what would become Eastman Kodak Company (in 1892) as the first international photofinishing concern. Soon, a seemingly endless line of new Kodak models offered more features and larger images, all contributing to the worldwide identification of the Kodak brand with the growing popularity of amateur photography.

Some 5200 Kodak barrel shutter cameras were made before a running change was made replacing the barrel shutter with a simpler sector shutter mechanism. The "improved" camera was still called a Kodak until the introduction of the larger No. 2 Kodak (with a 3½-inch diameter image) in October 1889, when the improved model was renamed the No. 1 Kodak.

No. 1 Kodak Camera *1889*

Eastman Dry Plate & Film Company, Rochester, New York. 1974:0037:1915.

With the introduction of the larger No. 2 Kodak in late 1889, a revision of the original model Kodak was retroactively named the No. 1. Its major modification was the replacement of the complex barrel shutter with a simpler, less-expensive sector shutter, along with minor hardware changes associated with the new shutter. Late in 1889, Eastman's Transparent film (nitrate) was introduced; all subsequent Kodak camera models (No. 1, No. 2, No. 3, No. 3 Jr., No. 4, No. 4 Jr.) were shipped with this, replacing Eastman's American film (paper-backed stripping film), which was more cumbersome to process. In the company's 1890 catalog, the No. 1 was described as "the original Kodak and it will always continue to be the Note Book of Photography." It remained factory-loaded with one hundred exposures, 2½ inches in diameter, and priced at $25. In total, about 10,000 No. 1 Kodak cameras were produced.

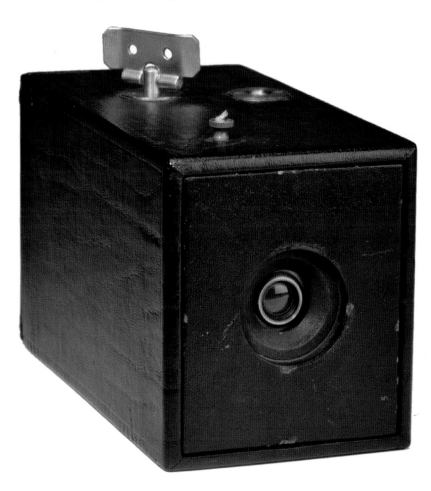

GEORGE EASTMAN
Todd Gustavson

A man with little education and no formal scientific training, George Eastman was one of the most influential men in the history of photographic technology. The shadow of his influence is still with us today, as the digital camera is yet another product of his company's research labs.

The youngest of three children, George Eastman was born July 12, 1854, at Marshall, New York. His father, George Washington Eastman, ran a commercial college about 150 miles away in Rochester, providing his family a comfortable life. In 1860 the family moved to Rochester, and two years later the elder Eastman passed away; young George was nearly eight years old. Mrs. Eastman opened a boarding house, and at age 14, Eastman left school to work as an office boy to help support the family. He was good with figures and a fastidious record keeper, and by age 20 he landed a job as a clerk with the Rochester Savings Bank.

In 1877, he became interested in investing in land in Santo Domingo. While Eastman was planning his trip to investigate the property, a colleague suggested he take up photography and document the parcel before making the purchase. Eastman followed his advice and became obsessed with photography, so much so that he shelved the trip. Eastman purchased a photography outfit for $49.58 from Henry D. Marks, a Rochester retailer. He then hired a professional photographer, George Monroe, to teach him the rather complicated wet-plate process. Patent attorney George Selden, whom Eastman would later engage professionally, also assisted in his photographic training.

Eastman set about learning as much about photography as possible. He subscribed to a publication for amateur photographers, the British Journal of Photography. In it he read Charles Bennett's article describing ripening, a way to increase the sensitivity of gelatin dry plates. This inspired Eastman to begin experimenting with his own dry-plate formulas in his mother's kitchen during off hours. These experiments eventually resulted in his inventing a successful system for making dry plates, and he opened a side business manufacturing photo plates for sale. The business quickly grew, and with the help of Selden, Eastman was granted a U.S. Patent (#226,503) in 1880 for a dry-plate coating machine. With the financial backing of Henry Strong, the Eastman Dry Plate Company was formed. The contract was signed on December 23, 1880. The next year Eastman resigned from the bank to devote his full energies to his new company.

George Eastman with his bicycle, unidentified photographer (American) ca. 1892. Gift of Eastman Kodak Company. Neg. Number 48723. 2011:0124:0001.

Though convenient, dry plates had the disadvantage of being both heavy and fragile. Eastman set his emulsion-making skills to solving these issues and in 1884 introduced Eastman's American Film, which used Rives paper instead of glass as the emulsion support. With the help of Rochesterian William H. Walker, a pioneer in the American system of camera building, Eastman designed and manufactured a holder for the new film. The Eastman-Walker roll holder could be adapted to fit many of the cameras manufactured in Europe and the United States. To reflect these new products, the company's name was changed to the Eastman Dry Plate and Film Company.

Eastman's Dry Plates and American Film were products generally intended for the professional market. At this time, a new market was developing for the needs of amateur photographers. In response, Eastman and Frank Cossitt, a company employee, began working on a new hand-held camera, the so-called Eastman Detective camera. The resulting camera never really got off the ground, but it gave Eastman some vital experience in the hand-held camera arena. His next camera, the "Kodak," was designed and built with the assistance of Frank A. Brownell (1859-1939) and successfully married the roll film holder to a hand-held detective camera. It also addressed the major problem of the American Film—the difficulty of processing it—by adding processing to the company's product line, thus creating the revolutionary professional photo-finishing industry.

A new flexible film without the cumbersome paper support was introduced for the Kodak in 1889. Thus, Eastman Transparent Film and its successors became the mainstay of the photographic industry as well as the fledgling motion picture industry. The success of the Kodak cameras was reflected in yet another and final company name change to the Eastman Kodak Company in 1892.

Eastman Kodak Company continued to be a leader in the photographic industry, ushering in many new products, the most successful of which was the Brownie camera of 1900. Designed and built by Brownell, the $1.00 Brownie produced quality images at a price that nearly everyone could afford. It sold in numbers that were almost unheard of during those times: 150,000 during its first year of production, and the entire Brownie family reached one million cameras sold by 1906.

Since the early days of photography, the chemical formulas for making sensitized material were concocted empirically by one or two people. However, to fully understand the chemical reactions involved in photography and to undertake the next hurdle, color, Eastman chose a different path. Eastman concluded that an industrial research laboratory would be necessary to accomplish this, and in 1912, he hired a chemist, Dr. Charles Edward Kenneth Mees (1882-1960). At the time, Mees was the production manager at Wratten and Wainwright, a dry-plate manufacturer in Croydon, England. To acquire him, Eastman boldly purchased the company. Under Mees's guidance, the Kodak Research Labs (KRL) became one of the most respected corporate research facilities in the world. A short list of advances spawned by KRL includes Kodachrome, Ektachrome, Kodacolor, Tri-X films, Estar film base, and digital photography.

Since the early days of photography, the chemical formulas for making sensitized material were concocted by one or two people, usually in an empirical manner. This was the method Eastman and his colleagues used to formulate both gelatin dry plates and flexible roll film. However, to fully understand the chemical reactions involved in photography and to undertake the next hurdle, color, a different path was chosen. Eastman concluded that an industrial research laboratory would be necessary to accomplish this, and 1912, he hired Dr. Charles Edward Kenneth (C.E.K.) Mees (1882-1960), a chemist trained at University College in London, England. At the time, Mees was the production manager at Wratten and Wainwright, a dry-plate manufacturer in Croydon, England. To acquire him, Eastman boldly purchased the company. Under Mees's guidance, the Kodak Research Labs (KRL) became one of the most respected corporate research facilities in the world. A short list of advances spawned by KRL include Kodachrome, Ektachrome, Kodacolor, Tri-X films, Estar film base, and digital photography.

No. 4 Kodak (Used by Robert E. Peary) *1889*

Eastman Dry Plate & Film Company, Rochester, New York.
Gift of Eastman Kodak Company. 1994:1480:0001.

This No. 4 Kodak is one of several used by then-Lieutenant Robert E. Peary on his 1897 Greenland expedition. Introduced in 1889 for $50, it was capable of producing forty-eight or one hundred pictures of 4 x 5 inches and weighed 4½ pounds. Still, Kodak literature claimed it was "much smaller than cameras by other makers for making single pictures." The camera featured an instantaneous shutter, rotating stops, adjustable speed, rack-and-pinion focusing, and two tripod sockets for horizontal or vertical timed exposures.

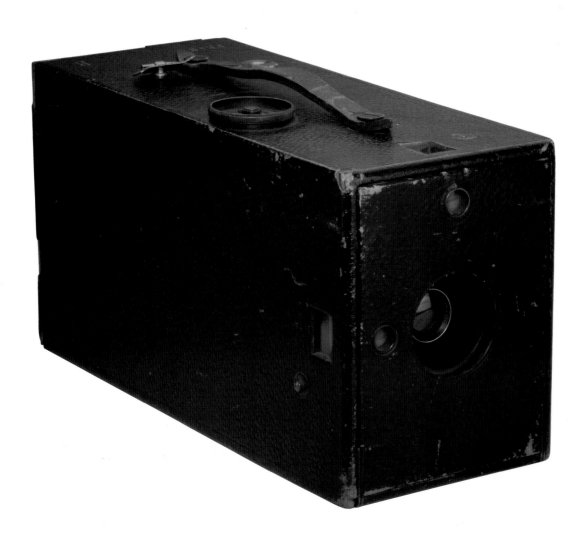

Luzo *1889*

J. Robinson & Sons, London, England.
Gift of Eastman Kodak Company. 1974:0037:1503

The roaring success of Eastman's Kodak in 1888 convinced rival manufacturers that the roll-film camera was here to stay. Henry Redding designed the Luzo to use the Kodak's film, but he improved on Eastman's camera by changing the location of the film spools, resulting in a much smaller box. The Luzo also incorporated a reflex viewfinder, a feature lacking in the Kodak. Built by J. Robinson & Sons of London, Redding's camera was constructed mainly of polished Spanish mahogany. The external shutter mechanism was a simple sector design powered by a rubber band; tension could be varied by a brass slide below the shutter. Like the Kodak, the Luzo took one hundred round pictures per roll. Unlike the Kodak, processing was not available through the manufacturer, which left the photographer to sort this out on his own.

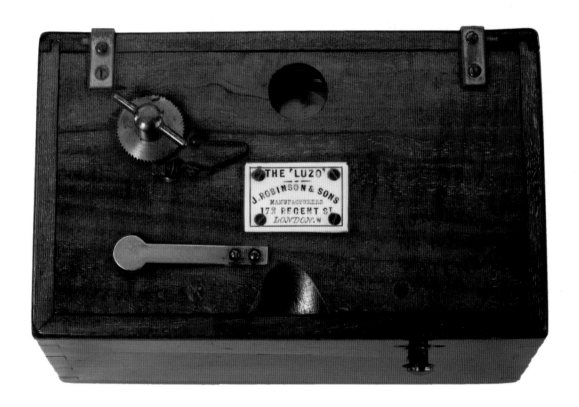

Photosphere *ca. 1889*

Compagnie Française de Photographie, Paris, France.
Gift of Eastman Kodak Company, ex-collection Gabriel Cromer. 1974:0037:1816.

As the ranks of amateur photographers swelled in the 1880s, camera manufacturers were pressured to make their products easier to tote along, yet robust enough to take the bumps encountered on photo outings. Compagnie Française de Photographie of Paris answered with their Photosphere in 1889. Made of patinated silver on brass, this odd-looking device used a rigid lens housing instead of a collapsing design. The lens was a periscopic 95mm f/13. The hemispherical part of the bell-shaped structure housed the spring-powered shutter, which had a matching shape. A tiny knurled knob on the side adjusted the spring tension for shutter speed settings, but it was strictly guesswork. Bubble levels on adjacent sides helped frame the subject, no matter which orientation of the 9 x 12-cm plates the photographer chose. A finder could be clipped on either of the two mounting shoes. Options like a twelve-plate magazine back and a clamp to secure the camera to your bicycle kept Photosphere popular and sales going along until the turn of the century.

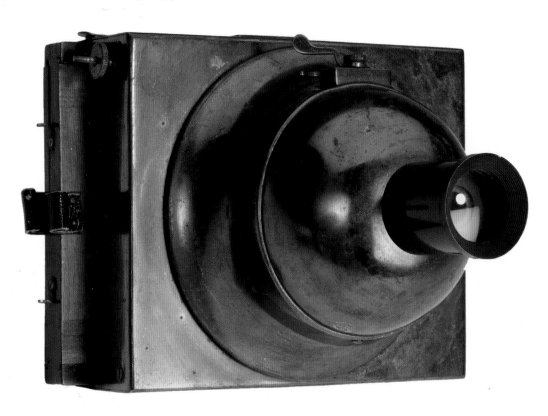

Kamaret *1891*

Blair Camera Company, Boston, Massachusetts. 1974:0037:0020.

Introduced in 1891 by the Blair Camera Company of Boston, the Kamaret was a leather-covered wooden box camera, capable of producing twenty, fifty, or one hundred 4 x 5-inch images on either roll film or dry plates. It was advertised as "Being nearly one-third smaller than any camera of equal capacity," a claim that was obviously aimed at Eastman's already introduced No. 4 Kodak. The smaller size was made possible by Blair's patented space-saving method of placing the film spools forward of the film plane. The original retail price was $40.

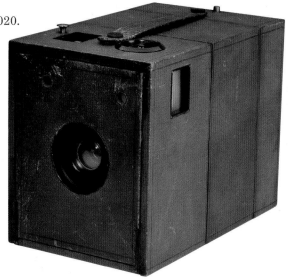

Model A Daylight Kodak *1891*

Eastman Company, Rochester, New York. 1974:0037:1080.

The Model A Daylight Kodak was introduced in 1891. Slightly larger than the No. 1 Kodak, it delivered twenty-four exposures of 2¾ x 3¼ inches on a special roll film that could be loaded in daylight because it was packaged in cardboard cartons with a black cloth leader and trailer. The deluxe leather-covered, wooden body retained the string-set sector shutter of earlier models. Kodak's 1892 catalog touted the camera to travelers and tourists as "the smallest camera that will make a good picture" with "advantages never before embodied in any other." It was priced at $8.50, and an outfit for developing and printing the pictures could be purchased for $1.50.

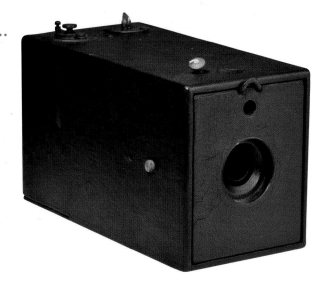

Model A Ordinary Kodak *1891*

Eastman Company, Rochester, New York.
Gift of Eastman Kodak Company. 1974:0037:1887.

Model B Ordinary Kodak *1891*

Eastman Company, Rochester, New York.
Gift of H. Cobb. 1974:0037:1121.

Model C Ordinary Kodak *1891*

Eastman Company, Rochester, New York.
Gift of Eastman Kodak Company. 1974:0037:1265.

Eastman introduced three models of Ordinary Kodaks in 1891. Like the No. 1 Kodak, they were all darkroom-only loaded roll-film cameras with a string-set sector shutter. Rather than the leather covering of earlier models, these featured a natural wood-finished body. The entire Ordinary Kodak line was discontinued in 1895.

The Model A (left) is easily distinguished from the Model A Daylight Kodak by its "plain" wooden body and lack of built-in viewfinder. Billing the Model A Ordinary as the "Young Folks' Kodak," the 1892 Kodak catalog asserted that with it, "any boy or girl, 10 years old or over, can readily learn to make the finest photographs." The camera featured a fixed-focus lens (always "in focus") and "V" sighting lines marked on its body that aided in aiming the camera. It sold for $6, a savings of $2.50 over the deluxe model.

The Model B Ordinary Kodak's viewfinder and shutter (middle) were concealed by a removable front panel and a felt lens cap. It had rotating stops in the lens "especially designed for young people who want a larger picture." For the selling price of $10, it came loaded for twenty-four pictures of 3½ x 4 inches.

The largest of the Ordinary Kodaks, the Model C (right) featured a focusing lever, adjustable shutter speeds, and two finders. Also, the camera's roll-film back could be removed and replaced with a glass plate holder. Priced at $15, it came loaded with twenty-four exposures for 4 x 5-inch pictures.

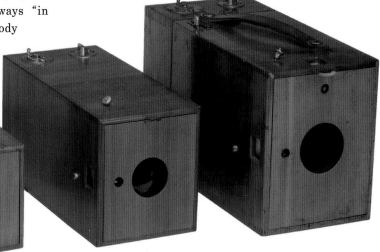

Anschütz Camera *ca. 1892*

C. P. Goerz, Berlin, Germany.

Gift of C. P. Goerz American Optical Company. 1974:0084:0042.

As photographic media became increasingly more sensitive, shutter designers came up with new ways to take advantage of the faster plates and films. In 1883, Ottomar Anschütz (1846-1907) refined the roller-blind shutter and mounted it just in front of the plate, close to the focal plane. Anschütz wanted to freeze the action of moving animals with little or no blurring. His solution was to make the width of the slit in the shutter curtain adjustable to achieve speeds up to 1/1000 second. Anschütz patented his invention and C. P. Goerz Optical Works incorporated it into a line of cameras produced in their Berlin factory. The first Anschütz cameras were boxes made of polished walnut and used 9 x 12-cm plates. This Anschütz box of 1892 has a Goerz Extra-Rapid Lynkeioskop lens with rack focusing and a lever-operated diaphragm. The viewfinder was a metal frame with thin wires as crosshairs. The focal plane shutter continued to be refined and was used in large- and small-format cameras for over one hundred years.

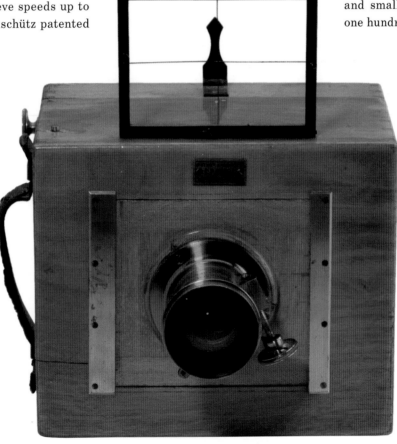

Bull's-Eye Camera *1892*

Boston Camera Manufacturing Company, Boston, Massachusetts. 1974:0084:0063.

The Bull's-Eye Camera was marketed in 1892 by Samuel Turner and his Boston Camera Manufacturing Company of Boston, Massachusetts. It was a simple roll-film box camera producing 3½-inch square images. The original Bull's-Eye Camera was the first to use printed paper backing on its film, with frame numbers visible through a small red celluloid window that became the standard for roll-film cameras. George Eastman, who always knew a good idea when he saw one, introduced a similar box camera called the Bullet in 1895. That same year, rather than continue payments on the red-window patent, Eastman bought Turner's company and the right to manufacture Bull's-Eye cameras. An original Bull's-Eye sold for $7.50, with extra twelve-picture film cartridges priced at fifty-five cents. The earliest examples, as shown here, have the "D"-shaped celluloid window; the later models have "O"-shaped windows.

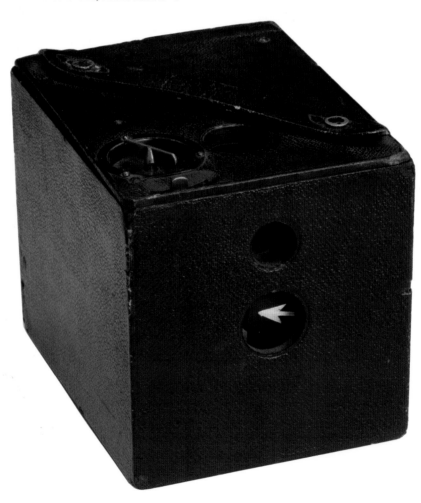

Pocket Kodak *1895*

Eastman Kodak Company, Rochester, New York.
Gift of Eastman Kodak Company. 1974:0037:1507.

..

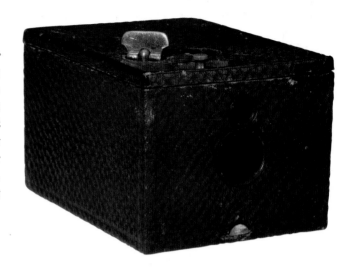

Continuing George Eastman's goal of bringing affordable photography to the common person, the Pocket Kodak was introduced in 1895 by Eastman Kodak Company, Rochester, New York. Enormously popular, it was a small, leather-covered wooden box camera. Easily held in the palm of the hand, it used either roll film or individual plates to produce images 1½ x 2 inches in size. It was attractive in either red or black leather covering and retailed for $5.

Steno-Jumelle *ca. 1895*

L. Joux & Cie, Paris, France. 1974:0037:2891.

..

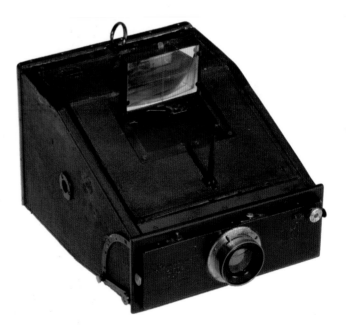

In the late nineteenth century, France introduced a type of camera known as the Jumelle, which means "twin" or "binocular." Generally wedge-shaped, this type of camera often had two lenses and resembled an opera glass. While some of them were stereo cameras and others had separate viewing and taking lenses, still others had a single lens and were merely wedge-shaped. The Steno-Jumelle, manufactured in 1895 by L. Joux & Cie of Paris, is of the last variety. A wedge-shaped aluminum box with pebble-grained leather covering and an eye-level Newton finder, this camera, like most of its kind, has a plate magazine with a push-pull changing action. It holds twelve 9 x 12-cm plates and is fitted with the Goerz Anastigmat lens and a guillotine shutter.

Sigriste *1899*

J. G. Sigriste, Paris, France. 1974:0037:0025.

This beautiful leather-covered wooden box camera was manufactured by the Swiss Jean Guido Sigriste in Paris. With its tapered form, a style sometimes referred to as a Jumelle, the Sigriste camera looks much like a fine piece of French furniture. Introduced in 1899, it was a mechanical marvel made in several format sizes, including stereo versions. The Sigriste featured a focal-plane shutter with one hundred available speed combinations from 1/40 to 1/2500 second, which were accomplished through the adjustment of spring tension and slit width. An internal bellows was fixed behind the lens and tapered to an adjustable slit in the focal plane that traveled across the plate. The push-pull magazine changer held twelve plates that were protected by a tambour door as the box was withdrawn. This particular 4.5 x 6-cm model has a 110mm f/3.6 Krauss Zeiss Planar lens in a helical focusing mount. The retail price, without lens, was 350 francs.

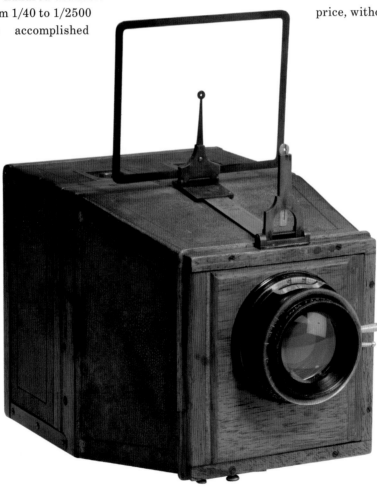

Le Champion Appareil Photograph-Complet *1900*

M. L. Friard, Paris, France.

Gift of Eastman Kodak Company, ex-collection Gabriel Cromer. 1974:0028:3475.

If you were at the Paris Exposition in 1900 and had forgotten your camera, for fifty centimes you could buy Le Champion Appareil Photograph-Complet. In a packet about three inches square by one-half-inch thick, M. L. Friard of Paris gave you everything needed to produce four pictures. Once opened, the heavy paper camera was unfolded and snapped together. In place was a sensitized dry plate, ready to be exposed by pulling the shutter string. A folded paper finder atop the camera helped compose the scene, and once the scene was captured, chemicals included in the kit developed the plate for printing. The outfit even included a paper funnel. Four sheets of print paper were inside, as well as a printing frame and the necessary chemistry. A set of detailed instructions guided the user through the process. Le Champion is the oldest one-time-use camera in the Eastman House collection.

Le Pascal *ca. 1900*

Japy Fréres & Cie, Belfort, France.
Gift of Eastman Kodak Company, ex-collection Gabriel Cromer. 1974:0037:1526.

Designed by François Pascal and introduced in 1899 by Japy Fréres & Cie of Belfort, France, Le Pascal was a small, leather-covered wooden box camera, unique for its film transport. The first roll-film camera to feature a rapid advance mechanism, it was claimed that a full roll of twelve exposures could be completed in less than six seconds. To operate, the user loaded the roll film into the camera, then wound the advance key, which simultaneously wound the spring motor, moved all the film to the take-up spool, and activated the shutter. Upon triggering the shutter release button, each exposure was rewound onto the original spool. This reverse film action would be used eighty years later in some 35mm cameras. A folding viewfinder also functioned as an interlock, preventing the shutter's release when folded flat. The original list price was 14,75 francs.

Brownie (ORIGINAL MODEL) *1900*

Eastman Kodak Company, Rochester, New York. 1978:1657:0002.

Introduced by Eastman Kodak Company in 1900, the Brownie camera was an immediate public sensation due to its simple-to-use design and inexpensive price of $1. Every individual, irrespective of age, gender, or race, could afford to be a photographer without the specialized knowledge or cost once associated with the capture and processing of images. An important aspect of the Brownie camera's rapid ascendancy in popular culture as a must-have possession was Eastman Kodak Company's innovative marketing via print advertising. The company took the unusual step of advertising the Brownie in popular magazines of the day instead of in specialty photography or trade magazines with limited readership. George Eastman derived the camera's name from a literary character in popular children's books by the Canadian author Palmer Cox. Eastman's astute union of product naming, with built-in youth appeal, and inventive advertising placement had great consequence for the rise of modern marketing practices and mass consumerism in the twentieth century.

The Brownie was designed and manufactured for Eastman Kodak Company by Frank A. Brownell, who produced all of Kodak's cameras beginning in 1888. The use of inexpensive materials in the camera's construction, and George Eastman's insistence that all distributors sell the camera on consignment rather than allowing them to set their own price, enabled the company to control the camera's $1 price tag and keep it within easy reach of consumers' pocketbooks. More than 150,000 Brownies were shipped in the first year of production alone, a staggering success for a company whose largest single-year production to date had been 55,000 cameras (the No. 2 Bullet, in 1896). The Brownie launched a family of nearly two hundred camera models and related accessories, which over the next sixty years helped to make "Kodak" a household name.

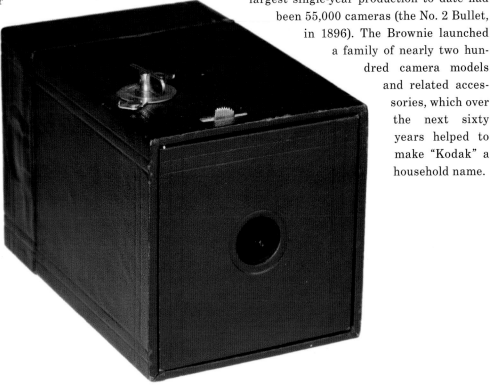

No. 1 Brownie (OWNED BY ANSEL ADAMS) *ca. 1901*

Eastman Kodak Company, Rochester, New York.
Gift of Ansel Adams. 1974:0037:1963.

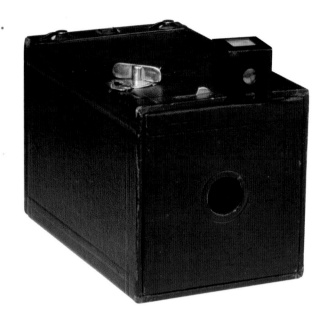

The No. 1 Brownie, introduced in October 1901, was actually the original Brownie with running changes included. Upon the introduction of the larger No. 2 Brownie, the original Brownie was renamed the No. 1, still using No. 117 film and producing 2¼-inch square images. It also had the hinged rear cover, a revision to the original Brownie's box lid cover that had proved troublesome. The original price was $1.

The camera shown here was the boyhood camera of Ansel Adams (1902-1984). It was a gift to him from his aunt for his first visit to Yosemite National Park in the summer of 1916. The fourteen-year-old Ansel was awestruck by the grandeur of the mountains and immediately began taking pictures.

No. 2 Brownie *ca. 1901*

Eastman Kodak Company, Rochester, New York. 1974:0037:1116.

The No. 2 Brownie camera, introduced in 1901, was still a cardboard box camera, but it included several important changes. It was sized for a new film, originally known as No. 2 Brownie film but renamed No. 120 in 1913 when Kodak gave numerical designations to their different films. No. 120 roll film is still in production today. In addition to the new film, which produced larger 2¼ x 3¼-inch images, the camera now sported two built-in reflecting finders and a carrying handle. With a retail price of $2, the No. 2 proved very popular, selling 2.5 million cameras before 1921 and remaining in production for more than thirty years.

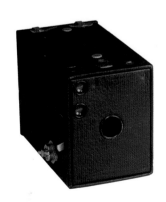

Buster Brown No. 2 *ca. 1906*

Ansco, Binghamton, New York.
Gift of Eastman Kodak Company. 1991:2786:0001.

The Buster Brown No. 2, introduced in 1906 by Ansco of Binghamton, New York, was their answer to the Kodak Brownie. This simple box camera was advertised as being designed with special reference to the wants of boys and girls. Like the Brownie, it made use of a popular cartoon character. The images were 2¼ x 3¼ inches on Ansco 4A (Kodak No. 120) roll film, and the original retail price was $2.

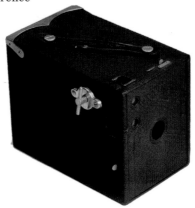

Français *ca. 1910*

L. F. G. & Cie, Paris, France.
Gift of Eastman Kodak Company, ex-collection Gabriel Cromer. 1974:0037:1495.

Even though by 1910 the roll-film camera was favored by amateur photographers, dry plates were still in use. L. F. G. & Cie of Paris made the tiny all-metal Français camera for use with 4 x 5-cm plates, which were packaged in pairs, enough to fit the two-sided holder that was mounted on a pivot shaft and swiveled like a portable chalkboard. A brass knob on the outside of the holder shaft let the user expose a plate, then shift the pointer from the "1" to the "2" position to make another. A simple lens and shutter on the front of the spice-can-shaped Français limited it to bright daylight use.

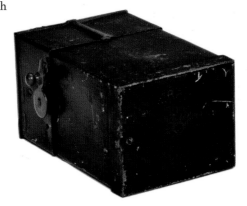

Dandy _ca. 1910_

Crown Camera Company, New York, New York.
Gift of Eaton S. Lothrop Jr. 2000:1037:0001.

The enormous success of Eastman Kodak Company's one-dollar Brownie attracted many would-be competitors. Crown Camera of New York City hoped to tap the growing market for inexpensive, foolproof photography with their tiny Dandy camera. The body was constructed of very thin cardboard covered with textured black paper. Exposures were made on sensitized 1-inch diameter metal discs packed in individual black envelopes. The photo discs were loaded by holding the envelope over a slot at the rear of the camera top, gently squeezing its sides, and allowing the disc to drop inside. A sliding metal cover sealed the slot. After taking the picture using the Dandy's primitive lens and shutter, the envelope was used to retrieve the disc, so it could be processed with the tank and chemicals included in the Dandy's one-dollar home photography outfit.

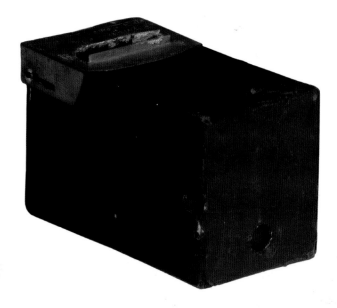

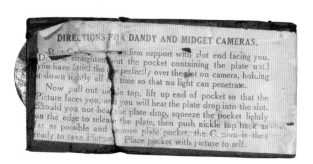

Cartridge Premo No. 00 *ca. 1916*

Eastman Kodak Company, Rochester, New York.
Gift of M. Wolfe. 1974:0028:3139.

Kodak box cameras came in many sizes, but none were smaller than the Cartridge Premo No. 00 introduced in 1916. The "double aught" was designed as a child's camera, but many adults bought one for themselves. Despite its size, not much larger than a box of 35mm film, the No. 00 was capable of images rivaling many larger cameras. The good quality lens and reliable shutter made it a great value at only seventy-five cents. Six-exposure rolls of the 35mm-wide film sold for a dime.

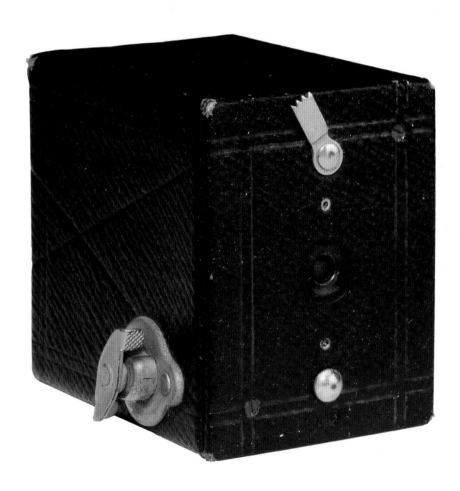

Ensign Cupid ca. 1922

Houghton-Butcher Ltd., London, England.
Gift of Kodak Ltd. 1974:0037:0138.

Instead of using a collapsible lens mount with bellows or telescoping design, Houghton-Butcher of London, England, chose to simplify the 1922 Ensign Cupid by placing the lens in a rigid metal snout on the tobacco-can-style body. The Cupid yielded twelve 4 x 6-cm half-frame images from each roll of six-exposure Ensign-Speedy 2¼B film. This was done by having two frame number windows on the camera back and a tag with instructions on how to wind the film. An f/11 lens and simple shutter eased the picture-taking exercise, making the Cupid ideal for beginners or children. The big crosshair finder folded flat when not in use. The tiny carrying handle was bright metal with room for only a single fingertip. Finished in black crackle, the camera was durable enough to take the abuse expected of new and young photographers. For fifteen shillings, the Ensign Cupid outfit included a reflex finder, leather case, and three rolls of film.

Kiddie Camera ca. 1926

Ansco, Binghamton, New York.
Gift of Eastman Kodak Company. 1991:0540:0001.

Photographic companies were always looking for ways to attract new customers, and encouraging children to try using a camera was a constant pursuit. In 1925, Ansco of Binghamton, New York, started making a special version of their Dollar Camera, a small basic box for 127 film. Other than the leather strap and cherry red covering, the Ansco Kiddie Camera was identical to the Dollar. The film loading process wasn't a job for young hands, however, and was best left to Mom or Dad. Despite the difficulties, many youngsters who started out on cameras like the Ansco Kiddie enjoyed taking their first photos and became lifelong shutterbugs.

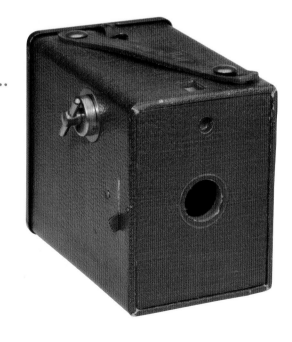

Okam *ca. 1926*

Okam, Slati any, Czechoslovakia. 1977:0737:0002.

In 1922, three years after establishing a textile company, Odon Keyzlar started Okam, a camera manufacturing business. The company produced twin-lens reflex box cameras using his recently patented shutter, which consisted of a pair of swinging panels just in front of the plate holder. The cardboard panels were covered with leather-grain textured paper and shaped to make them rigid as well as lightweight. They were arranged in a V shape, with the open end toward the lens. Turning a metal key on the camera top armed the shutter, and pressing a button behind the key tripped the mechanism. When the release was pressed, the panels would swing to the side, one following the other with a gap between them, allowing light to sweep across the film. To let more light through, the photographer could make this gap wider by adjusting the spring tension.

The compact Okam was quite hefty due to its heavy brass plate construction. Its lens is a 10.5cm f/6 Meyer-Görlitz Doppel-Anastigmat Helioplan, adjustable for focus from 2.5m to infinity. A lever on top of the camera could set the speed as fast as 1/1000 second. Double viewfinders allowed the 4.5 x 6-cm pictures to be oriented either vertically or horizontally. The Okam operation closed in 1929, and Odon Keyzlar worked as a photographer until 1939, when Czechoslovakia fell under Hitler's control.

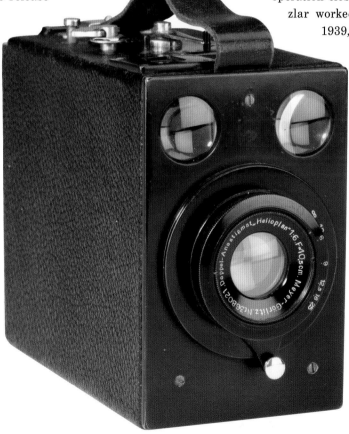

Yen cameras ca. 1930

Unidentified manufacturer, Japan.

Gift of Jerry Friedman. 2006:0270:0004 (folding); 2006:0269:0005 (box).

When it came to low-cost photography, yen cameras were in a class by themselves. Appearing in 1930s Japan and sold mostly by street vendors for a single yen, they had many variants in both box and folding styles. The folding types, such as this Nymco (below), looked more elegant, but worked exactly the same as the simpler boxes. Most yen cameras were made of wood, covered with various textured papers, and held together by tiny nails. Metal parts were stamped from very thin stock. The diminutive apparatus carried a wide assortment of brand names, including simply "Camera" or none at all.

One thing all yen cameras had in common was the procedure for taking the 30 x 45-mm photos. The cameras had a ground glass for framing the image, though the lens and focus were usually fixed. The shutter had two positions: open and closed. With the shutter held open by the

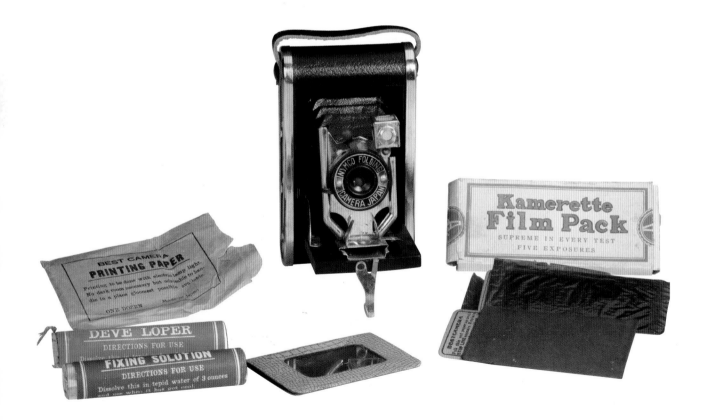

fingertip lever, the photographer composed the picture, then inserted a film pack in the slot provided. The film was very slow, even by 1930 standards, so the black paper film holder was capable of protecting the sensitized media from stray light. Once the film was inserted, a paper dark slide was pulled up, and the shutter kept open for the time recommended on the rice paper instruction sheet. For example, in winter, "on street," the shutter should be kept open for one second. A bright summer day called for 1/10 second, which assumed the user was able to accurately estimate fractions of seconds. A boxed kit contained everything necessary to make pictures, including chemicals for developing and fixing, a package of printing paper, and a cardboard printing frame. Prints were made using an electric light, then the exposed paper was placed in the same developer and fixer solutions used for the film.

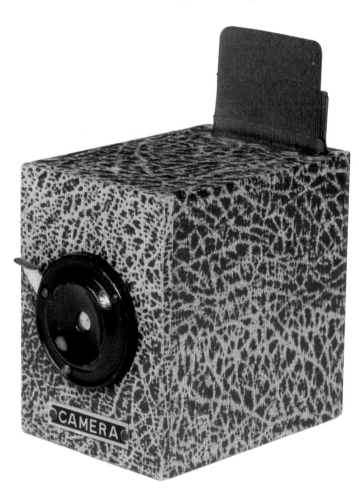

Flix II _ca. 1930_

Unidentified manufacturer, Japan.
Gift of Eastman Kodak Company. 1991:1587:0001.

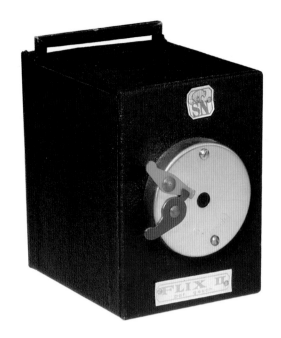

The Flix II was a simple box camera from an unidentified Japanese manufacturer, one of many such cameras made in the 1930s and referred to as Yen cameras, due to their selling price. It had a ground glass viewing screen and produced a 4.5 x 6-cm image from a single piece of film loaded in a paper film holder. Yen cameras were available from street vendors under numerous trade names.

Baby Box Tengor _1931_

Zeiss Ikon, Jena, Germany.
Gift of Eastman Kodak Company. 1999:0168:0003.

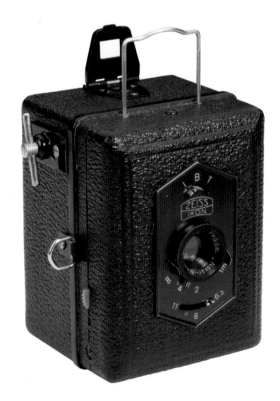

Zeiss Ikon, of Jena, Germany, is best known for its high-quality cameras and lenses. However, it also produced a line of inexpensive box cameras intended for children. Following in the footsteps of Eastman Kodak and its line of Brownie cameras, Zeiss looked to cultivate youngsters and turn them into lifelong photographers. A 1935 pamphlet described the Baby Box Tengor as "just the thing for boys and girls," adding "Miniature Picture Photography is also an attractive pastime for the advanced amateur." The camera produced sixteen 3 x 4-cm images on Zeiss A8 (Eastman 127) roll film. This specific example is fitted with a focusing 5cm f/6.3 Novar Anastigmat lens.

Pupille *ca. 1932*

Kodak AG, Stuttgart, Germany.
Gift of Cyril J. Staud. 1974:0037:2146.

The Pupille, originally produced by the Dr. August Nagel Camera-Werke of Stuttgart, was added to the company's lineup when Eastman Kodak Company bought the German firm in 1932. It was a small, palm-sized precision camera producing sixteen 3 x 4-cm images on No. 127 roll film. With its best lens, the Schneider f/2, it was billed by Kodak as having "a truly lightning fast lens." It also had a then-unique spiral focusing tube that eliminated the traditional bellows. The little feature-rich camera was priced at $90 in 1932.

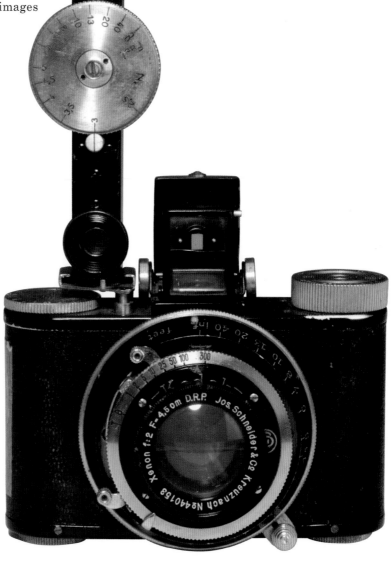

Boy Scout Brownie *ca. 1932*

Eastman Kodak Company, Rochester, New York. 1975:0015:0025.

..

The Boy Scout Brownie, produced in 1932 by Eastman Kodak Company, was one of many specialty cameras based on standard models. The original version made 2¼ x 3¼-inch images on No. 120 roll film and stayed in production just one year, before being replaced with the Six-20 Boy Scout Brownie, which used No. 620 roll film. A metal box camera with card-covered leatherette case in Boy Scout olive drab, it had a special name plate displaying the Scout insignia against a geometric design. The original retail price was $2.

Century of Progress *1933*

Eastman Kodak Company, Rochester, New York.
Gift of Eastman Kodak Company. 1975:0015:0023.

..

Another special model based on standard production cameras was the Century of Progress camera, introduced in 1933 by Eastman Kodak Company of Rochester, New York. It was issued to commemorate the Chicago World's Fair. Billed as "A Century of Progress International Exposition," the fair celebrated the hundredth anniversary of the incorporation of the City of Chicago. The camera was a special version of the Brownie Special No. 2, with a front panel depicting an art deco skyscraper. Its original retail price, at the fair, was $4.

Baby Brownie *ca. 1934*

Eastman Kodak Company, Rochester, New York.
Gift of Donald H. Evory. 1976:0017:0003.

A molded Bakelite-bodied box camera styled by Walter Dorwin Teague, the Kodak Baby Brownie of 1934 embodied Teague's classic art deco style, with strong vertical ribs in a band around the camera. It used a simple, folding open finder and produced eight images on No. 127 roll film. The retail price was the same as the original 1900 Brownie camera at $1.

Allbright *ca. 1934*

Ruberg & Renner, Hagen, Germany.
Gift of Eastman Kodak Company. 1974:0037:2540.

Low-cost, entry-level cameras seldom had any outstanding features to distinguish themselves from the horde of competitors. With the increasing use of molded plastics, style became an important way to attract buyers. Felix Ruberg, a manufacturer of bicycle parts, entered the camera market with a series of small No. 127 roll-film designs in the 1930s. That film size was popular because it was less expensive than the larger ones, such as Nos. 120 or 116, yet still made a good-sized negative for enlarging. The stylish Rubergs appeared to be made of plastic, but were metal-bodied and very robust. Plastic was used for the lens tube and mount, which were molded with threads to allow the lens to retract when not in use.

The Ruberg cameras sold for the equivalent of $2 to $3, depending on the model. This Allbright was notable for its finish, looking quite a bit like tortoise-shell plastic. Although an inexpensive instrument, the Allbright had features including a tripod socket, threads for remote release, and a two-position aperture setting. The viewfinder was of the folding type. World War II put an end to Ruberg's camera business. By 1942, the factory was turning out ammunition cases and other military products. When the war ended, the firm resumed production of bicycle components only, and never made another camera. In 1953, Ruberg went out of business altogether.

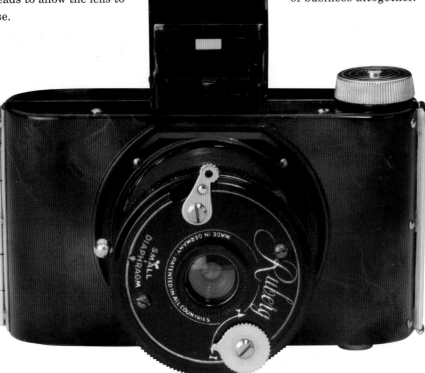

Brownie Junior 620 *ca. 1934*

Kodak AG, Stuttgart, Germany.
Gift of Eastman Kodak Company. 1999:1100:0001.

Six-20 Brownie Flash IV *ca. 1957*

Kodak Limited, London, England.
Gift of Eastman Kodak Company. 2000:0675:0005.

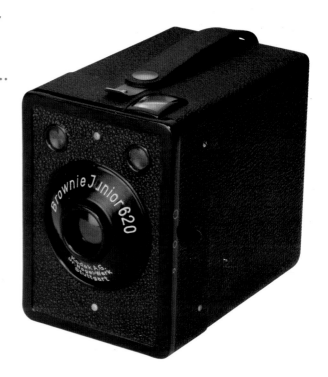

From the day in 1900 when Eastman Kodak launched the Brownie brand, the name has been synonymous with simple, low-cost, easy-to-use cameras. The Brownie line grew steadily with new models, improvements of existing designs, and expansion into foreign markets. Kodak operated manufacturing plants in many countries, each with its own marketing and engineering staff, resulting in products tailored to the tastes and preferences of the home markets.

The black 1934 Brownie Junior 620 from Germany (right) was almost as plain looking as the original Brownie box cameras. Made of metal covered with pebble-grain leatherette, it used Kodak's new 620 films. Two

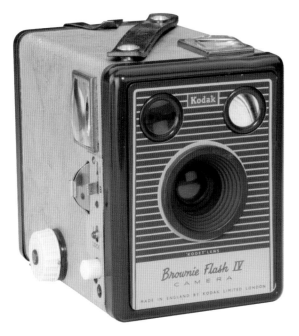

viewfinders, three aperture choices, and a time exposure setting were the extent of the Junior's amenities.

By contrast, the 1957 Six-20 Brownie Flash from London (left) was rather stylish, sporting a tan-and-brown color scheme with brass-colored metal parts, as if it was part of an upscale luggage set. For a box camera, the Flash IV had interesting features. The spec sheet included flash synchronization, of course, as well as two aperture stops, a yellow filter, tripod socket, and cable release threads.

Norton Camera *ca. 1934*

Norton Laboratories, Inc., Lockport, New York.
Gift of Dr. Henry Ott. 1983:0836:0001.

Advances in injection-molding technology helped spread the popularity of art deco design in the 1930s. As plastic cameras began to join product lines, stylists made use of the versatile materials with offerings like the Norton Camera. Norton Laboratories, a small company near Buffalo, New York, entered the camera business somewhat unintentionally. Universal Camera Corporation of New York City awarded the firm a contract to design a tiny roll-film camera made of Durez, the newest material from General Plastics. When disputes arose between contractor and customer, the deal unraveled. In order to recoup its investment, Norton made some slight changes to the design and began selling the little camera under its own name. At the same time, Universal found other manufacturing sources and sold its own version, the Univex A, which actually beat the Norton to market.

The cameras were built around the idea that a simple shutter and lens were good enough for acceptable snapshots in bright light. In appearance, they were very similar, though the viewfinders differed. Each used 35mm paper-backed rolls for six 1 x 1½-inch negatives. Norton's spool design, which employed a built-in winding knob, used film manufactured and packaged by

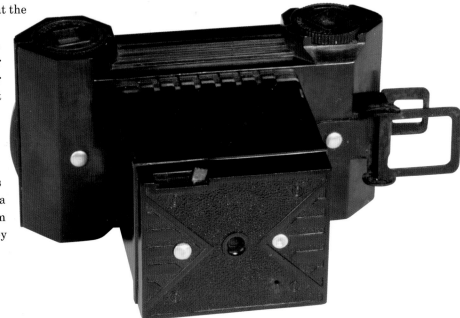

Eastman Kodak. The spooling of the Univex differed, and took Universal's No. 00 film made in Belgium by Gevaert. The biggest difference between the cameras was the list price. The Norton carried a fifty-cent price tag, while the "A" was priced at only thirty-nine cents, a huge advantage in the depression years. Sales of the Norton were lackluster, and Universal sued the manufacturer for infringement, which may have further discouraged buyers. Following a protracted legal conflict, the companies settled their differences. Norton left the photography business altogether after Universal bought the unsold cameras, modified them to accept the Univex film spools, and badged them as the Norton-Univex.

Baby Clover _ca. 1935_

Hagi Industrial Trading Corporation, Tokyo, Japan.
Gift of Eastman Kodak Company. 2010:0066:0006.

Japan's domestic camera industry blossomed in the 1930s, mostly with products that were essentially copies of European and American designs. Low-priced, simple cameras were big sellers, and the fastest way to get one to market was to "reverse-engineer" an already successful product. Kodak's Baby Brownie was a big seller in the U.S. and England, and the Hagi Industrial Trading Corporation in Tokyo studied it very carefully before introducing its Baby Clover camera. The styling of the Baby Clover didn't vary much from the Teague-designed Baby Brownie, having the same art deco theme in black Bakelite. Both cameras were built

to use 127 film in the identical 4 x 6.5-cm format. Internals were similar as well, except for the Baby Clover's metal, instead of plastic, film holder.

The flip-up viewfinder, winding knob, and film access latch were just short of interchangeable with the American product. Hagi did make one improvement with the addition of a leather handle to the body, a feature Kodak later adopted for the Baby Brownie's successor. Though clearly badged as a Clover, molded into the camera's top was a diamond-shaped logo with characters that were easy to mistake for the "EKC" brand on the top flap of the Baby Brownie's box. A coincidence?

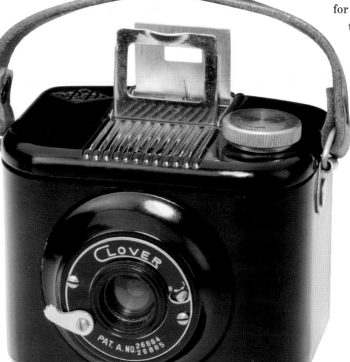

Kalart Flash Synchronizer *1935*

Kalart, New York, New York. 1976:0011:0317.

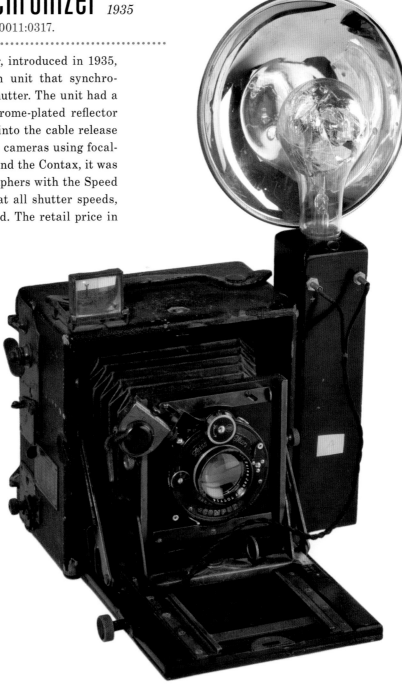

The Kalart Flash Synchronizer, introduced in 1935, was an early accessory flash unit that synchronized the flash with the camera shutter. The unit had a Bakelite battery holder with a chrome-plated reflector and a timing device that plugged into the cable release socket. Compatible with miniature cameras using focal-plane shutters, such as the Leica and the Contax, it was most often used by press photographers with the Speed Graphic camera. It synchronized at all shutter speeds, including 1/500 and 1/1000 second. The retail price in 1935 was $22.50.

Bantam Special *ca. 1936*

Eastman Kodak Company, Rochester, New York.
Gift of Eastman Kodak Company. 1991:2845:0001.

The Kodak Bantam Special, introduced in 1936, was a self-erecting roll-film camera using No. 828 film (also known as Bantam, as it was introduced for this camera). Another striking design by Walter Dorwin Teague in his trademark art deco style, it displayed strong horizontal bright metallic lines on a black enamel die-cast body. In addition to being stylish, it was a compact camera fitted with a 45mm f/2.0 Kodak Anastigmat lens (later renamed the Kodak Ektar lens); it is the first Eastman Kodak Company camera featuring a lens of this speed. Other features included a 1/500 second shutter and a split image rangefinder focus. It retailed for $110 in 1936.

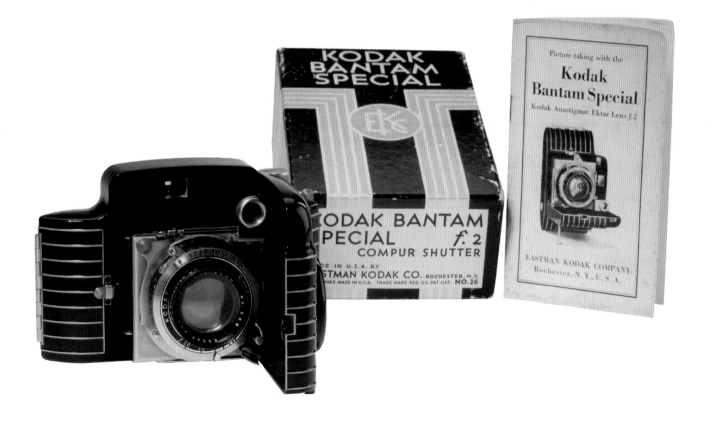

KODACHROME
Todd Gustavson

The search to produce stable and permanent images in natural color dates to the very beginning of photography. Hand-applied color and numerous chemical processes, such as the Hillotype (the color version of the daguerreotype), the Ives Kromogram, the Lumière Autochrome, and many others were introduced. Most were difficult and impractical, some almost impossible to carry out, even by trained professional photographers.

In April 1935, Eastman Kodak Company introduced Kodachrome film, considered by many to be the first modern multi-layer color transparency film. First rolled out as an amateur 16mm ciné film, the still photography version became available in September of the next year in 35mm and 828 roll film sizes. Larger sheet film was offered to the professional beginning in 1938, although Kodachrome was the film that brought color photography to the amateur photographer. Countless baby-boom families documented their personal histories, birthdays, graduations, holidays, and vacations on Kodachrome, creating slide shows projected with their Kodaslide projectors to show off imagery to friends and relatives.

Its brilliant colors were also highly popular with magazine photographers. *National Geographic* used it exclusively for more than half a century. One of the best-known *National Geographic* images, Steve McCurry's "Afghan Girl," was made on Kodachrome film. The very last Kodachrome rolls from the Kodak production line were designated to go to McCurry, with those precious transparencies to be archived at George Eastman House in Rochester, New York.

Kodachrome was the culmination of many years of investigation, with the research preformed by two professionally trained musicians, pianist Leopold Godowsky Jr. and violinist Leopold Mannes. Convinced they could come up with a better product after viewing the 1917 Prizma Color film *Our Navy*, Godowsky and Mannes began research on color photography in their spare time. Their efforts began to show promise during the 1920s, acquiring financial backing from the New York City investment firm of Kuhn, Loeb and Company. In 1930, their efforts came to the attention of Eastman Kodak Company, who contracted to move the two of them to Rochester, New York, where their process could be scaled for production.

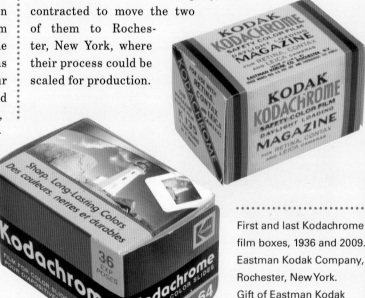

First and last Kodachrome film boxes, 1936 and 2009. Eastman Kodak Company, Rochester, New York. Gift of Eastman Kodak Company.

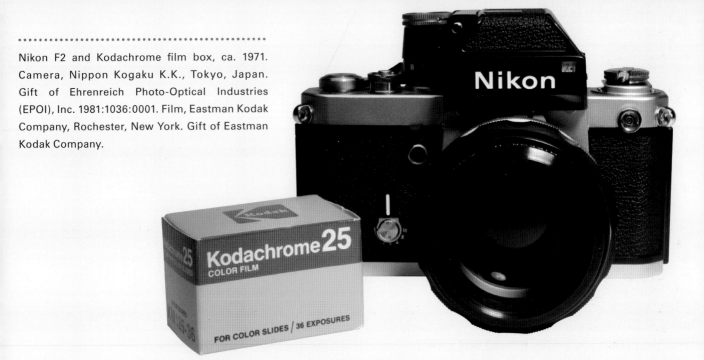

Nikon F2 and Kodachrome film box, ca. 1971. Camera, Nippon Kogaku K.K., Tokyo, Japan. Gift of Ehrenreich Photo-Optical Industries (EPOI), Inc. 1981:1036:0001. Film, Eastman Kodak Company, Rochester, New York. Gift of Eastman Kodak Company.

The finished product, named "Kodachrome," was a film like no other. Most earlier color photography systems were based on the additive process, using red, green, and blue as the primary colors creating a very dense transparency requiring an extremely bright light source for projection. Kodachrome used the subtractive process, using cyan, magenta, and yellow as the primary colors, creating a significantly less dense transparency than the additive process films. Another unusual trait was that it was a multilayer film containing no dye couplers; the color dyes were added to the appropriate film layer during processing. Processing the film in this manner gave Kodachrome images their unique saturated color look and created very stable, fade-resistant color images.

The Kodachrome of 1936 had its drawbacks. As it was a patented Kodak product, it could be processed only by Eastman Kodak Company; home processing was not possible. At ASA 8, it was a very slow film, even by standards

of the time when a typical black-and-white film would rate about ASA 25. This meant that with a hand-held camera it could be used only on bright sunny days, limiting its usefulness, especially in areas with little sunlight. During the 1950s, the film speed was boosted by a third to ASA 12, and in 1961 doubled to ASA 25 with the introduction of Kodachrome II. Kodachrome X of 1962 more than doubled that speed rating to ASA 64. Further investigation would bring about yet another film and processing upgrade during the 1970s, with a high-speed version, Kodachrome 200.

With a production life span of nearly seventy-five years, Kodachrome has earned the distinction of having been one of the longest-lived light-sensitive products. Like the Barbie doll and the Schwinn Sting-Ray, the film has become an icon of twentieth-century American pop culture. Idealized by the Paul Simon song "Kodachrome," the product has even gone a step further–memorialized in Utah's Kodachrome Basin State Park.

Purma Special *1936*

Purma Cameras Ltd., London, England.
Gift of Eastman Kodak Company. 1991:0977:0003.

The 1936 Bakelite-bodied Purma Special, styled by legendary American designer Raymond Loewy, was aimed at box camera users wishing to upgrade within the class. Made by Purma Cameras Ltd. in London, the sleek Special made sixteen 32-mm square images on each roll of 127 film. Removing the screw-on plastic cap brought the spring-loaded retractable lens barrel into position. A Beck Anastigmat 2¼-inch f/6.3 lens was standard, and several close-up lenses were available for shots as close as eighteen inches from the subject. The Special had some unique features, such as the molded plastic viewfinder lens, the first use of this material in a production camera.

The shutter had three speeds, with a very unusual method of selecting from them. When the camera was held horizontally, the shutter would trip in 1/150 second. Holding the body vertically one way would change the speed to 1/450, while holding it the opposite way gave 1/25 second exposure times. This odd feature made changing speeds easier than turning a knob or moving a lever, and with its square format, it made no difference which way the camera was oriented. This left only the shutter set lever, release button, and film advance knob for the user to control.

Introduced with a $14.75 price tag, significantly more than most box cameras, the Purma Special offered much better results than was typical for its type. Production continued without change until 1951. The Purma Plus, which replaced the Special, had the same specifications but added a provision for flash. The later version was offered until 1958.

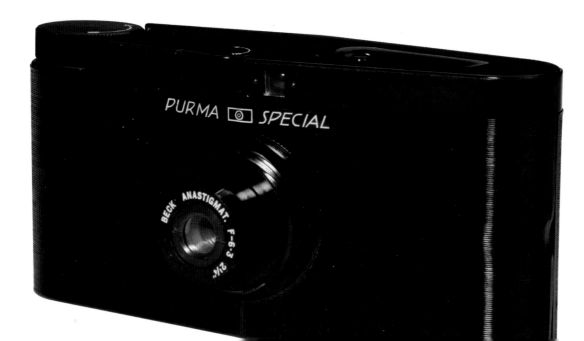

Super Kodak Six-20 *1938*

Eastman Kodak Company, Rochester, New York.
Gift of Eastman Kodak Company. 2001:0636:0001.

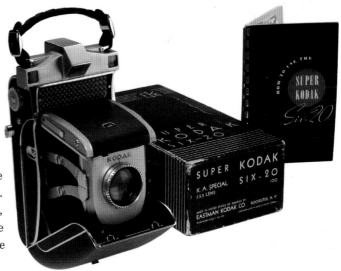

Introduced in 1938 as the world's first automatic exposure camera, the Super Kodak Six-20 used a large selenium photocell to control the aperture before the exposure was made. With a clamshell design styled by Walter Dorwin Teague, it featured a wide base rangefinder and a crank wind film advance and produced 2¼ x 3¼-inch images on No. 620 roll film. Though advanced, the camera was unreliable, which, coupled with a high retail price of $225, made it the least widely sold of the Kodak cameras aimed at the general public.

Flashmaster 127 *ca. 1939*

Monarch Manufacturing Company, Chicago, Illinois.
Gift of Eastman Kodak Company. 1991:0977:0005.

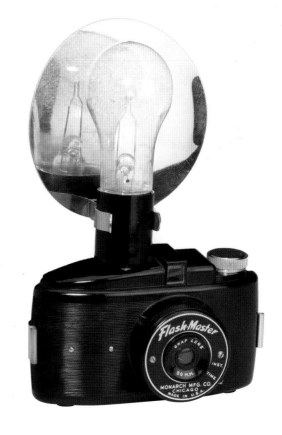

Introduced in 1939 by the Monarch Manufacturing Company of Chicago, the Flashmaster camera was one of the many brand names marketed from the West Lake Street facility also used by Falcon and Spartus. The Flashmaster created sixteen half-frame images on No. 127 roll film and was known for its internally synchronized flash attachment, powered by two penlight (AA) batteries. The $4.50 retail price included the reflector and one flash bulb.

New York World's Fair Bullet *1939*

Eastman Kodak Company, Rochester, New York.
Gift of Eastman Kodak Company. 1999:1097:0031.

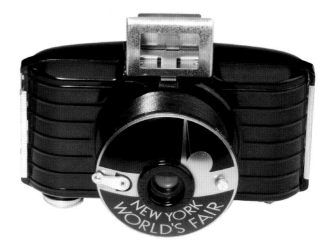

The New York World's Fair Bullet camera was produced in 1939 and 1940 to commemorate the World's Fair of those years. Originally released in 1936, the Eastman Bullet was designed by Walter Dorwin Teague in his characteristic art deco look with heavy horizontal ribs. The commemorative camera was a standard Bullet with the addition of a special metal faceplate also designed by Teague and name plate featuring the Fair's Trylon and Perisphere logo. Although not listed in the Kodak catalog, reportedly 10,000 units sold through dealers and at the fair for a retail price of $2.

Six-20 Flash Brownie *ca. 1940*

Eastman Kodak Company, Rochester, New York.
Gift of Eastman Kodak Company. 1974:0037:1181.

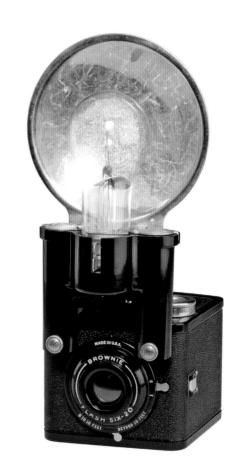

Eastman Kodak Company's first internally synchronized flash camera, produced from 1940 to 1954, was known initially as the Six-20 Flash Brownie and later as the Brownie Flash Six-20. It was a trapezoidal metal box camera producing 2¼ x 3¼-inch images on No. 620 roll film. The flash holder used the large General Electric No. 11A (Washbash 00) flash bulb, though an adapter was available for the smaller No. 5 bulb. The retail price was $5.75, with flash holder.

Spartus Press Flash *ca. 1940*

Utility Manufacturing Company, Chicago, Illinois. 1974:0037:0140.

Introduced in 1939, the Spartus Press Flash was arguably the first camera with a built-in flash reflector. A Bakelite box camera with art deco design elements on the body and name plate, it had a flash reflector for Edison base bulbs built into the top surface and produced 2¼ x 3¼-inch images on No. 120 roll film. At introduction, the retail price was $5.95.

The Spartus Press Flash was virtually identical to the Falcon Press Flash. Both were manufactured by the Utility Manufacturing Company of Chicago, which had a tangled corporate history. Operating from a building on West Lake Street, the company went through numerous ownership changes and brand names, marketing cameras under the names Falcon, Spartus, Herold, Galter, Regal, Monarch, Monarck, and Spencer, among others.

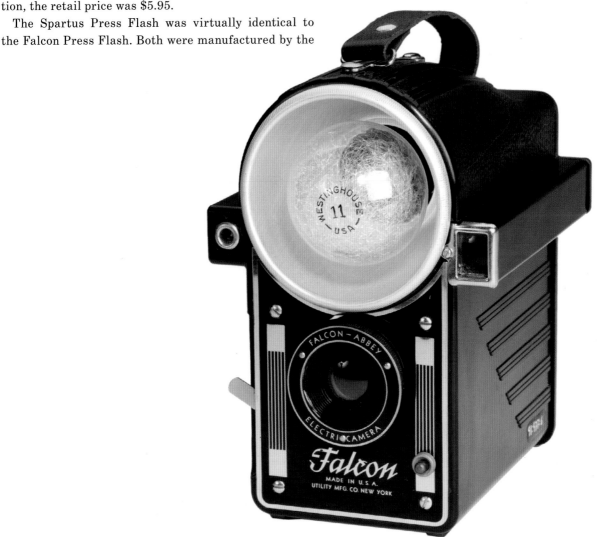

Encore *ca. 1940*

Encore Camera Company, Hollywood, California.
Gift of Eastman Kodak Company. 1991:1587:0010.

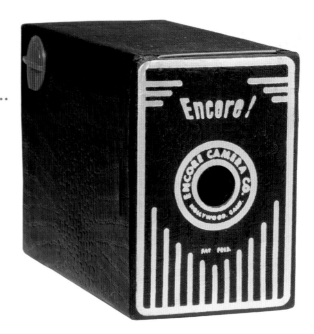

The Encore camera of 1940 was an inexpensive, cardboard camera with factory-loaded film. After pictures were taken, the still-loaded camera was returned to the factory with $1 for processing, just like the original 1888 Kodak camera. The Encore was sometimes used as an advertising premium, often printed with a company's promotional message.

Mickey Mouse Brownie *ca. 1946*

Eastman Kodak Company (attrib.), Rochester, New York. 1999:1114:0001.

The Mickey Mouse Brownie story is shrouded in mystery, having been unknown until about 1995. At that time, several cameras surfaced with the explanation that Eastman Kodak Company had worked up a prototype, in cooperation with Walt Disney, for this special version. Neither company has records of such a project, though there is one known example complete with an original printed box.

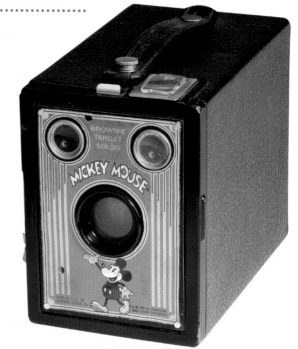

The basis for the camera is the Brownie Target Six-20 of 1946 with a special faceplate depicting Mickey Mouse. Curiously, though the camera is a 1946 model, the style of Mickey Mouse and the Disney Company logo date to the 1930s. Also of interest is that those cameras that have surfaced use three different types of faceplate attachment hardware. Since the decal and box look to be of the period, perhaps there is reason to believe that Kodak did initiate a special project in the 1930s. In any event, great interest in these cameras by camera and Disney collectors alike has led to high prices realized at auction.

Rondine *ca. 1948*

Ferrania Fabbrica Apparecchi Fotografici, Milan, Italy.
Gift of Eastman Kodak Company. 2010:0066:0005.

Milan, Italy, has long been considered the industrial design center of Europe, where even the most basic products are a blend of style and functionality. Cameras are no exception, as the Ferrania Rondine (Swallow) ably demonstrates. A manufacturer of film since 1923, Ferrania branched out into cameras in the 1940s. The compact Rondine had an all-metal construction, with exposed surfaces that were highly polished to contrast with the imitation leather covering. It used a Ferrania Linear 75mm f/8.8 lens to make eight 4 x 6.5-cm images on No. 127 film. While the lens was adjustable for focus, that was the extent of the user-set controls. The single-speed shutter release sat below the lens, next to a tiny sharp-edged toggle for time exposures. The snapshooter had a choice of finders: a waist-level reflex finder rigidly mounted above the lens, or the fold-up sports finder on top. A socket for a flash power cord made indoor photos possible. Loading film in the Rondine was unusual in that the camera came apart at the side, rather than having a hinged rear door as most of its competitors did. The camera's smart looks were enhanced by a choice of five colors for the leatherette covering, in addition to basic black–exactly what you'd expect in a Milanese product.

Brownie Hawkeye Flash Model *ca. 1950*

Eastman Kodak Company, Rochester, New York.
Gift of Fred W. Hoyt. 1981:0038:0004.

The Kodak Brownie Hawkeye Flash Model, produced from 1950 to 1961, was the most popular Brownie camera of all time. Though a simple box camera in a molded black Bakelite body, it featured an attractive art deco design and a brilliant waist-level finder. Introduced a few months after the non-synchronized model, it used a detachable flash holder and produced twelve 2¼-inch square images on No. 620 roll film. The retail price in 1950 was $6.95 for the camera alone and $12.75 for the outfit.

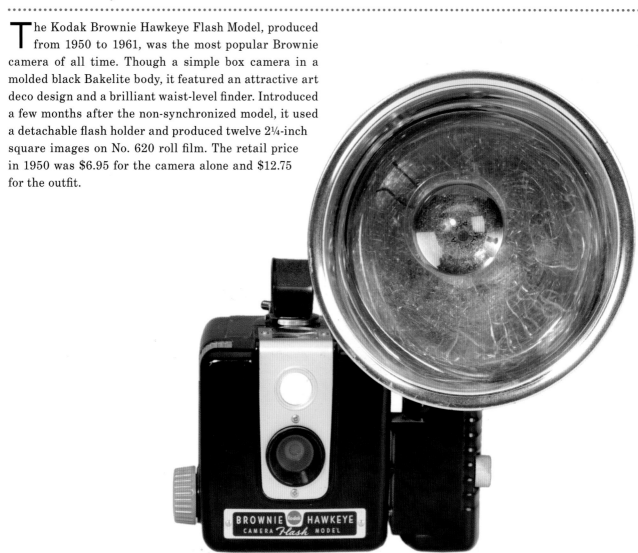

Brownie Hawkeye Flash Model (BLUE) *ca. 1950*

Eastman Kodak Company, Rochester, New York.
Gift of Eastman Kodak Company. 1996:0596:0006.

Very likely the most successful Brownie camera ever, the Kodak Brownie Hawkeye Flash camera was produced from 1950 through 1961 by Eastman Kodak Company of Rochester, New York. It seems everyone had one. The original model was released in 1949 (selling only until 1951) as a non-flash synchronized Bakelite twin-lens reflex box camera with art deco styling and a large bright finder at a retail price of $5.50. The next year, the Flash model was released with a price of $6.95. Both cameras were very striking in their black and gray design, though the camera shown here with a painted blue finish is actually a prototype that was never released. Since Bakelite was available only in black and brown, any other color required painting. The extra cost of a painted finish probably accounts for this prototype never having reached production.

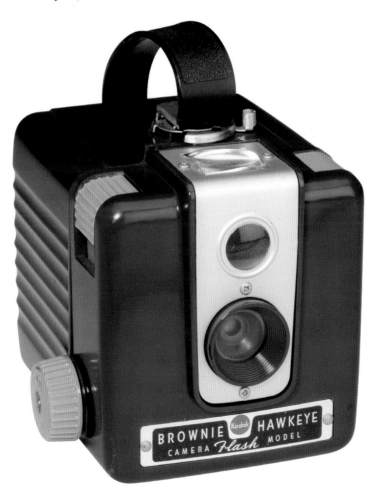

Petie Vanity *ca. 1956*

Walter Kunik KG, Frankfurt, West Germany.
Gift of Fred Spira. 1985:1044:0004.

Camera manufacturers have a long history of promoting their products as being ideal gifts for "that special someone." Boxed outfits from major brands like Kodak and Ansco got the full-page color treatment in popular magazines every December. Both firms went a step further in the 1930s and made vanity packages that included a colorfully styled camera in a case with various cosmetic items. This idea was behind the creation of the Petie Vanity sold by Kunik. The Petie camera was a subminiature, toy-like item similar to the Hit cameras from postwar Japan. Stamped from thin metal, the Petie used tiny spools of paper-backed film for making 14-mm square negatives. A crude shutter and lens made pictures of poor-to-fair quality, and few people used these cameras more than once.

The Petie Puderdose (powder puff) version was housed in a nicely finished metal case the size and shape of a Vanity Kodak. While one side of the case had a space for the Petie to slip into, the other side had a small door that opened to reveal a mirror and face powder. Next to the camera were two removable metal tubes, one marked "film" that was long enough to store a couple of spare rolls, and one that held lipstick. The case was a handsome piece, although its art deco trim was about twenty years out of style. Bright chrome contrasted with shiny enamel, available in several colors, for about eight 1956 dollars. Kunik also sold a cigarette lighter with a slip-in Petie, as well as a music-box version.

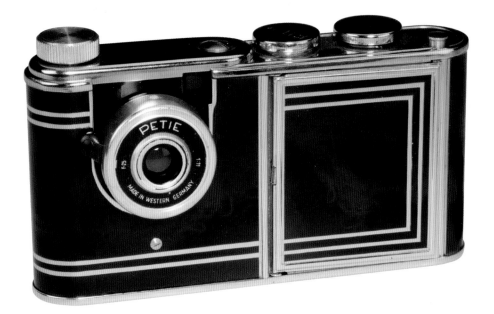

Brownie Starflash *ca. 1957*

Eastman Kodak Company, Rochester, New York.
Gift of Eastman Kodak Company. 1996:0474:0001.

The Brownie Starflash, produced from 1957 to 1965, was the first Kodak camera with a built-in flash. A popular item, it used No. 127 roll film to produce twelve images, 1⅝ inches square in size. With Ektachrome transparency film, newly available in that size, it also could make "super slides," the largest image to still fit a 2-inch square mount. First issued only in black, the cameras were available in colors during the middle of the run in red, white, or blue but only as part of an outfit. A rare Coca-Cola version was offered as a premium. In 1957, the camera alone retailed for $8.50 and the outfit for $9.95.

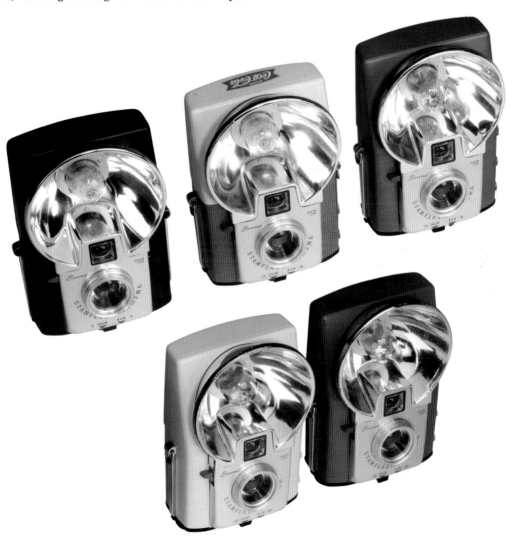

Kappa Nu Vest Pocket Hawk-Eye *1930*

Eastman Kodak Company, Rochester, New York.
Gift of Thomas P. Gregory Jr. 2002:1359:0001.

Kappa Nu Brownie Holiday Flash Camera *1956*

Eastman Kodak Company, Rochester, New York.
Gift of Francis J. Calandra. 2007:0310:0001.

In the early part of the twentieth century, Jewish students were typically excluded from most college fraternities. Kappa Nu Fraternity, which was founded by six men of the Jewish faith at the University of Rochester in 1911, numbered twenty-six chapters at its peak. In 1961, Kappa Nu and several other fraternities were folded into Zeta Beta Tau, another fraternal organization. ZBT began in 1898 as a Zionist youth group with members from several universities in New York City, but through several reorganizations and the addition of many chapters, it became a non-sectarian fraternity in 1954.

This Vest Pocket Hawk-Eye, in orchid with rose bellows (top), is a commemorative camera. Dated January 1, 1930, it displays the fraternal seal of Kappa Nu on the front door, though it is not known what event was celebrated by the addition of a special front plate. Also unknown is whether Eastman Kodak Company produced a special camera for the fraternity, or some other person or company did a conversion to the standard model. The Vest Pocket Hawk-Eye, as the name implies, was a pocket-sized folding-front camera using No. 127 roll film to produce images of

1⅝ x 2½ inches. Manufactured during the years 1927 through 1934, it used a meniscus lens in a shutter having T (Time) and I (Instantaneous) speeds, with four apertures on a rotating wheel, and employed a rotating bright finder.

This commemorative Brownie Holiday Flash Camera (bottom), which is also distinguished by the Kappa Nu fraternal seal, has the inscription "Rochester 1956" nicely screen printed on the top in a gold color. As with the Vest Pocket Hawk-Eye, it is not known what event was celebrated by this modification of a standard model. Again, Eastman Kodak Company's role in the project is not known. The Brownie Holiday Flash was a brown Bakelite-bodied eye-level box camera manufactured between 1954 and 1962. This camera was produced with a Dakon plastic lens, which replaced the Kodet lens in 1955, and produced eight images of 1⅝ x 2½-inches on No. 127 roll film. The little camera was very attractive, sporting a brown braided-cloth neck strap and a winding knob and shutter release in a nicely contrasting tan color.

Brownie Starmatic *ca. 1959*

Eastman Kodak Company, Rochester, New York. 1974:0037:0084.

Introduced in spring 1959, the Brownie Starmatic stayed in production into 1963. Although Kodak pioneered automatic exposure control with the Super Kodak Six-20 in 1938, this was the company's first affordable auto-exposure camera. The Starmatic, like the Starflash, used No. 127 roll film to produce twelve 1⅝-inch square images. Unlike the Starflash, it returned to the use of a separate flash holder. It retailed for $34.50 in 1959.

Fotron *ca. 1960*

Traid Corporation, Encino, California.
Gift of Charles Benton. 1989:0904:0001.

The Traid Fotron camera, introduced in the early to mid-1960s, had several new technology features, including auto exposure, motorized film advance, built-in electronic flash, built-in battery charger, and "Snap Load" cartridge film. It produced ten square images on No. 828 film, which was processed via mailer by Traid, a "pioneer in America's space and defense systems." The cameras were marketed exclusively through door-to-door sales, selling at up to $415.

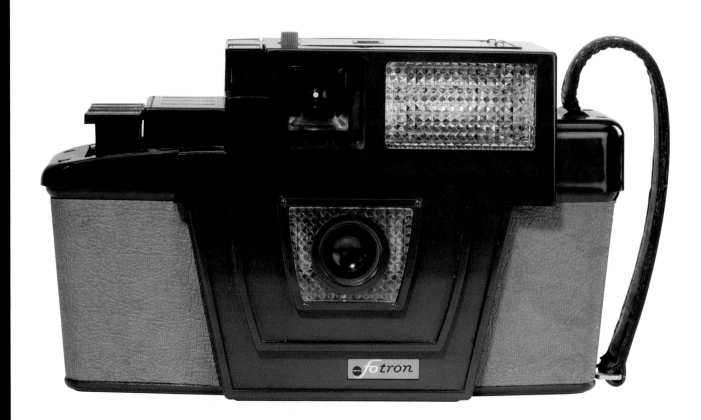

Hawkeye Flashfun *ca. 1961*

Eastman Kodak Company, Rochester, New York.
Gift of 3M Foundation, ex-collection Louis Walton Sipley. 1977:0415:0115.

Eastman Kodak Company became the dominant force in the business by selling inexpensive, easy-to-use cameras by the millions. Eye-catching style helped sell Kodaks to first-time buyers, and straightforward operation kept them buying film. Kodak designed a series of colorful plastic 127 roll-film cameras in the 1950s with built-in flash, eliminating the need to affix and remove a flashgun. The 1961 Hawkeye Flashfun was one of the last of this line and like most Kodaks was sold as a complete outfit that included film, flash bulbs, and even batteries. These cameras were soon replaced by the quick loading Instamatics, which carried on the Kodak tradition of easy, low-cost photography for everyone.

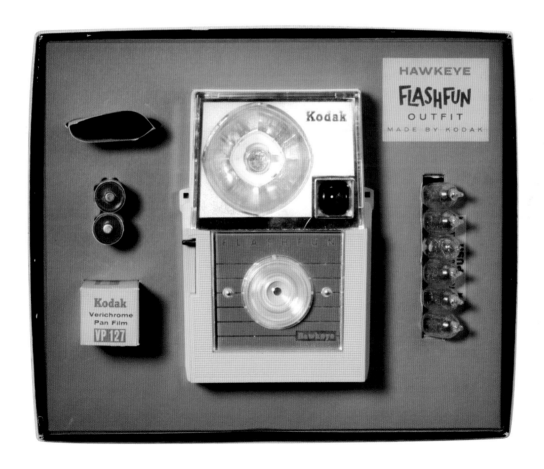

Brownie Fiesta 3 *ca. 1962*

Kodak Argentina S.A.I.C.
Gift of Eastman Kodak Company. 1999:1099:0001.

Rio 400 *ca. 1965*

Kodak Brasileira, São Paulo, Brazil.
Gift of Eastman Kodak Company. 2001:0117:0001.

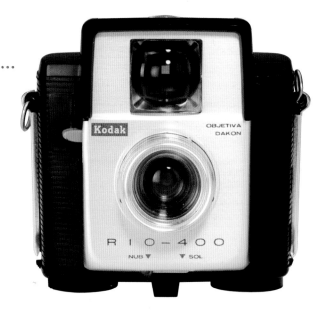

The Baby Brownie of 1934 was the first in the Brownie camera line to be built with a plastic body. By the 1950s, all American Brownies were made with this material. Plastics freed the stylists to design the cameras in all sorts of shapes, textures, and colors.

During the early 1960s, Eastman Kodak expanded its manufacturing capacity to include South America. The 1962 Fiesta 3 (below), manufactured in the U.S., Spain, and Argentina, was an attractive combination of angles and curves and was one of the last of the roll-film Kodaks. The Argentine version differed from the

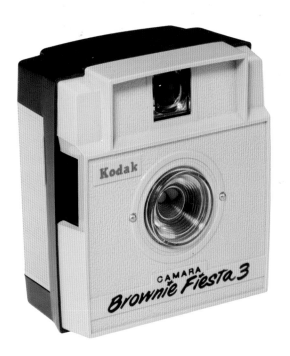

American version mainly in color selection and the spelling of "Camara" on the nameplate. Spanish was used for all nomenclature and notations, inside and out.

The Brazilian-made Rio 400 (above) was unusual in that although it was identical to the U.S. Brownie Starlet, it wasn't badged as a Brownie. The special edition celebrated the four hundredth anniversary of the city of Rio de Janiero and had Portuguese markings on the camera and box.

Instamatic 100 *1963*

Eastman Kodak Company, Rochester, New York.
Gift of Eastman Kodak Company. 1974:0037:0246.

The Kodak Instamatic 100 camera was introduced in 1963. In various forms, the Instamatic line would stay in production for more than twenty years. The 100 was a simple little plastic box camera with fixed focus, a pop-up flash gun, and rapid lever wind. Its use of a drop-in cartridge was not novel. Attempts to utilize cartridge loading began in the 1890s, but none was as successful as the Kodak No. 126 cartridge, which revolutionized the snapshot industry. The Instamatic 100 outfit retailed for $16 in 1963.

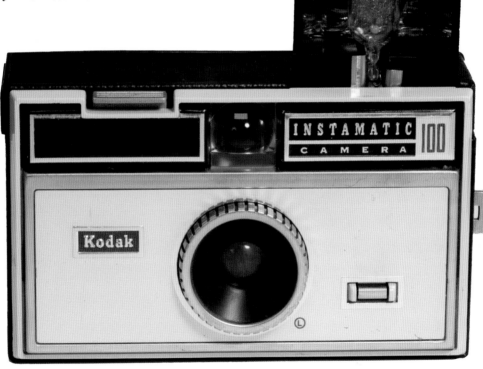

Photo-Pack-Matic *ca. 1967*

Fex, Lyon, France.
Gift of Eastman Kodak Company. 1991:1587:0007.

The Photo-Pack-Matic was a one-time-use camera made by Fex of Lyon, France, in the mid-1960s. It came preloaded with black-and-white film for twelve 4-cm square exposures. When the last shot was snapped, it was sent to Fex for processing and your prints came by return mail. Photo-Pack-Matics were sold mostly in France, for the U.S. equivalent of $2.50 in 1967. Processing was included in the price. The single use, or "disposable," idea wasn't new, but it wouldn't become popular until large manufacturers like Eastman Kodak Company and Fuji entered the market two decades later.

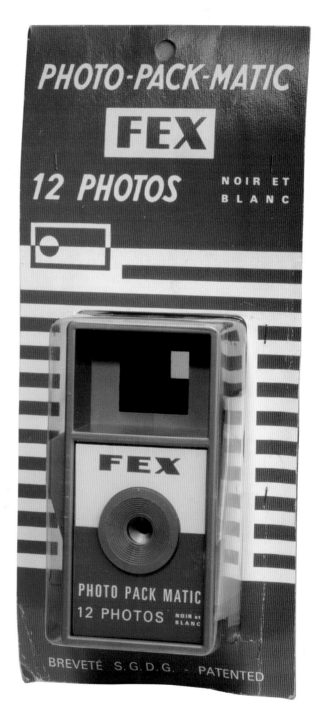

Autopak 800 *ca. 1969*

Minolta Camera Company, Ltd., Osaka, Japan.
Gift of Dr. Max Presberg. 1993:1503:0004.

The 1963 roll-out of the Instamatic cameras, with their drop-in 126 Kodapak film cartridges, brought millions of new snapshooters to the market. With no more clumsy rolls to deal with, no more rewinding needed before changing film, no need to ever touch film at all, photographers snapped them up, and Eastman Kodak had an immediate hit. Other camera makers were quick to launch their own cartridge-loading lines, hoping to grab a bigger share of the amateur market. Kodak itself expanded the product range with features such as automatic exposure, coupled rangefinders, and power winding.

Not long after Kodak introduced its new line, Japan's Minolta jumped into the easy-load pool. The company steered away from the low end of the market with its 126-format Autopak cameras, which were well-engineered and attractive, designed to give superior results while still being uncomplicated in operation. Unlike Kodak's own upscale Instamatics, the Autopak 800 had the look of a precision 35mm rangefinder camera, a Minolta specialty. The viewing window was bright and clear, and the yellow split-image spot easy to see while adjusting the focus knob. Once the photographer zeroed in on the subject, the large chromed shutter release admitted light through a 38mm f/2.8 Rokkor lens to expose a 28-mm square of film, which then automatically progressed to

the next shot, thanks to the spring-motor film advance. The 800 was the first to employ "smart flash," a feature now found on most cameras. Its CdS meter determined whether flash was needed and would fire the flashcube when necessary, a decision the user could override with the press of a button. The Autopak 800, which retailed for about $80, was the flagship of Minolta's early quick-load cameras. The company produced the line well into the 1970s, when the Autopak was superseded by the smaller 110 Pocket Instamatics.

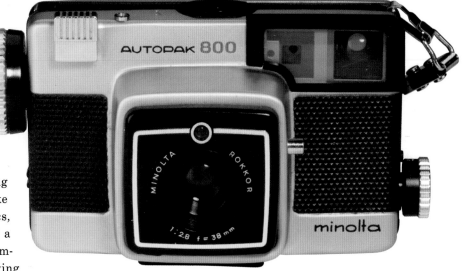

Fling 110 *ca. 1987*

Eastman Kodak Company, Rochester, New York.
Gift of Eastman Kodak Company. 1992:0258:0001.

The one-time-use or "disposable" camera concept had been tried many times prior to the introduction of the Kodak Fling in 1987. Flings were simple plastic cameras sold pre-loaded with 110-size film. After exposure, camera and all were returned to the photofinisher, who cracked it open to remove the film. The size of a 110 film box, the Fling had a simple finder and a ridged thumb-wheel advance. Kodak soon replaced the 110 Fling with the Fling 35 to keep up with competitors' one-time-use 35mms, which made much better pictures. The "Fling" name didn't last long either. Criticized as a product with a name that suggested it was destined for landfills, Kodak redesigned the cameras for disassembly and recycled most parts into new cameras.

In 1995, Kodak one-time-use cameras carried list prices from $6.95 for the basic model to $19.95 for one equipped with a portrait-lens. Processing costs varied widely from lab to lab but were consistent with the same charges for equivalent lengths and sizes.

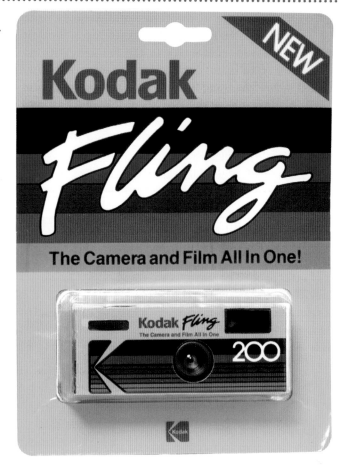

Kodak Stretch 35 *ca. 1989*

Eastman Kodak Company, Rochester, New York.
Gift of Eastman Kodak Company. 1992:0255:0001.

A s a follow-up to the successful Fling, the first Kodak one-time-use camera, in 1989 Eastman Kodak Company introduced the Kodak Stretch 35. With its fixed-focus, 25mm wide-angle lens and masked film plane, the Stretch 35 was designed to take panoramic photographs as the user saw a scene through the viewfinder. Instead of cropping the pictures during the printing process, the editing was done in-camera, using just a little more than fifty percent of the vertical coverage of the film. The resulting prints were 3½ x 10 inches. The Stretch 35 retailed for $12.95.

Fuji one-time-use camera *ca. 1990*

Fuji Photo Film Company, Ltd., Tokyo, Japan. 1990:0238:0001.

A lthough Fuji Photo Film of Tokyo didn't invent the one-time-use camera, they can take credit for being first on the market with a modern version you could take to any one-hour photofinisher for prints. Previous one-time-use cameras required you to mail them back to the manufacturer to get your pictures processed. Loaded with standard Fujicolor ISO-100 film in the 110 size, Fuji's HR100 was used without removing the paper carton dressed to match Fujicolor film packages. Cutouts in the carton for the lens, finder, shutter, advance wheel, and exposure counter added up to what Fuji called the "Film with lens."

The success of this camera soon attracted Eastman Kodak Company and others to the market. The 110 format was joined, and then replaced, by 35mm versions like the Quicksnap Flash with built-in electronic strobe. One-time-use cameras specialized for close-up, telephoto, and panoramic photography were soon sold everywhere, often in a choice of film speeds. Initially, Fuji labeled the Quick-snaps as "disposable," but that word soon disappeared and the discarded plastic parts were retrieved for recycling.

D-Day 50th Anniversary Camera *ca. 1994*

Kodak Pathé, Paris, France.
Gift of Nicholas M. Graver. 1995:0882:0001.

In 1994, to commemorate the fiftieth anniversary of the start of Operation Overlord, popularly known as the Normandy Invasion, on June 6, 1944, the D-Day camera was produced by Kodak Pathé, the French subsidiary of Eastman Kodak Company. A one-time-use 35mm camera, it had a cardboard wrapper printed in seven European languages, including German, and featured images of Eisenhower, Churchill, and de Gaulle, along with the U.S., British, French, and Canadian flags.

Asti Cinzano one-time-use camera *1997*

Unidentified manufacturer, Hong Kong, China.
Gift of Todd Gustavson. 1999:0141:0001.

Shortly after the introduction of one-time-use cameras like the Fuji QuickSnap of 1987, manufacturers of these cameras began to utilize the printable outer wrap for promotional offerings. One such use was an Asti Cinzano-wrapped one-time-use camera, made in China by an unknown manufacturer. The 1997 promotion included the camera and a 750-ml bottle of Asti Cinzano Sparkling Wine in a star-studded cellophane bag with gold elastic tie.

REFLEX

Reflex cameras—those that have a mirror placed at a forty-five degree angle to the optical path to correct image orientation—can be traced back to portable cameras obscura dating from the 1600s. The camera Daguerre used to demonstrate his process in the mid-1800s was a reflex, although the mirror was located behind the ground glass and removed during exposure.

As photographic equipment evolved, reflex cameras fell by the wayside, but during the 1890s, they were reintroduced by a number of firms. The new handheld reflex was designed with a mirror in front of the focal plane, and required a hinged mechanism to swing it out of the way during exposure. This complex design used the same lens to compose and take images.

Soho Tropical Reflex *ca. 1905*

Marion & Company Ltd., London, England. 1974:0037:2909.

Based on a design by A. Kershaw in London, England, this type of tropical camera was originally distributed by Marion & Company Ltd., also of London. Due to several mergers and company name changes and a production run of more than forty years, cameras of this design have worn numerous manufacturer labels. This specific example is made by Soho Limited and dates from the 1940s. Constructed of French polished teakwood and brass hardware, the Soho Tropical Reflex camera has a special red leather bellows and focusing hood, making it among the most attractive cameras ever produced. It incorporates some novel mechanics, with the reflex mirror moving back as it retracts, allowing the use of shorter focal length lenses. The rotating back is matched with a rotating mask in the reflex viewer to accommodate horizontal and vertical use.

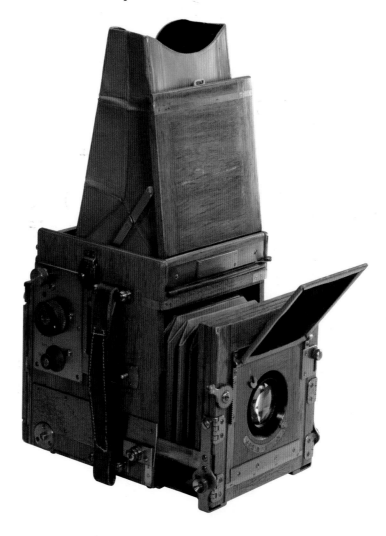

Premograph *ca. 1907*

Eastman Kodak Company, Rochester, New York. 1974:0037:1618.

The Premograph brought reflex viewing to amateur photographers in 1907. A reflecting viewer permitted the operator to see, in advance, the image right side up as it would be captured. The box SLR camera featured an automatic lens cover that opened when the lens was moved into picture-taking position and closed automatically as the lens was retracted. Twelve exposures of 3¼ x 4¼ inches came in the Premo film pack, which allowed individual films to be removed for processing before the entire pack was used. A succeeding model, the Premograph No. 2, sold for $20 in 1909 and with more advanced lenses went as high as $54.

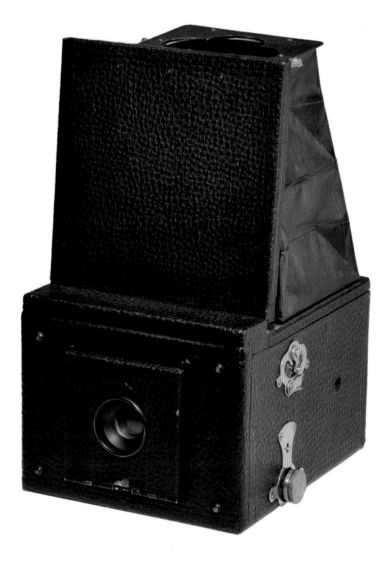

1A Graflex 1909
Folmer & Schwing Division of Eastman Kodak Company, Rochester, New York. 1974:0037:2381.

1A Speed Kodak 1909
Eastman Kodak Company, Rochester, New York. 1974:0037:1412.

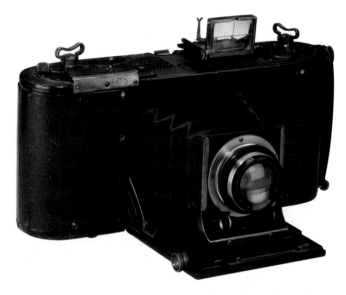

Introduced in 1909, the remarkably similar 1A Graflex (below) and 1A Speed Kodak (right) were most likely made at Eastman Kodak's Folmer & Schwing Division on Caledonia Avenue (now Clarissa Street) and Ford Street in Rochester. Thought to be the first, and possibly only, "collaboration" cameras built by the Folmer & Schwing

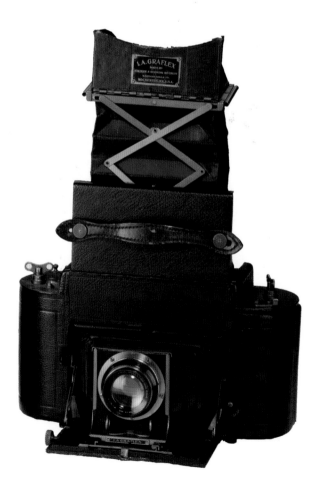

Division, these siblings share the same fine grain morocco leather covering, Graflex focal plane shutter with shutter-speed indexing plates, lens selection, and 2½ x 4¼-inch image size. The Graflex is slightly larger than the Speed Kodak to accommodate its single-lens reflex mirror box and focusing hood.

The cameras illustrated here are each fitted with Series Ic Bausch & Lomb Zeiss Tessar lenses, and they provide an excellent example of George Eastman's price point strategy. The 1A Speed, which sold at $78.50, including the lens, was one of the most expensive in the Kodak line of folding cameras; the 1A Graflex, at $100.50 with lens, was the least expensive in the Graflex SLR line of cameras.

Delta Reflex (OWNED BY ALVIN LANGDON COBURN) *ca. 1910*

J. F. Shew & Company, London, England.
Bequest of Alvin Langdon Coburn. 1967:0059:0001.

In the early 1900s, the single-lens reflex hand camera became popular with serious photographers and remained so in the decades to come. Most were similar to the Delta Reflex 3¼ x 4¼-inch revolving back model made by J. F. Shew of London in 1909. A tall leather viewing hood unfolded for sighting the image from the lens, reflected by an angled mirror onto a ground glass screen. This permitted the photographer to adjust the rack-and-pinion focus for the sharpest possible image. But pictorialists such as Alvin Langdon Coburn (1882-1966), whose camera is illustrated here, wanted a somewhat diffused image for the entire depth and used "soft-focus" lenses like those made by Pinkham & Smith of Boston. Coburn used P&S Semi-Achromatic lenses to make his artistic portraits and landscape scenes, and his testimonials helped sell other impressionistic photographers on the concept. Although they designed and manufactured their own products, both J. F. Shew and Pinkham & Smith sold broad lines of photographic apparatus and supplies made by firms in England, Europe, and the United States.

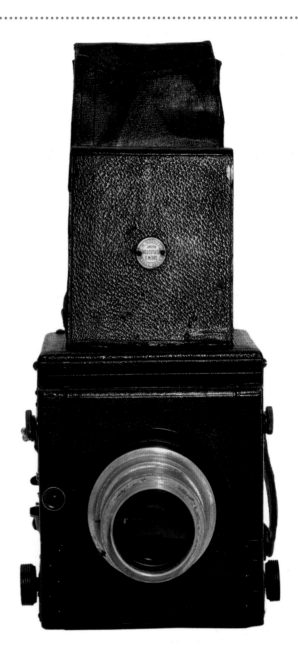

RB Auto Graflex (OWNED BY ALFRED STIEGLITZ) *ca. 1910*

Folmer & Schwing Division of Eastman Kodak Company, Rochester, New York.
Gift of Georgia O'Keefe. 1974:0037:0032.

American photographer Alfred Stieglitz (1864-1946) was dedicated to establishing photography as art through his own work and that of others. Stieglitz opened Gallery 291 in New York to showcase works that otherwise would not be seen by the public. His Folmer & Schwing Auto Graflex 4 x 5-inch camera may not have been a joy to behold, but the hard-working photographer learned it was one to use. No polished wood, shiny brass, or luxurious Russia leather on this single-lens reflex field piece. Stieglitz wasn't interested in a show horse. He needed a workhorse, and his Auto Graflex with the Goerz Celor 8¼-inch f/5 lens and reliable focal-plane shutter had enough flexibility to grab images of fast action as well as capture the splendor of the Manhattan skyline. Its revolving back could be set from portrait to landscape orientation in one second. Folmer & Schwing of Rochester, New York, built all Graflex cameras to endure the rigors and roughness of hard travel and to be ready when called upon. The Auto Graflex had a lot in common with Alfred Stieglitz.

Ensign Folding Reflex Model D *ca. 1912*

Houghtons Ltd., London, England.
Gift of Eastman Kodak Company. 2003:0265:0001.

Every successful enterprise has people who keep their eyes on the competition in order to stay ahead of them. Eastman Kodak was no exception, and it routinely acquired samples of new products from other camera makers, studied them carefully, and responded accordingly. Such examinations would have looked not only for clever ideas but also possible infringement of company patents. In turn, Kodaks were scrutinized by manufacturers everywhere.

Houghtons' Ensign cameras, manufactured in London, England, competed directly with the Graflex line of equipment, which Eastman Kodak had owned since 1905. As a rival product, this Ensign Folding Reflex went straight from the dealer's shelf to Kodak in Rochester. It has no lens because the Ensign customer had a choice of fitments instead of a predetermined camera-lens combination. The camera body alone was priced at $110. Choosing the recommended Carl Zeiss Jena Tessar 135mm f/4.5 added $40 to the sticker, but the retailer would mount any suitable lens desired. For the money, the buyer got a reflex camera with a 1/1000-second focal-plane shutter, shifting lens board, and a mirror of the finest crystal glass. The Folding Reflex Model D took plates of 3¼ x 4¼ inches in an Ensign double holder. The location of the tripod threads allowed such use in the vertical format only, and for this work, focus was on the rear ground glass with the leather reflex hood folded down. When collapsed, the Model D became an easy-to-stow compact package that kept all the vitals well protected.

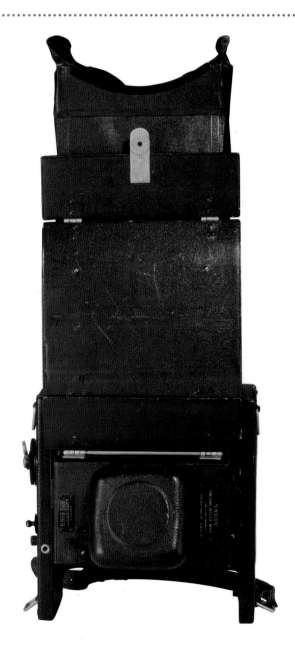

Minex Tropical *ca. 1920*

Adams & Company Ltd., London, England. 1974:0028:3131.

Adams & Company of London built cameras for the discriminating individual for whom price was no object. Only the finest materials were used in their 1920 Minex Tropical single-lens reflex folding cameras. Polished teakwood bodies with lacquered brass fittings told the world you insisted on the best, while the bellows and viewing hood of Russia leather had the feel of a kid glove. But, after all, this was still a camera, so Minex had to deliver superior results, and it could. The Taylor-Hobson Cooke Aviar 5¼-inch f/4.5 lens in the leather-covered mounting board had a teak and brass flip-up door for protection when not in use. The brass focus racks had three-inch extensions that could be unfolded to allow the lens and bellows to travel beyond the edge of the baseboard for telephoto work. Capturing fast action was easy with the Minex's 1/1000-second focal-plane shutter. Unlike most other camera manufacturers, Adams only sold direct from their 24 Charing Cross Road premises.

At £85 for the 3½ x 2½-inch model, the Minex Tropical was not within the means of working folks, but Adams did take trade-ins toward the purchase price. The used cameras were refurbished and sold through Adams' Second-Hand Apparatus store.

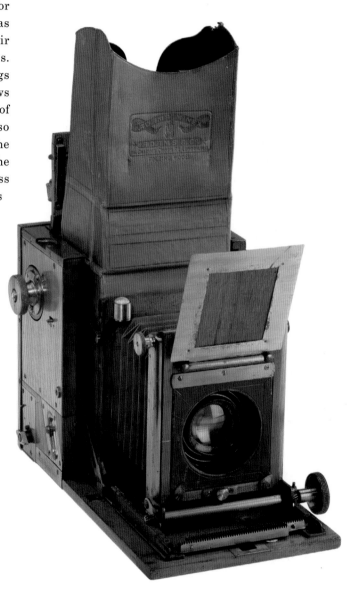

Graflex Series B (RED LEATHER COVERING) *1926*

Folmer Graflex Corporation, Rochester, New York.
Gift of Graflex, Inc. 1974:0037:2399.

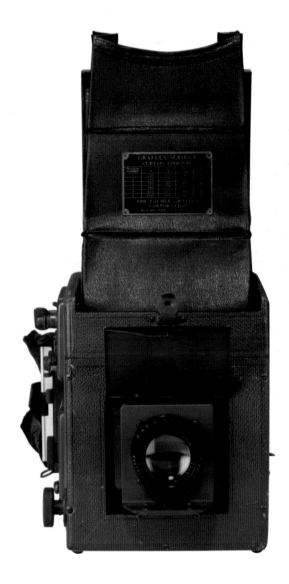

The Graflex family of cameras, numbering nearly two dozen, was in production until 1973. The first model was introduced in 1902 by Folmer & Schwing Manufacturing Company, which became a division of Eastman Kodak in 1905. Years later, after Kodak signed a consent decree agreement for violation of the Sherman Anti-Trust Act in 1926, the company was spun off as Folmer Graflex Corporation.

Through all its corporate lives, Folmer continued to manufacture these handheld, folding, box-style, single-lens reflex cameras. Fitted with Folmer's multiple-aperture, rubberized-cloth focal plane shutter with speeds to 1/1200 second, the Graflex models used a mirror mounted just behind the lens, providing the photographer a right-side-up image-sized view of what was being photographed.

The Series B was added to the Graflex line in 1923 and was its entry-level camera of the period. According to the company order book, this red leather covered camera, serial number 150,991, was produced in a lot of three hundred Series Bs in 1926. Since the order book does not mention anything specific about this camera, one is left to speculate about its unusual covering. Was it a special order that was never shipped? Did someone cover it using leftover material? Or could it be a color study? Around the time this red instrument was produced, Eastman Kodak hired Walter Dorwin Teague to give a face-lift to the company's cameras. Given the close relationship between the two companies (after the split, Kodak continued as Graflex's sales agent), one can envision similar thinking at Folmer. In any case, this is the only known red-leather-covered Graflex.

Miroflex 9 x 12 *ca. 1927*

Zeiss Ikon AG, Dresden, Germany.
Gift of Douglas Carroll. 1974:0084:0118.

When Germany's four largest photographic firms merged in 1926 to form Zeiss Ikon AG, the best features and products from each company were combined to create new lines of cameras to better serve customers and their varied needs. One result was the Miroflex 9 x 12, billed in 1927 as a "Combination Sport and Reflex Camera." A carryover product from Contessa-Nettel, one of the component manufacturers making up the new company, the Miroflex was unusually versatile. An easy-to-carry, single-lens reflex camera that was only about three inches thick when folded, it also had a collapsible viewing hood for waist-level use, complete with a mirror that projected the scene from the lens onto the ground glass viewing screen.

To use the Miroflex in "Sport" mode, the viewing hood remained folded, and the wire finder was raised, along with the rear sight, to allow for eye-level use. To focus, the photographer turned a small knob on the right side to lower the mirror, then moved the focus lever on the 150mm f/4.5 Tessar lens until the image was at its sharpest. Another, larger knob cocked the thirteen-speed (plus Time and Bulb) focal-plane shutter, which could be set as fast as 1/2000 second to capture action. The mirror was then returned to the resting position, and the release button pressed. The Miroflex could also be used as a view camera by replacing the plate or film-pack holder with the ground glass screen, locking the shutter open, and focusing through the lens. It remained in Zeiss Ikon's catalog until 1936.

Primarflex *ca. 1936*

Curt Bentzin, Görlitz, Germany.
Gift of Philip Condax. 1974:0028:3347.

The Primarflex, manufactured by Curt Bentzin in Görlitz, Germany, was introduced in 1935. It was a high-quality 6 x 6-cm single-lens reflex camera anticipating the Hasselblad, which was introduced a dozen years later. There is some reason to believe that the young Victor Hasselblad became familiar with the Curt Bentzin company early in his career, having been sent to Dresden to learn the photo business. Like the Hasselblad, the Primarflex had a compact square box shape and used No. 120 roll film. The retail price with standard lens was $145 in 1937.

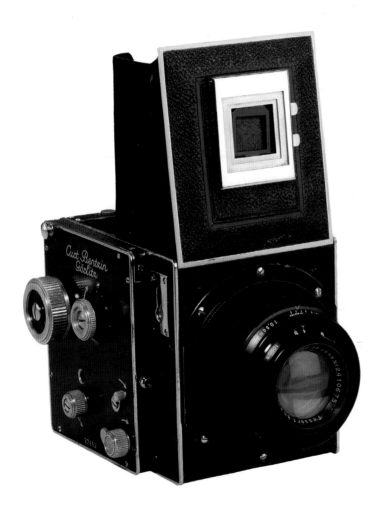
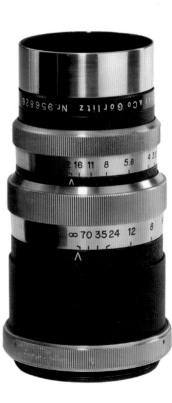

Home Portrait Graflex *1937*

Folmer & Schwing Division of Eastman Kodak Company, Rochester, New York.
Gift of Graflex, Inc. 1974:0037:2462.

As one might expect, the Home Portrait Graflex was designed for photographers looking for a camera to make portraits at home. It used a 5 x 7-inch format that was popular with portrait photographers prior to World War II. The camera was produced from 1912 through 1925 by the Folmer & Schwing Division of Eastman Kodak Company of Rochester, New York, and then by successor Folmer Graflex (also of Rochester) from 1926 to 1945. This example is from 1937, according to company serial number records. Its list price was $350, including the No. 35 Kodak Anastigmat, a ten-inch f/4.5 lens.

Like all Graflex single-lens reflex camera models, the Home Portrait was an SLR fitted with the company's multiple aperture, rubberized-cloth focal-plane shutter. This version had shutter speeds from one to 1/500 second. And like higher-end Graflex models, the camera had a revolving back, a necessity for framing horizontal or vertical images on large rectangular-format reflex cameras. What made this instrument unique is that, unlike all other Graflex models, the lens could pivot vertically off-axis, allowing the photographer to alter depth of field without adjusting the lens opening. This effect, known as Theodor Scheimpflug's Rule—*when the extended lines from the lens plane, the object plane, and the film plane intersect at the same point, the entire subject plane is in focus*—is useful in portraiture, when a decrease in depth of field may be desirable to soften the focus of the background. Conversely, an extended depth of field is useful in table-top photography. Either way, while common to most view cameras, this capability is generally not found on reflex cameras.

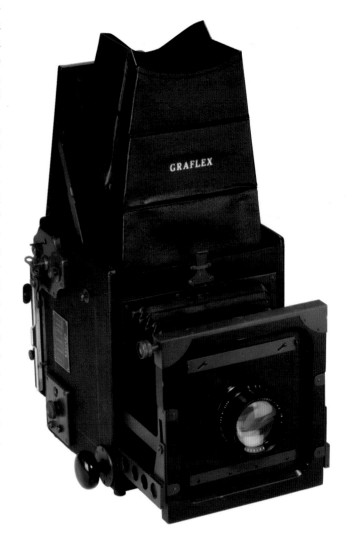

Hasselblad 1600F *1948*

Victor Hasselblad AB, Göteborg, Sweden.
Gift of Eastman Kodak Company. 1974:0037:0072.

During World War II the Royal Swedish Air Force asked inventor Victor Hasselblad if he could make an aerial camera like one they had found in a wrecked German airplane. His answer was, "Well, not exactly. I can do better." The resulting aerial camera bore a striking resemblance to the eventual Hasselblad 1600F, which was officially introduced in 1948 as the Hasselblad camera. Only after the subsequent release of the 1000F model did it become known as the 1600F. All Hasselblad cameras have been manufactured by Victor Hasselblad Aktiebolag, Göteborg, Sweden.

In Hasselblad's effort to produce the "ideal camera" for the professional photographer, his 1600F was near perfection. It was the first camera designed with a modular concept; his single-lens reflex design was farsighted. The central camera body could accept a variety of interchangeable lenses, film magazines, and viewing systems. Measuring less than four inches square and six inches long, the medium-format camera boasted a fast 1/1600-second shutter speed and a thin, lightweight, stainless steel foil focal-plane shutter.

Tapping into a longstanding family relationship with Eastman Kodak Company, Hasselblad had Kodak design the camera's standard 80mm Ektar lens, as well as the 55mm, 135mm and 254mm lenses.

The retail price at introduction for a complete 1600F camera (body, lens, and magazine) was $548 but was reduced to $479 by 1953.

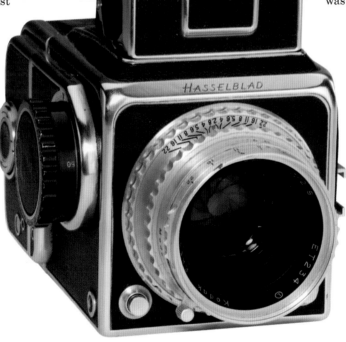

Super D *1948*

Graflex, Inc., Rochester, New York.
Gift of Graflex, Inc. 1983:0576:0001.

Manufactured from 1948 through 1958 by Graflex in Rochester, New York, the Super D was a large-format, single-lens reflex camera, made from seasoned Honduras mahogany covered with a fine morocco grain leather. The last of the Graflex family of single-lens reflex cameras, it offered several major improvements over earlier models. The Super D was fitted with the company's dependable multi-aperture focal-plane shutter, which had speeds from 1/30 to 1/1000 second, and was synchronized for flash bulbs. The flash cord contact and Graflite mounting plate were built into the camera body. The 190mm f/5.6 Graflex Optar lens was coated for better color reproduction. It was mounted in an automatic diaphragm that allowed full aperture focusing, but would stop down to the pre-set taking aperture when the shutter was released. The ground-glass image was made even brighter by the use of an Ektafield lens, the Graflex trade name for the Fresnel lens. This type of lens, which is now commonly used in all SLR cameras to evenly distribute light across the ground glass, creates an image that has virtually the same brightness from center to edge. The Super D was available in two sizes, for either 3¼ x 4¼- or 4 x 5-inch images. The 4 x 5 shown had a list price of $279.50.

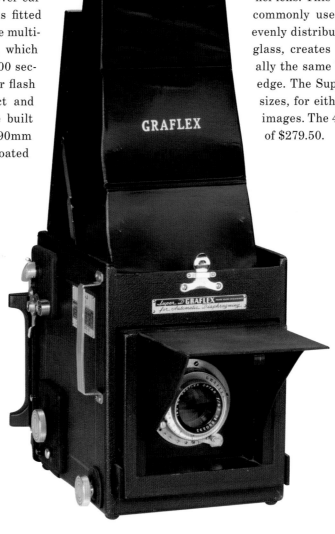

Hasselblad 500C _ca. 1957_

Victor Hasselblad AB, Göteborg, Sweden.
Gift of Eastman Kodak Company. 1999:0163:0001.

Introduced in 1957, the Hasselblad 500C was destined to become an instant classic. Built by Victor Hasselblad AB, Göteborg, Sweden, it succeeded the 1600F and later 1000F cameras, both of which used focal-plane shutters. The new 500C was still basically the same 2¼-inch square reflex medium-format SLR, but with the new Synchro-Compur leaf shutter built into every lens.

It offered full aperture viewing, automatic diaphragm, and flash synchronization at all shutter speeds. As with previous Hasselblad cameras, interchangeable film magazines allowed for an easy mid-roll change from one film type or format to another. In 1970, the 500C was modified slightly and became the 500C/M, which had a quick-change viewing screen.

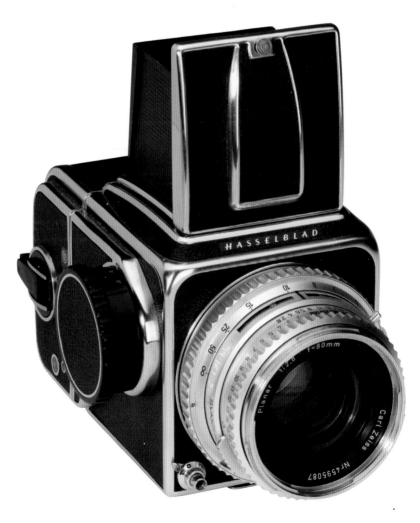

Mamiya RB 67 Pro S *ca. 1970*

Mamiya Camera Company, Tokyo, Japan.
Gift of Bell & Howell Mamiya Company. 1978:0692:0001.

Introduced in 1970 by the Mamiya Camera Company, Tokyo, the Mamiya RB 67 Pro S appeared similar to, but was larger than, conventional medium-format SLRs in the 6-cm square format. Its 6 x 7-cm format used No. 120 roll film and was often referred to as "the ideal format" because it had the correct proportions to be wholly enlarged to 8 x 10 inches.

In appearance, the RB 67 differed from the other 6 x 7-cm camera of the time, a Pentax, which resembled a very large 35mm camera. The "RB" designation means the camera had a revolving back and could be easily used in either a vertical or horizontal orientation. Some consider the RB 67 the Japanese version of the legendary Graflex SLR.

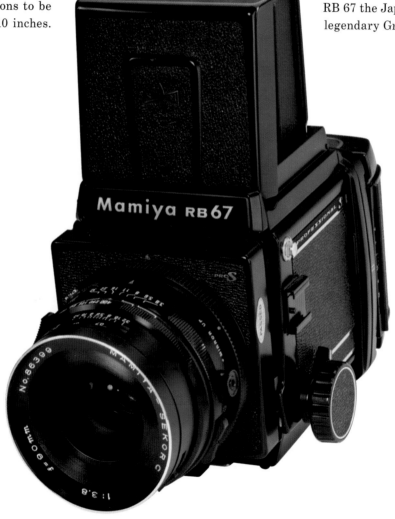

TWIN-LENS REFLEX

Two-lens cameras, those using separate yet identical lenses for viewing and taking images, date back to the mid-1860s. Though uncommon, the cameras were especially convenient for portrait photography, as the two-lens design allowed the photographer an uninterrupted view of the subject while composing and taking the photograph.

In the mid-1880s, a mirror was added at a forty-five degree angle behind the viewing lens, transforming the camera into a reflex. This improvement inverted the viewed image and changed the camera from a tripod mounted eye-level to a hand-held waist-level instrument. During the late 1920s, the German firm Franke and Heidecke introduced a roll film version, the Rolleiflex. This design became one of the most copied of the twentieth century.

Magazine Twin-Lens "Artist" Camera *ca. 1899*

London Stereoscopic Company, Ltd., London, England. 1974:0037:0028.

Twin-lens reflex cameras were in quantity production long before the Rolleiflex appeared and defined the breed. One example was the Magazine Twin-Lens "Artist" Camera sold by London Stereoscopic and Photographic Company, Ltd., in 1899. Conceptually very similar to the later German product, the Magazine Twin-Lens had two lenses in an over-and-under mounting on a moveable panel. Light from the upper lens was reflected by a mirror to the underside of a ground glass. A door atop the box-shaped camera opened to reveal the viewing screen. The photos were taken by the bottom lens, the firm's own Black Band Rapid Rectilinear six-inch f/7.5 working through a Unicum shutter from Bausch & Lomb in Rochester, New York. The lens board was focused by turning a brass knob on the lower right side, which adjusted the distance using a rack-and-pinion drive. A rear door opened to access the magazine for the 3¼ x 4¼-inch plates or sheets, and a lever on the side transferred the exposed plates and brought fresh ones in place.

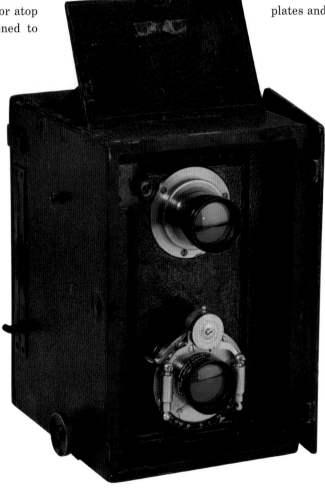

Rolleiflex I *ca. 1929*

Franke & Heidecke, Braunschweig, Germany. 1974:0084:0121.

Introduced in 1929 by Franke & Heidecke of Braunschweig, Germany, the Rolleiflex was an instant classic. Rollei's compact twin-lens reflex design was constantly improved and manufactured well into the 1990s and was copied by many companies throughout the world. What made it popular was that the 6-cm square format, being more than four times larger, made sharper enlargements than 35mm film. The large reflex finder screen, although it gave a mirror image of the subject, was bright and made it easy to focus the 7.7cm f/3.8 Carl Zeiss Jena Tessar lens. The Compur shutter with rim-set controls had a maximum speed of 1/300 second. Rolleiflexes were favorites of professionals and serious amateurs alike, prized for their superior optics, durable all-metal construction, and extensive catalog of accessories. The Rolleiflex I cost $75 in 1929.

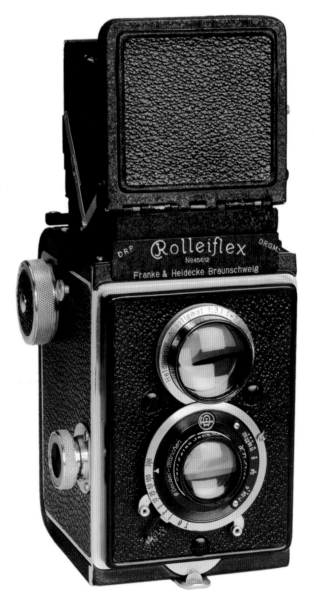

Rolleicord *1933*

Franke & Heidecke GmbH, Braunschweig, Germany.
Gift of John Arlia. 2006:0021:0001.

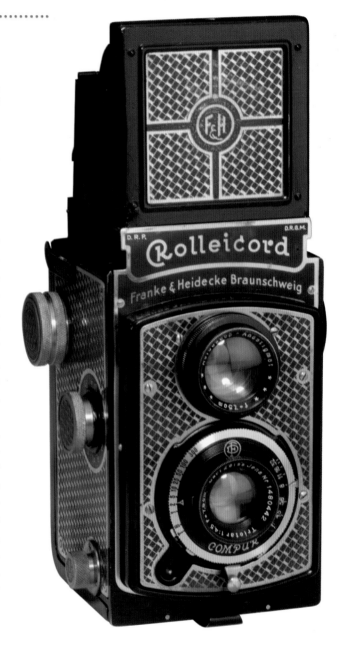

Franke & Heidecke hit a home run with its 1929 Rollei-flex. Almost immediately, imitations of the twin-lens reflex camera were marketed by makers looking to take advantage of the demand. Their offerings, which were not exact copies, sold for less than the real thing. Buyers of the knockoffs tended to like the concept of the original, but didn't need all its features and capabilities, or welcome its high price tag. In 1933, Franke & Heidecke countered the competition by introducing its own alternative, the Rolleicord. Similar in appearance and operation to the Rolleiflex, the new camera was priced at $70, compared to $112 for its older sibling.

The designers met this price point by eliminating some of the Rolleiflex's features. The Rolleicord had the same twin-lens focus system, but used the cheaper Zeiss Triotar instead of a Tessar lens. Gone were the finger-tip adjusters for shutter speed and f-stop, replaced with conventional rim-set controls that had to be set prior to viewing the scene in the reflex finder. The small window readout visible at waist level was also out. And the rapid advance crank so appreciated by Rolleiflex users gave way to a knurled knob that turned the take-up spool and indexed the exposure counter on the left side.

Despite all the design changes, the Rolleicord retained the folding metal hood, complete with sports finder and critical-focus magnifier. Nor did cost-cutting shortchange the buyer on style. Instead of leather, the "mirror-reflex for everyman" had nickel-plated, art deco panels on four sides, with the model name proudly displayed above the lens panel. Rolleicords were built with the same attention to detail and quality expected from Franke & Heidecke, and owners enjoyed years of service. Many later traded up to the Rolleiflex, a move that surely didn't displease the company treasurer.

Ikoflex (850/16) *ca. 1934*

Zeiss Ikon AG, Stuttgart, Germany. 1974:0084:0126.

The first twin-lens reflex made by Zeiss Ikon AG was the Ikoflex, introduced in 1934. A very sturdy camera, it had a cast magnesium body that in early versions (as shown here) was a painted leather texture. Features included a rapid film advance lever on the lower front. Unique in running the film horizontally, rather than vertically, the Ikoflex produced 2¼ x 2¼-inch images on No. 120 roll film. It retailed for $36 in 1934.

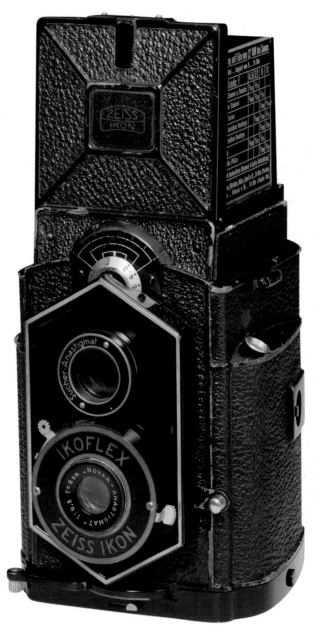

Superfekta ca. 1935

Welta-Kamera-Werke GmbH, Freital, Germany. 1974:0028:3353.

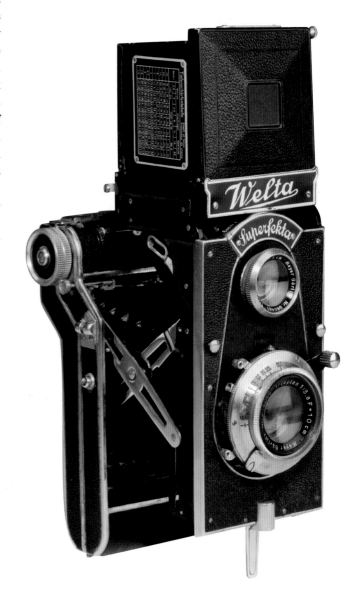

The almost immediate success of the 1929 Rolleiflex twin-lens reflex camera produced a wave of imitators hoping to claim some market share. Not only did they copy Rollei's concept, they retained the 6-cm square format as well. After deciding to cash in on the TLR boom, Welta-Kamera-Werke of Freital, Germany, broke rank introducing its Superfekta. For starters, the designers chose the atypical 6 x 9-cm format. Then, instead of building around it with the usual box form, they went with a folding bellows style. To be sure, this followed a certain logic, as the company had turned out almost nothing but bellows designs since its beginnings in 1914. While the unconventional approach did allow for a somewhat smaller camera when collapsed, making room for the mirror and viewfinder hood gave the Superfekta an unusual dog-leg shape. The hood was similar to those on most twin-lens cameras, except for being masked to show the rectangular format seen through the Trioplan viewing lens. The taking lens could be either another Trioplan or the extra-cost Tessar. Both lenses were focused together by the front-mounted lever, with exposure adjustments set by rim dials on the taking lens.

The Superfekta's default format was in the vertical or "portrait" orientation. To shoot in landscape format while retaining the viewfinder in the waist-level position, Welta designed a rotating bellows-and-back assembly. A simple twist to the right moved the back 90 degrees to the horizontal detent, and the camera was ready to snap the entire wedding party, something the 6 x 6 cameras weren't much good for. In the postwar years, with Welta-Kamera-Werke under East German control, there was no place for elegant products like the Superfekta. In its final years, the company tried the 6 x 6 Rolleiflex-style market, but with little success. A series of mergers and consolidations in the 1950s led to the end of the Welta brand.

Twinflex *ca. 1939*

Universal Camera Corporation, New York, New York.
Gift of Eastman Kodak Company. 2010:0066:0013.

The business climate didn't favor new ventures during the Great Depression, but in 1933 partners Otto Githens and Jacob Shapiro took a chance and launched Universal Camera Corporation in New York City. Their idea was to mass produce low-cost cameras and equipment to serve a penny-watching public. The success of Universal's first product, the Univex A, gave the company the resources for an expanded catalog with ever more sophisticated (and expensive) offerings. In 1939, they announced the Twinflex, a $4.95 plastic twin-lens reflex that used the unique Univex 00 roll films. The camera was made of Textolite, a relatively new material from General Electric that was strong and stable, and could be molded into complex shapes with a wide variety of surface textures. The twin-lens concept wasn't new, but it was seldom found in low-priced equipment.

Lacking the versatility of the expensive European TLRs, the Twinflex did have one feature not often found in the low-priced field. Its adjustable focus enabled the photographer to sight the subject in the ground-glass viewing screen and turn the metal knob below the lens until the image was at its sharpest. The user had only to press the pearlized plastic shutter button to capture the scene. Though time exposures could be taken by lifting the metal tab above the lens panel, the camera had no tripod socket. A folding metal hood shielded the viewing screen from glare and protected it when closed.

Twinflex advertisements claimed, "You get the picture you see." To that end, both the viewing lens and the taking lens were identical, and moved as a unit for accurate focus. Although the camera was an attractive product that made good pictures, the timing of its introduction was unfortunate. The war in Europe had cut off deliveries of Univex film, and Universal was in the midst of one of its frequent cash-flow crises. Defense contracts awarded during World War II kept the firm going, but in the postwar years it could no longer compete. The company went bankrupt in 1952.

Automatic Reflex *ca. 1947*

Ansco, Binghamton, New York.
Gift of Philip G. Maples. 1987:1604:0002.

After World War II, many photographic manufacturers wanted to take advantage of the twin-lens reflex camera's popularity. Ansco of Binghamton, New York, entered the 2¼ x 2¼ TLR market in a big way with the 1947 Automatic Reflex. Advertised as "America's Finest" TLR, the Automatic came with a sturdy aluminum body and coated 83mm f/3.5 lenses. Like the Rollei, it had the focus knob on the side, but also a ridged wheel on either side of the lens panel for fingertip focusing. The large shutter set-and-release levers were also located near the top lens. A side-mounted crank lever handled the job of film advance. This was a well-made premium camera with a price to match at 225 post-war dollars. Poor sales led to big price reductions in the 1950s, but foreign competitors dominated the medium-format field and Ansco abandoned the model soon after.

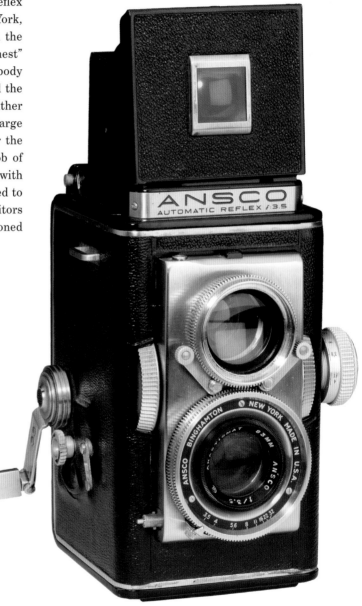

КОМСОМОЛЕЦ (Young Communist) *ca. 1946*

GOMZ, Leningrad, USSR. 2005:0279:0001.

An exact copy of the popular 1930s German Voigtländer Brilliant, the Комсомолец, or Komsomolet (Young Communist), was intended for young Soviets with limited experience in photography. The twin-lens reflex design made twelve 6 x 6-cm images on a roll of 120 film. Manufacture began in 1946 at the GOMZ factory in Leningrad, which was the only Russian manufacturer of twin-lens reflex cameras. This camera was succeeded by several improved versions that sold in the millions under Lubitel name.

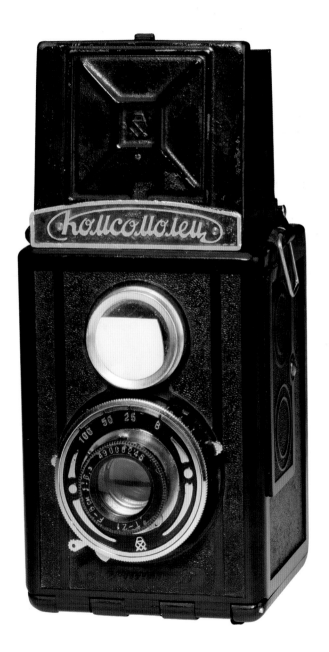

Brilliant TLR *1949*

Voigtländer AG, Braunschweig, West Germany.
Gift of Eastman Kodak Company. 1999:1013:0021.

After putting its twin-lens reflex Brilliant into production around 1932, Voigtländer, of Braunschweig, West Germany, ruled the low-price segment of that market until after World War II, when Kodak launched the Duaflex. In 1949, the German firm added an updated Brilliant to its line for $29.50. The postwar model had a plastic body and, like the Kodaks, it used 620 film. Moreover, through the use of some clever design, the Brilliant could also accept a 120-size spool. The back cover had the ruby window familiar to roll film users, where the frame numbers were revealed, but there was also an exposure counter on the camera's right side.

Unlike the more expensive TLRs, the low-end cameras had a fixed-focused viewing lens that served only as a finder. The Brilliant's

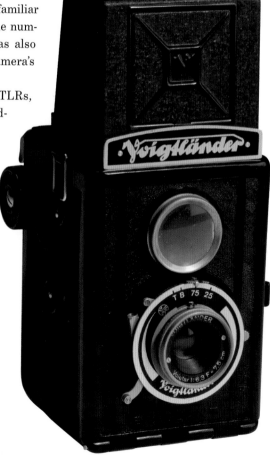

Voigtar 75mm f/6.3 taking lens was adjustable for distance and marked with three zones: Portraits, Groups, and Landscapes. The shutter had only two speeds, plus T and B, but it also had a self-timer. A cable release socket and tripod threads gave the camera a pretense of being more sophisticated than it was. Accessories such as a clip-on light meter and various filters could be stored in a compartment behind a door on the left side. There was no provision for flash, making the Brilliant primarily an outdoors-in-daytime camera. From a distance, the apparatus looked the part of an expensive German twin-lens, and with its black finish and Voigtländer badge could easily be mistaken for one, but it had the soul of a box camera.

Anscoflex *ca. 1954*

Ansco, Binghamton, New York.
Gift of GAF Corporation. 1985:1250:0040.

The Anscoflex was introduced in 1954 by Ansco, of Binghamton, New York. It was a very sturdy, attractive, twin-lens reflex camera, a style very popular at the time. The unique feature was a sliding combination lens cover and viewfinder sunshade that had the appearance of a tambour door, which in operation slides vertically to uncap the lens and becomes the front part of the viewfinder shade. The camera, constructed in a gray and silver metal case, was styled by the renowned Raymond Loewy and retailed for $15.95.

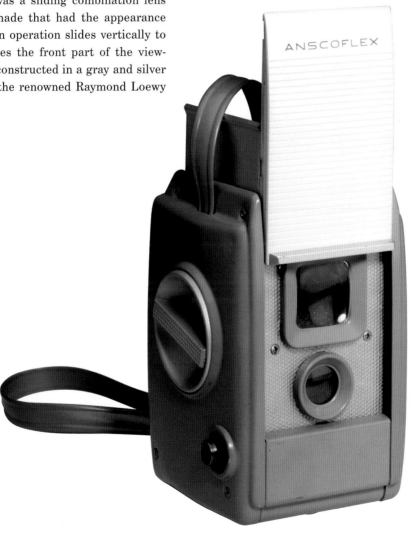

Kalloflex Automat *1954*

Kowa Optical Works, Nagoya, Japan. 1988:0076:0001.

By the mid-1950s, countless manufacturers produced Rollei-style twin-lens reflex cameras. To set it apart from the rest, any new TLR had to offer something special. As a latecomer to the twin-lens game, Kowa needed its 1954 launch of the Kalloflex Automat to be a home run. At first glance, the Kalloflex looked like every other pretender to the Rolleiflex throne, but a closer look revealed it to be the standout that it was. It had a pair of 75mm f/3.5 Prominar lenses that Kowa billed as "Tessar type," referring to the highly regarded German Zeiss design. The advance lever, located on the right side like a Rollei, circled the focus knob, which was often found on the opposite side of other instruments. This concentric mounting meant that to turn the winding crank, it was no longer necessary to switch the camera from the right to the left hand after each exposure.

The Kalloflex's controls for aperture and shutter speed were on either side of the bottom lens and could be adjusted with the thumb and index finger of your free hand, with the values visible in a small window that could be seen while viewing. Also easy to see was the depth-of-field scale on the crank hub, paired with the distance setting on the focus control knob. The shutter release on the lower part of the lens panel was within easy reach of the photographer's left forefinger. The usual complement of TLR features like flip-up magnifier, flash sync, and exposure counter were in their usual spots. A significant price advantage over German cameras sealed the deal for many buyers. The $149.50 list was almost $100 less than a comparable Rolleiflex. Kowa eventually abandoned the TLR market when tastes changed, as sales of 35mm SLRs increased, and the professional users found 6 x 6-cm SLRs with their quick-change lenses and film magazines more versatile. Kowa successfully made both types.

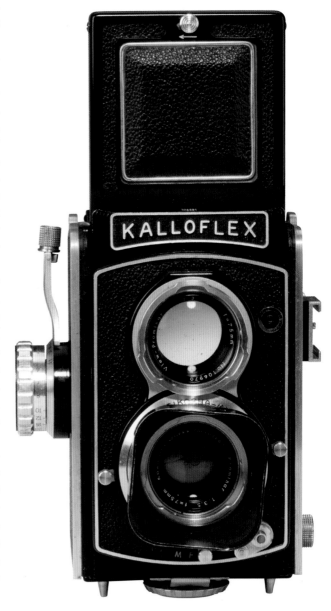

Autocord *ca. 1955*

Chiyoda Kogaku Seiko K.K. (Minolta), Osaka, Japan.
Gift of Richard L. Marriot. 1985:1558:0001.

The twin-lens reflex camera became popular for a number of reasons. For one, the focusing was more accurate and less bother than with a view camera. Also, the TLR was as easy to use as a single-lens reflex design but without the added mechanical complexity of a moving mirror. The top lens was for viewing. A mirror projected the image to the waist-level screen for the photographer to frame the subject. The bottom lens took the picture. A single focus control moved both lenses together, so when the finder image was at its sharpest, the taking lens was set correctly. The standard for TLR cameras was the Rolleiflex of 1929, which was quickly and widely imitated.

Minolta was making its own models by 1936, and by the time the Autocord reached the market in 1955, the company was a well-established maker of twin-lens equipment. The Autocord is a 6-cm square format camera and uses 120 roll film, as do most TLRs. The pop-up magnifier for precise focus was standard as well. Minolta fitted the Autocord with a matched pair of 75mm Rokkor lenses, the lower one incorporating a Seikosha MX shutter with flash synchronization. Similarities to the Rollei products abound, including the film advance crank, metal viewing hood, and the shutter-speed/f-stop scales visible when viewing. There are also many differences between the Japanese and German designs. A Rollei is focused by turning a knob on the side of the camera, and the Minolta by a lever below the lens board. The film-load door on the Rollei swings upward, the Minolta's downward. Accessories such as auxiliary lenses, sunshades, and filters were designed with a bayonet mount, also a commonality in the twin-lens world. The Minolta TLR cameras enjoyed a big price advantage over their European competitors. The Autocord listed for $99.50, $50 less than the cheapest Rollei twin-lens model.

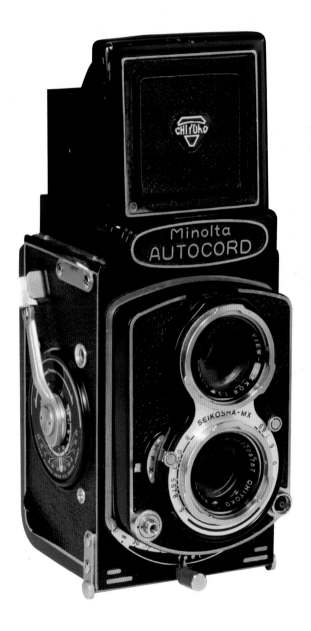

Rolleiflex 3.5E *1956*

Franke & Heidecke, Braunschweig, West Germany.
Gift of Rollei Corporation of America. 1978:0766:0001.

The Rollei name is best known for the twin-lens reflex roll-film cameras made by Franke & Heidecke in Braunschweig, Germany (West Germany, 1946–1990), since 1929. After World War II, many other camera manufacturers introduced TLRs, which only made the design more popular. In 1956, the E-series made its way into the TLR market as the first Rolleiflex with a built-in meter. The 3.5E was fitted with either a Carl Zeiss Planar or Schneider-Kreuznach Xenotar 75mm lens. The meter on the 3.5E wasn't coupled to the shutter-speed knob, so it took two steps for the photographer to adjust for light conditions. The F-series, which replaced the E in the Rolleiflex lineup in 1960, rectified this shortcoming.

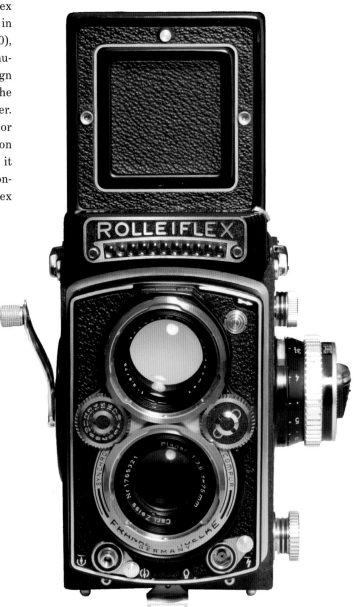

Rolleiflex 4 x 4 *1957*

Franke & Heidecke, Braunschweig, West Germany. 1974:0028:3051

Not long after the first Rolleiflex twin-lens cameras were introduced in the late 1920s, Franke & Heidecke of Braunschweig, West Germany, announced a scaled-down version for a 4-cm square format on No. 127 film. The Baby Rollei, as it became known, was dropped in 1938, but returned to the catalog in 1957. This version was nicknamed the Gray Baby because of its color scheme. The 4 x 4 negatives were roughly half the size of those made by the big 6 x 6 Rolleiflexes, and the camera's price of $133 was about half what the larger-format models cost.

The Baby had most of the features that made the Rollei name renowned and a favorite of professionals worldwide. Bringing the 60mm f/3.5 Xenar lens into razor-sharp focus was just a matter of turning the large knob on the side and viewing the image projected on the ground glass by the 60mm f/2.8 Heidosmat viewing lens until it was perfect. The Synchro-Compur shutter had a top speed of 1/500 second, and the smallest aperture setting of f/22 gave a depth of field from six feet to infinity. The folding metal finder hood housed a flip-up magnifier for even more precise adjustment. A door on the hood could be opened for eye-level viewing. Frames were advanced by a knob on the side opposite the focus control, below which was a counter window to let the user know when all twelve shots were made. Although nearly twice the size of a 35mm frame, the 4 x 4 format yielded slides that

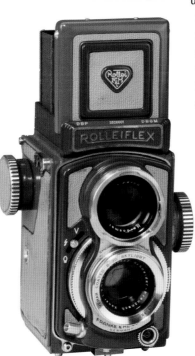

used standard two-inch-square mounts and could be shown with most projectors and screens. Just as it did for the Baby's bigger sisters, Rollei offered a complete line of accessories for the little camera: lenses, filters, flashes, meters, a pistol grip, and even a panorama head that indexed 360 degrees to shoot ten frames to be printed together for a scene ten times wider than it was high. The Baby Rolleiflex enjoyed a somewhat longer run than its prewar ancestor, lasting until 1968.

Rolleiflex 2.8F Aurum *ca. 1983*

Franke & Heidecke, Braunschweig, West Germany.
Gift of Berkey Marketing Companies, Inc. 1983:0694:0001.

The Rolleiflex 2.8F Aurum of 1983 descended from a long, distinguished line of twin-lens reflex cameras dating back to the pioneer 1929 Rolleiflex made by Franke & Heidecke in Braunschweig, Germany. The Aurum (Latin for "gold") was finished in black with alligator leather and gold-plated metal parts. Other than the finish and trim, it was a standard 2.8F model, long regarded by professionals and serious amateurs alike as one of the finest cameras produced anywhere. The Rolleiflex 2.8F took twelve 6-cm square images on a roll of 120 film, or twice as many on 220, for cameras so equipped. The 80mm f/2.8 lenses, Compur shutter, bright focus screen, and coupled meter made it a favorite medium-format tool, especially for location shots where the Rolleiflex's ruggedness and reliability were important. Rolleiflex 2.8Fs were mounted with either Zeiss Planar or Schneider-Kreuznach Xenotar lenses.

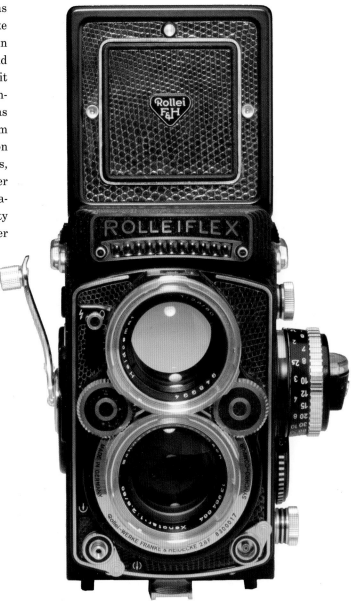

FOLDING

Nearly every camera manufacturer worldwide was producing folding bellows cameras during the first half of the twentieth century. Designed on the foundation established by the box snapshot cameras, folding cameras produce large negatives necessary for quality photographs in a smaller, more easily transportable package. Unlike box cameras, whose lens focus distance is permanently set, folding cameras require the photographer to move the lens to the proper focusing distance. This is accomplished with one of several mechanisms: a folding strut, lazy tongs, a folding bed with manually extensible lens board, or a folding bed with an auto-extensible lens board, all using a folded bellows to connect the lens with the camera body.

Micromégas *ca. 1875*

J. Fleury Hermagis, Paris, France.
Gift of Eastman Kodak Company, ex-collection Gabriel Cromer. 1974:0037:1676.

One of the few collapsible box cameras produced in the last quarter of the nineteenth century, J. Fleury Hermagis's pocket-sized Micromégas is reminiscent of Charles Chevalier's much larger Grande Photographe, manufactured some thirty years earlier. Made of polished French walnut with hinged edges, the 8.5 x 9.5-cm format camera folded flat with its focusing glass and lens board removed. Focus was accomplished by rotating the helical thread lens in its mount.

The choice of the camera's name was inspired by a 1752 short story by the French writer and philosopher Voltaire (François-Marie Arouet). Recognized as an early precursor of the literary genre of science fiction, Voltaire's tale shares its title with the name of the primary character, Monsieur Micromégas, an absurdly gigantic alien who wonders at the smallness of the earth and its inhabitants, amidst the vastness of the universe. A narrative based on the interplay of earthly and celestial proportion and scale, Micromégas had great public appeal in the eighteenth and nineteenth centuries for its questioning of conventional knowledge and wisdom. Like Voltaire's story, the design of this camera reveled in an unorthodox approach to comprehending the world.

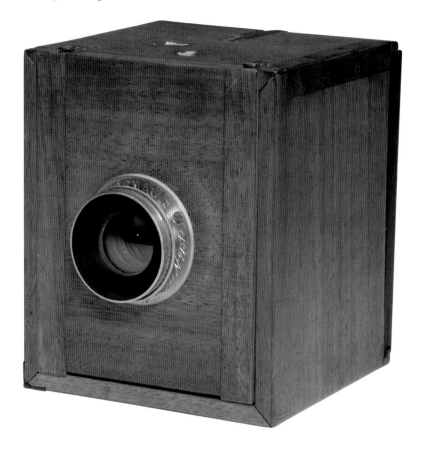

Omnigraphe *ca. 1887*

E. Hanau, Paris, France.

Gift of Eastman Kodak Company, ex-collection Gabriel Cromer. 1974:0037:2314.

A benefit of dry-plate photography was that it allowed a photographer to carry a supply of ready-to-use plates. For manufacturers, a logical design step would be a camera that carried extra plates inside; another would be a camera that allowed the plates to be easily changed. Hanau of Paris took these steps and, using a pull-push plate changer, incorporated them into its 1887 Omnigraphe folding camera. After exposing a 9 x 12-cm plate, the photographer needed only to pull the nickel-plated brass handle on the magazine to allow the used plate to fall into the bottom of the chamber. A tambour door rolled out with the plates to keep them covered, and when the drawer was pushed back inside the camera, a fresh plate was in position. A counter on the back of the Omnigraphe tracked the number of shots. Scissors or "lazy tongs" folding struts supported the Rapid Rectilinear lens. This version had a single speed rotating disc shutter.

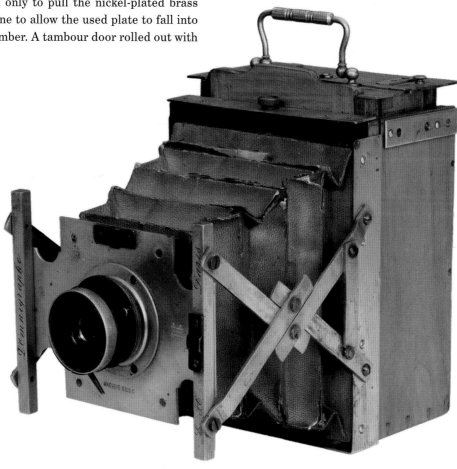

Folding Pocket Kodak *1897*

Eastman Kodak Company, Rochester, New York.
Gift of Eastman Kodak Company. 1991:2641:0002.

The first of a long series of folding cameras, the 1897 Folding Pocket Kodak made pictures in a new format of 2¼ x 3¼ inches and collapsed to a thickness of only 1½ inches. The slim camera could be carried in a (large) pocket or on a bicycle in the separately available case.

Simple in operation, the self-setting shutter was always ready to make an exposure. The "Film Cartridge System" allowed loading in daylight. Distinctly different from later models, the lens window was a recessed conical shape. It was priced at $10 without film.

Pocket Monroe A *1897*

Monroe Camera Company, Rochester, New York.
Gift of Eastman Kodak Company. 2002:0957:0002.

The city of Rochester, New York, is most often associated with Eastman Kodak Company, but many other producers of photographic equipment were located there, including the Monroe Camera Company. The firm's line of cameras, designed for and marketed to "Wheelmen and Tourists," was promoted as high-quality, precision instruments of robust build. Its Pocket Monroe A was the last of a series of very compact folding cameras that were ideal for "wheelmen," as bicyclists were called in the late nineteenth century.

The series debuted in 1897 with the Vest Pocket Monroe, which made 2 x 2½-inch images on dry plates. A second version followed in a larger size, to be joined by the Pocket A as the largest format, at 3¼ x 4¼ inches. Of leather-covered hardwood construction, the Pocket series had its lens board mounted on a pair of brass struts commonly called "lazy tongs." The achromatic lens was fixed for any distance exceeding six feet, and was mounted ahead of a simple repeating sector shutter and behind a three-position wheel-stop disc. A right-angle viewfinder could be rotated to allow use for either portrait or landscape orientation.

Although the name suggests that the cameras were made to be carried in the rather large pockets of that era, Monroe offered a leather carry case with buckle straps located for hanging from a bicycle cross bar. The cases were large enough to hold a sufficient number of plates for an entire afternoon's outing.

Monroe's Pocket line was discontinued when the company merged with four other Rochester camera makers to form the Rochester Optical Company in 1899. Four years later, the new firm would become part of Eastman Kodak Company.

Vest Pocket Monroe *1898*

Monroe Camera Company, Rochester, New York. 1974:0037:1553.

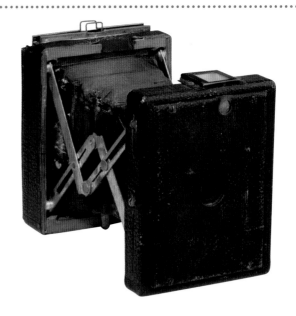

Introduced in 1897 by Monroe Camera Company of Rochester, New York, the Vest Pocket Monroe predated the Gaumont Block-Notes, making it one of, if not the first, tongs-style "vest pocket" type of miniature-plate camera. From a collapsed size of less than 1½ inches, including the double plate holder, the camera extended to 4¼ inches on brass lazy-tong struts. The first versions' struts were nickel plated; shown here is the 1898 version, which has brass struts. The Vest Pocket Monroe sold at a retail price of $5 and produced 2 x 2½-inch images.

Monroe Camera Company, along with the Premo, Poco, Rochester, and Ray Camera companies, was absorbed into the Rochester Optical Company in 1899, which was acquired by Eastman Kodak Company in 1903.

No. 3 Folding Pocket Kodak De Luxe *ca. 1901*

Eastman Kodak Company, Rochester, New York. 1974:0037:1347.

The No. 3 Folding Pocket Kodak De Luxe was a specially trimmed version of the standard No. 3, manufactured by Eastman Kodak Company, Rochester, New York, in 1901. A vertical-style folding bed camera, the No. 3 produced 3¼ x 4¼-inch images on No. 118 roll film. The most popular of the Folding Pocket Kodak line, around 300,000 units were manufactured by 1915, when it was replaced with the Autographic models.

The De Luxe version was trimmed in brown Persian morocco covering, including the lens board, and featured a gold silk bellows. It had a Kodak name plate of solid silver and came in a hand-sewn carrying case with silver trim. Only seven hundred De Luxe models were produced. The retail price was $75, compared to $17.50 for the standard model. This camera is an unnumbered factory model that was never offered for sale.

Block-Notes *ca. 1902*

L. Gaumont & Cie, Paris, France.
Gift of Homer Phimister. 1974:0037:0034.

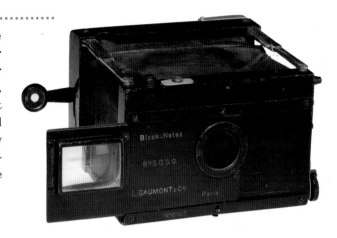

Introduced in 1902 by L. Gaumont & Cie of Paris, the Block-Notes was among the earliest of the popular precision-made vest pocket cameras, which folded flat for ease of carrying and produced reasonably sized images, typically around 4.5 x 6 cm. On this camera, the flat front lens holder and rear plate holder, both black-enameled sheet metal, were connected by a bellows and held open by folding struts. Sliding the combination front viewing element and lens cover also cocked the shutter. The list price was 220 francs.

Challenge Dayspool No. 1 Tropical *ca. 1903*

J. Lizars, Glasgow, Scotland. 1974:0084:0090.

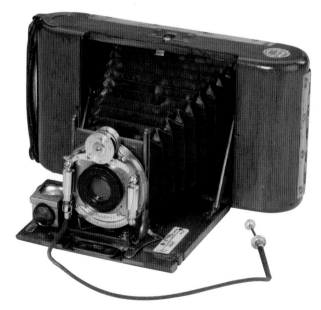

The cameras from J. Lizars of Glasgow, Scotland, saw duty in every corner of the British Empire. To ensure dependability in the hot dampness of India or Africa, Lizars used Indian teakwood for cameras like this 1903 Challenge Dayspool No. 1 Tropical. As the name suggests, it could be loaded in daylight with spooled 3¼-inch-wide film. The removable back could be replaced by a holder for sheet film or dry plates. A Beck Symmetrical lens with Bausch & Lomb Unicum shutter was provided on the basic version. The lens mount had rising and shift movements for perspective adjustment. A Dayspool No. 1 Tropical cost ten shillings more than the standard leather-covered model price of 3 12s. 6d. The camera was offered with a variety of British and German lenses at extra cost.

No. 3A Folding Pocket Kodak, Model A *ca. 1903*

Eastman Kodak Company, Rochester, New York. 1974:0037:2577.

The No. 3A Folding Pocket Kodak, Model A, introduced in 1903, was manufactured by Eastman Kodak Company, Rochester, New York. It was a folding bellows camera of leather-covered wood and metal construction. Though Folding Pocket Kodak cameras had been manufactured since the late 1890s, the significance of this model was the introduction of the new "postcard" format, which produced 3¼ x 5½-inch images on No. 122 roll film. The prints could be made on postcard stock, with the reverse side printed for address (a message area was added in 1907), and mailed as postcards. The original price was $20.

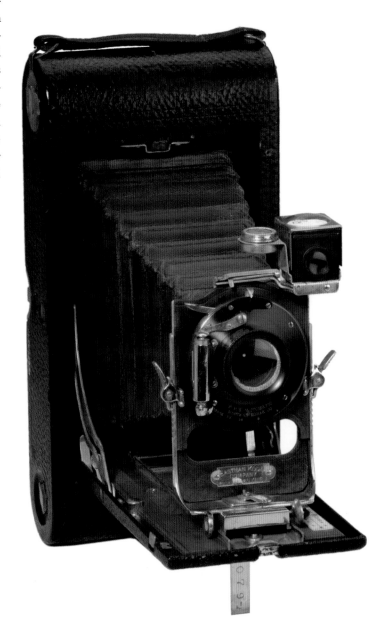

No. 4 Screen Focus Kodak, Model A *1904*

Eastman Kodak Company, Rochester, New York.
Gift of Paul Lange. 1974:0037:1235.

The 1904 No. 4 Screen Focus Kodak permitted focusing on a ground glass without removing the roll of film from the camera. Thus, accurate focusing could be done for each exposure as with a plate camera. To do so, the roll holder, protected with a dark slide, was rotated away ninety degrees from the focal plane. An extension bed allowed focusing on subjects as close as twenty-two inches.

With daylight-loading film, the camera could make twelve exposures of 4 x 5 inches. By removing the roll holder, it could operate as a plate camera. In total, about four thousand cameras were manufactured and sold over a six-year period. The Screen Focus Kodak initially sold for $30 and was available with a wide variety of lenses and shutters.

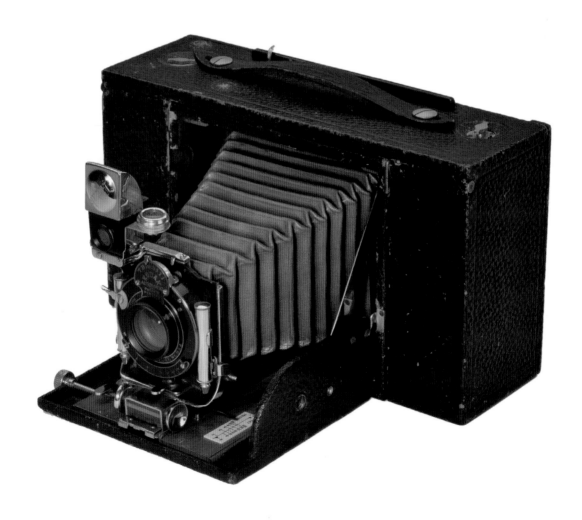

Nattia *ca. 1905*

Adams & Company Ltd., London, England.
Gift of Graflex, Inc. 1974:0037:2313.

Making photography easy and convenient for amateurs kept many camera designers busy after George Eastman's extraordinary success with the Kodak. The goal for companies such as Adams was to offer a sturdy, capable camera that could be carried in a coat pocket or purse. In 1905, the engineers at Adams's London works created what they called "The Best" pocket camera available. The versatile Nattia could use dry plates, cut film, or roll film, simply by changing from one holder to another. Focusing was easy with the rack and pinion with distance scale, and a bright finder made for fast framing of subjects. The shutter behind the Ross 9-inch f/6.3 Zeiss Patent Protar lens was set with a push-pull rod and tripped with a button at the exact location of the user's index finger. Being an Adams camera, the Nattia had the features of larger cameras, such as a rising front and two bubble levels (for vertical and horizontal images). Best of all, the nineteen-ounce Nattia folded into a tight, tidy package that could be toted along and be ready for action in seconds. It was priced under £17.

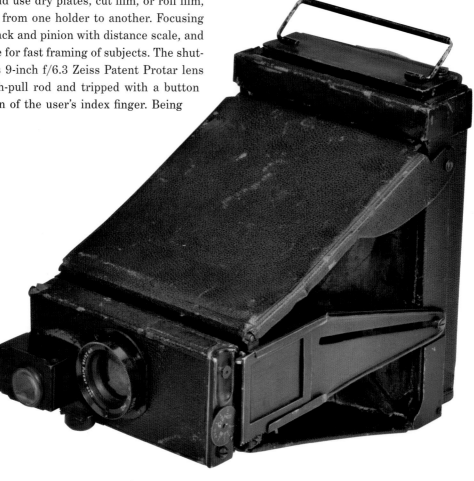

Seneca Model H *ca. 1905*

Seneca Camera Company, Rochester, New York.
Gift of Donald Weber. 2006:0341:0001.

Upon first inspection, the Seneca Model H looks like a typical early 1900s folding roll-film camera, featuring a polished mahogany bed and maroon leather bellows. A closer look reveals a rather unusual hinged door located in the back, which, when opened, uncovers a sheet of clear glass. This is a focusing back used in conjunction with Ansco Vidil roll film, a special film that mounted a semi-transparent parchment paper focusing screen before each piece of sensitized film. This somewhat odd arrangement provided an accurate method for composing and focusing, similar to the ground glass system used by view cameras, while supplying the convenience of roll film. At that time, the majority of roll film cameras used highly inaccurate reflecting finders and distance scale focusing.

From today's perspective, the Vidil film system is a fairly complicated way to compose and focus a camera. However, due to the rather slow film speed of the time roughly ASA 5, compared to a modern average of about ASA 400, proper exposures required a large lens opening and slow shutter speed, resulting in very little depth of focus. An accurate focusing system is a solution to this problem. Vidil was listed in the Ansco catalogs for only about five years. Its high selling price, about twice that of other roll films, may have been its downfall.

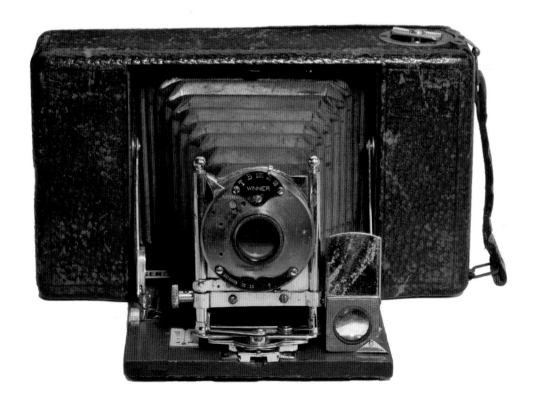

No. 4A Folding Kodak *ca. 1906*

Eastman Kodak Company, Rochester, New York. 1974:0028:3341

Introduced in 1906, the No. 4A Folding Kodak was the largest of the conventional roll-film cameras. Derived from the No. 3A Folding Pocket Kodak, the camera's picture size was increased to 4¼ x 6½ inches. Normally fitted with a Double Combination Rapid Rectilinear lens and No. 2 Bausch & Lomb Automatic shutter, the 4A offered many other lens and shutter options, especially in the United Kingdom. With its folding design and aluminum framework, the camera was portable enough to use while traveling. A glass plate adapter and film holders were available separately. The basic model sold for $35, but more advanced optics could push the price over $100.

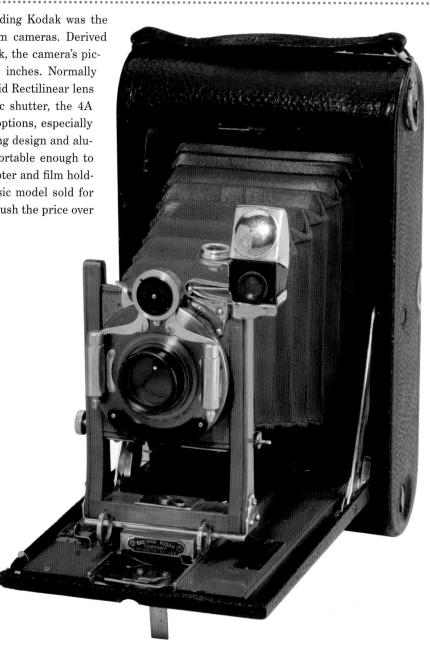

Atom Model A _ca. 1909_

Ica AG, Dresden, Germany.
Gift of Ralph Alexander. 1978:0143:0001.

Atom Model B _ca. 1909_

Ica AG, Dresden, Germany.
Gift of Dr. Carl Yackel. 1991:2221:0001.

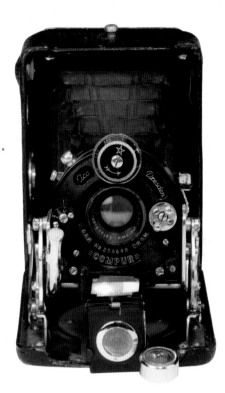

In the early years of the twentieth century, improvements in plates and films allowed designers to create smaller cameras. Buyers liked their portability, as many were tiny enough to fit in a shirt pocket. In 1909, Ica AG of Dresden, Germany, showed its new Atom cameras, which folded to a size smaller than a sardine tin, but could reward the photographer with photos worthy of larger, more expensive cameras. Ica boasted that the negatives were sharp enough to make 14 x 17-inch prints.

The Atom was made in two versions. The Model A (right) made 1¾ x 2-inch images on dry plates or film packs, in the portrait (vertical) orientation, while the Model B (below) made negatives of the same size, but in the landscape (horizontal) format. The Atom Model A ranged in price

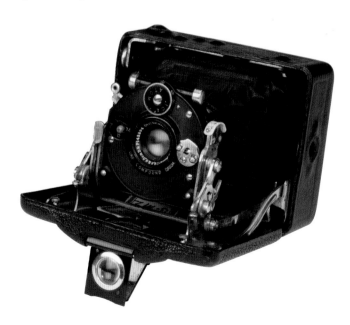

from $23 to $62, depending on the lens-shutter combination. The base model came equipped with a Helios Double Aplanat f/8 lens and automatic shutter, while the high-end choice was delivered with a Carl Zeiss Tessar f/6.3 lens and Compur shutter. The Model B was available with either a Hekla Anastigmat f/6.8 lens for $48 or a fast Carl Zeiss Tessar f/4.5 for $89.50, both with Compur shutter.

Both models had large folding mirror finders, with the one on the Model B hanging under the lens bed when erected for use. The photographer could also focus through the lens using the ground glass and moving the focus lever on the strut assembly. Both versions could be tripod mounted and had provision for a cable release. The Atoms were popular with the public, and they were made until 1925, when roll-film miniature cameras were introduced.

Vest Pocket Kodak *1912*

Eastman Kodak Company, Rochester, New York.
Gift of 3M Foundation, ex-collection Louis Walton Sipley. 1977:0415:0098.

"So flat and smooth and small as to go readily into a vest pocket" was the claim in Kodak's 1912 catalog that introduced the new Vest Pocket Kodak. When closed, this camera was one inch thick, but in use its lens and shutter pulled out on struts known as "lazy tongs." It made exposures of 1 x 2½ inches and enlargements could be made to postcard size for fifteen cents. The meniscus achromatic lens was pre-focused, and the ball bearing shutter offered settings for Time, Bulb, 1/25, and 1/50 second. The beginning of a long-lived series, it was originally offered for a price of $6.

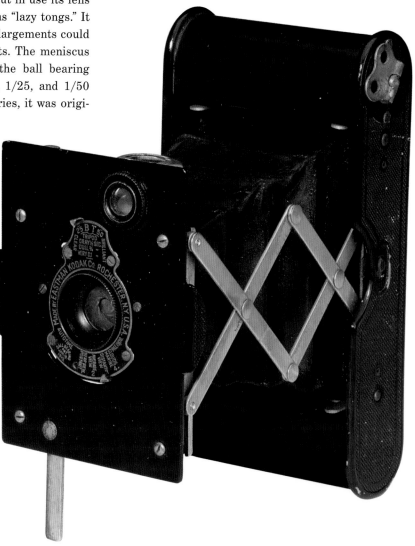

No. 1-A Folding Pixie *ca. 1913*

Gundlach-Manhattan Optical Company, Rochester, New York.
Gift of Arthur Rathjen. 1974:0037:1538.

Like any successful consumer product line, Kodak's Brownie line, launched in 1900, inspired imitators hoping to cash in on its popularity. Other photographic companies, such as Ansco, with its Buster Brown cameras, and Gundlach-Manhattan, followed Eastman Kodak's lead in using a whimsical character from children's literature as a marketing tool. The idea was to attract children to photography, which the companies' simple box cameras certainly did, though the lines grew to include more sophisticated equipment.

For its camera mascot, the Gundlach-Manhattan Optical Company of Rochester, New York, chose the Pixie, which, like the Brownie, was borrowed from Celtic folklore. The 1-A Folding Pixie had a square-cornered body covered with simulated black leather. Its rear panel could be opened by sliding it upward for loading or removing the roll of 116 film, each good for six 2½ x 4¼-inch exposures. List prices were either $8, with a meniscus achromatic lens, or $10, with a Rapid Rectilinear lens. Wollensak, another Rochester company, supplied the single-speed shutters.

Best known for its line of Korona professional cameras, Gundlach-Manhattan introduced the Pixie in an attempt to enter the low-price market dominated by Eastman Kodak. However, already on a downhill course, the company was later sold several times, and limped along under various names until 1972.

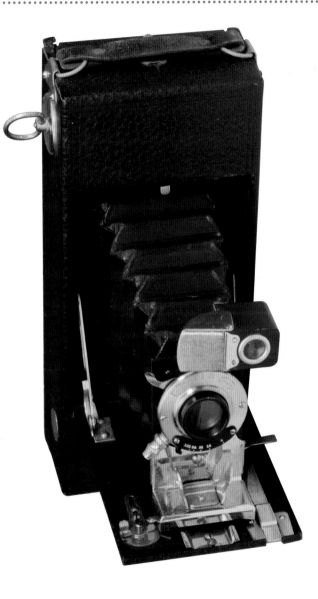

Miniatur-Klapp Focal Camera *ca. 1913*

Heinrich Ernemann AG, Dresden, Germany.
Gift of Eastman Kodak Company. 2001:1837:0003.

The term "miniature camera" has been loosely applied to pieces of equipment ranging in size from those tiny ones that would get lost in your pocket to studio units nearly the size of a breadbox. Even under the broadest definition, the Ernemann Miniatur-Klapp, manufactured in Dresden, Germany, has a secure place on any roster of quality miniature cameras. The Klapp (collapsible) line was extremely popular and made in several sizes, with the Miniatur-Klapp being the smallest. When folded, it was roughly the size of a fresh bar of soap. Its features rivaled those of the firm's large cameras, sporting a 75mm f/4.5 Ernotar Anastigmat lens in the basic $100 model, with a faster f/3.5 Carl Zeiss glass optional for an additional $40.

Opening a Miniatur-Klapp for use was a snap. The cover door opened downward and a light pull on the lens board extended the leather bellows until all four struts locked. There was no need of a supporting bed. Stiff metal struts ensured the lens would be held rigidly in place, parallel to the film plane.

All Klapps had cloth-curtain, focal-plane shutters with a 1/1000-second top speed that made good use of the fast optics. The top-mounted precision finder (known as a Newton finder), which folded when not in use, could be aimed quickly by centering the crosshairs in the target notch above the lens. Precise focus was just as easy. Using the ground glass with the shutter locked open, the photographer simply moved the lever on the lens board until the image was clear and sharp. After resetting the shutter, the ground glass was removed and replaced with a plate or film-pack holder, and the exposure made. Ernemann advertised its instruments as "the last word in scientific camera construction," and their many customers agreed.

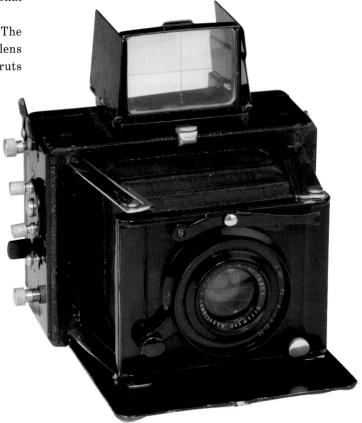

Alba 63 *ca. 1914*

Albini Company, Milan, Italy.
Gift of Philip Condax. 1977:0737:0008.

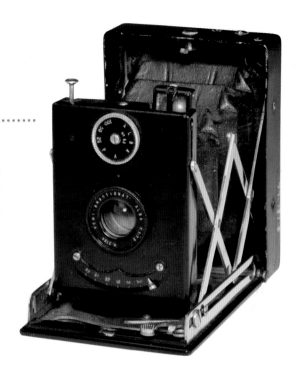

A nother vest pocket camera, the Alba 63 was introduced in 1914 and made by Albini Company of Milan, Italy. This attractive, all-metal, black-enameled body with plated struts had a folding bed, a Newton finder, and a ground glass viewing screen. It produced a 4.5 x 6-cm image on dry plates.

Korok Hand Camera *1914*

Konishi Honten, Tokyo, Japan.
Gift of Eastman Kodak Company. 1991:2846:0001.

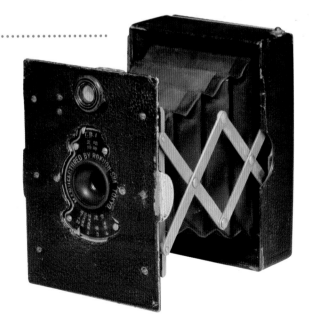

T he oldest Japanese camera in the Eastman House collection is the Korok Hand Camera, introduced in 1914 and made by Rokuoh-sha, the manufacturing branch of Konishi Honten of Tokyo. A vest pocket-style camera, it bears a resemblance to the Contessa Duchessa, a German plate camera. Korok is an abridgement of Konishi Rokuemon, a name by which the founder of Konishi Honten was known. Established in 1873, the company went through a number of name changes over the years, with Konica likely the best known outside of Japan. Now known as Konica Minolta, the firm transferred some digital camera assets to Sony Corporation in 2006 and withdrew from the camera and photo imaging business.

Kodak folding strut camera *ca. 1915*

Eastman Kodak Company, Rochester, New York.
Gift of Eastman Kodak Company 1993:1392:0004.

No one actually knows how many experimental and prototype cameras have been made since Alphonse Giroux's 1839 pioneering picture-makers, especially since many never entered production and were either scrapped or tucked away, never to be seen again. Eastman Kodak's goal of making a camera to suit every sort of user meant that the company worked full time to design, build, and test every conceivable size, shape, and style of instrument, hoping to make something that would catch every buyer's eye.

As negative sizes shrank with improvements in film resolution, so did the size of many cameras. In late 1909, the British firm of Houghtons Ltd. introduced its Ensignette, which was a true pocket camera: collapsed, it was barely the size of a gentleman's carte-de-visite case and less than an inch thick. The Ensignette had no folding bed, but instead supported the lens assembly on four locking struts that held everything securely in place.

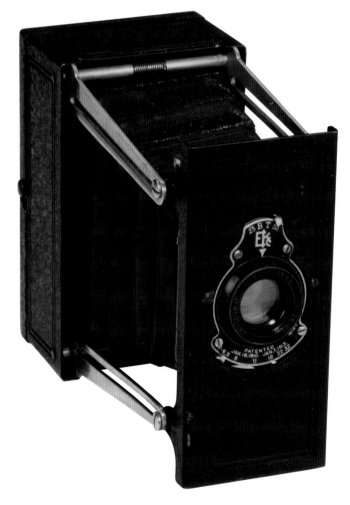

When Houghtons couldn't make enough Ensignettes to meet demand, Kodak saw an opportunity to make an American camera in the same style. In 1915, the company put its designers to work, and the model shop built this tiny metal box-and-bellows sample for evaluation. The body and rear panel were steel, the struts and lens board made of sheet brass. The lens and shutter were stock items, borrowed from the Vest Pocket Kodak. Although the Ensignette was a roll-film camera, Kodak's design study used sheet films of 1½ x 2½ inches at a time when the roll films were becoming the dominant medium. Perhaps that's why the project never reached the production stage. Or it may have been because Kodak's own Vest Pocket cameras were selling well, and the company had no desire to become its own competitor.

Vest Pocket Kodak Autographic Special <small>(OWNED BY ANSEL ADAMS)</small> *ca. 1915*

Eastman Kodak Company, Rochester, New York.
Gift of Ansel Adams. 1974:0037:1248.

George Eastman purchased the Autographic patent from Henry J. Gaisman, founder of the Autostrop Company that manufactured safety razors, for $300,000 in 1914. The autographic feature allowed the photographer to make a note on the film backing with a metal stylus through a hinged door on the back of the camera. By briefly exposing the open door to the sky, the notation printed through to the film. This feature, introduced by Eastman Kodak Company in 1915, added eleven years and about 1.75 million units to the production of the popular Vest Pocket Kodak.

The Vest Pocket Autographic Kodak Special was the same collapsing roll-film camera as the original, but with better lenses, pin grain leather covering, and nickel-plated fittings. It used No. A-127 film, the "A" designating the additional autographic layer. The retail price in 1916 was $11.50.

The camera shown here was used by the young Ansel Adams (1902-1984) on his second visit to Yosemite National Park in 1917. Having photographed Yosemite the previous year with his No. 1 Brownie, Adams now used this new camera, which had a better lens, the f/7.7 Kodak Anastigmat. At the young age of fifteen, he was already concerned about the quality of his photography, though he wouldn't make it his profession until about 1930.

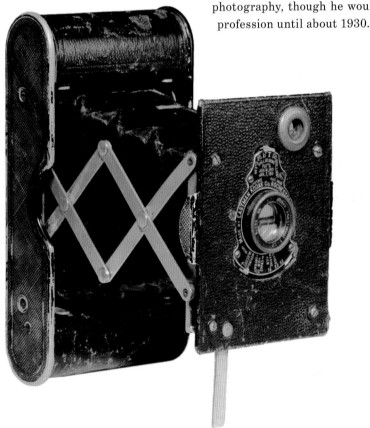

No. 3A Autographic Kodak Special, Model B with Rangefinder *ca. 1916*

Eastman Kodak Company, Rochester, New York.
Gift of Thomas E. Hunt. 1987:0380:0001.

The No. 3A Autographic Kodak Special, Model B, was introduced in 1916 by Eastman Kodak Company of Rochester, New York, as a running change of the No. 3A Folding Pocket Kodak. The 3A Autographic Special was the first camera to offer a coupled rangefinder. Not a small camera, it produced images in the popular 3¼ x 5½-inch postcard size on No. A-122 roll film. Indeed, Kodak claimed, "We have been careful not to let the desire for mere compactness destroy the optical efficiency." With a rising front, rack-and-pinion focusing, f/6.3 Zeiss Kodak Anastigmat lens, a finish of genuine Persian morocco leather, and the coupled rangefinder, this was a quality instrument at a retail price of $66. It remained in production for twenty-one years.

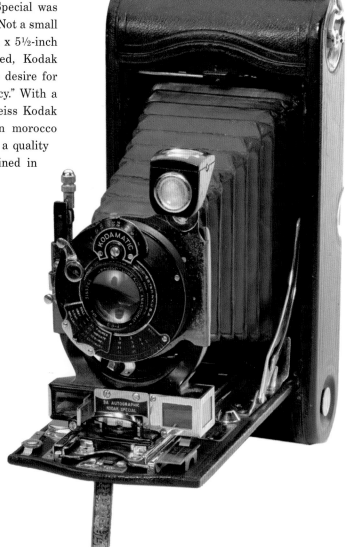

Piccolette *ca. 1919*

Contessa-Nettel AG, Stuttgart, Germany.
Gift of Mario A. Gennosa. 1974:0037:2251.

When the Piccolette was first introduced to America in 1919 as "a radical departure from the accepted pocket camera," it was clearly being contrasted with the Vest Pocket Kodak. While Contessa-Nettel AG of Stuttgart, Germany, used the same No. 127 roll film to produce 1⅝ x 2½-inch images in its aluminum-bodied folding camera, the Piccolette did offer some improvements over the Kodak. Most significant was the drop-out film holder, which made loading film easier. It also had an extension on the lower front lens board acting as a support when the camera was open, without having to swing a separate leg into place. The original Piccolette, however, did not have an optical viewfinder, using a wire frame finder instead, as seen in the camera shown here. By 1920 an optical finder was incorporated.

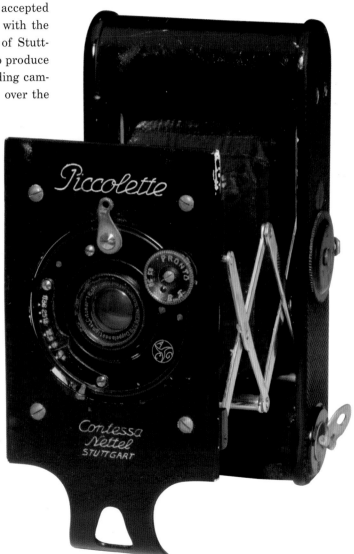

Tropen Klapp Camera *ca. 1920*

Ernemann-Werke, Dresden, Germany.
Gift of Mrs. R. C. Campbell. 1974:0037:2648.

A sportsman of the 1920s demanded only the best equipment in his pursuit of excitement, whether sailing, playing polo, or big game hunting. Ernemann-Werke in Dresden, Germany, catered to the well-heeled adventurer with their line of Ernemann Sportsman focal-plane cameras. With these sturdy, compact, precision Klapp (collapsible) designs, action on the field of play could be captured with the fast lenses and shutters Ernemann provided. For harsh environments, the Tropen Klapp 6.5 x 9-cm version used teakwood and lacquered brass construction. The helical-mount Ernon 12cm f/3.5 lens could be quickly focused, using the ground glass or the distance scale and folding Newton finder. Selecting one of the twenty-four shutter speeds and setting the diaphragm behind the lens helped deliver precise exposures. The sportsman considered the $150 spent on a Tropen Klapp a fair price for "The World's Finest Camera."

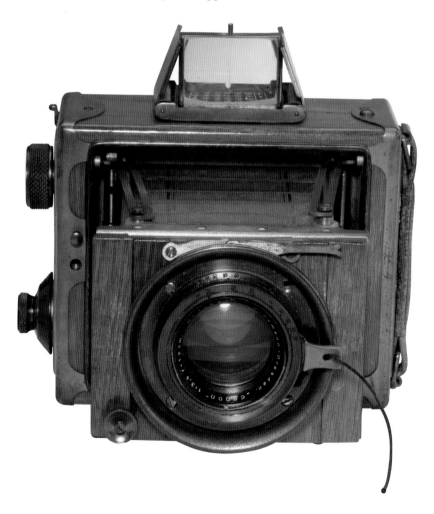

Makina *ca. 1920*

Plaubel & Company, Frankfurt, Germany.
Gift of Eastman Kodak Company. 1974:0037:2901.

Advances in photographic technology were used to great advantage by Plaubel of Frankfurt, Germany, in the design of their 6.5 x 9-cm Makina series of cameras. Improved films that permitted sharp images from smaller formats made convenient "vest pocket" cameras possible, and the Makina was one of the first to enter the market in 1912. It was a folding-type camera using the "lazy tongs"-style struts that locked rigidly in place when the bellows was extended. The strut-locking plates in the lens panel moved by turning the focus knob, and as the strut angle changed, so did the lens-to-film distance. A scale and pointer indicated the range. The photographer had a choice of viewfinders: a folding optical unit or the wire sports frame for scenes with action, or the rear ground glass for still subjects. Plaubel made their own lenses, this one a fast Anticomar 10cm f/2.9 with a dial-set Compur shutter that had a 1/200 second maximum speed. The German-made Makina was improved and refined over the years and remained in production until about 1960. This model from around 1920 cost $95.

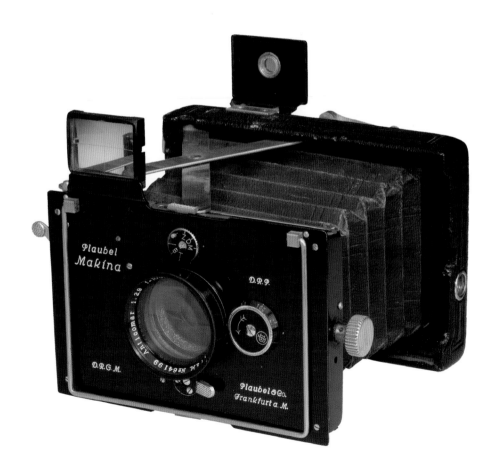

1A Automatic *ca. 1924*

Ansco, Binghamton, New York.
Gift of GAF Corporation. 1985:1250:00

Almost from the beginning of the photographic industry, a constant push to simplify the process of taking pictures kept engineers busy. In 1924, Ansco of Binghamton, New York, introduced motorized film advance in a folding camera with the 1A Automatic. The key-wound spring motor brought the next frame rapidly into position when the shutter release was pressed, allowing the six 2½ x 4¼-inch exposures on special rolls of Ansco Speedex 6A film to be made in rapid-fire succession. A fingertip button on the lens bed handled focusing of the Ansco Anastigmat f/6.3 lens. F-stops down to f/32 and shutter speeds to 1/100 second were set with conventional rim controls. The 1A Automatic was priced at $75, much more than similar Anscos without automatic winding.

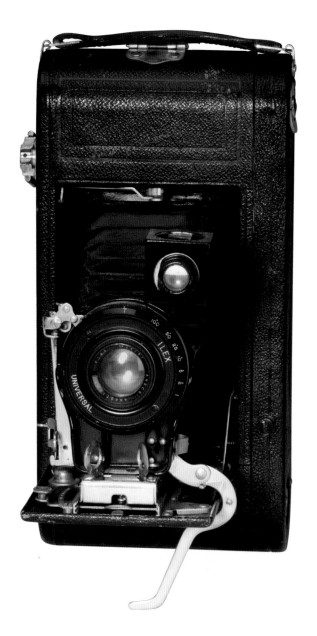

Vest Pocket Kodak Series III *ca. 1926*

Eastman Kodak Company, Rochester, New York.
Gift of Eastman Kodak Company. 1999:0197:0132 (snakeskin);
1999:0197:0129 (alligator); 1999:0197:0130 (green hand-tooled leather).

U nusual versions of Kodak's colorful Vest Pocket cameras exist in several forms. For example, custom-made faceplates are known with fraternal organization insignias. Color variations were sometimes nothing more than production changes. These three special variations may have been prototypes for management review, presentation models made in very limited numbers, or after-market conversions. The snakeskin-covered Vest Pocket Kodak Special (left) has matching brown hardware and name plates. The alligator-skin VPK Series III (middle) is also matched in brown albeit a different shade. The green VPK Series III (right) is covered in elaborately embossed leather with hand-painted accents in green, blue, and red. The 1930 Vest Pocket Kodak Series III in the colors of blue (Bluebird), green (Cockatoo), brown (Jenny Wren), red (Redbreast), and gray (Seagull) were priced from $12 to $18 depending on the lens and shutter combination. The VPK Special was $23.

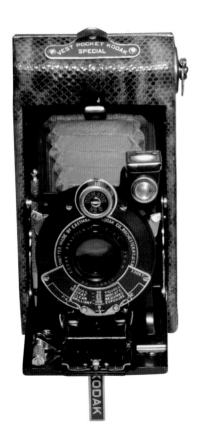
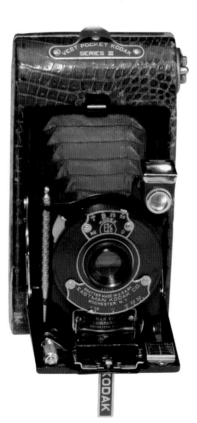
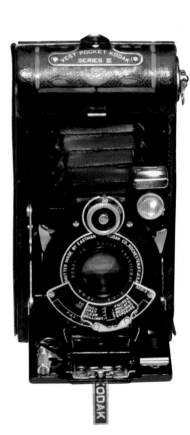

Watch Pocket Carbine No. 12 Tropical *ca. 1926*

Houghton-Butcher Manufacturing Company, Ltd., London, England.
Gift of Eastman Kodak Company. 1990:0128:0002.

Many European camera manufacturers offered "tropical models" of their standard designs, aimed at "climbers, travellers, explorers, big-game-hunters, pioneers of all kinds," as the Houghton-Butcher catalog of 1927 described the Watch Pocket Carbine No. 12 Tropical. The main difference between standard and tropical designations lay in the materials used in its construction. It was assumed that tropical cameras would be subjected to rough use in hot, humid lands, and therefore they were made of wood, metal, and leather that could withstand such conditions. The Tropical No. 12 had a body made of teak, because of the wood's resistance to moisture and insects. The metal parts were brass with what was termed a "Florentine bronze" finish, and the Russia leather bellows was treated against insect damage. Even the protective case was special, being made of soft chamois leather.

One of Houghton-Butcher's line of Watch Pocket cameras, the No. 12 Tropical makes one wonder what sort of timepieces English gentlemen of the day carried, as the camera measured 8 x 3½ inches.

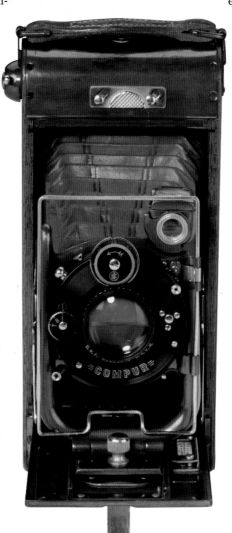

Most of the specifications for its non-tropical sibling are repeated in the tropical model. The No. 12 took six 2½ x 4¼-inch negatives on each roll of 116 film through either of two finders. A common waist-level reflex finder above the lens rotated for use in either horizontal or vertical formats. The front part of the wire sports finder could swing into place when needed, and the rear sight was in a sliding mount on the rear cover. The choice of lens-shutter combinations ranged from the Aldis Uno Anastigmat 4.7-inch f/7.7 with a six-speed shutter on the cheapest model, priced at £6 17s., to the Zeiss Tessar f/4.5 with Compur shutter, for £13 7s. To focus, the bellows could be extended to lock into one of four notches on the distance scale, from five feet to infinity.

Just as SUVs are purchased by people who never intend to go off-road, tropical cameras were purchased by photographers who never ventured into the steamy jungles. The teak and brass lent the tropicals an air of precision, style, and prestige, with the added advantage of ruggedness that allowed them to outlast their more common counterparts.

Tropen-Favorit _ca. 1927_

Zeiss Ikon AG, Dresden, Germany.
Gift of Birdsall Nichols. 1981:2772:0001.

Zeiss Ikon AG of Dresden, Germany, produced cameras for what they called "all the world," meaning they were designed to withstand extreme climates. This special 9 x 12-cm plate and film pack folding camera was built with a teakwood body to withstand the punishing humidity and heat of the tropics. The leather parts were specially treated to repel insects, and nickel plating helped keep the metal looking new. Made in the early 1930s, it is similar to Zeiss Ikon's Tropen-Adoro. A Carl Zeiss Jena Tessar 15cm f/4.5 lens worked through a Compur shutter with a top speed of 1/200 second. Its front rise and shift adjustments for perspective control, reflex viewer with bubble level, and wire frame sports finder were useful for composing pictures. The Tropen-Favorit could be focused like a typical view camera, viewing the image on ground glass, or like a typical folding camera, by estimating the distance on the focusing scale on the base. Both adjustments were controlled with the camera's rack-and-pinion movement.

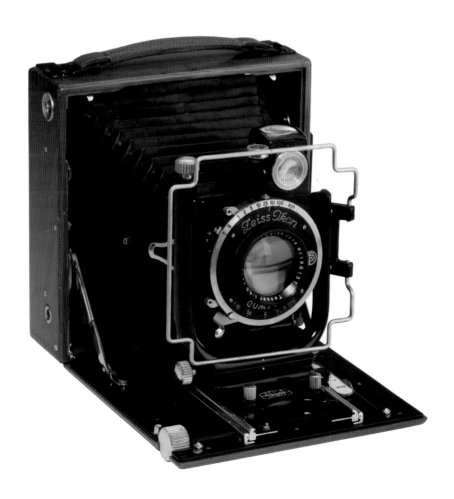

Luxus-Cocarette I *ca. 1928*

Zeiss Ikon AG, Dresden, Germany.
Gift of Eastman Kodak Company. 1999:0168:0002.

In 1926, five German companies merged to form Zeiss Ikon AG: Carl Zeiss (Jena), Contessa-Nettel, Ernemann, Goerz, and Ica. After the merger, Zeiss continued making many of the component companies' products under the Zeiss Ikon name, and the Contessa-Nettel Luxus-Cocarette I was one. Luxus (Latin for "extravagance") cameras were usually standard products dressed in exotic materials and aimed at well-to-do photographers who didn't want to be seen using the same equipment as working folks. This Luxus-Cocarette I made by Zeiss Ikon of Dresden, Germany, was functionally identical to the standard Cocarettes, but had a rich-looking, brown leather covering with matching bellows, and metal parts polished to a higher luster than usual. This added panache to an instrument that was already well above average, though the price premium was considerable in 1928 dollars. The standard 6 x 9 Cocarette with the 105mm f/4.5 Tessar lens and Compur shutter was about $40, while the fancy-trimmed Luxus set a buyer back $71. Both laborer and tycoon got the same lens-shutter combination, waist-level and sports finders, fingertip lever focusing, and bubble level.

These cameras were available in four sizes, from this 6 x 9-cm model to 8 x 14 cm. Loading the Cocarette was somewhat easier than loading other folding cameras of the period. Rather than having a hinged or removable back, the side panel opened like a drawer, bringing the spools with it. Once loaded, the exposure

numbers were visible through the ruby window, which had a sliding metal cover for extra protection. Luxus versions of cameras are not common in today's catalogs. To grab market share in the digital age, a camera needs more than good looks to stand out from the competition.

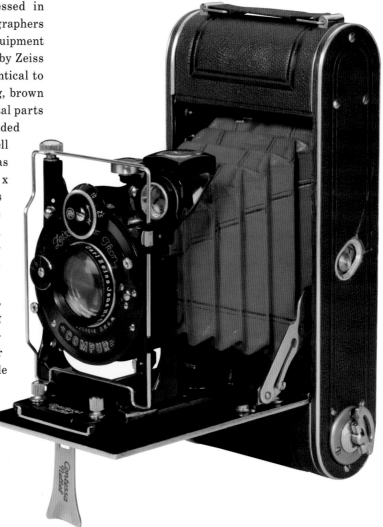

Kodak Ensemble *ca. 1929*

Eastman Kodak Company, Rochester, New York.
Gift of Eastman Kodak Company. 1975:0015:0015.

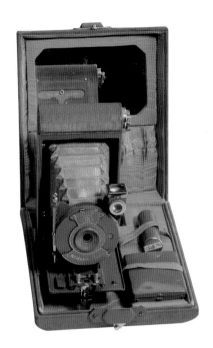

The Kodak Ensemble, introduced in 1929, was a Kodak Petite camera packaged in an attractive suede fabric-covered strap-style hard case, with a mirror, matching lipstick, powder compact with rouge, and change pocket. It was marketed for the holidays as the "gift for the searcher who is looking for something a little different, something novel, but thoroughly practical." The Petite used No. 127 roll film to produce 1⅝ x 2½-inch images. Obviously aimed at women, it came in three colors—beige, green, and rose—and retailed at $15 for the outfit. The cosmetics were supplied by The House of Tre Jur.

Gift Kodak *1930*

Eastman Kodak Company, Rochester, New York.
Gift of Eastman Kodak Company. 1993:1392:0001.

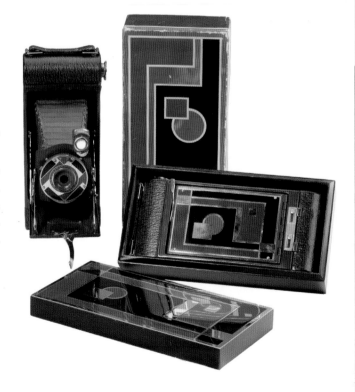

The Gift Kodak, introduced in 1930, like the Ensemble and the Coquette, was aimed at the holiday gift-giving season. Unlike the other two, the Gift Kodak had a distinctly masculine appeal. A special version of the 1A Pocket Kodak with a bed and shutter plate design in brown and red enamel and polished nickel, it produced 2½ x 4¼-inch images from No. 116 roll film. The camera was covered in brown leatherette, and the gift box was an ebony-finished cedar box with an inlaid cover matching the camera face. The retail price was $15.

Kodak Coquette *ca. 1930*

Eastman Kodak Company, Rochester, New York.
Gift of Eastman Kodak Company. 1974:0028:3452.

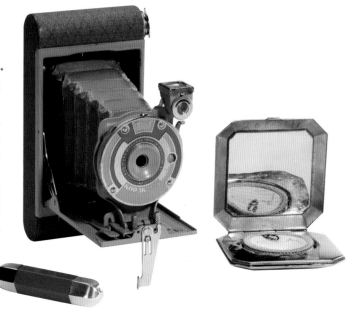

The Kodak Coquette, introduced in 1930, included a Kodak Petite camera, like the Ensemble of the previous year. This time, the color selection was strictly blue. The exterior was a striking face with a geometric art deco pattern in two tones of blue enamel and nickel designed by Walter Dorwin Teague. Inside, the camera used No. 127 roll film to produce 1⅝ x 2½-inch images. Packaged with a matching lipstick and compact, the Coquette aimed at high style and was marketed as being for "the smart, modern girl...a bit of Paris at your Kodak dealer's." The Teague-designed gift box was a striking silver and black with a geometric pattern. Including cosmetics by Coty, the retail price was $12.50.

Camp Fire Girls Kodak *ca. 1931*

Eastman Kodak Company, Rochester, New York.
Gift of Eastman Kodak Company. 1975:0015:0011.

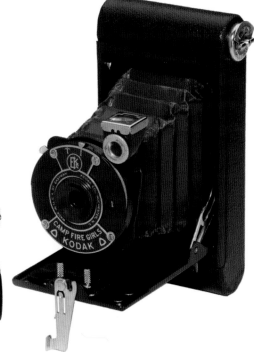

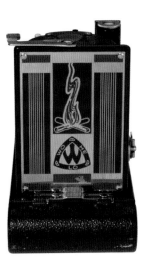

The Camp Fire Girls Kodak camera, introduced in 1931, was, like the Boy Scout and Girl Scout Kodaks of the prior year, a special version of the Vest Pocket Kodak Model B. Covered in brown leatherette and using No. 127 roll film, it featured an enameled plate with the Camp Fire Girls logo on the front door and "Camp Fire Girls" on the shutter plate. The retail price in 1931 was $6. It is the rarest of the three U.S. scouting cameras.

Peggy II _ca. 1931_

G. A. Krauss, Stuttgart, Germany.
Gift of Jack Pearce. 1974:0037:2973.

The Krauss brothers, operators of a camera store in Stuttgart since 1895, came to conclude that they could make better products than those they sold. Each brother started his own manufacturing business, Gustav remaining in Stuttgart, and Eugene relocating to Paris. In his first decade, Gustav made only plate and folding roll-film cameras, but, like many others, saw opportunity in the demand for miniature cameras and the ready availability of 35mm films. The success of the Leica drew many firms to the miniature market, each with its own vision of the ideal product. Gustav Krauss called his new 35mm camera the Peggy, and packed it with enough clever features to justify its $80 price tag. Soon after the Peggy went on sale, Krauss followed up with the Model II, which had a built-in coupled rangefinder and listed for $115 with a Zeiss Tessar f/3.5 lens. Other Zeiss and Schneider-Kreuznach lenses were optional and could raise the price to $175.

The Peggy was manufactured to exacting standards of quality, essential for any maker looking to steal customers from Leica. It came with a pair of reloadable film cassettes that resembled the soon-to-become-standard Kodak daylight cartridge, but with hinged doors and removable spools for loading the film in the darkroom. Once loaded, the cassettes could be inserted and removed in daylight, and held enough film for thirty-six exposures of the standard 24 x 36-mm format. Should the

photographer want to develop a partial roll, a built-in sliding knife blade would cut the film so the exposed frames could be removed for processing.

Focusing the Peggy's lens was easy with the rangefinder and the ridged knob on the top plate, which moved the lens to or fro. The button for the precise Compur shutter was in the ideal spot for fingertip actuation, and the advance knob also operated the exposure counter. Krauss used brass and aluminum for most of the Peggy's construction, which helped establish the little camera's reputation for performance and reliability. It remained in the company's line until 1934, when both Krauss brothers suspended camera manufacturing.

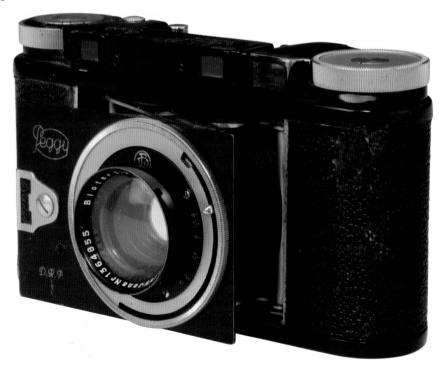

Prominent (6 x 9 CM) *1932*

Voigtländer & Sohn AG, Braunschweig, Germany.
Gift of T. Harasymchuk. 1974:0084:0124.

The 1930s was a time of great progress for the photographic industry. Innovations like coupled rangefinders, light meters, and faster films and lenses made photography easier and more predictable, especially for the beginner. In 1932, Voigtländer, of Braunschweig, Germany, and maker of precision optical instruments since 1756, managed to pack all of these features into one new camera: the Prominent. This strange-looking device was basically a folding roll-film camera for the Brownie No. 2 film, otherwise known as No. 120. With its various knobs, dials, and lumps, all of which served a purpose, the Prominent was hard to ignore, whether folded or opened. One knob advanced the film to shoot the next image. The standard was 6 x 9 cm, but inserting a mask and using the second of the two ruby windows on the back allowed for smaller, 6 x 4.5-cm frames, thus yielding twice the number of exposures.

The Prominent's Heliar f/4.5 lens and Compur shutter weren't unusual in this type of camera, but its coupled rangefinder was. A knob on the right side moved the lens while the shooter looked through the sight and brought the two images together, indicating correct distance. Mounted next to the optical viewfinder on the left side, an extinction light meter made short work of selecting the proper aperture and shutter speed settings. This sort of advanced technology didn't come cheap. With the lens and leather case, the Prominent was a $75 camera. There were certainly less expensive roll-film designs in the showcases, but once one added the cost of buying an accessory rangefinder (which wouldn't be coupled to the lens) and a light measuring meter, the Prominent's sticker didn't seem so steep.

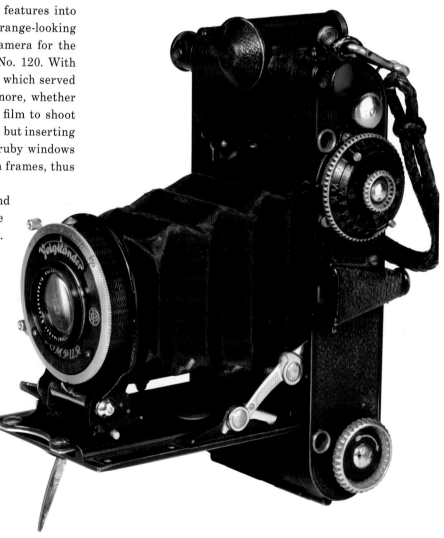

Univex AF *ca. 1935*

Universal Camera Corporation, New York, New York.
Gift of Eastman Kodak Company. 1991:1587:0005.

The Univex AF camera was manufactured in 1935 by Universal Camera Corporation of New York City, a company founded by two successful businessmen who reasoned that America needed a line of cameras affordable to all. The AF was an attractive, palm-sized, collapsible camera of cast metal construction with paper bellows, available in a variety of colors. An important sales point for a nation trying to come out of the Great Depression was the retail price of $1. It produced six 28 x 38-mm images on Univex No. 00 roll film that was manufactured in Belgium and priced at ten cents. Though quite successful, with twenty-two million rolls sold by 1938, the film's manufacture was suspended in 1940, after the German occupation of Belgium.

Super Ikonta B (530/16) *ca. 1937*

Zeiss Ikon AG, Dresden, Germany.
Gift of Homer W. Smith. 1982:2231:0001.

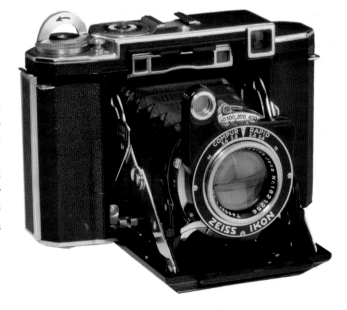

The Zeiss Super Ikonta B, manufactured by Zeiss Ikon AG, Dresden, was a medium-format camera that folded flat for convenience. It provided a 6-cm square image on No. 120 roll film. The 530/16 model was produced from 1937 through 1956 and featured a combined rangefinder and viewfinder window. With the Zeiss Tessar lens, the Super Ikonta B is considered by many to be the best folding roll-film camera ever made. The retail price in 1937 was $150.

Makina 67 *ca. 1979*

Plaubel Feinmechanik und Optik GmbH, Frankfurt, West Germany.
Gift of Plaubel USA. 1981:2329:0001.

Plaubel was a German camera maker that entered business as a distributor and maker of lenses at the turn of the twentieth century. Its Makina cameras, which were first manufactured around 1912, formed a respected line of medium-format equipment that was produced into the 1980s. These folding-strut cameras collapsed into a small, easily toted package, yet were fitted with large, fast, interchangeable lenses and a coupled rangefinder. In the mid-1970s, Plaubel became a Japanese-owned company, and its later models, such as this Makina 67, were made in Japan. Designed and manufactured by Konica, the 67 was a 6 x 7-cm format, reduced from the 6 x 9 cm size of the German-made cameras.

The original Makina concept was still the heart of this camera, but a number of changes were made in addition to the format. The 67, which retained the scissors-strut folding mechanism, sported an 80mm f/2.8 Nikon Nikkor lens, but unlike the older models, did not have interchangeable lenses. Its rangefinder was still coupled to the lens focus control, but adjustment was by a knob atop the camera, another difference of the Japanese design. Film was advanced by a rapid-wind lever near the focus control. The Copal leaf shutter had ten speeds plus Bulb and was tripped by pressing the button in the center of the focus knob. The top plate also accommodated the frame counter and shoe for the flash, which was synchronized at any shutter speed. Even with the lens retracted, the Makina 67 wasn't small, unless it was being compared to competing 6 x 7 cameras. Ruggedly built in the Makina tradition, it was a very capable instrument, but not one for beginners, even with a built-in light meter. When the shot was framed, the viewfinder indicated if the speed or aperture needed to be changed, a step that could be adjusted with the thumb knobs on the lens body. The Makina's $1,000 list price didn't discourage buyers, but when the Japanese firm of Mamiya, which manufactured the last of these cameras, went out of business, it brought the long, proud history of the Makina to an end. These cameras are still sought by medium-format fans a quarter-century after the last Makina left the factory.

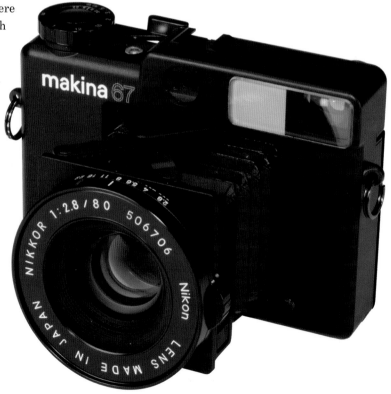

35MM

The genesis of 35mm photography can be traced to George Eastman's Kodak camera, the first to use nitrocellulose roll film. In July 1891, W. K. L. Dickson, an employee of Thomas Edison's New Jersey laboratory, visited Eastman's Rochester manufactory and ordered four fifty-foot lengths of 1-inch wide film, a size half the width and twice the length of that used in Eastman's No. 1 Kodak. Rectangular perforations were made on each edge of the film, four per 1¾-inch image frame, matching those used on Edison's Kinetograph, to evenly advance the film. These dimensions became the standard for 35mm film.

Simplex *1914*

Multi Speed Shutter Company, New York, New York. 1982:2412:0001.

● ●

The great popularity of the 35mm camera in pre-digital days began in the late nineteenth century when Thomas Edison's laboratory selected 35mm as the width of the film they would use for their motion picture system. Movie studios used large rolls of the perforated film stock and made available short leftover lengths. It wasn't long before still cameras were built around this film size, and the 1914 Simplex was one of the earliest. The Multi Speed Shutter Company of New York already built movie cameras, so they knew well the film they chose for the Simplex. Movie frames were set at 24 x 18 mm and, at first, the 35mm still cameras adopted this format. However, by removing a metal mask from the film plane, the Simplex's Bausch & Lomb Zeiss Tessar 50mm lens could cover two frames, producing a 24 x 36-mm negative. This "double-frame" size soon became the standard for 35mm cameras, leading to designs such as the Leica in the 1920s. Fifty feet of film could be loaded into a Simplex. That was enough for 400 double-frame exposures, or twice as many 24 x 18-mm images.

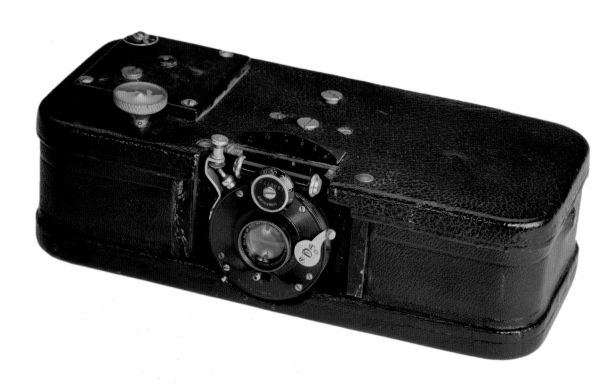

Tourist Multiple *1914*

New Ideas Manufacturing, New York, New York.
Gift of Mrs. John S. Ames. 1974:0084:0106.

In the early part of the twentieth century, Henry Herbert, co-founder of a New York photographic supply company, learned he could buy leftover motion picture film for a penny per foot. Herbert saw an opportunity in that, and in 1914 introduced one of the first still cameras designed to use 35mm film. The pound-cake-sized Tourist Multiple was a well-made, superbly engineered product designed to take professional-quality photos. Its recessed Bausch & Lomb–Zeiss Tessar 50mm f/3.5 lens could be focused as close as twenty-four inches from the subject. The lens board was movable for perspective corrections, and the pop-up Newton finder followed the lens. The all-metal focal-plane shutter was self-capping, with a maximum speed of 1/200 second. A half-turn of a nickel-plated lever reset the shutter and precisely advanced the film for the next shot.

The Tourist Multiple was billed as the "Camera of the Future," which was more than typical marketing hype. The design was revolutionary and truly ahead of its time. A single daylight-loading magazine held fifty feet of Eastman Kodak ciné film that provided 750 exposures of 18 x 24-mm images. For just $4, a traveler could document an entire vacation without giving any further thought to film. Back at home, the camera could be mounted to the New Ideas Lantern and projected on a ten-foot screen. The Tourist Multiple sold for $175, a considerable sum in 1914. With the projector included, the price was $250. Unfortunately, the World War put a severe damper on tourism, and sales of the camera were poor. It was discontinued after a production of only one thousand.

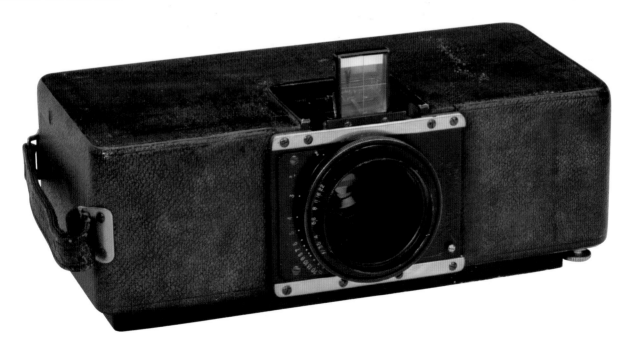

Sept *ca. 1922*

Etablissements André Debrie, Paris, France. 1974:0037:2071.

André Debrie of Paris, manufacturer of the Sept (French for the number seven), named their 1922 camera for the seven very different functions it was designed to perform. This multi-functioned $225 apparatus shot 35mm ciné film in eighteen-foot lengths and could take either motion pictures or still photographs. It also could project movies or be used as an enlarger to print negatives onto either photographic paper or positive film. A spring motor both drove the movie mechanism and could advance frames for the still camera, which could shoot individual frames, timed exposures, or a burst of shots in quick succession. Movie studios were a market for short lengths of 35mm film, and the demand for shorts fueled the development of the 35mm cameras that would eventually become the prevalent format around the globe.

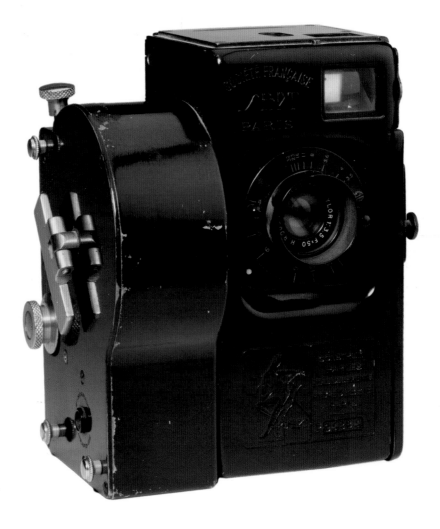

Furet *ca. 1923*

E. Guérin & Cie, Paris, France. 1974:0028:3245.

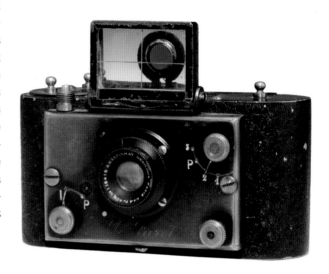

The availability of 35mm ciné film led to a revolution in still camera design. Format sizes varied by manufacturer, but E. Guérin & Cie of Paris designed the 1923 Furet to shoot a 24 x 36-mm frame. Used earlier on the Simplex of 1913 and then adopted by Leica, this size became the world standard for 35mm cameras. The Furet body was cast aluminum and most of the rest was brass. Its lens was a fixed-focus 40mm f/4.5 Hermagis with a variable aperture. A three-speed shutter, a folding Newton viewfinder, and a frame counter added to the usefulness of the black-crackle-finished camera. The shutter release button was located on the top right side. Barely three-and-one-half inches wide, the petite Furet was one of the smallest 35mm cameras ever built.

Sico *ca. 1923*

Wolfgang Simons & Company, Bern, Switzerland. 1974:0037:0052.

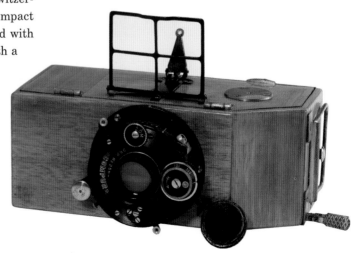

In 1920, Wolfgang Simons & Company of Bern, Switzerland, produced an early 35mm camera. The compact Sico had a five-inch-long body made mostly of wood with brass fixtures. The 35mm film was unperforated with a paper backing and rolled for twenty-five exposures of 32 x 40 mm. A ratchet mechanism advanced the film by raising the flat knurled pull next to the finder. The 6cm f/3.5 Sico Rüdersdorf lens was controlled by a Compur 1/300 second shutter and focused by a lever under the shutter housing. The Sico could be used as a projector by mounting it to the optional Projektionsapparat.

0-Series Leica *1923*

Ernst Leitz GmbH, Wetzlar, Germany. 1974:0084:0111.

tarting about 1905, when he worked at the firm of Carl Zeiss in Jena, Germany, Oskar Barnack (1879-1936), an asthmatic who hiked for his health, tried to create a small pocketable camera to take on his outings. At the time, cameras using the most common format of 13 x 18 cm (5 x 7 inches) were quite large and not well suited for hiking. Around 1913, Barnack, by then an employee in charge of the experimental department of the microscope maker Ernst Leitz Optical Works in Wetzlar, designed and hand-built several prototypes of a small precision camera that produced 24 x 36-mm images on leftover ends of 35mm motion picture film. Three of these prototypes survive. The most complete one has been dubbed the "Ur-Leica," meaning the very first or "Original Leica," and is in the museum of today's firm of Leica Camera AG in Solms, Germany.

Barnack used one of his cameras in 1914 to take reportage-type pictures of a local flood and of the mobilization for World War I. That same year, his boss, Ernst Leitz II, used one on a trip to the United States. However, no further development of the small camera took place until 1924, when Leitz decided to make a pilot run of twenty-five cameras, serial numbered 101 through 125. Still referred to as the Barnack camera, these prototypes were loaned to Leitz managers, distributors, and professional photographers for field testing. The evaluations were not enthusiastic, as the testers thought the format too small and the controls too fiddly, which they were. For instance, the shutter speeds were listed as the various distances between the curtains instead of the fraction of a second it would allow light to pass. In spite of its reviews, Leitz authorized the camera's production, basing his decision largely on a desire to keep his workers employed during the post-World War economic depression. An improved version of the 0-Series Leica, the Leica I, or Model A, with a non-interchangeable lens, was introduced to the market at the 1925 Spring Fair in Leipzig, Germany. The name "Leica," which derives from Leitz Camera, appeared only on the lens cap.

Shown here is an 0-Series Leica, serial number 109. It is one of three known examples with the original Newton viewfinder.

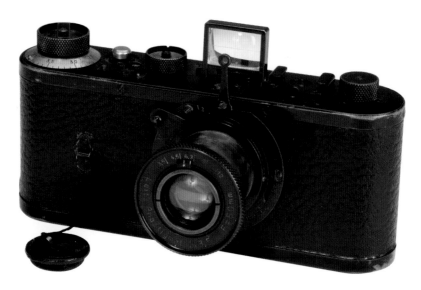

Leica I Model A *1925*

Ernst Leitz GmbH, Wetzlar, Germany. 1974:0037:2925.

Introduced in 1925 at the Leipzig Spring Fair in Germany, the Leica I Model A was the first production model of the Leica camera manufactured by the firm of Ernst Leitz GmbH in Wetzlar, Germany. It claimed to be "the smallest camera with a focal plane shutter." A horizontally running focal-plane shutter provided speeds from 1/25 to 1/500 second. It came with a non-interchangeable, collapsible 50mm f/3.5 lens sold in three variations, Anastigmat, Elmax, and Elmar, the Elmar being the most common. The black enamel body had a placement of feature controls that was imitated so often it became a standard. Early examples like this one had a large mushroom-shaped shutter release button. The camera sold for $114, and the optional "FODIS" rangefinder accessory cost $11. The serial number of the camera shown here is 5283.

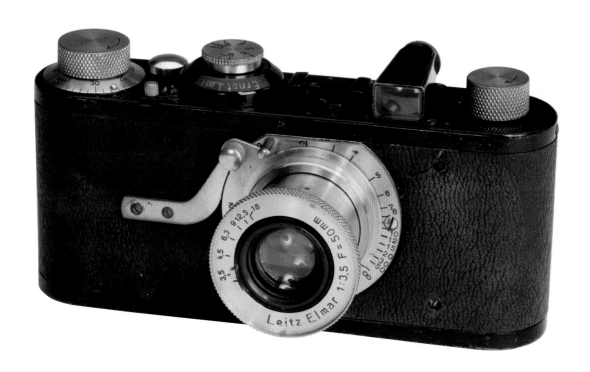

A BRIEF HISTORY OF LEICA CAMERA AG
Rolf Fricke

The origin of the firm Leica Camera AG of Solms, Germany, goes back to a very modest enterprise called the Optisches Institut, founded in 1849 in Wetzlar (approximately 10 km/6 miles from Solms) by a frail 23-year-old man named Carl Kellner (1826-1855). Kellner had devised a successful new ocular for astronomical telescopes, called the *Orthoskopisches Ocular*, which was later adapted for use on microscopes. Encouraged by compliments from noted scientist Johann Carl Friedrich Gauss, among others, Kellner also began to manufacture microscopes, which soon became the company's primary product. Kellner passed away in 1855 at the age of 29. His successor, Friedrich Christian Belthle (1829-1869), hired Ernst Leitz I (1843-1920) in 1864. Leitz became a partner in 1865, and when Belthle died, Leitz I became sole owner of the company, which he renamed the Optisches Institut von Ernst Leitz in 1870. Leitz I had acquired practical experience in instrument making in Switzerland, and with his talent for streamlining operations, the firm's fortunes began to improve. Practicing what today is called market research, he visited scientific institutes in England, France, the United States, and Russia in order to promote his microscopes.

As production grew, the company moved to larger buildings. His happy marriage produced five children, among them Ernst Leitz II (1871-1956), who began a thorough apprenticeship at age 17 at his father's firm in 1889. Leitz I guided the company through the turbulent post-World War I period, and when he passed away in 1920, Ernst Leitz II became the new head of the enterprise.

Very much in keeping with the Leitz family's humanitarian tradition, he made the risky decision in 1924 to place an unconventional small 35mm camera in production in order

The Ernst Leitz Wetzlar factory, 1957. Courtesy Leica Camera AG.

to avoid having to lay off many of his employees because of the difficult economic times–despite the objections of experts who were accustomed to large-format cameras. These experts had been given a small series of approximately twenty-five so-called "0-Series" test cameras, numbered from 101 to 125, that were based on a prototype of what is now called the "Ur-Leica," the brainchild of Oskar Barnack (1879-1936). Barnack had come to Leica from Zeiss in 1911, where his early designs of such a camera had been rejected. Leitz I gave the asthmatic Barnack generous freedom to look after his health.

The camera was referred to under several names, including "Liliput," "Leca," and simply the "Barnack Camera." When the makers of the Krauss "Eka" camera protested that "Leca" sounded too much like their "Eka," Leitz adopted the now-famous name "Leica," a blend of the words Leitz and Camera. The first production camera, not yet marked "Leica," was introduced to the public at the Leipzig Spring Fair of 1925.

Improved models followed at regular intervals, with a major change occurring in 1954 when the legendary Leica M3 with interchangeable bayonet mount lenses was introduced. Today its basic form is still reflected in the successful full-frame digital Leica M9, produced at the current Leica Camera AG facility in Solms.

Leitz Wetzlar flourished to its peak in the 1960s, with subsidiaries in Canada (Ernst Leitz Canada Limited) and Portugal (Leica–Aparelhos Ópticos de Precisão, S.A.). When the significantly lower costs of manufacturing in the Far East threatened the feasibility of production in Wetzlar, a solution was found in 1971 in establishing a collaboration with the Minolta Camera Company of Osaka, Japan, that lasted well over ten years. A Swiss manufacturer of optical instruments, Wild Heerbrugg, part of the Swiss conglomerate of Schmidheiny, acquired a majority share of Leitz in 1974. Schmidheiny gradually increased its share in the firm, and when the Leitz family could not come up with additional funds needed for continued operation, Schmidheiny gained control of the firm and in the late eighties broke it up into its major divisions. Because the name Leica was a well-known

Oskar Barnack (1879–1936), inventor of the Leica camera. Courtesy Leica Camera AG.

Leica Camera AG headquarters in Solms, Germany, 2010. Courtesy Leica Camera AG.

worldwide trademark, all Leitz products were renamed "Leica," including the renowned Leitz microscopes and Leitz binoculars. The venerable name "Leitz" was thus eliminated from the historic company's new vocabulary.

The famous brand name "Leica" is now controlled by a holding company, Leica PLC, and any company that uses the name "Leica," including Leica Camera AG, must pay royalties to that company. The microscope division became Leica Microsystems CMS GmbH, which was sold to the Danaher Corporation of Washington, D.C., in 2005. Another spin-off was Leica Geosystems, which was sold to a Swedish concern. Ernst Leitz Canada Limited became Wild Leitz Canada Limited in 1987, which was sold to Hughes Aircraft Company in 1990 and then became Hughes Leitz Optical Technologies, with rights to use the Leitz name for five years. When those rights expired, Leica PLC refused to grant a license to continue using the name Leitz, and the company was renamed ELCAN Optical Technologies. The name ELCAN was derived from the company's original name, Ernst Leitz Canada Limited. In 1997 it became part of the giant defense contractor Raytheon Company of Waltham, Massachusetts, as part of the acquisition by Raytheon of Hughes Aircraft's defense business units. ELCAN now has subsidiaries in Spain and Texas. The former Leitz Wetzlar administration building is now the Wetzlar Town Hall.

A management buyout took over the photographic division, makers of the world-renowned Leica cameras and sports optics, which became Leica Camera AG, now a privatized company located in Solms, Germany. It has plans to move to new facilities in Leitz Park, returning to Leica's ancestral town of Wetzlar, in 2013.

Rolf Fricke, Retired Director of Marketing Communications, Kodak Professional Photography Division; President Emeritus, Leica Historical Society of America

Le Cent Vues *ca. 1925*

Etablissements Mollier, Paris, France.
Gift of Michel Auer. 1974:0028:3248.

While Le Cent Vues can't lay claim to being the first camera designed around 35mm film, it served as the template for many to come. The camera's name refers to the capacity of its reloadable film cassettes, which was enough for one hundred half-frame (18 x 24mm) images. Like many French cameras of the day, Le Cent Vues had the look of machinery. Almost every part was metal, finished in chrome, black enamel, or in the case of the bottom plate, engine-turned aluminum (shown). The removable cover, which slipped off for film access, was covered in black leather.

Though quite compact for its one-hundred-exposure capacity, Le Cent Vues had the feel of a hefty precision instrument. A seven-speed Compur shutter controlled the light allowed to pass through the 40mm f/3.5 Hermagis Anastigmat lens. To load the film, the photographer had to lift the hinged pressure pad and slip the film leader into the slot in the take-up cassette. The cassette was then opened and the core removed, after which everything was reassembled, the pad lowered and locked, and the cover replaced. A top-mounted finder aided in viewing the subject, and focus was set by the helical lens mount adjusted with a lever on the lens barrel. A 0 to 99 counter visible on the bottom plate kept track of the film supply.

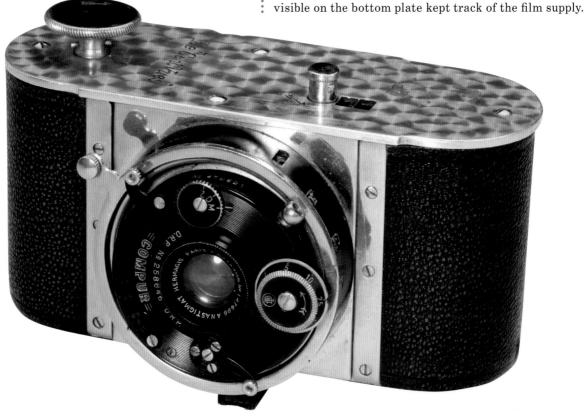

Ansco Memo _1927_

Ansco, Binghamton, New York.
Gift of Bausch & Lomb. 1982:0824:0001.

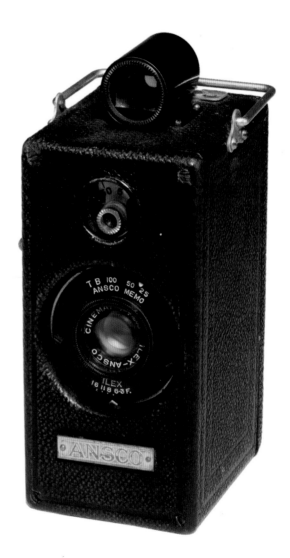

With a complex corporate history and roots that predated George Eastman's birth, the Ansco brand was a serious rival to Eastman Kodak in the photographic business. One of the innovative products made in Ansco's Binghamton, New York, facility was the 1927 Memo. The company's entry into the 35mm market, this camera was among the first designed around the film made originally for motion picture studios. Moviemakers often sold unused film stock for pennies, prompting a number of camera manufacturers to take advantage of this cheap supply and offer "miniature" 35mm cameras to an eager public.

A finely crafted wooden box camera carried easily in the palm of the hand, the Memo cost $20 for the leather-covered, fixed-focus model. With either a Bausch & Lomb or Wollensak f/6.3 focusing lens it sold for $30 and $35 respectively. The polished wood version was the high end at $40, which included a brass finish on the metal parts. Ansco sold prepackaged 35mm ciné film in square cassettes for fifty cents per roll, sufficient for fifty half-frame (18 x 24-mm) exposures. The film was advanced by moving the spring-loaded knob on the back cover, which also indexed the frame counter above the lens. The viewfinder was of the Galilean type, attached to the top, and the six-speed (plus Time and Bulb) repeating Betax shutter was tripped by pulling the release lever on the right side.

Like Eastman Kodak, Ansco was a one-stop source for both amateur and professional photographers. Many accessories were offered for the Memo user, including a projector and everything needed to develop and print pictures at home. Ansco even published a periodical, the _Memo-Random,_ to further enhance the Memo lifestyle.

Q. R. S. Kamra *ca. 1928*

Q. R. S. Co., Chicago, Illinois.
Gift of Graflex, Inc. 1974:0037:2075.

The Q. R. S. Kamra was introduced by the Q. R. S. Co., Chicago, in 1928. Perhaps better known for its player piano rolls, the firm manufactured this 35mm camera in a brown marbleized Bakelite body and marketed it as taking "instantaneous pictures instantly." It claimed to shoot forty pictures in twenty seconds from a daylight loading metal cartridge. This was accomplished by cranking the film into position while maintaining your sight on the subject, then capturing the image with a slight reverse motion on the crank. The company later became QRS-DeVry Corporation and then DeVry, which became famous as a mail-order electronics institute. The retail price of the camera, or Kamra, was $22.50 in 1928.

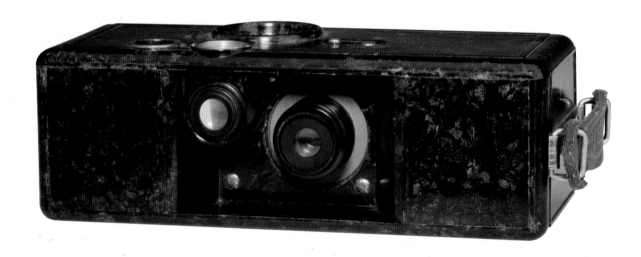

Leica I Model B (RIM-SET COMPUR) *1930*

Ernst Leitz GmbH, Wetzlar, Germany. 1974:0028:3346.

Known as the Compur Leica, the Leica I Model B featured a lens mounted in a Compur leaf shutter, which provided the slow shutter speeds that were lacking on the Leica I Model A. Early Model B Leicas had a dial-set Compur shutter; later ones had a rim-set Compur shutter. The model shown here is a rim-set Compur Leica, on which speeds from one second to 1/300 second (plus Bulb and Time) were set by rotating a ring around the face of the shutter. The independent shutter-cocking lever made double exposures possible. The exposure counter was relocated from under the film advance knob to the space previously used for the shutter speed dial. Produced in small batches, dial-set Compur Leicas were built from 1926 to 1928, and rim-set Compur Leicas from 1928 to 1931.

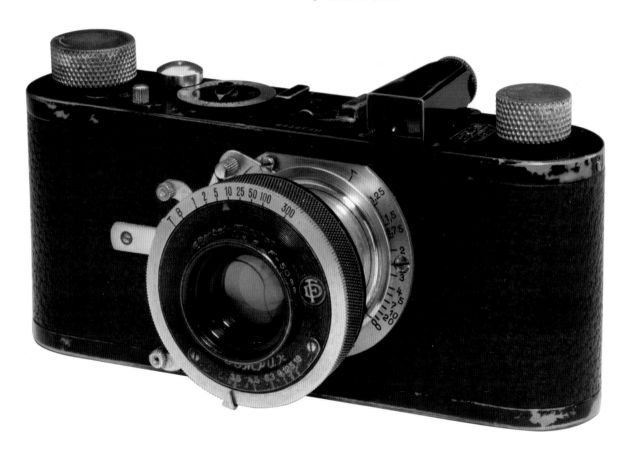

Leica II Model D *ca. 1932*

Ernst Leitz GmbH, Wetzlar, Germany. 1974:0028:3087.

Remote Shutter Release "OOFRC" *ca. 1935*

Ernst Leitz GmbH, Wetzlar, Germany. 1974:0028:3247.

The Leica II or Model D, manufactured from 1932 to 1948, was the first Leica model with a built-in coupled rangefinder. The camera pictured here was made in the first year of production and has a finder with a built-in yellow filter to improve contrast. Attached is an unusual mechanism called the Remote Film Advance and Shutter Release, code-named "OOFRC" and produced from 1935 to 1939, which allowed remote operation of the camera. This feature is especially useful in studying wildlife. By pulling one string, the film was advanced and the shutter cocked. A second string tripped the shutter to make an exposure. The pull-up film rewinding knob extends above the rangefinder housing for easier rewinding. The Leica II sold for $56 (without lens or case) and the release for $24.

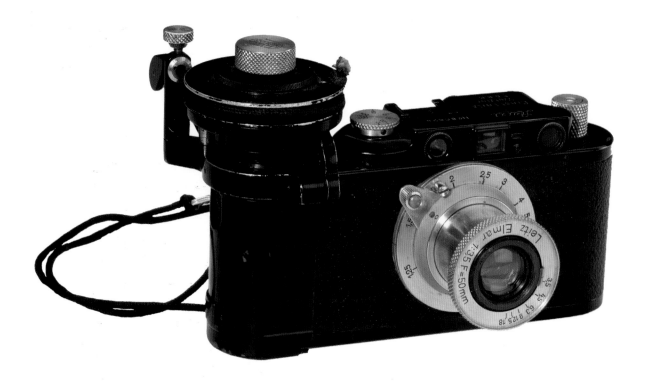

Contax I (540/24) *ca. 1932*

Zeiss Ikon AG, Dresden, Germany.
Gift of 3M Foundation, ex-collection Louis Walton Sipley. 1977:0415:0004.

The success of the Leica camera following its debut in 1925 was not lost on Zeiss Ikon AG of Dresden, Germany. Their entry into this new market was the Contax in 1932. It differed from the Leica in many ways, beginning with its brick-shaped body. The removable back made film loading much easier than the Leica. The Contax had a coupled long-base rangefinder for accurate focus of the ten available bayonet-mount lenses. A ridged wheel next to the shutter button made it easy to focus quickly and make the exposure. The Contax shutter was a metal focal plane that moved vertically and had a top speed of 1/1000 second, twice as fast as rival Leica's. A large knob next to the lens was turned to wind the shutter and advance the film. The Contax used either standard 35mm magazines or a pair of special cassettes. The model pictured has a fast 5cm f/1.5 Carl Zeiss-Jena Sonnar lens and cost $256.

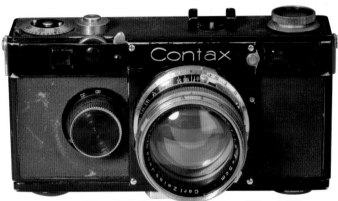

Retina I (TYPE 117) *1934*

Kodak AG, Stuttgart, Germany.
Gift of Eastman Kodak Company. 1992:0259:0001.

The Retina I (Type 117) was Kodak's first 35mm miniature camera. Introduced in December 1934, it was manufactured by Kodak AG, the German subsidiary of Eastman Kodak Company in Stuttgart. The Retina I was the first camera designed and released by the renowned Dr. August Nagel after his company was acquired by Eastman Kodak Company. It was a compact, leather-covered metal body with self-erecting lens, and it was the first camera to use the now familiar Kodak 35mm daylight-loading film magazine. The retail price with f/3.5 lens was $57.50.

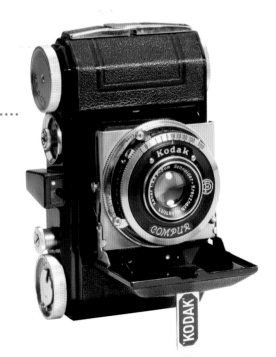

Super Nettel *ca. 1934*

Zeiss Ikon AG, Dresden, Germany.
Gift of Mrs. C. V. Fields. 1977:0337:0001.

As demand for 35mm cameras grew, an increasing number of manufacturers designed products around the format. The German firm Zeiss Ikon responded with the Contax, Contaflex, and this camera, the Super Nettel. Zeiss Ikon, like its in-country rival, Leitz, made precision equipment using the best materials and workmanship, and charged accordingly. The Super Nettel cost $110 in the U.S., during a period of severe economic depression. To justify this cost, the camera offered features that gave the photographer great results. The lens, a Carl Zeiss Tessar 50mm f/3.5, could be accurately focused with the coupled rangefinder. A quick turn of the knurled wheel above the lens allowed the split-image of the subject to be perfectly converged. When not in use, the lens assembly retracted into the body, thanks to the bellows-and-strut design and the lens bed that served as a cover door. The metal focal-plane shutter was set when the film was advanced to the next frame, and tripped by the button in the center of the film-winding knob. Seven speeds, plus Bulb, were selected with a quick lift-and-turn action of the same knob. The top speed available was 1/1000 second. There were two options for loading film: the Retina-style Kodak magazine, which was advanced and rewound with knobs on opposite ends of the top plate, and a cassette-to-cassette system, which eliminated rewinding. The Super Nettel remained in production until about 1938.

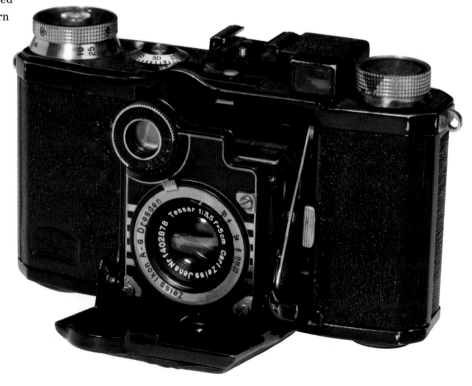

Welti *ca. 1935*

Welta-Kamera-Werke GmbH, Freital, Germany.
Gift of Eastman Kodak Company. 2010:0066:0014.

In the 1930s, the growing popularity of 35mm films brought many new players to the miniature camera game. Not long after Eastman Kodak's German factory began shipping the new Retina 35mm cameras in late 1934, Welta-Kamera-Werke in Freital released its own folding 35, the Welti. This new camera had much in common with the Retina, including its use of the Kodak 35mm daylight-loading film cassette. Almost identical in size, the cameras had similar controls and used Compur shutters. The Welti employed many of the same Schneider-Kreutznach lenses Kodak fitted to the Retinas, although this one has a Steinheil Cassar 50mm f/2.9. Zeiss Tessar lenses were also used. The accessory clip on the camera's top plate was most often used to mount a rangefinder, also a common addition to a Retina.

The Welti improved over the years, with postwar models having coupled rangefinders, faster lenses, and flash synchronization. These were naturally more expensive than the simpler Welti of the 1930s, so the company re-introduced the original edition as a way to meet a price point worthy of its old slogan: *Es ist ja so billig!*–"It's so cheap!"

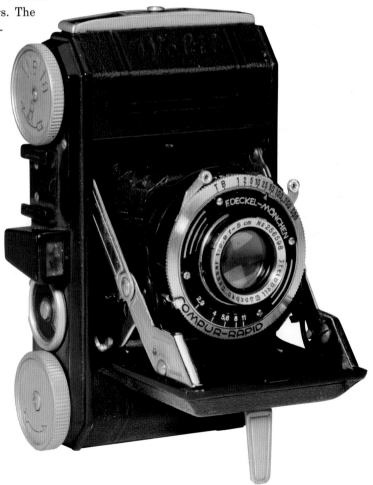

СПОРТ (Sport) *1935*

GOMZ, Leningrad, USSR.
Gift of Eastman Kodak Company. 1990:0128:0004.

The СПОРТ (English translation: Sport) camera, manufactured by GOMZ in Leningrad, USSR, in 1935, is reputed to be the second-ever 35mm SLR, the Ihagee Kine Exakta being introduced about a month earlier. Capable of producing fifty images, 24 x 36 mm, on 35mm film in special cassettes, it had a large boxy housing on top, containing the reflex viewing hood and an optical eye-level finder. The GOMZ factory changed its name to "Leningrad" during the economic restructuring of the early 1950s and became "Lomo" in 1965.

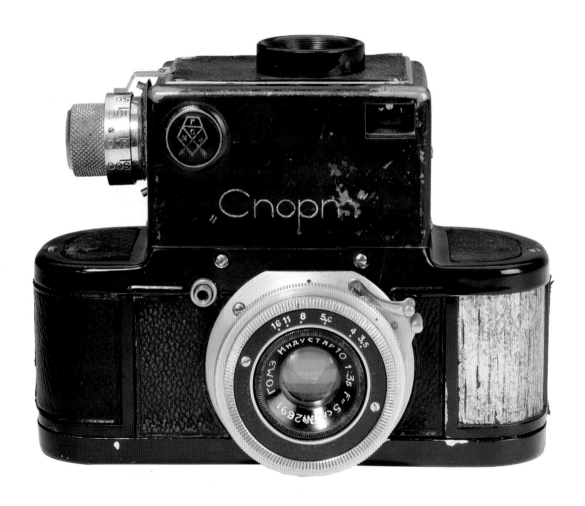

Leica Single Exposure *ca. 1936*

Ernst Leitz GmbH, Wetzlar, Germany. 1974:0028:3364.

Designed for testing film or making exposures when less than a full roll of film was required, the Leica Single Exposure is a tiny view camera. A metal housing holds a lens in front and a ground glass viewing back, while an accessory shoe allows the use of a viewfinder to match the lens in use. Exposure is controlled by a special IBSOR shutter that is mounted to the front of the lens. To make an exposure, the viewing back is exchanged for a metal film holder. A dark slide protects the film from additional exposure. Introduced in 1934, the camera came in two versions with different shutters, "OLIGO" at $31.50 and "OLORA" at $12.75.

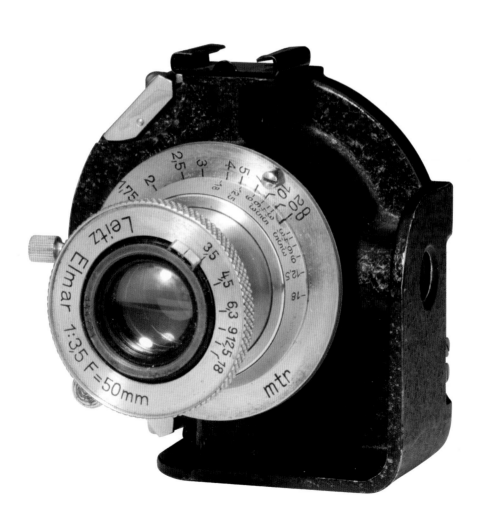

Contax II *ca. 1936*

Zeiss Ikon AG, Stuttgart, Germany.
Gift of Elizabeth L. Warner. 1992:0694:0012.

Zeiss Ikon's Contax of 1932 quickly became a favorite of professionals and connoisseurs for its accurate focusing and line of superb lenses. Improved models were added to their catalog in 1936, including the Contax II. Changes to the new Contax included moving the winding knob from the front to the top, with the release button relocated to the knob's center. Also, a single viewing window on the back eliminated the separate viewport for the coupled rangefinder. Retained from the original was the quiet focal-plane shutter, upgraded to a top speed of 1/1250 second. The folding support "foot" mounted on the camera's base plate helped steady the camera when using the new self-timer operated by the chrome lever on the front. With a Carl Zeiss Jena 5cm f/2 Sonnar lens, the chrome Contax II was priced at $275. The Contax rangefinder line continued with only minor changes until the 1960s.

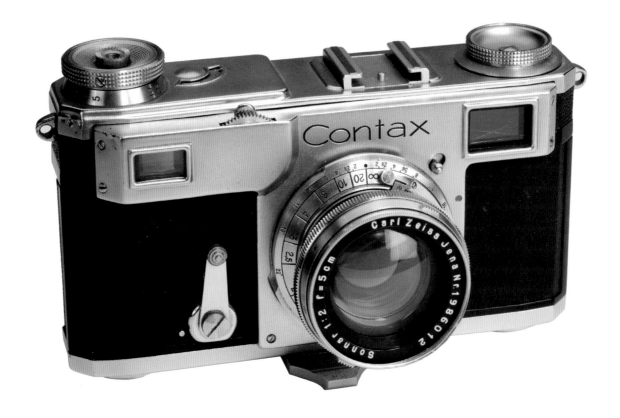

Argus A _ca. 1936_

International Research Corporation, Ann Arbor, Michigan.
Gift of Argus, Inc. 1974:0037:0057.

The Argus A of 1936 was certainly not the first American-made 35mm camera—it followed the Simplex of 1913 in the "double frame" horizontal 24 x 36-mm format—but it could claim to be the least expensive precision American-made 35mm. At a mere $12.50, its retail price was a fraction of the cost of the Simplex and far less than the German Leica.

Manufactured by International Research Corporation of Ann Arbor, Michigan, the Argus A had a resin body, similar to Bakelite, and featured a good-quality lens in a fast shutter. Unfortunately, it used the company's own proprietary film cartridge rather than the recently introduced Kodak 35mm film magazine.

By 1939 Argus had introduced the A2, which was a model A with an integral exposure meter. The A2 assumed the price position of the A at $12.50, while the original model was reduced to $10, making it an even better bargain.

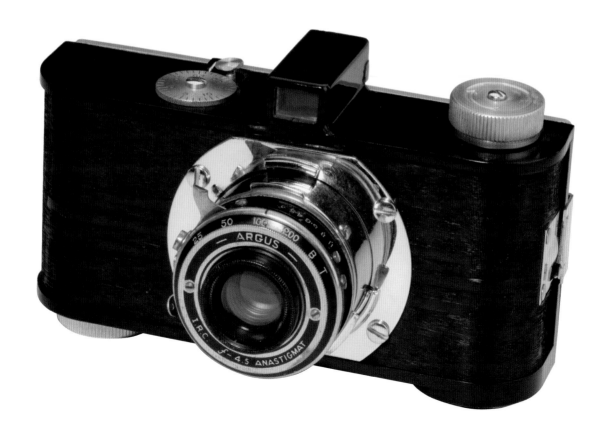

Karat *1937*

Agfa Camera-Werk, Munich, Germany.
Gift of Eastman Kodak Company. 2010:0066:0001.

The success of the Leica camera and the pace at which 35mm films were being improved brought one new model after another to the miniature camera field. The venerable German firm Agfa, already a major manufacturer of box and folding cameras, entered the 35mm fray in 1937. The Karat was a handsome piece, with its art deco faceplate and curved body finished in black. Ruggedly built, the all-metal camera was made very compact by having the lens mounted on a small bellows and retracted when not in use. The lens was Agfa's 5cm f/6.3 Anastigmat, controlled by an Automat shutter with a maximum speed of 1/100 second.

Although it used the same 35mm film as its competitors, the Karat had its own take-up system. The film was loaded into a metal cassette and fed into an identical cassette, eliminating the need to rewind before removing it for processing. Named "Rapid Cassette" by Agfa, this time-saving method was adopted by several other manufacturers. In the end, the Kodak system, which required rewinding before removal, won the battle for acceptance, although Agfa produced cameras with Rapid Cassettes well into the 1970s. The Karat line was improved over the years, including the addition of a coupled-rangefinder model offered in 1941. It lasted until the late 1950s, superseded by the Optima series.

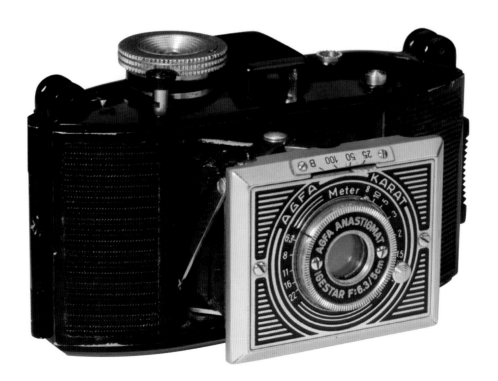

Kine Exakta I <small>(RECTANGULAR MAGNIFER)</small> *ca. 1937*

Ihagee Kamerawerk, Dresden, Germany. 1974:0037:1597.

The Ihagee Kamerawerk in Dresden, Germany, introduced a single-lens reflex design in 1933 they named Exakta. This wedge-shaped camera took size 127 roll film and had a folding viewfinder hood and a mirror that allowed the photographer to compose and focus through the same lens used for making the exposure. Though not a new idea, Exakta utilized it in a very small body. In 1936 Ihagee built the Kine Exakta I, which used a 35mm film magazine, making it the world's first 35mm SLR camera. It had a cloth focal-plane shutter with a maximum speed of 1/1000 second and interchangeable lenses. The film advance lever and shutter release were on the left side. Lens choices included Ihagee's own Exaktar 5.4cm f/3.5 and various Zeiss Ikon and Schneider units. The Kine Exakta remained on the market for about ten years and sold for up to $275 with a Zeiss Biotar f/2 lens. The example shown here is the Kine Exakta I, fitted with a rectangular magnifier on the viewing hood; the first version, the Exakta, used a smaller round magnifier.

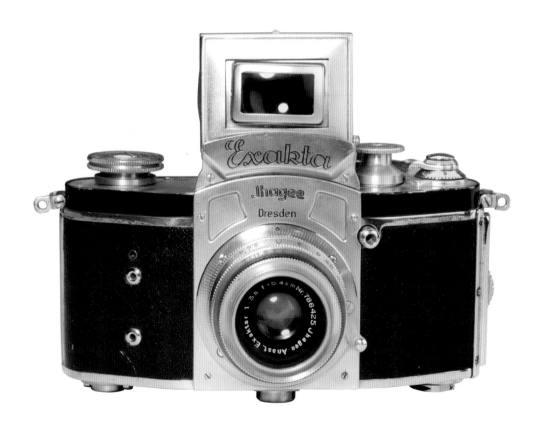

Canon S *ca. 1938*

Seiki Kogaku Kenkyusho, Tokyo, Japan.
Gift of Harry G. Morse. 1981:2297:0029.

Working from a single room in a Tokyo apartment in November 1933, motion picture camera repairman Goro Yoshida, together with his brother-in-law Saburo Uchida and Takeo Maeda, founded Seiki Kogaku Kenkyusho (Precision Optical Instruments Laboratory), later known as the Canon Camera Company. These men were determined to build a 35mm rangefinder camera comparable in design to the Leica II, introduced in Germany in 1932, but with a price more accessible to the Japanese public. With funding from a friend, Dr. Takeshi Mitarai, they embarked on a research project that resulted in the camera prototype Kwanon, named after the thousand-armed Kwannon, the Buddhist goddess of mercy. As early as June 1934, the company publicized its new camera in print advertisements, seeking to drum up public support. However, the Kwanon camera and subsequent design variants never reached the production stage for want of quality optical elements.

Instead, in February 1936 Seiki Kogaku Kenkyusho introduced the Hansa Canon camera, built in cooperation with Nippon Kogaku Kogyo (the Nikon Corporation predecessor). With lenses, viewfinder, and rangefinder systems supplied by Nippon Kogaku, the Hansa Canon realized the company founders' aspiration for a more affordable, high-quality camera. The design success of the Hansa Canon not only won immediate public admiration but also irrevocably changed the Japanese camera industry. The popular Canon S, shown here, was released in 1938. It retained the original camera's pop-up finder but moved the frame counter to the top of the camera's frame, under the advance knob, as found in Leica cameras.

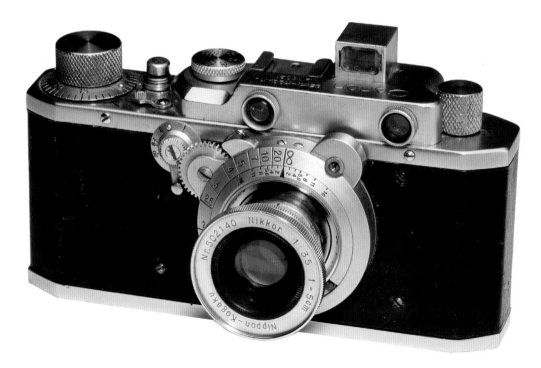

ФЭД (FED) *ca. 1938*

Dzerzhinsky Commune, Kharkov, Ukraine. 2004:0919:0001.

Organized in 1927, the F. E. Dzerzhinsky commune in Kharkov, Ukraine, was a rehabilitation colony for 150 orphaned boys and girls, thirteen to seventeen years of age. Named after Felix Edmundovich Dzerzhinsky, the founder of the Soviet secret police who died in 1926, the community initially produced craft goods, such as clothing and furniture, to serve its needs. Later, the communards began taking orders for their products from outside the colony. Funds accumulated from the sale of these goods, along with a loan from the state, allowed the commune to expand its manufacturing facility, and in 1932 an electric hand drill was added to the inventory. In 1934, camera production began with the fabrication of ten prototype copies of the famous Leica. The first 35mm camera made in the USSR, this knockoff of the popular and versatile handheld German camera was named FED, using Dzerzhinsky's initials to honor him. By June 1941, when Germany invaded the Soviet Union, 175,000 FED cameras had been manufactured. Production of the camera was discontinued during World War II, as manufacturing facilities were relocated to Bersk and retooled to make airplane parts for the Soviet Air Force. After the war, FED production resumed, first at the Bersk factory and, starting in 1946, also at a new Kharkov plant. By the end of its run in 1970, nearly two million FED cameras had been produced. Illustrated is a FED 1c, ca. 1938.

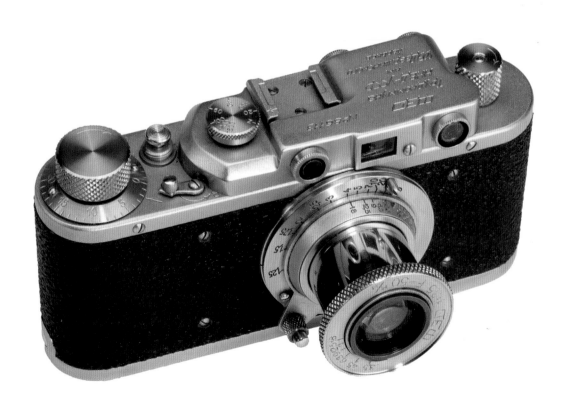

Argus C3 *ca. 1939*

International Research Corporation, Ann Arbor, Michigan. 1974:0037:2750.

...

Known fondly as "The Brick," the Argus C3 was introduced in 1939 by International Research Corporation of Ann Arbor, Michigan, which changed its name to Argus, Inc., in 1944. The camera's nickname derived from both its shape and the fact that it was reliable and durable. The C3 was a very popular 35mm coupled rangefinder camera with internal flash synchronization, and it remained in production until 1966. The retail price, including case and flash, was $69.50 in 1939.

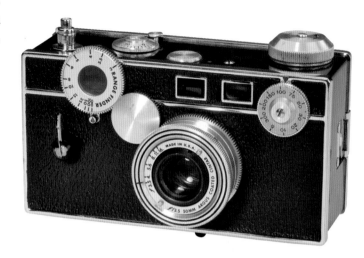

Robot Luftwaffen Model *ca. 1940*

Otto Berning & Company, Düsseldorf, Germany.
Gift of Jacques Bolsey. 1974:0037:0147.

...

Robot cameras were made by Otto Berning & Company in Düsseldorf, Germany, beginning in 1934. Their main feature was an automatic film advance powered by a spring motor. The Luftwaffen Model was made for the German military during World War II and differed from the civilian Robots in having a taller winding knob, all metal parts painted black, and "Luftwaffen-Eigentum" engraved on the back. Early Robots used 35mm film but took one-inch square exposures and required special film cassettes. Robots of the 1950s used standard 35mm film magazines, but most models still took square pictures. The small size and high-quality optics of the camera kept sales going through the 1960s.

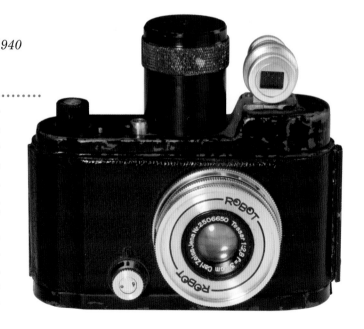

Leica IIId *1940*

Ernst Leitz GmbH, Wetzlar, Germany.
Gift of Gerald Lippes. 2008:0428:0027.

Manufactured from 1940 to 1946 in Wetzlar, Germany, the IIIc was the first Leica with a die-cast body and one-piece top plate; it was slightly longer than earlier models. The next edition, the IIId, was the same as the IIIc, but for an added self-timer, which was the first one fitted to a Leica. According to company records, only 457 IIId cameras were made, and in two batches: serial numbers 36,0001 to 36,134 and 367,001 to 367,325.

Also notable is the material used for the shutter curtains during wartime production of both cameras. Prior to World War II, Leitz acquired shutter curtain material from the Rochester, New York-based Graflex, Inc. However, with the outbreak of war, this arrangement was rendered impossible, and Leitz had to find a new curtain material suitable for camera shutters. The substitute curtain, which was red on one side and black on the other, was used as a "stop gap" during wartime production. After the war, an all-black parachute material was found to be satisfactory and used for both new production and repaired cameras. Historically, Leitz offered a program to update older camera models to new specifications, a policy that was quite effective, especially after the war. This practice was likely responsible for frequent replacement of the red shutter material with the more common black, making those cameras still fitted with the original red curtains quite rare.

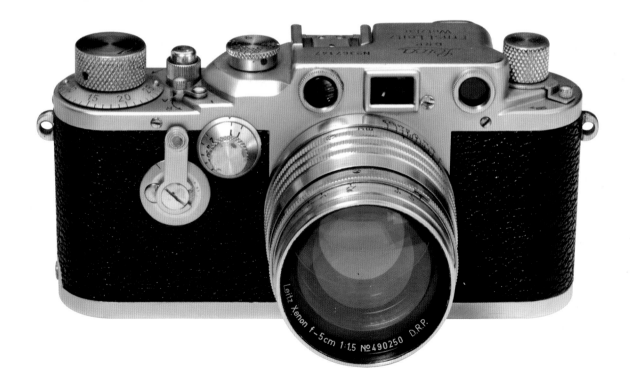

Ektra (35mm) *ca. 1941*

Eastman Kodak Company, Rochester, New York.
Gift of Ruth Yuster. 1991:0274:1-6.

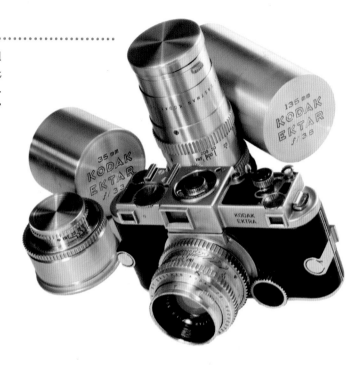

In the late 1930s, Eastman Kodak Company felt it had the ability and technology to design the globe's best camera, and they set out to do so. The result was introduced in 1941 as the "world's most distinguished camera." The Kodak Ektra was a high-quality, precision camera system using 35mm film and interchangeable lenses that were considered among the best. A number of features were firsts for 35mm rangefinder cameras. They included six coated lenses, ranging in focal length from 35mm to 153mm, interchangeable backs, parallax-compensated finder, built-in optical zoom finder, lever film advance, film rewind lever, and a very long based coupled rangefinder. Such a marvelous camera came with a high price. The camera and 50mm f/1.9 lens retailed for $300 in 1941. All five accessory lenses cost an additional $493.

Leica IIIc K version *ca. 1941*

Ernst Leitz GmbH, Wetzlar, Germany. 1974:0028:3246.

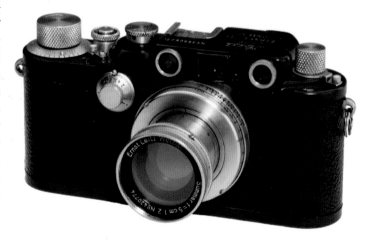

The Leica IIIc K version was usually distinguished by a "K" suffix to the serial number and/or a white letter "K" stamped on the shutter curtain. This marking identified a "Kugellager" (English translation: ball-bearing) shutter designed to operate reliably in extreme temperatures. Aside from the shutter differences, the camera was identical to the regular production Leica IIIc, with a coupled rangefinder and separate dials for fast and slow shutter speeds. Many "K" cameras had additional military markings, though some were sold to civilian customers. Typically finished in gray paint, others had a satin chrome finish. Not including lens or case, the Leica IIIc sold for $81.

Leica Reporter Model GG *ca. 1942*

Ernst Leitz GmbH, Wetzlar, Germany. 1974:0037:2926.w

Many photographic tasks benefit from film rolls longer than the standard (ca. 1940) eighteen or thirty-six exposures, especially those that require rapid shooting, when time spent reloading can mean the loss of one or more critical shots. Used by street photographers, photojournalists, aerial photographers, and audiovisual studios, the Leica 250, also called the Leica Reporter, was designed to accept special cassettes that held ten meters (approximately thirty-three feet) of 35mm film, enough for 250 exposures. The camera used two identical cassettes: one containing the film supply and another to take up the exposed film, thus eliminating the need to rewind the long film.

There were two basic models. The Model FF was black with nickel knobs and a maximum shutter speed of 1/500 second. It was based on the Leica III (F) and was introduced in 1934 at a cost of $178.50 for the body, or $228 with a 50mm Elmar lens. The Model GG, black with chrome knobs and a maximum shutter speed of 1/1000 second and based on the Leica IIIa (G), was introduced in 1936. In addition to a few chrome-plated models, there was also a version of the Model GG that accepted a special electric Leica Motor. This combination was mounted on the underside of German "Stuka" dive bombers to record the results of their actions during World War II. The camera shown here is a Model GG, serial number 353619, produced in late 1942 or early 1943.

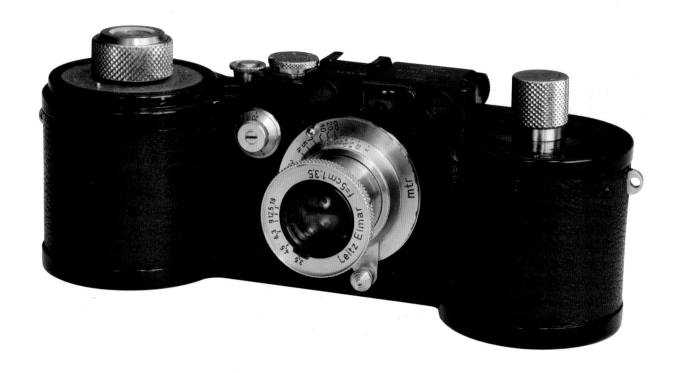

Kardon 35 *ca. 1945*

Premier Instrument Company, New York, New York.
Gift of Harry G. Troxell. 1987:1515:0001.

..

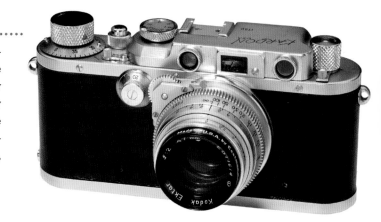

Manufactured in 1945 by Premier Instrument Company of New York, the Kardon 35 was sold to the U.S. Army Signal Corps as well as civilians. Proclaimed by its maker as the "world's finest 35mm camera," it was very similar to the Leica IIIa. In fact, Premier's sales literature claimed that lenses and most accessories were interchangeable between the two cameras. The retail price, including a coated Kodak Ektar f/2 lens, was $306.25.

MS-35 *ca. 1946*

Clarus Camera Manufacturing Company, Minneapolis, Minnesota.
Gift of J. Shean. 1974:0028:3141.

..

At first glance, the Clarus MS-35 seems to be an American Leica. It has many of the same features as the German camera, such as coupled rangefinder, 1/1000 second focal-plane shutter, and the style of a precision photographic instrument. The Wollensak Velostigmat 50mm f/2.8 lens added to its élan. Introduced by the Clarus Camera Manufacturing Company of Minneapolis in 1946, the MS-35 had been designed before World War II. Aside from being awkward and heavy, the cameras were also unreliable. Many of them failed shortly after purchase and were returned for repair or a refund of the $116.25 purchase price. The firm's owners finally ironed out the kinks, but by then a wary buying public chose competitors' products over Clarus, and the inevitable financial problems brought the story to an end.

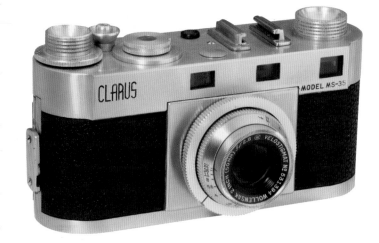

Winpro 35 Flash *1947*

Webster Industries, Webster, New York.
Gift of Eastman Kodak Company. 2009:0167:0001.

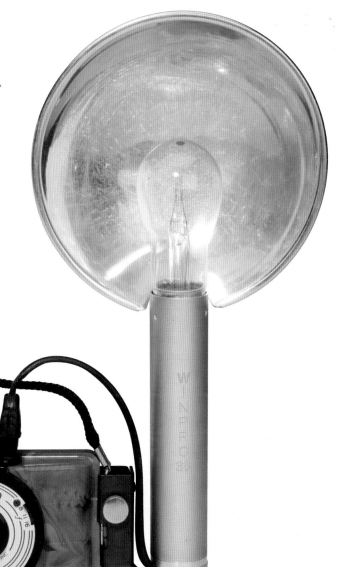

Postwar Rochester, New York, seemed an unlikely place for a small company to get into the camera manufacturing business, but that didn't deter Claude Wright and his partners from establishing Webster Industries in a small farming town a short drive from the headquarters of Eastman Kodak. The new enterprise purchased a design from Kryptar Film, another Rochester firm, and set about refining it for production. Improvements included several patented innovations contributed by Julius Henne, who had come over from Kodak. Named the Winpro 35, the simple yet stylish result was the first 35mm camera with an injection-molded plastic body. The material selected was Tenite, supplied by a Kodak subsidiary in Tennessee. The strength of this plastic was dramatically demonstrated by dropping the Winpro from a window several stories above the sidewalk, and then showing that the camera still functioned normally.

When introduced in 1947 at $10.95, the Winpro was a hit with the public, and some 150,000 were sold. Features such as the 40mm Crystar fixed-focus lens and foolproof exposure counter made the camera an easy sell to former box camera users. The addition of the Flash model added to its appeal. In 1950 the company left its Webster home for southern New York. Later, an ownership change spelled trouble for the venture, especially when quality levels fell below what was expected from a product billed as a "precision-built 35mm camera." By the mid-1950s the Winpro had plenty of competition from big names like Kodak, Ansco, and Argus. The planned upgrade to a focusing Wollensak lens and a stereo version expired on the drawing board, and all production ceased in 1955.

Duflex *ca. 1947*

Gamma Works for Precision Engineering & Optics, Ltd., Budapest, Hungary. 1978:0686:0007.

Made by the Gamma Works in Budapest, Hungary, the Duflex was created from patents granted in 1943. However, World War II delayed the camera's introduction until late 1947, around the time the factory became state-owned. Production stopped in 1949, after only about 600 to 1,000 units were made. The Duflex was the first 35mm SLR to have a metal focal-plane shutter, instant return mirror, automatic stop down diaphragm, and a viewfinder with an image-correcting prism. It is also one of the few non-Japanese cameras to use the 24 x 32 mm image format.

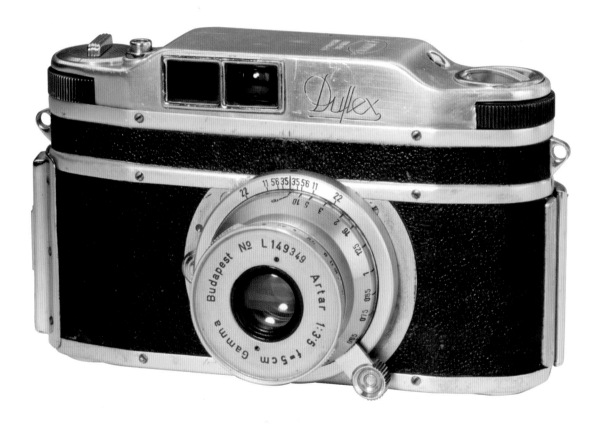

Nikon *1948*

Nippon Kogaku K. K., Tokyo, Japan.

Gift of Eastman Kodak Company. 1990:0128:0005.

Taking the best features of Leica and Contax rangefinder cameras as its starting point, the original Nikon (usually referred to as the Nikon I by collectors), the first production camera from Nippon Kogaku, sought to improve upon both. Introduced in 1948, it combined a horizontal cloth focal-plane shutter and a rangefinder similar to the Leica with a body shape, focusing controls, and bayonet lens mount derived from the Contax.

Nippon Kogaku was new to camera manufacturing but had been a leading producer of optics since 1917. Accordingly, the Nikkor lenses supplied for its new camera were already in use on Canon and other cameras of the time. The Nikon came with either an f/3.5 or f/2 collapsible 5cm lens. Additional Nikkors with focal lengths of 3.5cm, 8.5cm, and 13.5cm were also available. As with all Japanese products

intended for export in the years immediately following World War II, the camera and lenses were engraved "Made in Occupied Japan."

The 24 x 32-mm image size used by the Nikon allowed forty exposures on a standard roll of 35mm film. Unfortunately, this size was incompatible with U.S. standard Kodachrome mounts, a problem quickly recognized by the Overseas Finance and Trading Company (OFITRA), the first American importer of the Nikon, as a severe limitation to U.S. market acceptance of the camera. Ultimately, only several hundred cameras were manufactured before the format increased to a still non-standard 24 x 34 mm with the introduction of the Nikon M in 1949. The Nikon S, introduced in 1951, became the first camera from Nippon Kogaku to use the standard 24 x 36-mm format.

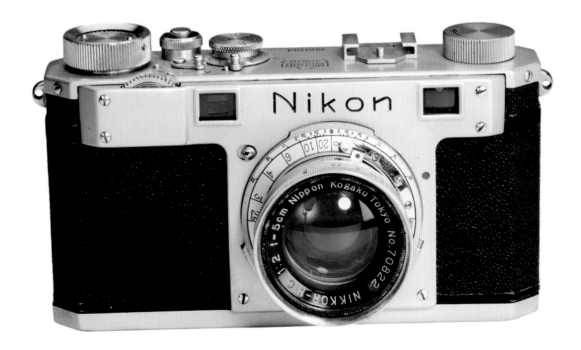

Foton *ca. 1948*

Bell & Howell Company, Chicago, Illinois. 1981:1296:0009.

Introduced in 1948, the Bell & Howell Foton was a high-quality, attractively styled 35mm camera. It had a die-cast body, coupled rangefinder, and a unique spring motor drive that allowed for bursts of six frames per second. A feature-rich product, the Foton debuted at a retail price of $700. However, even after a price reduction to $500, it didn't find enough buyers and was discontinued in 1950.

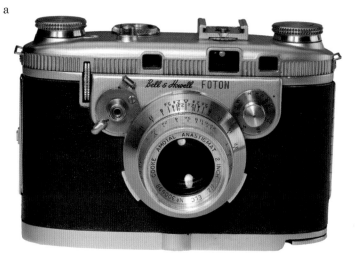

Contax S *ca. 1949*

Zeiss Ikon, Dresden, East Germany.
Gift of Eastman Kodak Company. 1974:0037:0076.

The first 35mm single-lens reflex camera to use a pentaprism to give the photographer a right-side-up view of the subject, the Contax S was introduced in 1949 by Zeiss Ikon of Dresden, East Germany. It originated the form that defined the 35mm single-lens reflex and continues in the twenty-first-century digital SLR. With a screw mount lens and a knob for film advance, the camera also had a shutter release button on the front that angled outward to place it right at the user's fingertip. The Contax S was superseded by improved models and continued in production until the 1960s, although the name was changed to Pentacon in the 1950s due to disputes with the West German Zeiss Ikon firm in Stuttgart.

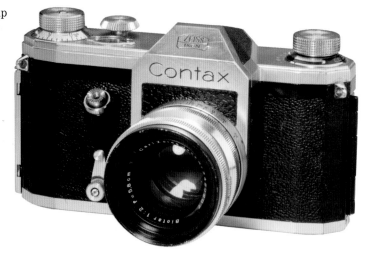

Vitessa *1950*

Voigtländer & Sohn AG, Braunschweig, West Germany.
Gift of Eastman Kodak Company. 2001:1664:0001.

Voigtländer had been making quality optics for nearly two centuries when it introduced the Vitessa 35mm in 1950. The camera listed for $149.95 and was an immediate hit. The Ultron 50mm f/2 lens was mounted on a bellows, which allowed it to be retracted into the metal body and covered by a pair of "b arn doors." When extended for use, the lens was focused by turning the ridged thumbwheel while sighting through the coupled rangefinder. The Compur-Rapid shutter's speed and aperture settings were selected using the rim controls behind the lens, while a single push of the tall plunger on the left side of the top plate both cocked the shutter and advanced the film. With all that done, the release button on the right could be pressed to make the picture on film from any standard 35mm cassette. The photographer could keep track of the frames by checking the counter next to the lens. This elegant camera remained in production until the mid-1950s, when it was superseded by newer, simpler models.

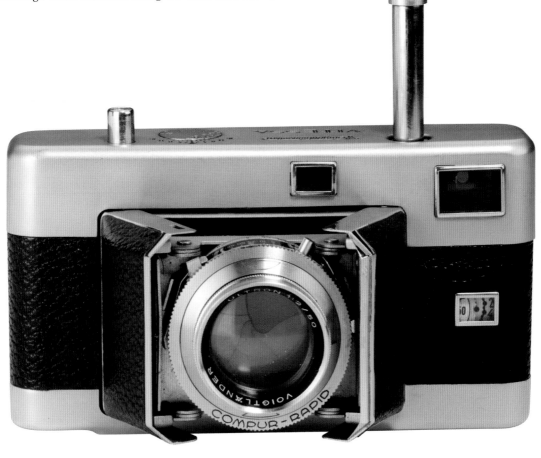

Смена-2 (Smena-2) *ca. 1950*

GOMZ, Leningrad, USSR. Gift of Dr. Anthony Bannon. 2009:0328:0001.

Huashan *ca. 1950*

Unidentified manufacturer, China. 2008:0554:0006.

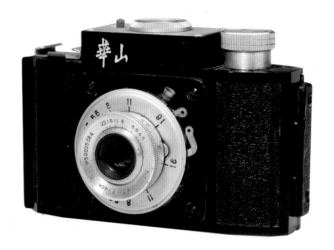

Just as the camera industry in the USSR produced mostly copies of German, and later, Japanese designs, factories in China shortened the time needed to ramp up camera production by duplicating the Soviet copies. In the early 1950s, the state-owned GOMZ works began selling the basic yet stylish Смена (below), an all-Bakelite camera that was patterned after the Regula, an inexpensive postwar German model. Features included a focusing lens, variable speed shutter, adjustable aperture, and an exposure counter, as well as a connection for flash. Like the earlier Agfa Karat, the camera used 35mm film in a cassette-to-cassette system, which didn't need to be rewound after exposure. This limited film options, as the camera couldn't accept standard daylight load cartridges. The Смена was not updated to use the standard films until the late 1960s.

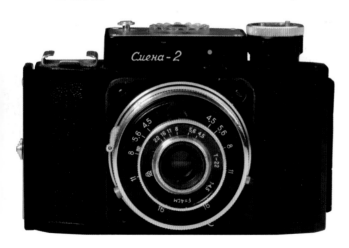

Shortly after the Смена went on sale, a nearly identical camera started being produced in China. The Huashan (above) was an almost exact replica of its Soviet cousin, with only cosmetic differences. Parts were interchangeable between the two products. This sharing of designs kept prices low and also boosted sales.

Signet 35 *1951*

Eastman Kodak Company Rochester, New York.
Gift of Robert Consler. 1974:0049:0003.

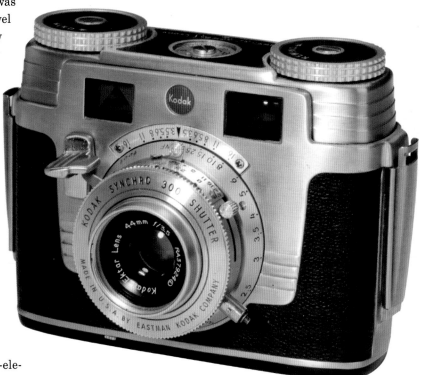

Introduced in 1951, the Kodak Signet 35 was the first in the series of 35mm, eye-level Signet cameras from the 1950s. Strikingly designed in a compact art deco style by Eastman Kodak's Arthur H. Crapsey, it replaced the clunky-appearing Kodak 35 rangefinder model, discontinued the same year. The number in the model name most likely alluded to film size, 35mm, as with the Pony 135, introduced the previous year. The subsequent Signet models used even-numbered names: 30, 40, 50 and 80. Another distinction for the series's premiere camera was its die-cast aluminum alloy body, as the successors were made of plastic. It was also the only Signet to use the respected 44mm f/3.5 Ektar lens.

A Kodak print ad from 1954 detailed "37 good reasons why this camera is worth more than $87.50." Among the features extolled were the luminized four-element Ektar lens, a Tessar-formula design able to stop down to f/22 and focus as close as two feet. At 44 mm, the focal length closely matched the diagonal of the 24 x 36-mm negative for a correct "normal" angle of coverage. The coupled rangefinder had a triangular split-image focusing area, and was combined with the viewfinder in a single window. The Kodak Synchro 300 shutter provided speeds to 1/300 second and internal flash synchronization. The lens and shutter were mounted on an all-metal focusing helix with fifty ball bearings for smooth operation. The large winding and rewinding knobs made operation easy, even when the photographer wore gloves. The lens bezel was threaded for series V lens attachments, and all operating scales were visible from above. Another notable feature was the sliding rule exposure calculator built into the removable back plate, which was set for the Kodak film being used. It could be used for other film brands, if one knew the comparable ASA speed rating.

Prominent (35MM) *ca. 1952*

Voigtländer & Sohn AG, Braunschweig, West Germany.
Gift of Myron Bernhardt. 1989:1162:0010.

Voigtländer has been manufacturing cameras in Braunschweig, Germany (West Germany, 1946-1990), since 1840, and through the years has made every style and type. The Prominent was a coupled rangefinder 35mm camera with interchangeable lenses and flash-synchronized Synchro-Compur leaf shutter with speeds to 1/500 second. An unusual feature was the top-mounted focus knob on the left side, instead of the usual knurled ring on the lens. Several lenses were available for the camera, from 35mm wide-angle to 150mm telephoto. Voigtländer made the Prominent from 1951 until 1960.

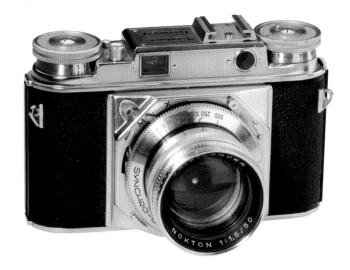

Rectaflex Rotor *ca. 1952*

Rectaflex, Rome, Italy. 1974:0037:2536.

The 1952 Rectaflex Rotor was a 35mm SLR camera made in Rome, Italy, with a rotating three-lens turret, a successful feature on movie cameras since the 1920s. In the days before zoom lenses, the idea was to make lens swapping easier. The Rectaflex's pistol-grip handle had a trigger linked to the shutter actuator. Its rotor lock release was an easy-to-press thumb button and allowed the photographer to select a normal, wide-angle, or telephoto lens, all while keeping the subject framed in the finder. Designed with many features desirable to the serious shooter, the camera's weight wasn't among them.

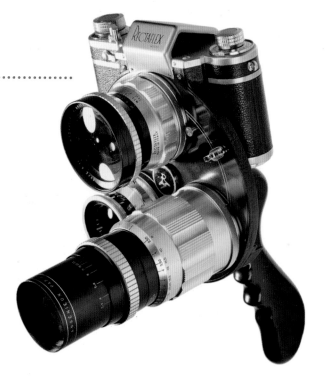

Nicca IIIS *ca. 1952*

Nicca Camera Works, Ltd., Tokyo, Japan.
Gift of Elizabeth L. Warner. 1992:0689:0001.

When World War II came to an end in 1945, the economies of Japan and Germany were buried in the rubble of bombed-out factories. Their photographic industries had been conscripted into service producing war materiel, guaranteeing they'd be in the crosshairs of Allied bombsights on a regular basis. In addition to rebuilding facilities that would put people back to work, postwar revival efforts centered mostly on resuming production of previous models until newer designs could be tooled up and manufactured.

Germany's Leitz picked up where it had left off, but in Japan the expedient method of copying an existing European product led to cameras like the Nicca 35mm rangefinder. The rousing success of the Leica inspired many imitators the world over, including in the U.S., though few reached the flattery of the Nicca line. Gambling that Leitz did not have the resources to challenge infringements, Nicca Works tapped into a pent-up demand for knock-offs. Not only did the company's cameras strongly resemble the Leica, but parts were almost completely interchangeable between the two. The major differences between the German and Japanese designs were the name on the top plate and the brand of lenses. Leicas were fitted with Ernst Leitz optics, and the Nicca came with Nikkor lenses. Both lens lines used the same threaded mount and were totally interchangeable.

In the United States, the Nicca IIIS was also sold by Sears, Roebuck and Co., under its Tower brand. These near-replicas of the legendary Wetzlar cameras had a huge price advantage over Leica. The basic body, without lens, listed for $210 in Leica's catalog, with Sears selling the Nicca-built Tower body for $122.50. For the Leica with a 50mm f/1.5 Summarit lens, the buyer had to hand over $434, while a Tower with the excellent Nikkor f/1.4 glass cost only $285. Nicca improved its line by making versions of newer Leica models, but by 1958 the firm was acquired by Yashica, which abandoned both the Nicca brand and its reverse-engineering business model.

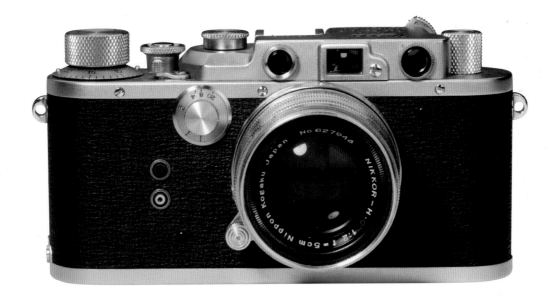

Contaflex I (861/24) *ca. 1953*

Zeiss Ikon AG, Stuttgart, West Germany. 1974:0037:2974.

..

Introduced in 1953 by Zeiss Ikon AG of Stuttgart, West Germany, the compact Contaflex incorporated an interlens shutter instead of the traditional cloth focal plane shutter found in other SLRs. With the introduction of the Contaflex II the following year, the original was renamed Contaflex I. The Contaflex III brought interchangeable front lens elements to the line. The retail price of the original Contaflex was $153.

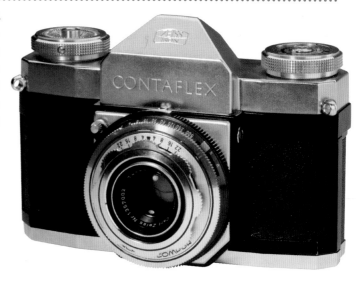

Leica M3 (DOUBLE STROKE) *1954*

Ernst Leitz GmbH, Wetzlar, West Germany.
Gift of Eastman Kodak Company. 1999:0161:0002.

..

Introduced in 1954 at the Photokina trade show in Cologne, West Germany, the Leica M3 quickly became a favorite of photojournalists for its nearly silent operation. Many of its features were improvements over previous models: the lens mount changed to bayonet-type; shutter speeds were on a single dial; the viewfinder automatically compensated for aiming errors resulting from the distance between the taking lens and the viewer (parallax); the film was advanced and the shutter cocked by means of a lever that required two quick strokes; and a hinged door on the camera's back simplified film loading. It cost $288 for the body alone, and adding a faster lens like the 50mm f/1.5 Summarit brought the total to $469.

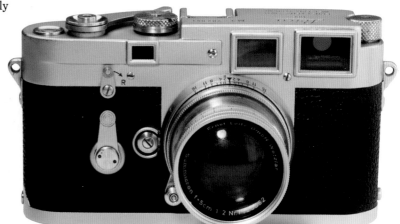

Nikon S2 *ca. 1954*

Nippon Kogaku K. K., Tokyo, Japan. 1974:0028:3048.

The Nikon S2, manufactured from 1954 through 1958, is identified by a serial number beginning with "61" as the first of seven digits. The second-generation Nikon rangefinder camera was designed to fix the shortcomings of the earlier I, M, and S models. After consulting with a select group of end-users, Nippon Kogaku added a number of features to the S2 that made it a viable competitor to the Leica M3: an increased top shutter speed of 1/1000 second, rapid film advance lever, folding rewind crank, and a larger viewfinder window permitting ninety percent image viewing. There are two versions of the S2: the original (shown here) featuring chrome shutter speed and flash sync dials, and a later version with black-painted shutter speed and flash sync dials.

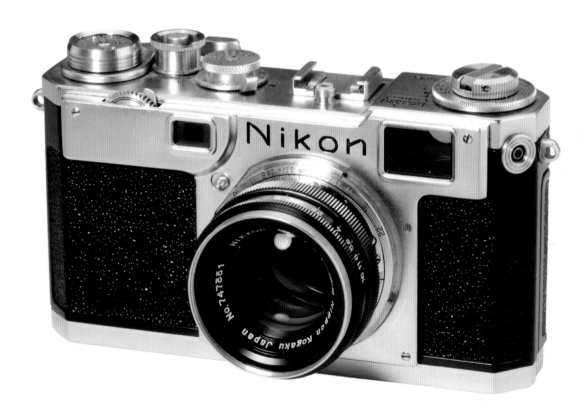

Asahiflex IIB *1954*

Asahi Optical Company, Ltd., Tokyo, Japan.
Gift of Asahi Optical Company. 1981:1296:0025.

Introduced in 1954 by Asahi Optical Company, Tokyo, the Asahiflex IIB was a further evolution of the Asahiflex I, Japan's first 35mm SLR, which appeared in 1952. The Asahiflex IIB was the first 35mm SLR to use an instant return mirror, which became the world standard. By 1957, the Asahi camera line was known as Asahi Pentax cameras, although in the U.S. they were labeled Honeywell Pentax for the American corporation that imported them into the 1970s. Since then, the name on the plate has been simply Pentax. In June 2007, after an earlier attempt at a merger failed, Hoya Corporation announced a buyout of Pentax Corporation that would make it a wholly owned subsidiary while retaining its brand name.

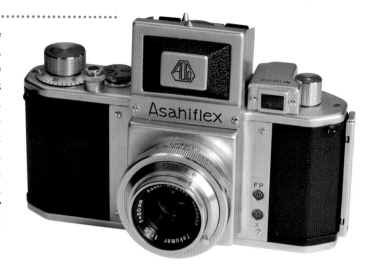

Periflex 1 *1955*

K. G. Corfield Ltd., Wolverhampton, England. 1974:0037:2803.

The Periflex was the product of Sir Kenneth Corfield's pursuit of an economically priced, high-quality 35mm camera body with a focal-plane shutter and a Leica lens mount. His goal was a camera that Leica owners could purchase for use as a second body. To reduce the bulk of a conventional camera, the Periflex uniquely eliminated the rangefinder and incorporated a periscope that was lowered behind the lens for focusing. The photographer then used the conventional viewfinder to compose the picture. The original model was released in 1953 by K. G. Corfield Ltd. of Wolverhampton, England, and sold for £29 with lens. Shown here is the Periflex 1 (silver) of 1955.

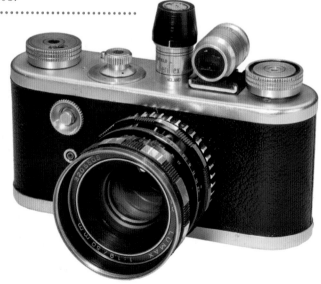

Noble 3-35 *1956*

Noble Camera Manufacturing Company, Detroit, Michigan. 1997:2369:0001.

One of the most unusual 35mm cameras ever made was the Noble 3-35. Designed by Sam Noble, an ex-Army photographer, the 3-35 was an attempt to eliminate the need for photographers to carry multiple cameras on assignment. Typically, professional photographers using 35mm equipment juggled multiple cameras, loaded with different film types and/or fitted with lenses of different focal lengths. Noble's camera had the unique feature of simultaneously accepting three different rolls of film, allowing the photographer to expose combinations of black-and-white or color films without having to

switch camera bodies or media. This was accomplished by rotating the lens shutter assembly, the most expensive part of any camera, to the appropriate roll film. The camera's other features were common to the 35mm equipment of the day: interchangeable lenses, rangefinder focusing, and flash sync for either flash bulbs or electronic flash. Whether due to price ($299.50 in 1957), distribution (Noble sold direct and apparently had trouble filling orders), or yet another reason, the 3-35 didn't catch on.

This is thought to be the only surviving example.

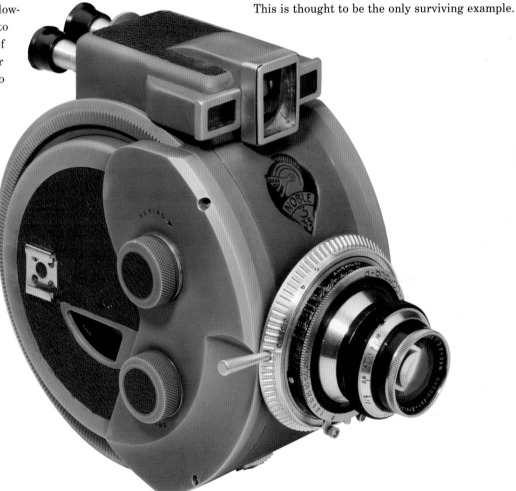

PHOTOGRAPHIC FILM
Robert Shanebrook

Photographic film manufacturing is capital intensive and technically complex, requiring international marketing and distribution to sell the volume necessary for efficient production. In the twentieth century, a worldwide customer base made film one of the most popular and profitable consumer products.

The genius of George Eastman's marketing strategy was to hide the complexity of film manufacturing and photofinishing behind the slogan "You press the button, we do the rest." Beginning in 1900, Eastman Kodak Company combined this strategy with the one-dollar Brownie camera to bring photography to the masses. And Kodak prospered.

The silver halide technology used to make today's films is fundamentally the same as was used in Mr. Eastman's dry plates of the 1880s. Then, as today, silver combined with salt (halide) is suspended in gelatin with tiny amounts of other materials, and then spread on a substrate (base). The film is then cut into pieces that are configured for exposure inside a camera. After exposure, the black-and-white film development process converts the exposed silver halide to black metallic silver, forming a negative image. Then, the negative is printed onto another negative-acting film or paper, creating a tonally correct reproduction of the photographed scene—a positive image.

For color photography, the combination of materials must perform an even more complex function. In a fraction of a second, the image of a scene that strikes the film's surface has to be recorded in a way that simulates how the human visual system perceives the brightness levels and colors of that scene. To further complicate the task, the developed image needs to remain unchanged for at least many decades.

Like black-and-white film, color film uses silver halide crystals suspended in gelatin to record light. However, in order to create a full-color reproduction of a scene, individual records of the red, green, and blue light are needed. Each color is

Roll coating machine, model, ca. 1980. Gift of Eastman Kodak Company. Image by Robert L. Shanebrook.

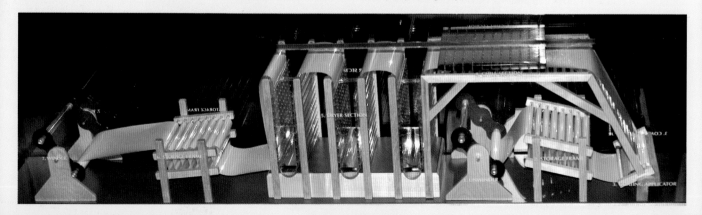

Estar coating machine, Kodak Park, ca. 1985. Courtesy Eastman Kodak Company. Image by Robert L. Shanebrook.

recorded on a separate layer. Much like a dessert made using several layers of colored gelatin, color photographic film is similarly constructed, only with very, very, thin layers. The imaging portion of a modern color negative film combines at least eight light-sensitive layers and six or more non-imaging layers, for a total thickness equal to about half the diameter of a human hair. The layers individually record the red, green, and blue light. During development, an appropriately colored dye forms around each exposed microscopic silver halide crystal, resulting in a color dye image.

The developing process also removes the silver and other materials, leaving a stack of dye images in gelatin on the transparent plastic base. In negative color film, the dark and light areas are reversed, and the recorded colors are the complements of the colors in the original scene. Printing the negative to a similar-acting material produces a positive with colors similar to those of the photographed subject. In transparency (reversal) film, the polarity is reversed during developing, resulting in a positive image with colors that also correspond to the original.

Active imaging materials make up only a very small proportion of film. By weight, film is ninety percent substrate, seven percent gelatin, and just three percent silver and other imaging chemicals. By themselves, the dyes are imperfect and will produce poor color reproduction. To overcome this, extensive color corrections are required. The corrections require the addition of materials to the film to implement complex mechanisms that improve color reproduction.

Making film is demanding work. The task is almost too complicated to even think about. Chemistry has to be prepared, including the growing of microscopic crystals. More than two hundred discrete chemicals must be combined in minute, precise amounts. In production, they will be uniformly coated in extremely thin layers onto miles and miles of a plastic base before being cut, spooled, and packaged. Because film is a light-sensitive material, all this must be done in the dark. To perform satisfactorily, the film must not contain any dirt particles that can be seen, even with a magnifying glass. It has to be protected from chemical contaminants, and the photographic characteristics need to remain constant, both within a roll and from roll to roll.

The world is full of an enormous amount of astoundingly complex technology. No single process or technique is likely to seem breathtaking to anyone familiar with what today's engineers can accomplish. Yet consider the billions upon billions of photographs stashed in drawers and attics, each of which began with a brief exposure on a piece of film. Any one of these images might be seen as the most inexpensive, high-quality, and easy-to-use, human-readable memory device in the world.

Adapted from Robert L. Shanebrook, *Making KODAK Film (Rochester, NY: Robert Shanebrook, 2010), www.makingKODAKfilm.com.*

Leica IIIg *ca. 1956*

Ernst Leitz GmbH, Wetzlar, West Germany. 1974:0028:3020.

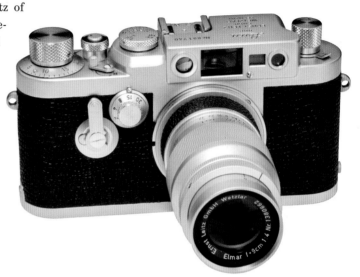

The Leica IIIg, introduced in 1956 by Ernst Leitz of Wetzlar, West Germany, was the firm's last rangefinder camera to use screw-mount lenses. Its improved viewfinder system had one eyepiece for both viewing and focusing and included framing for 50mm and 90mm lenses. The sequence of shutter speeds was revised to match the geometric progression of the aperture scales, making exposure settings more convenient. The IIIg also featured a self-timer, a diopter adjustment for the viewfinder, and a film reminder dial on the back of the camera body. At introduction, it sold for $244.50, including an Elmar 50mm f/3.5 lens. This example is shown with the 90mm f/4 Elmar lens.

Retina Reflex (TYPE 025) *ca. 1956*

Kodak AG, Stuttgart, West Germany. 1974:0037:2917.

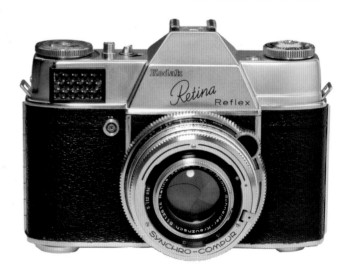

The Retina Reflex type 025, the first single-lens reflex Retina camera, was manufactured by Kodak AG, the German subsidiary of Eastman Kodak Company in Stuttgart, West Germany. Shown at Photokina in 1956, the prototype 025/0 was soon followed by the production model, the type 025. In addition to the reflex finder, it featured a split image rangefinder and was the first Retina with an integral exposure meter. The retail price was $215.

Leica MP *1957*

Ernst Leitz GmbH, Wetzlar, West Germany.
Gift of Gerald Lippes. 2008:0428:0059.

In 1955, photojournalists Alfred Eisenstaedt (1898–1995) and David Douglas Duncan (b. 1916) were supplied with special versions of the 1954 Leica M3, fitted with the Leicavit trigger-wind film advance mechanism. The Leica MP was derived from these customized cameras, as other working professionals would benefit from a faster-handling camera. Production began in October 1956 with a small batch of eleven cameras, serial numbered 1 through 11, while the rest of the run, which totaled 402 cameras, was made the next year. Cameras serial numbered 12 through 150 were finished in black enamel paint, and numbers 151 through 402 were finished in chrome.

Easily identified by the "MP" serial number prefix, these cameras were based on the M3, but with several changes: the top plate was fitted with the manual-set film counter used on the Leica M2; the brass film advance gears were replaced with ones made from more durable hardened steel; and a Leicavit trigger-wind film advance mechanism, with the MP designation, was supplied with each camera. The pristine condition of this example is unusual, as MPs typically received hard use by photojournalists working on assignment in the field. It is fitted with the optical viewfinder version of the 35mm f/2 Summicron. The "bugeyes," in conjunction with the M3 and MP cameras' rangefinder/viewfinder, adapt the viewfinder to accurately frame the image made by the wide-angle 35mm lens.

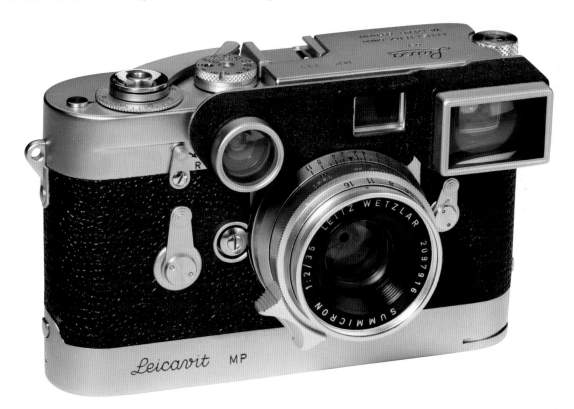

Nikon SP *ca. 1957*

Nippon Kogaku K. K., Tokyo, Japan.
Gift of Nippon Kogaku. 1974:0037:0112.

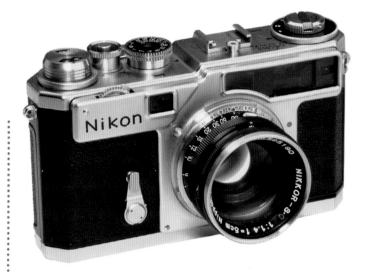

Manufactured between 1957 and 1964, the Nikon SP was the company's third-generation rangefinder camera. It is easily identified by the placement of "Nikon" directly below the focusing wheel on the camera's front and a serial number beginning with "62" as the first of seven digits. The camera features include Nikon's rubberized cloth focal-plane shutter, with speeds to 1/1000 second, universal viewfinder with color-coded bright frame lines for 5cm, 8.5cm, 10.5cm, and 13.5cm lenses, and an auxiliary finder next to the viewfinder for 2.8cm and 3.5cm lenses. With slight modifications, the SP could be fitted with a battery-powered motor drive. Some of the later cameras were supplied with a titanium foil shutter, also used on the Nikon F reflex camera.

The quality build of the SP made it a favorite among photojournalists, with some considering it the best rangefinder camera ever made. Produced in fairly small numbers, with only about 23,000 made during the seven-year run, it most certainly set the stage for Nikon professional cameras to come.

Symbolica (10.6035) *ca. 1959*

Zeiss Ikon AG, Stuttgart, West Germany.
Gift of Eastman Kodak Company. 1991:0540:0005.

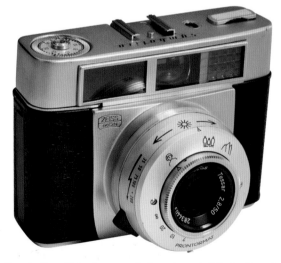

Zeiss Ikon of Stuttgart, West Germany, built some modestly priced 35mm focusing cameras that lacked rangefinders, thus requiring the photographer to estimate distances. In 1959 they sought to cut cost and complexity while still providing accurate focusing. The Symbolica II replaced the rangefinder with a set of pictographs on the lens focus ring, showing settings for a single person close-up, a group, and a mountain range. Detents at each zone symbol set the 50mm f/2.8 Tessar lens for the corresponding situation, although it was a sometimes a compromise. A numerical scale was still provided for those with a good eye for distances. These symbols have since been adopted by other manufacturers for their own zone-focus models.

The Symbolica II had a coupled meter visible in the viewfinder and fingertip knobs on the aperture control ring that the user rotated until the meter needle was centered.

Nikon F *1959*

Nippon Kogaku K. K., Tokyo, Japan.
Gift of Ralph Alexander. 1977:0051:0001.

Perhaps no camera better represents photojournalism in the 1960s than the Nikon F, an omnipresent image-maker that seemingly covered every event of the period. At the time, many professional photographers already saw the 35mm rangefinder as a bit old-fashioned, and the Nikon entry into the field crystallized the clear advantages of the more advanced SLR. Not that the Nikon F was the first from Japan—most other Japanese camera manufacturers already had one on the market—but it quickly became "the" 35mm SLR. A number of features would recommend the Nikon F, but what sold it was its renown for quality and durability that may have almost single-handedly repositioned the Japanese photographic industry, upending a post-war reputation for shoddy production. In describing the F's robust construction, famed camera repairman Marty Forcher called it "a hockey puck."

Introduced in 1959 at the list price of $329.50 (Nikon Fs were many things, but cheap wasn't one of them), the F was Nippon Kogaku's first 35mm single-lens reflex camera. Intended as the centerpiece of the Nikon System, it was sold alongside the rangefinder Nikon SP, an older sibling that shared about forty percent of its parts. But the Nikon System was about more than just cameras. It was a complete integration of compatible components that would eventually include a plethora of accessories: lenses from 6mm to 2000mm in focal length; motor drives; interchangeable viewfinders and viewing screens; close-focusing bellows; flash units; and, when necessary for a specialized job, custom-built items. All were made to accommodate the needs of the professional photographer. The flow of new accessories was so constant that a 1971 Nikon F ad declared, "There has never been an up-to-date photograph made of the Nikon System."

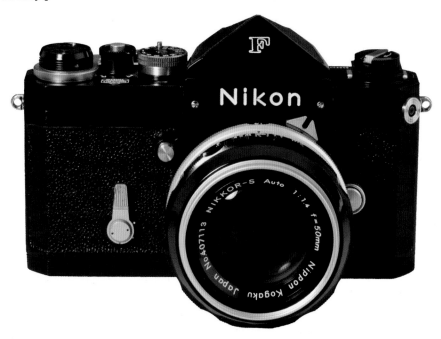

Contarex (Bullseye) *ca. 1959*

Zeiss Ikon AG, Stuttgart, West Germany.
Gift of Jeff Dodgson. 1993:0515:0001.

In the arena of precision 35mm rangefinder cameras, Zeiss Ikon first challenged Leitz with its 1932 Contax and persistently nipped at the Leica's heels for many years thereafter. Zeiss introduced its first 35mm single-lens reflex, the Contaflex, in 1953, and made continuous improvements to the design until leaving the business in the 1970s. Next in line was the long-anticipated Contarex, which upon its 1959 arrival proved to be worth the wait. Like its predecessor, the Contarex was a prism SLR, but the similarity ended there. The new camera had a focal-plane shutter, with speeds to 1/1000 second, interchangeable lenses, single-stroke advance, and a built-in selenium cell light meter whose appearance led to the model's nickname, "Bullseye." The innovative meter was coupled to the speed and aperture controls, the first time this had been done with a focal-plane shutter. Visible through a small window on the top plate beside the prism housing, the meter could also be seen in the viewfinder. By simply changing either the shutter speed or f-stop until the meter needle was centered between two arrows, perfect exposure was possible almost every time. These readings were accurate for whatever film speed the user set on the ASA dial, from 10 to 1300.

Zeiss, which had long been celebrated for its excellent lenses, designed the Contarex around a family of six, including the standard 50mm f/2 Planar lens. The longest was the 250mm f/4 telephoto, the shortest a 21mm f/4.5 super-wide Biogon. The shutter also had a self-timer feature with a variable delay, a shoe for mounting a flash, and a viewfinder with a dual split-image and Fresnel focus screen. The Contarex catalog listed accessories such as focusing bellows for extreme close-ups, and a microscope mount for even closer work. Zeiss Ikon continued manufacturing and improving the Contarex until 1972.

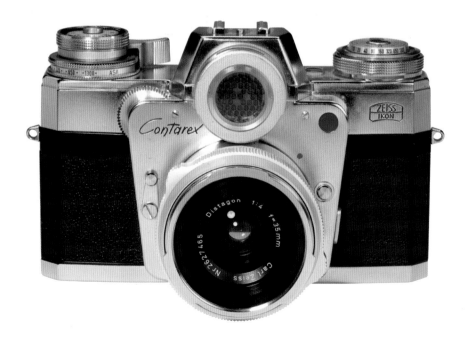

Alfa *ca. 1960*

Warszawskie Zaklady Foto-Optyczne (WZFO), Warsaw, Poland. 2008:0554:0005.

The state-owned company Warszawskie Zaklady Foto-Optyczne (WZFO) in Warsaw, Poland, spent its first decade manufacturing copies of German and Russian cameras. By the 1960s, WZFO was ready to introduce a product of its own to showcase the firm's design and engineering capabilities. The result was the Alfa, a cast-metal-bodied 35mm camera with some unusual features. The unconventional vertically styled body employed a film path that traveled from bottom to top, one of the only full-frame (24 x 36-mm) cameras so designed. Its default "portrait" format meant the camera had to be held sideways when taking the horizontal pictures that are the standard orientation for most 35mm cameras. The Alfa used standard 35mm film in a cassette-to-cassette system that allowed the photographer to remove the exposed film without rewinding.

Once the Alfa's film was loaded, operation was straightforward. The 45mm f/4.5 Euktar lens could be set to shoot as close as 1.2 meters (approximately 4 feet), and the shutter set at one of three speeds by rotating the ridged plastic controls on the lens mount. The aperture setting was selected the same way, with three Waterhouse stops available. The release button was located on the front plate just under the lens, allowing the camera to be gripped with thumb and forefinger while composing the picture with the large, bright viewfinder. A gentle squeeze would trip the shutter, and after a few turns of the advance knob on the left side, the Alfa was ready for the next exposure. An accessory shoe and power cord socket made flash pictures possible. Style was a large part of the camera's appeal, with its coffin-shaped housing available in several bright enamel finishes to complement the aluminum washboard faceplate and ivory-colored plastic trim. The Alfa was priced at just under £8 in the UK, one of its best markets.

Canon Dial 35 *ca. 1963*

Canon K. K., Tokyo, Japan.
Gift of K. Donald Fosnaught. 1984:0167:000

The Canon Dial 35 was introduced in 1963 as a half-frame 35mm camera. Its unusual style incorporated a vertical-format body, which worked well with the shape of the half-frame image. The similarity to a telephone dial of the circular light meter surrounding the lens actually suggested the name. It had a spring-wind film advance motor extending beneath the camera, which also served as a handle and mimicked the style of the then-popular movie cameras.

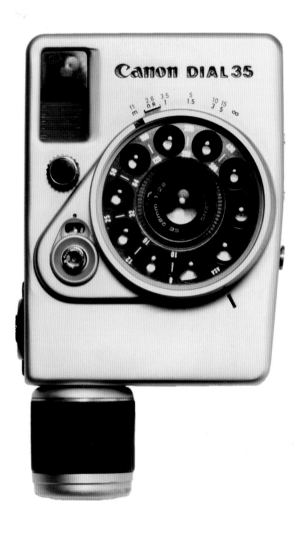

Spotmatic *ca. 1964*

Asahi Optical Company, Ltd., Tokyo, Japan.
Gift of Asahi Optical Company. 1981:1296:0027.

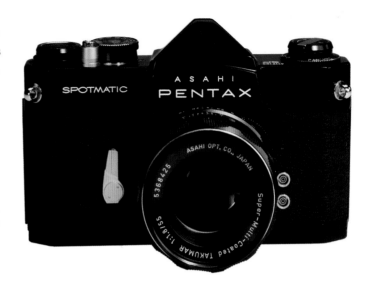

The Asahi Pentax SP, introduced in 1964, was manufactured by Asahi Optical Company, Ltd., of Tokyo. Commonly referred to as the Spotmatic, it was the production model of their 1960 Spotmatic prototype, the world's first SLR with through-the-lens metering (TTL). In the U.S., the camera was imported by Honeywell and carried their name on the pentaprism. The SP body eventually became the K-1000, a favorite of high school and college photography students due to its relatively modest cost, simplicity, and all-manual controls generally required by photography instructors.

Canon 7S *ca. 1964*

Canon K. K., Tokyo, Japan. 1977:0138:0001.

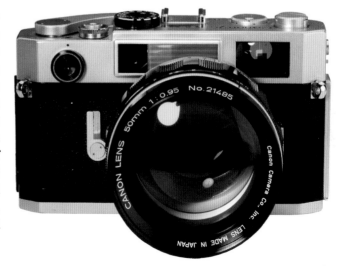

The 35mm rangefinder has been a popular camera design since the 1930s. Canon of Tokyo, Japan, made their reputation with the coupled rangefinder featuring interchangeable lenses. The cameras of the Canon 7 series had threads for screw-mount lenses but also a breech-lock bayonet mount for the huge 50mm f/0.95 unit billed as the "World's Fastest Lens." A focal-plane shutter with a maximum speed of 1/1000 second allowed for full use of the massive lens. Selling for almost $500 in 1964, the 7S added an improved battery-operated CDS light meter and a top-mounted accessory shoe to its earlier sibling model, the Canon 7. The last rangefinder Canon camera, it had available lenses in focal lengths from 19mm to 1000mm.

Ленинград (Leningrad) *ca. 1964*

State Optical-Mechanical Works (GOMZ), Leningrad, USSR.
Gift of Fred Spira. 1985:1044:0003.

The majority of post-World War II Soviet cameras were copied from, or at least patterned after, European designs from such makers as Zeiss Ikon, Leica, and Hasselblad. However, the Leningrad 35mm rangefinder made by GOMZ was an all-USSR effort, and a prize-winning one at that, for it was awarded the Grand Prix at the Brussels World's Fair of 1958. A spring-wound power film advance allowed the Leningrad Autowind to snap pictures as fast as one could press the shutter button. The film transport did not have sprocket wheels like most 35mm cameras, so the film could travel much faster to the take-up spool. The spring motor also set the focal-plane shutter, which had a top speed of 1/1000 second, as well as a self-timer.

The Leningrad's rangefinder had three distinct rectangles for the interchangeable screw-mount Jupiter lenses, each rectangle marked with the corresponding focal length. The finder had a diopter adjustment for eyeglass wearers, but the camera didn't have a meter. It did have a PC flash socket, and a cable release thread in the shutter button. Changing film required removing the back, not unusual at the time, though competitors were building new cameras with hinged doors. The Leningrad remained in production until 1968. By then, rangefinder cameras from Japan and Europe were available with automatic exposure and other new features, making the Soviet camera less attractive.

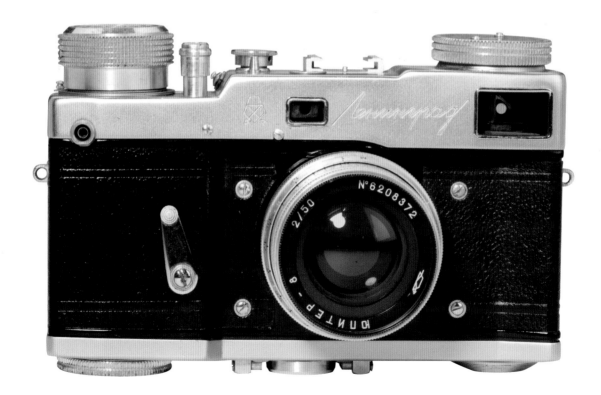

Canon Pellix *ca. 1965*

Canon K. K., Tokyo, Japan. 1974:0028:3054.

The Canon Pellix 35mm SLR camera, introduced in 1965, was a unique design employing a "pellicle" semi-silvered mirror. The semi-silvering allowed seventy percent of the light to pass through to the film and the remaining thirty percent to reflect up to the finder, eliminating the usual moving mirror. There was a resulting drop in brightness in the finder and on the image, estimated to be about one-third of a stop, offset somewhat by a fast f/1.4 lens. The stationary mirror had the advantage of not blocking the shot at the moment of exposure, but it also required a metal focal-plane shutter to prevent the burn-through a cloth shutter would suffer from bright sunlight. The retail price in 1966 was $299.95.

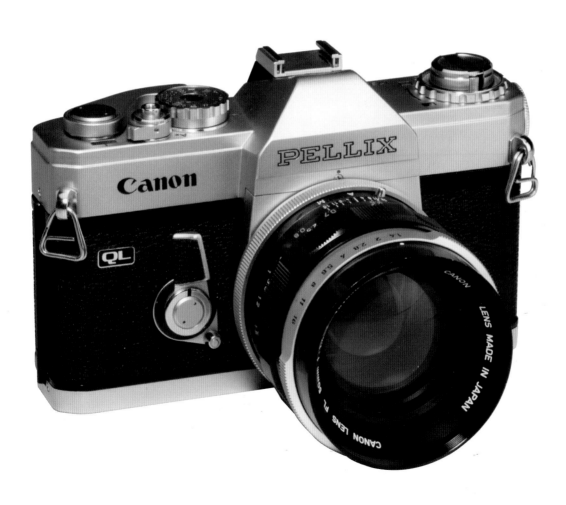

Rollei 35 *ca. 1966*

Franke & Heidecke, Braunschweig, West Germany.
Gift of Elizabeth L. Warner. 1992:0681:0005.

Mention the name Rollei to anyone who knows photography, and they'll likely think of the legendary twin-lens reflex cameras used for fashion photos, sports, and other professional jobs. In the late 1960s, the firm of Franke & Heidecke decided to expand its offerings with some 35mm equipment. One notable result was the compact Rollei 35. Other manufacturers were making 35mm cameras that were as small as the Rollei, but most were half-frame designs. The Rollei shot the same 24 x 36-mm images the bigger cameras made while packaged in a body less than 4 inches long and 2½ inches high. Despite its pocket-size dimensions, this camera was loaded with advanced features such as a Tessar lens, coupled metering, and 1/500 second Compur shutter. Rollei made the size possible by using a retractable mount for the 40mm f/3.5 lens, and by locating the rewind crank, exposure counter, and hot shoe on the bottom plate, so as not to crowd the advance lever, meter, and release button on the top.

The Rollei 35 had no rangefinder, but the wide-angle lens needed focusing only for distances between three and twenty feet, easy enough to estimate. Beyond that, the dial could be left at infinity. Exposure setting used the match-needle method, and turning either the shutter speed dial or the aperture would bring the meter needles together for perfect pictures. At $229.95 in 1969, the potential buyer needed only to see the Rollei brand to know it would be money well spent. The smallest full-frame 35mm that fit the description "precision camera" remained in production for thirty years.

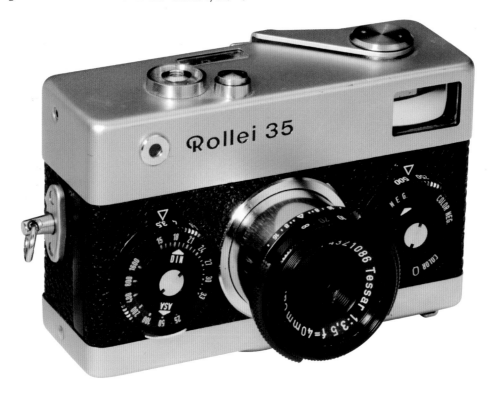

Leica M4 *ca. 1967*

Ernst Leitz GmbH, Wetzlar, West Germany.
Gift of Elizabeth L. Warner. 1992:0677:0035.

Ernst Leitz of Wetzlar, West Germany, continued the evolution of Leica's M-series rangefinder camera with the M4, introduced in 1967. The most visible improvement is the angled rewind knob. However, the camera sports a shopping list of advancements over the earlier M3 and M2 cameras, including an easy loading film take-up system; a bright frame viewfinder for 35mm, 50mm, 90mm, and 135mm lenses; standard PC flash socket; and a more ergonomic plastic-tipped film advance lever. The M4 list price was $288 without lens, and adding the 50mm f/1.4 Summilux lens brought the price to $501. This example has a satin chrome finish; black paint and black chrome versions were also available.

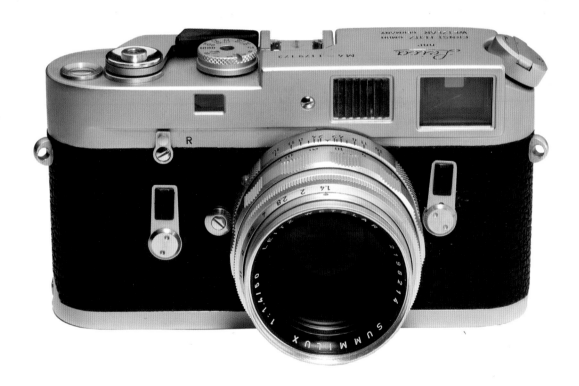

Alpa 10d *1968*

Pignons SA, Ballaigues, Switzerland.
Gift of Eastman Kodak Company. 1999:0172:0001.

Like many camera manufacturers, Pignons SA of Ballaigues, Switzerland, got its start making precision instruments. The Swiss company decided to make cameras for the consumer market as a hedge against the frequent lulls in its core business. Jacques Bolsey, who would later market cameras under his own brand made in the United States, designed the initial entry. Pignons continued in the camera business with a series of 35mm single-lens reflex models made with the traditional Swiss attention to quality control. This became more important as competitors from Japan steadily improved their cameras throughout the postwar era.

By the time the Alpa Model 10d reached customers in 1968, features such as an instant-return mirror, single-stroke lever film advance, and coupled light meter were expected in an SLR camera. A list price of $629 included the Kern-Macro-Switar 50mm f/1.9 lens, which focused from seven inches to infinity, and the 1/1000-second focal-plane shutter, which was a necessity for any camera in this class. The Alpa's electronic metering was of the match-needle variety, with the meter visible in the viewfinder. Shutter and aperture settings determined the needle position, which was based on the film speed. The ASA dial ranged from 3 to 6400, and the shutter had synchronization for X, F, and M flash units. All Alpa lenses were bayonet mount for rapid changing, available in a full range from extreme wide-angle to 500mm telephotos and several zooms. Also fast was the film advance lever, which was pulled from front to back, the opposite of most lever-advance cameras. The shutter release button was on the front, near the lens, not on the top plate like on Japanese cameras. A touch of luxury was next to the rewind knob: a rectangular gold plate where the proud owner's monogram could be engraved by a jeweler.

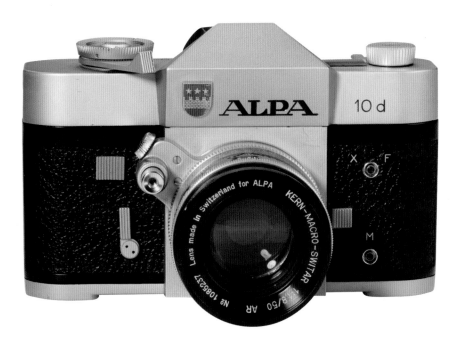

Leica M5 *ca. 1971*

Ernst Leitz GmbH, Wetzlar, West Germany.
Gift of Elizabeth L. Warner. 1992:0677:0026.

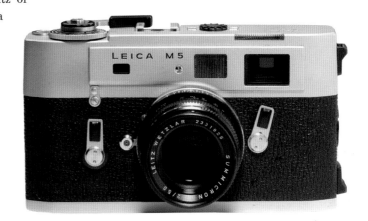

The Leica M5, introduced in 1971 by Ernst Leitz of Wetzlar, West Germany, was the first Leica rangefinder camera to offer through-the-lens exposure metering. An exposure sensor mounted to an arm swung into the space between the lens and film, exactly measuring the light reaching the film; it retracted just before the actual exposure. The body styling was a significant departure from the prior M-series models. This earlier example has only two strap lugs (both on one end of the camera), while later versions offered three lugs. The M5 body alone cost $627, and with the Summicron 50mm f/2 lens shown here, it cost $849.

Nikon F2 *ca. 1971*

Nippon Kogaku K. K., Tokyo, Japan.
Gift of Ehrenreich Photo-Optical Industries (EPOI), Inc. 1981:1036:0001.

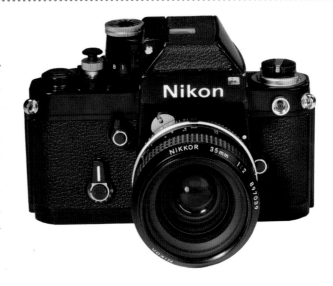

The Nikon F2, introduced in 1971, was manufactured by Nippon Kogaku of Tokyo. Billed as an "Evolutionary System" that advanced the venerable F of 1959, the F2 carried over the appearance and legendary reliability of its predecessor. Knowing its base of professionals, Nikon continued to stress the system concept. All prior Nikkor lenses fit the new camera, and accessories allowed the photographer to meet specific needs. The many featured improvements included a faster shutter speed of 1/2000 second, larger mirror for full image view, interchangeable hinged film back, flash-ready light, short stroke advance lever, repositioned shutter release, meter-on indicator, and rapid rewind crank, among others. The F2 with the 50mm f/1.4 Nikkor lens carried a list price of $550.

Olympus OM-1 *ca. 1973*

Olympus Optical Company, Ltd., Tokyo, Japan.
Gift of Robert A. Sobieszek. 1985:1247:0001.

Olympus of Tokyo, Japan, was a latecomer to the crowded 35mm full-frame single-lens reflex arena. After joining the game with a rather ordinary entry in 1971, Olympus hit a home run with the OM-1 in 1973. Almost overnight, the OM-1 became the star of the entire industry. Olympus applied what they learned from their successful half-frame 35mm Pen SLR to their new design. Much smaller and lighter than its competition, the OM-1 had a brighter viewfinder with easily changed focusing screens, plus an extremely quiet focal-plane shutter with a 1/1000 second maximum speed. Olympus introduced the OM-1 as a full system with dozens of Zuiko lenses (from an 8mm f/2.8 fisheye to a 1200mm f/14 telephoto), motor drives, 250-exposure magazine, and every sort of adapter and accessory for any application. Later OM models featured improvements including fully automatic exposure, autofocus, and even more accessories.

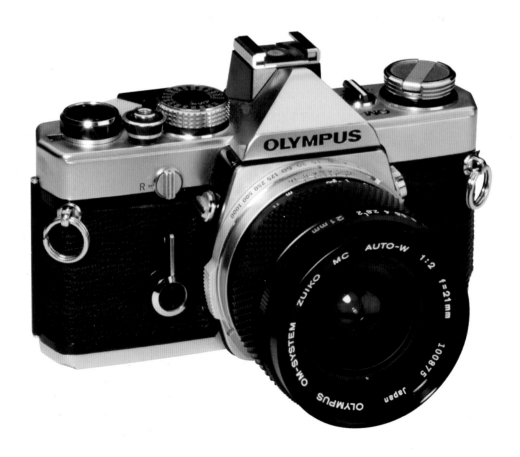

Leica CL 50 Jahre *ca. 1975*

Minolta Camera Company, Ltd., Osaka, Japan.
Gift of Eastman Kodak Company. 1999:0161:0004.

Leitz Minolta CL *ca. 1976*

Minolta Camera Company, Ltd., Osaka, Japan.
Gift of Gerald Lippes. 2008:0432:0002.

Minolta CLE *ca. 1981*

Minolta Camera Company, Ltd., Osaka, Japan.
Gift of Minolta Camera Company. 1984:0165:0003.

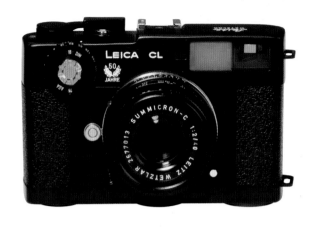

The Leica brand has long been synonymous with high-quality German rangefinder cameras. Yet when Ernst Leitz GmbH decided to make the compact Leica CL (top), the company farmed the job out to Minolta in Japan, marking the first time a Leica was manufactured outside of Germany. While not in the same class as the Leica M series, the CL was no stripped-down, entry-level camera. Offering many of the same features as the M5, it was a much smaller and lighter package and, at $525, cost less than half what Leitz wanted for the bigger camera. The CL had an extremely accurate coupled rangefinder, a 1/1000-second focal-plane shutter, and precise metering right at the film plane. Its standard lens was a German-made Leitz Summicron-C 40mm f/2, with optional Leitz Elmar-C 90mm f/4 telephoto at extra cost. Many of the existing Leitz M lenses could also be used on the camera.

Although the Leica CL sold well enough, the company suspected that many of those sales were coming from the M5's customer base, and the little camera was discontinued in 1976. However, Minolta had been marketing the CL (middle) in Japan as the Leitz Minolta CL, and maintained production under that name for a few more years. The Leitz lens was replaced by an identical Minolta M-Rokkor, which was interchangeable with the German lenses. Sold in the U.S. as the Minolta CL, this all-Japanese product was identical to the Leica-branded camera.

In 1981, Minolta gave the CL a major overhaul. Known as the Minolta CLE (bottom), the new camera was similar in appearance to the CL, but considerably advanced. A longer rangefinder base meant a slightly larger body, which had a hinged rear door instead of the removable back panel favored by Leica. The film speed dial had an automatic setting for aperture-preferred exposures, using stepless shutter speeds. The meter read the light at the film surface, and the electronic shutter had a self-timer delay. Minolta also offered a 28mm f/2.8 wide-angle lens. For several years, the CLE had the distinction of being the most technically sophisticated M-mount camera, until it was finally eclipsed by Leica's own M7. At $784 for a CLE with the 40mm M-Rokkor, the Minolta rangefinder wasn't cheap, but it was still hundreds less than a Leica.

Canon AE-1 *ca. 1976*

Canon, Inc., Tokyo, Japan,
Gift of Canon USA, Inc. 1985:0966:0003.

Introduced in 1976, the Canon AE-1 was a shutter-preferred, auto-exposure camera and the first 35mm SLR to use a central processing unit (CPU). The CPU regulated operations like exposure memory (known then as exposure lock), aperture value control, and the self-timer. The rest of the camera's circuitry, which controlled functions such as shutter speeds and the exposure counter, was traditional analog. An aggressive advertising campaign and automated modular construction techniques that lowered production costs resulted in sales of five million units, making the AE-1 the best-selling 35mm SLR of its day and Canon the top Japanese camera manufacturer.

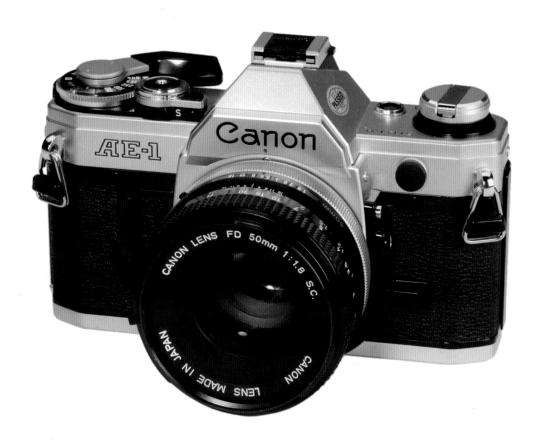

Konica C35AF *ca. 1977*

Konishiroku Photo Industry Company, Ltd., Tokyo, Japan.
Gift of Berkey Marketing Companies, Inc. 1978:0915:0001.

Konishiroku Photo Industry Company, Ltd., of Tokyo introduced the Konica C35AF in late 1977. The world's first production autofocus camera, it used the Visitronic AF system developed and produced by the American firm Honeywell. Other features included programmed automatic exposure and a built-in electronic flash.

The C35AF had a passive autofocus system, which, like an electronic rangefinder, senses the distance by triangulation—calculating the subject's distance by determining the angular variation between two widely spaced detectors. Two years later an active autofocus system was introduced by Canon in the AF35M. Ultimately, the active system gained traction and proved to be more popular.

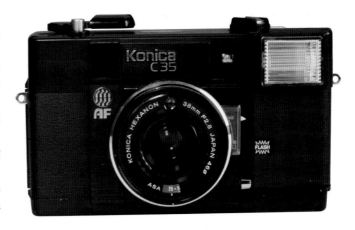

Canon Sure Shot AF35M *ca. 1979*

Canon, Inc., Tokyo, Japan.
Gift of Canon USA, Inc. 1983:0577:0001.

The Canon AF35M, introduced in 1979 by Canon, Inc., of Tokyo, was called the Sure Shot in the U.S. and the Auto Boy in Japan. It was the first camera to employ infrared focusing—an active autofocusing system. A passive autofocus system uses available light to fix on an object and often fails in low-light conditions. Sure Shot's system provided its own light source that sent out an infrared signal and received the reflected light to measure distance. The signal was limited to twenty-seven feet, at which point the camera selected infinity focus. Canon's strategy of giving the camera a name instead of just a model number brought back a practice that had lost popularity in the photo industry. However, as one of the most popular

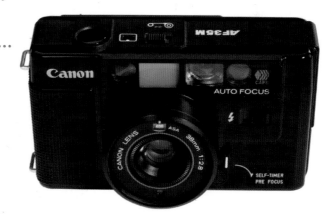

cameras ever made, with nearly one million sold in North America alone, the Sure Shot started an industry-wide naming trend.

Olympus XA2 *ca. 1980*

Olympus Optical Company, Ltd., Tokyo, Japan.
Gift of Olympus Camera Corporation. 1981:1296:0021.

The Olympus XA series of ultra-compact 35mm cameras, produced by Olympus Optical Company, Ltd., of Tokyo, debuted in 1979. The XA had a coupled rangefinder for focus, automatic exposure, and an f/2.8 Zuiko lens. The XA2 had a zone-focus system and programmed shutter instead of rangefinder and aperture-priority, and an f/3.5 lens. The XA1 was simpler yet, with a fixed-focus f/4 lens. All the XA cameras had the same sliding cover that functioned as the lens protection and on-off switch. A detachable flash kept the body as small as possible. Film advance was handled by a ridged thumbwheel on the right side. The XA cameras stayed in production until the mid-1980s, when autofocus cameras with power winders began to dominate the sales charts.

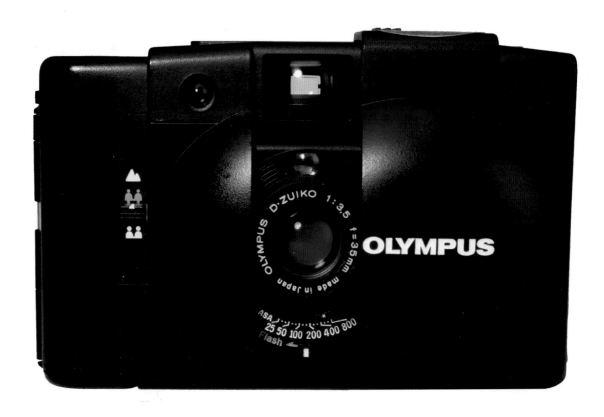

Nikon F3 *ca. 1980*

Nikon, Inc., Tokyo, Japan.
Gift of Nikon, Inc. 1981:3208:0001.

In 1980, Nikon passed the torch to a new flagship model, the F3. Built on the system approach used by its predecessors the F and F2, it still shared the same bayonet lens mount but was fitted with a more accurate electronically controlled titanium foil shutter, a battery-saving built-in LCD meter, and automatic exposure control. Also like the earlier cameras, it accepted interchangeable finders and viewing screens, making the camera adaptable to just about any photographic assignment. Famed Italian auto designer Giorgetto Giugiaro consulted on the camera's exterior design, creating an appealing look. The Nikon F3 was one of the cameras used by NASA on the Space Shuttle, and Eastman Kodak Company chose the F3 as the basis for its Kodak DCS 100 professional digital camera in 1991.

At introduction, the F3 retailed for $1,174.90, including a 50mm f/1.4 lens. It remained in production for more than twenty years, some five years longer than its older sibling, the F model. An autofocus model, the F3AF, was introduced in 1983. Three sequential models concluded with the Nikon F6. A true workhorse, the F3 no doubt cut the mustard in the field, yet it never really gained the iconic status held by its older mechanical siblings.

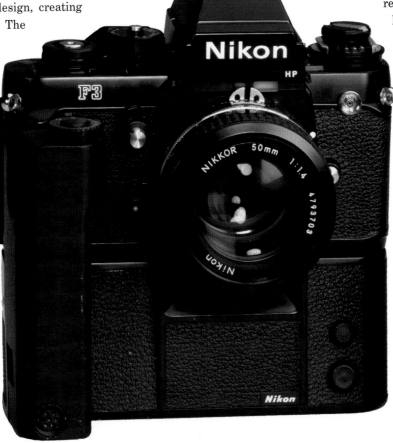

Rolleiflex SL2000F *ca. 1980*

Rollei Fototechnic GmbH, Braunschweig, West Germany.
Gift of Berkey Marketing Company. 1983:0694:0002.

The Rolleiflex name dates back to 1929, with the introduction of the first model in a very successful line of 6 x 6-cm twin-lens reflex cameras. That format would remain in production for more than seventy-five years. The company later made other types of cameras under the Rolleiflex brand, including a line of 35mm SLRs. Most of its 35mm cameras were indistinguishable from dozens of other makes coming out of Europe and Japan, but the Rolleiflex SL2000F was a sharp break from convention. The shape itself set it apart, as the camera looked and worked a lot like Rollei's modular medium-format SLRs. In addition to the eye-level prism finder found on all 35mm SLRs, the SL2000F had the waist-level finder of its larger-format siblings. A flip-up magnifier aided ultra-critical focusing, and the viewing screen was removable so that optional screens could be substituted according to user preference. Another family resemblance was the use of interchangeable magazines, which allowed mid-roll film changes. Exposure settings were made using the shutter speed dial on the top and the aperture ring on whichever of the many available lenses was mounted. Dozens of bayonet-mount lenses, from Rollei or Zeiss, were designed to fit the SL2000F, in lengths from 14mm to 1000mm, as well as several zooms. Fifteen speeds, from sixteen seconds to 1/1000 second, were possible. The speed dial could also be set to "A" for aperture-priority automation or "X" for flash synchronization. A shutter button on each side of the camera allowed for both right- and left-handed operation. The power winder was part of the package rather than an option, with a quick-change pack of five AA cells that also powered the meter and shutter.

Despite its great features and performance, the SL2000F never found traction in the market. Its $2000 price tag made buyers hesitate at a time when the competition was bringing new 35s with more automation to the showcases, selling them at a fraction of the cost of this Rolleiflex. With breakthroughs like autofocus and digital imaging on the horizon, there was no future for a machine like the SL2000F, and it faded into history.

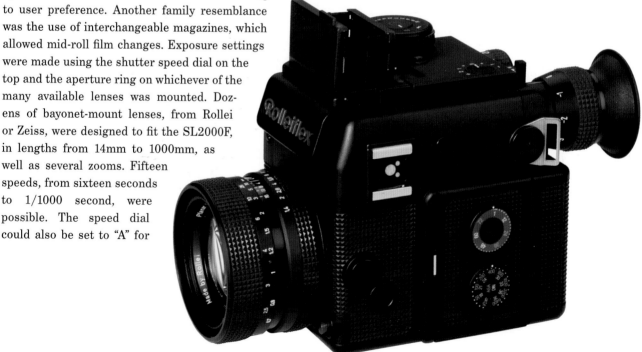

Nikon FM2 *ca. 1982*

Nippon Kogaku K. K., Tokyo, Japan.
Gift of Nikon, Inc. 1983:0583:0001.

The Nikon FM2, introduced in 1982 by Nippon Kogaku of Tokyo, was the last all-manual mechanical Nikon SLR. Recognizing that a portion of its customer base was still uncomfortable with auto-anything, the company billed the camera as "The Perfectionist's Nikon," while the brochure stated "Automation is fine, but you want to be in control." Two significant improvements were X flash synchronization to 1/200 second and a shutter speed of 1/4000 second, both the world's fastest. The shutter speed was made possible by the development of a new titanium focal-plane shutter with a honeycomb pattern that reduced the thickness of the blades and thus the weight of the moving parts by fifty-eight percent. The retail price of the FM2, body only, in black was $313.50. With the 50mm f/1.4 AI Nikkor lens shown here, the price was $614.50.

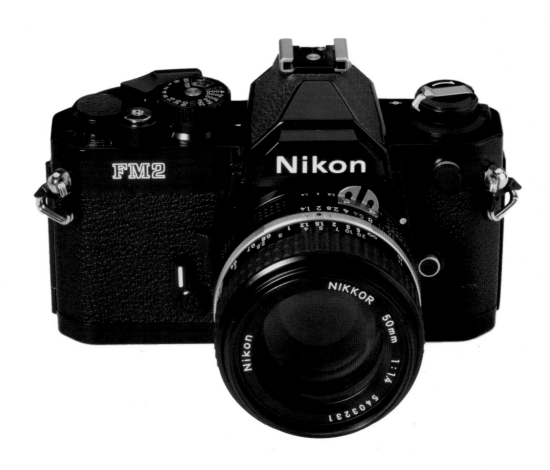

Leica M6 *1984*

Ernst Leitz, Wetzlar, West Germany.
Gift of Leica USA, Inc. 1988:1020:0001.

Leica M7 *2002*

Leica Camera AG, Solms, Germany.
Gift of Gerald Lippes. 2008:0428:0054.

The M-series Leica, designed by a team led by Willi Stein and Dr. Ludwig Leitz in the 1950s, is considered by many to be the finest 35mm rangefinder ever produced. Over the years, many improvements were made to the camera, but in an evolutionary way, so that newer models bear more than just a casual resemblance to those of the 1950s. Few, if any, apparatus have evolved in this manner, but then, Leicas are not like other cameras.

In 1984, Leitz introduced the Leica M6 which, simply explained, was a Leica M4-P updated with a built-in exposure meter. The short-lived Leica M5 of the previous decade had also featured a built-in exposure meter, but it used a cell on a swing-away arm that required a larger body to accommodate its 1970s vintage electronics. By the mid-1980s, smaller components allowed an LED meter system to be fitted into the classic Leica M shape. Powered by a three-volt battery, and rated for films from ISO 6 to 6400, a stationary sensor read the light reflected from a white dot located on the center of the shutter curtain. This allowed for accurate "practically off the film plane" exposure sensing. Like the earlier Leica M4-P, the Leica M6 viewfinder featured bright frame lines for three pairs of lenses: 28 and 90mm; 35 and 135mm; and 50 and 75mm. The 21mm lens, not framed in the finder, used an auxiliary top-mounted viewfinder.

In 2002, the M7 continued the Leica M camera evolution, this time adding an aperture-preferred automatic exposure system. To operate the camera, the photographer simply chose a lens opening, while the electronically controlled shutter, selecting from a speed range of thirty-two seconds to 1/1000 second, provided the correct exposure. Of course, as one would expect, the camera could also be used for metered manual operation, with the metered LEDs visible in the viewfinder. Virtually all Leica M accessories (motor drives and lenses) also fit the M7. The camera requires more power (a six-volt battery) to operate the shutter, has a larger shutter speed dial to accommodate the additional timed speeds of two and four seconds and the Auto setting, and its body is slightly taller than its earlier Leica M siblings.

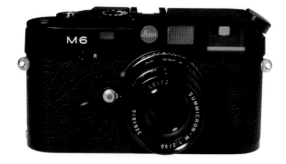

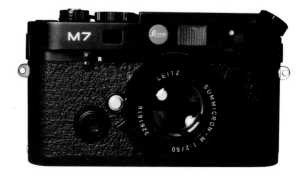

Maxxum *ca. 1985*

Minolta Camera Company, Ltd., Osaka, Japan.
Gift of Minolta Company, Ltd. 1985:0961:0005.

When Minolta Camera Company, Ltd., of Osaka, Japan, announced the Maxxum 35mm single-lens reflex system in 1985, the market for SLR thirty-fives was jolted from its doldrums. With a body molded of tough polycarbonate, the Maxxum was both attractive and dent-resistant. A technological leap, it packed features like programmed exposure, autofocus, and power winding into a normal-sized body for true point-and-shoot operation. Autofocus lenses for 35mm SLRs weren't new, but previously they were bulky, slow, and expensive. The Maxxum design moved the focus drive motor inside the camera, so its lenses were no larger than conventional designs. Minolta's focus system was remarkably fast, no matter which of the eighteen AF lenses was mounted. Customers wanting to do their own exposure settings and focus could set the camera for full manual control. The Maxxum became an almost immediate target for the competition, and most eventually caught up, but Minolta's technology set standards still in place in the digital age.

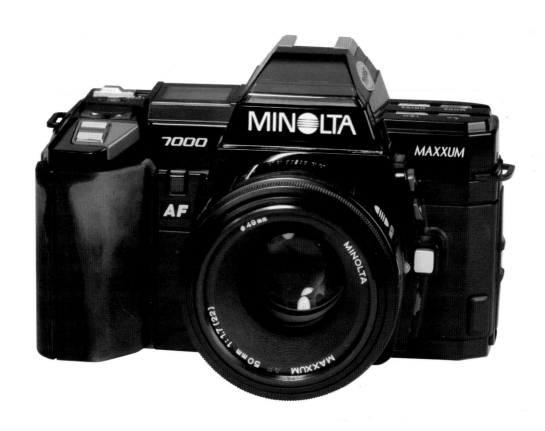

Olympus O-Product *ca. 1988*

Olympus Optical Company, Ltd., Tokyo, Japan.
Gift of Mr. and Mrs. Robert L. Freudenheim. 2003:1101:0002.

The O-Product, despite its unusual styling, was a point-and-shoot 35mm camera with features and specifications similar to the Olympus Stylus 35. Made in limited quantities by Olympus Optical Company of Tokyo, the 1988 camera had an aluminum body with a unique round-peg-in-a-square-hole shape. The lens cover opened and closed via a chrome lever resembling an alarm clock key, and the shutter release was a dime-sized button flush with the front panel. The detachable flash was plastic painted the same silver as the body. Automatic exposure, autofocus, and power wind/rewind helped the O-Product live up to the motto revealed when the film door was opened: "Functional imperatives molded to artistic form."

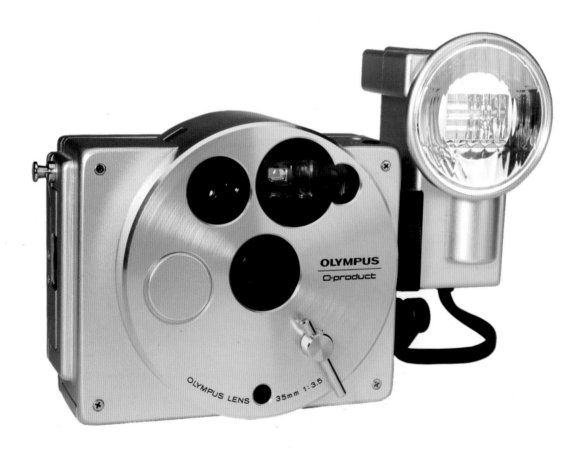

Canon Photura *ca. 1990*

Canon, Inc., Tokyo, Japan.
Gift of Canon USA, Inc. 1991:2785:0001.

Although probably the only 35mm camera that could be said to resemble a beer stein, the Canon Photura actually looked and functioned more like a video camcorder than a still camera. When the hinged lens cap swung open, the camera turned on, as the inside of the cap, which now faced the photographer's subject, held the flash unit. The handle provided a grasp similar to camcorders of the time, which allowed for one-handed operation. As a point-and-shoot with autofocus and built-in zoom lens, the camera was designed for everything to be done with the right hand. With the hand inside the strap, the thumb supported the camera while a single finger controlled the zoom and shutter. Perhaps this novel form and grip prompted Photura's slogan: "Hold the future of photography in your hand." Other features included dual viewfinders, for shooting at eye or waist level, and a date back with five pre-programmed messages like "Happy Birthday" and "Congratulations." No wonder that Canon proclaimed the Photura as "Daring to be different."

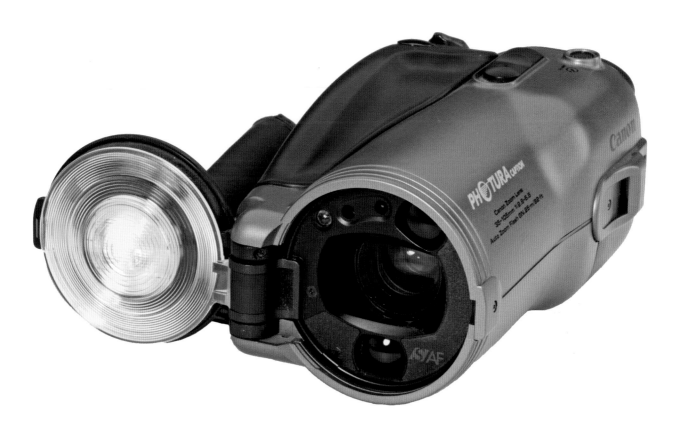

Contax T2 *ca. 1991*

Kyocera Corporation, Tokyo, Japan.
Gift of Yashica, Inc. 1991:2829:0002.

Although Zeiss Ikon AG stopped producing Contax cameras in 1961, the revered brand was revived in 1975 by a joint venture with Yashica of Tokyo. In 1990 this successful collaboration produced the Contax T2, a titanium-bodied compact with all the features that made point-and-shoot 35mms so popular. A lithium battery fueled the T2, from the power winder to the retractable Carl Zeiss 38mm f/2.8 Sonnar T* lens (* indicating the improved, powder-coated version of the Sonnar T) and the metal slide that covered the lens when the camera was switched off. Automatic exposure and flash were expected on cameras of this type, but the T2 also provided manual control. The focus knob could be locked at infinity or adjusted until the finder gave the green light signaling correct focus for the subject. A ring on the lens adjusted the aperture, if desired, and turned off the automatic flash. The finder displayed the shutter speed selected by the camera program. A premium-priced camera at $550, the Contax T2 used some exotic materials at wear points. The pressure plate was made of hard ceramic, and the viewfinder elements were scratchproof sapphire glass. Even the shutter button was built for long life, made with polished synthetic sapphire.

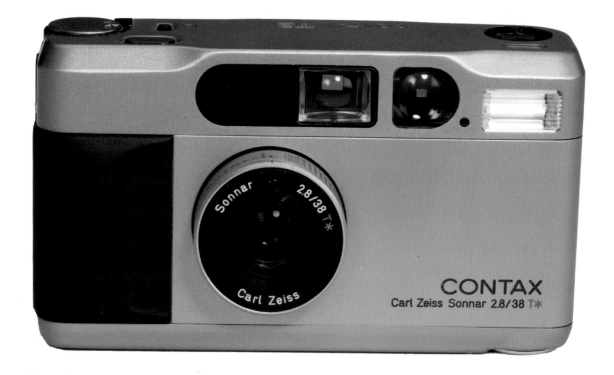

FX-4 *ca. 1994*

Samsung Aerospace Industries, Tokyo, Japan.
Gift of Samsung Aerospace Industries. 1994:1478:0001.

The Samsung FX-4 35mm camera featured a distinctive design by F. A. Porsche meant for maximum ergonomic comfort and user friendliness. A large zoom lens (snout), curved grip (ears), and symmetrical autofocus (eyes) led the company to poke fun at itself in the user's manual in which the camera was represented as a cartoon elephant. The camera was well featured with a 38mm to 140mm zoom lens and numerous user-selectable exposure, flash, and focus modes. Samsung introduced it at PMA, the American trade fair of the Photo Marketing Association, in the fall of 1994, ten years after producing its first independent camera design.

Nikon 28Ti *ca. 1996*

Nikon Camera Inc., Tokyo, Japan.
Gift of Eastman Kodak Company. 2010:0066:0011.

When it started to become obvious in the late 1990s that the film camera was in its twilight years, manufacturers tried to create some buzz and usher the old technology out in style. Designed to be the last word in 35mm point-and-shoot gear, Nikon's 28Ti seemed the result of someone's order for "the best you can do and hang the expense." The camera was named for its 28mm f/2.8 lens and titanium body, which was both light and strong. Naturally, it had autofocus, automatic exposure, power winder, and auto flash, but so did many cameras priced far lower than the 28Ti's $1220 sticker. Nikon endowed the 28Ti with multi-mode flash, which could be set to Automatic—leaving the decision to the light meter—plus Always On or Always Off. Exposure control could be set to Programmed or Aperture Priority, and a pair of doors at the film plane could mask the image for a panorama effect by sliding a button next to the finder. Instead of a knob or LCD readouts for aperture, exposure compensation, and counter, Nikon placed an analog dashboard on the top plate, with black numbers and needles on a white background, resembling an old-school sports car instrument panel. Rather than the thumbnail-cracking slide button most cameras used to unlatch the rear door, Nikon used a folding key that popped the back open with a quarter-turn. When the power was switched off, a lens cover closed over the glass, helping it stay dust- and scratch-free. The 28Ti helped give the long and proud era of Nikon film cameras a proper send-off.

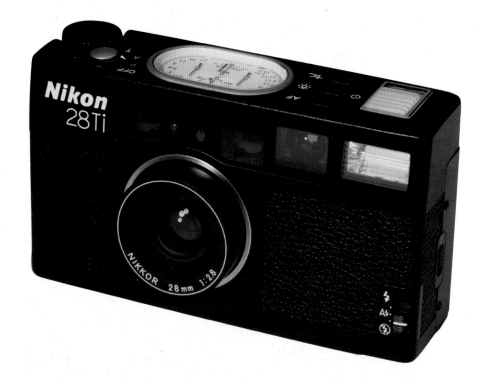

PROFESSIONAL

Photography, like most trades, has always had a line of tools designed with the professional in mind. Whether for location or studio work, manufacturers have produced purpose-built cameras with features tailored to meet photographers' specific needs. These are the flagship cameras and are typically used to promote the rest of the company's product line. And as one would expect with tools used on a daily basis, professional cameras tend to be more robust and more expensive than their amateur cousins. Many of the features now seen in amateur cameras saw their debut in the professional's tool bag.

Carte-de-visite camera (OWNED BY ANDRÉ-ADOLPHE-EUGÈNE DISDÉRI) *ca. 1860*

Unidentified manufacturer, France.
Gift of Eastman Kodak Company, ex-collection Gabriel Cromer. 1974:0037:2590.

Photography studio operators depended on a steady flow of customers in order to make ends meet, and this often meant coming up with novel products and services. Since portraiture made up the bulk of their business, variations on the form were in order. Starting in the late 1850s in Europe, and a bit later in America, a very popular portrait format was the carte-de-visite, a fits-in-your-palm, 3½ x 2½-inch, card-mounted paper photograph that people exchanged with family, friends, and business associates. In order to make production faster and cheaper, cameras with multiple lenses were designed to take two or more identical images in a single exposure.

Photographer André-Adolphe-Eugène Disdéri (1819-1889) patented a method of producing eight carte-de-visite images on a single wet collodion plate. Produced by an unidentified French manufacturer, this camera belonged to Disdéri himself. The camera is of the double-box type with a repeating back, which allowed the plate holder to slide from side to side, doubling the number of images per plate. Access to focus the four Petzval portrait lenses was through the hinged doors mounted on the camera's sides. In essence, the Disdéri carte-de-visite system lowered the cost of making portraits.

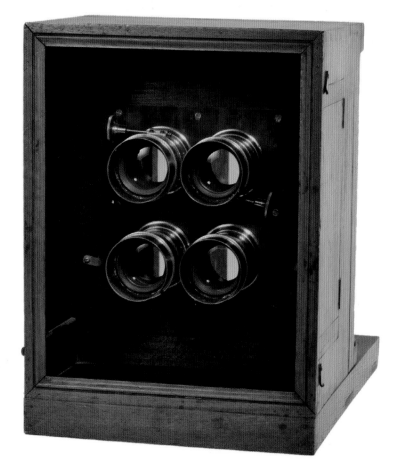

Wing Multiplying Camera *ca. 1862*

Simon Wing, Boston, Massachusetts.
Gift of the Wing Estate. 1974:0037:2889.

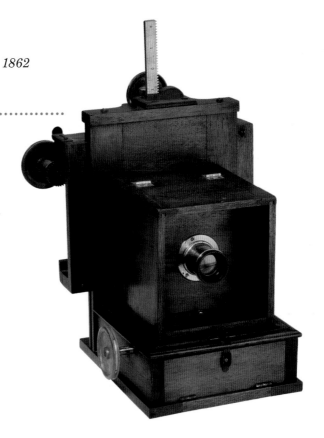

In the early 1860s, Simon Wing (1826-1910) of Boston, Massachusetts, introduced a number of studio multiplying cameras that, as the name suggests, allowed photographers to make an increased number of images on a single plate. This was achieved by moving either the lens or the back to allow exposure of different areas of the plate. Such cameras were commonly used in the production of tintypes, which were inexpensive direct-positive collodion images on a thin metal plate. Wing recognized the popularity of his apparatus for making tintypes and in 1863 patented a card mount that enabled the metal images to be displayed in the pages of photographic albums.

This particular camera could be fitted with a single lens or a set of four lenses. Depending on the lens and back configuration, a single image or up to seventy-two images could be produced on a single 4 x 5-inch plate.

Gem Apparatus *ca. 1880*

J. Lancaster & Son, Birmingham, England.
Gift of Eastman Kodak Company,
ex-collection Gabriel Cromer. 1983:1421:0081.

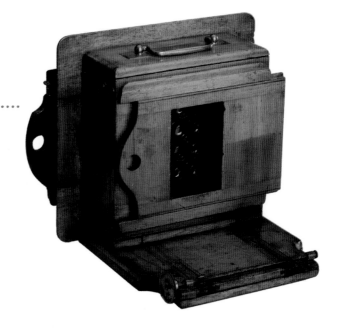

The Lancaster Gem Apparatus, of about 1880, produced twelve identical "gem"-sized images (less than one inch square) with a single exposure. Small, inexpensive photographs produced on ferrotype plates were very popular in the 1880s and 1890s. The lenses were simultaneously focused on a ground glass, and internal partitions kept the images separated. An opening in the sliding front panel served as the shutter, making manually "timed" exposures. The camera's back accommodated wide plates for making more than a single group of images on a plate. Its list price was £5.

New Gem Repeating Camera *ca. 1882*

Simon Wing, Charlestown, Massachusetts. 1974:0037:0155.

Simon Wing designed his New Gem Repeating Camera in 1882 to make fifteen 1 x 1-inch images on a 5 x 7-inch metal "tintype" plate. The New Gem could do this by means of its moveable mount for the Darlot 120mm f/6 periscopic lens. The mount could be locked in one of three vertical positions in the brass frame, which itself was free to move sideways to be set at each of the five scribed marks. Overlapping sliding panels moved with the lens board to seal against light leaks. Inside the hardwood box, a rectangular wooden tube that moved with the lens and extended to almost touch the plate kept the image edges distinct. An eye-level viewfinder was mounted on a brass stalk attached to the moveable board so it was always aligned with the lens. The shutter was attached to the front of the lens and operated by a squeeze bulb and rubber tube. After development, the plate was cut apart to make the postage-stamp size pictures. Wing's Charlestown, Massachusetts, cameraworks priced the New Gem at $6.50.

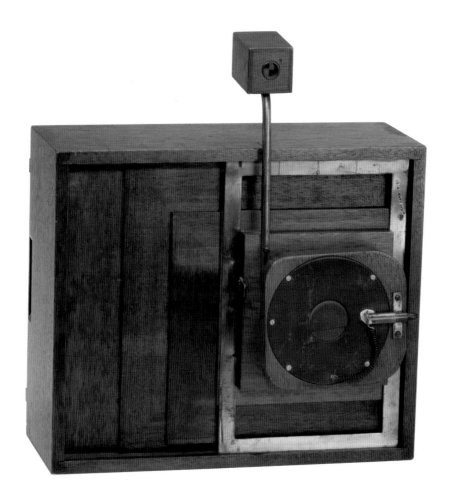

Gem Camera *ca. 1895*

J. Audouin, Paris, France.
Gift of Eastman Kodak Company. 1974:0037:2494.

Known as multiplying cameras, the many-lensed machines used to make cartes-de-visite soon used even more optics to make another popular photographic format, the tiny "gem" photos. Usually less than an inch tall, these came in a variety of media and products. A person could buy pins or pendants that held the tiny likenesses of loved ones, stamps that could be pasted to envelopes, or even buttons to be sewn on to garments. Several makers offered cameras to take these pictures, some with as many as sixteen lenses. This example, by J. Audouin of Paris, used twelve lenses aimed at an egg-crate divider to group a dozen images on a single plate. The rear standard adjusted for focusing, and when the image was sufficiently sharp, the ground glass screen was replaced by a sensitized plate. With the slow emulsions of the day, no shutter was needed. A simple dark cloth over the lenses did the job, provided the subject could sit perfectly still for the few seconds it took to make the exposure.

Today, the concept of multiple identical portraits on a single sheet survives in the school picture business, although the multiplying is performed in the printing process and not by the camera.

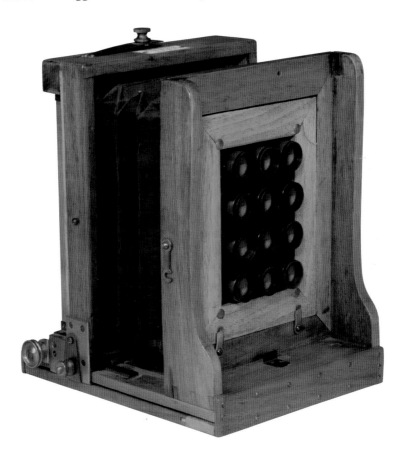

Multiplying camera *ca. 1900*

Jacob Schaub, Logan, Utah.
Gift of Dr. Raymond J. Bungard. 1992:1043:0001.

The multiplying camera had been around for more than four decades before Jacob Schaub of Utah patented his in 1900. The idea was to divide a plate or sheet of film into equal parts and expose each portion with a separate image. Some designs utilized moveable lenses, others multiple lenses, and some used both. Schaub's had one fixed lens, but the back could be indexed for six, fifteen, or twenty-four pictures. Inside the bag bellows a square tube behind the lens could accept one of the three reducing extensions according to image size desired. After that, the photographer squeezed a bulb to open the shutter, and viewed the ground glass while turning the lens focus knob, after which he closed the shutter again. Inserting a plate holder was easy with the bail lever that pulled the focus screen back far enough to slip in a holder without effort. Brass leaf springs secured the holder when the bail was released. A unique system of dividing the plates into equal sections used three rows of equally spaced holes in the back, which were adjusted by a geared movement. A lever under each cover had a pin that fit into the holes and locked the back for each exposure. The levers themselves were pivoted and locked in place to pick up the correct series of dividing holes. Schaub's camera never took off, and only a few were made.

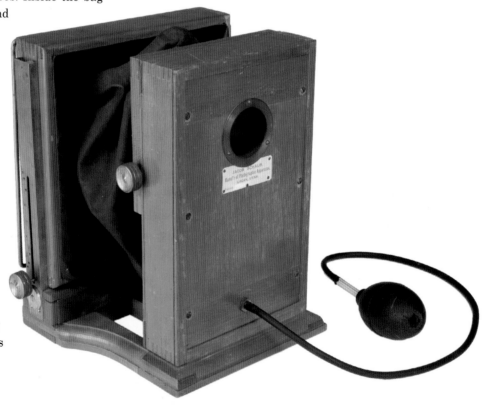

Century Grand Studio Camera *ca. 1904*

Century Camera Company, Rochester, New York. 1978:1371:0057.

It would seem to go without saying that the essential tools of the portrait photographer would be a studio and a camera. And yet, for the portrait photographer of the past, it was not as simple as that. Just as any hammer won't do the job right for the carpenter, most cameras were not suited to the work of the portrait photographer. When nails are pounded, the tool of choice is a claw hammer, not a mallet or ball-peen or sledge, and when formal portraits were made, the best camera for the job was a studio, not a field, detective, or subminiature model. Cameras, like hammers, are designed for specific purposes.

For more than fifty years, the Century Studio camera was the prime apparatus used for portraiture. The company began producing cameras in 1900 and within two years listed studio cameras in its catalogs. Eastman

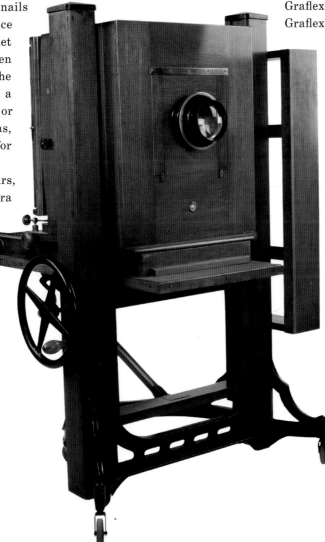

Kodak Company acquired Century in 1903 and Folmer & Schwing Manufacturing in 1905, merging the two to create its professional apparatus division, which produced studio cameras through 1926. After that, the division was spun off and the new company continued to make the Century Studio Camera, first as Folmer Graflex (1926-1946) and then as Graflex, Inc. (1946-1955). The camera was sold separately or in a grouping known as the Century Universal Studio Outfit, which consisted of the camera, the Semi-Centennial Stand, and one plate holder. Numerous styles of backs were offered, allowing the photographer a choice of image sizes.

Royal Mail Stamp _1907_

W. Butcher & Sons, London, England. 1997:0207:0001.

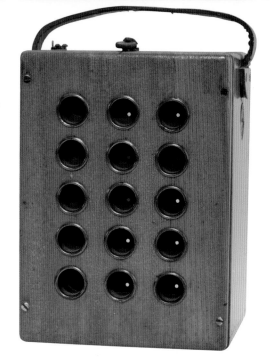

The Royal Mail Stamp camera, manufactured from 1907 to 1915 by W. Butcher & Sons of London, was another multiplying camera. Unlike the moving-lens, moving-back cameras, this polished mahogany fixed-focus camera was designed to expose all images simultaneously. Typically, it was used to make multiple copies of cartes-de-visite or cabinet portraits, and Butcher offered a copy stand for that purpose. The camera shown here was outfitted with a fifteen-lens front that made fifteen stamp-sized images, $\frac{3}{4}$ x $\frac{7}{8}$ inches each, on a $3\frac{1}{4}$ x $4\frac{1}{4}$-inch plate. The front was removable and could be replaced with a three-lens set, allowing the camera to produce either three or six exposures.

Press Graflex _ca. 1908_

Folmer & Schwing Division of Eastman Kodak Company, Rochester, New York. Gift of Graflex, Inc. 1974:0037:2593.

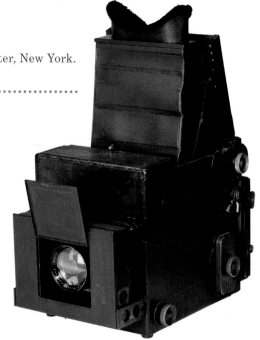

Manufactured by Eastman Kodak Company's Folmer & Schwing Division in Rochester, New York, from 1907 to 1923, the Press Graflex shared features with many Graflex cameras of the time. These included an extensible front with no bed, a detachable spring back holding individual plates or a film pack, a focal-plane shutter curtain, and a large reflex viewing hood that was contoured to the photographer's face. The Press Graflex was available only in the 5 x 7-inch size and, as the name implies, was targeted to the newspaper photographer. The retail price with a Bausch & Lomb Zeiss Tessar lens was $169.50.

Penny Picture Camera *ca. 1910*

Eastman Kodak Company, Rochester, New York. 1974:0037:2660.

Built for the seasonal resort photographer, the Penny Picture Camera was the smallest member of the Eastman Kodak family of flat-bed studio cameras. With roots that extended back to the original Century Camera Company, the Penny was an established standard in many studios that might be in operation only a few months each year. Fitted with a repeating back capable of both horizontal and vertical movements, the 5 x 7-inch camera was indexed for producing eight different exposure counts, for as many as twenty-four images on a single plate. This versatility made it quite useful for producing a variety of the inexpensive memento photos that were the bread and butter of the photographer who catered to a vacationing clientele. And at $40, including the No. 5 Century Portrait lens, the price made it an affordable tool for such brief but intense work.

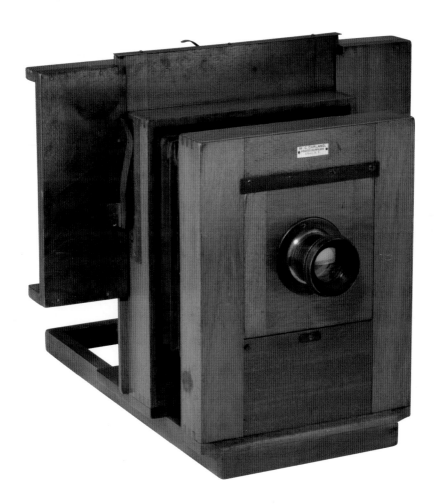

Ermanox (4.5 x 6 cm) *ca. 1924*

Ernemann-Werke, Dresden, Germany.
Gift of Mike Kirk. 2001:0484:0001.

Ermanox (9 x 12 cm) *ca. 1924*

Ernemann-Werke, Dresden, Germany.
Gift of Charles Spaeth. 1974:0037:1475.

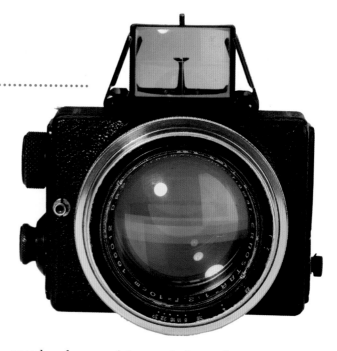

Before the Ermanox, indoor pictures and other low-light situations needed very long exposure times or some form of flash device. In 1924, the Ernemann-Werke in Dresden, Germany, announced a different approach to available light photography with what they billed as "the most efficient camera in existence." The Ermanox's massive 10cm f/2 Ernostar lens dwarfed the cigarette-pack-sized body (right) and could focus enough light on a 4.5 x 6-cm film plate to record scenes using normal room light with a shutter speed fast enough to freeze motion. The focal-plane shutter had a 1/1000-second top

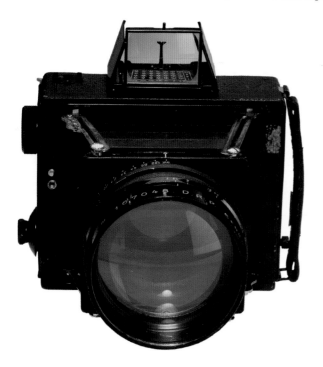

speed and was quiet enough for unobtrusive use during a theater performance. Focus could be done three ways: through the lens with a ground glass screen, using the distance scale on the lens ring, or using the folding Newton finder on the top of the camera. The camera was priced at $190.65, which included a film pack adapter, three plate holders, and a carrying case. Larger Ermanox models were added, such as this 9 x 12 cm (left) with a collapsing bellows and a 16.5cm f/1.8 lens, which otherwise was a scaled-up version of the original camera. It sold for $550 in 1926.

Studienkamera C *ca. 1927*

A. Stegemann, Berlin, Germany.
Gift of Robert L. Bretz. 1974:0028:3450.

The German Studienkamera (studio camera) C was designed by photographer Heinrich Kühn and produced by A. Stegemann of Berlin in the late 1920s. It is a monorail-style view camera, which provides a studio photographer with the most flexibility for camera movements and lens choice because both the front and rear standards can be mounted on virtually any location on the common rail support.

This camera is fitted with a Rodenstock Imagon lens, a soft-focus lens also designed by Kühn, who is best known for his pictorialist imagery. The Imagon, introduced in 1931, used a system of interchangeable diaphragm discs, each with a different-sized main aperture, to control the relative sharpness of the image. Rotating each disc revealed a secondary series of smaller apertures that modified the softness of the image. Advocates of the Imagon lens claim the secondary aperture accounts for the "clear yet luminous, defined yet soft, irradiated effect" described in Rodenstock literature.

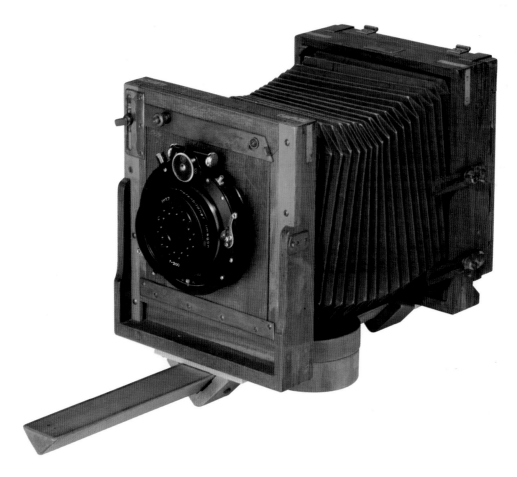

Spido Pliant Gaumont Type Tropical *ca. 1925*

L. Gaumont & Cie, Paris, France. 1974:0028:3132.

French cameras of the early 1900s, especially those from Gaumont of Paris, often had a particularly industrial appearance, yet less in a modern sense than in a back-to-the-future, Jules Verne kind of way. Their designs hark back to the days when engineering marvels were works of iron, like the Eiffel Tower, instead of moving toward the curvy, streamlined look of speed that we now associate with the twentieth century. Even with its teakwood body, a material more readily associated with handcraft than machine work, the Spido Tropical had the feel of a one-off prototype. The Tropical was part of Gaumont's Spido series of pliant (folding) cameras popular with press photographers. The vertical focal plane shutter could freeze sports action with its 1/2000 second maximum speed. A Newton finder with pendulum sight folded down when not in use. The mounting board for the Zeiss Krauss Tessar 13.5cm f/4.5 lens had rise and shift movements for perspective corrections. The teak and brass magazine held a dozen 9 x 12-cm film plates that could be quickly changed by pulling the magazine out by its handle and pushing it back in place. Loading and unloading the plates was a darkroom job.

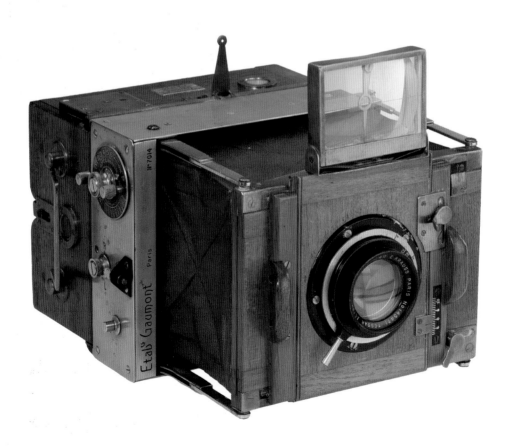

Ermanox Reflex *1926*

Zeiss Ikon AG, Dresden, Germany. 1974:0028:3102.

In 1926, the same year Ernemann-Werke AG added the Ermanox Reflex to its catalog, the company joined with four other major German photographic manufacturers to form Zeiss Ikon. The new firm retained many of the existing products from the individual companies, including the Ermanox Reflex. The original Ermanox was a sensation when introduced in 1924. Until then, indoor pictures required either very long exposure times or some sort of flash. The Ermanox was fitted with a lens five times faster than the typical cameras of the day, giving it a welcome low-light capability. With a smallish body barely large enough to fit its outsized lenses, the camera was unusual in appearance as well as function.

The Ermanox Reflex, a single-lens reflex model and the last of its line, sported an impressive 10.5cm f/1.8 Ernostar lens custom-built by Carl Zeiss Jena. The waist-level finder gave the photographer the image seen by the big lens, thanks to the retracting mirror housed inside the camera's heavy cast metal body. Alternatively, a folding hood on the back panel could be fitted with a ground glass screen for viewing directly through the lens once the shutter was locked open and the mirror raised. In either case, lens focus was adjusted by turning a small knob on the lens barrel that rotated the helical band on the movable part of the lens assembly. The shutter's fastest speed was 1/1200 second, and for low-light shots at slower speeds, the camera could be tripod mounted. The Reflex was used mostly with packs of 4.5 x 6-cm film sheets, although single sheets could be shot in the film holder. Not a cheap camera at $275, it was delivered with a vertical focal-plane shutter, the Zeiss lens, three film holders, and leather carrying case. The film pack adapter was a $39 option. While the Ermanox was in production only until 1929, it became a benchmark for available-light photography.

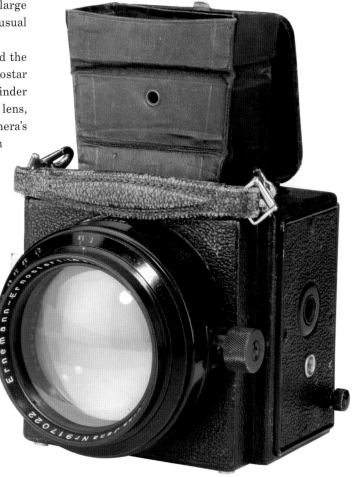

Anniversary Speed Graphic (USED BY JOE ROSENTHAL) *1940*

Folmer Graflex Corporation, Rochester, New York.
Gift of Graflex, Inc. 1974:0037:2885.

I n 1912 the Folmer & Schwing Division of Eastman Kodak Company introduced the first Speed Graphic. This was to become one of the best-known cameras of the twentieth century, particularly with news photographers in the 1930s, displacing the larger 5 x 7-inch Press Graflex as their camera of choice. The camera borrowed many of the features of the company's Cycle Graphic camera, but was simplified to emphasize the focal plane shutter in a more compact body.

In celebration of fifty years of camera manufacturing, in 1940 the Folmer Graflex Corporation introduced the Anniversary Speed Graphic. The camera was available in two sizes, 3¼ x 4¼ and 4 x 5. Improvements included a rising and shifting front on a new steel dropping bed, and a new tandem track with rack-and-pinion focusing from either side. It was made more attractive with new chrome details, though the wartime cameras had all-black trim, as shown here. The retail price with a 5½-inch Kodak lens was $125 in 1940.

This very camera was used by Pulitzer Prize-winner Joe Rosenthal to capture the famous flag-raising at Iwo Jima in 1945.

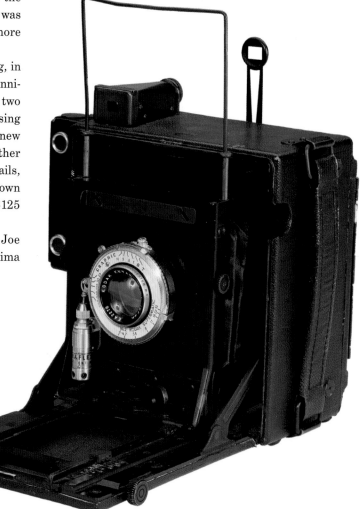

Medalist II *ca. 1946*

Eastman Kodak Company, Rochester, New York.
Gift of Allen C. Priday. 1987:1509:0001.

The Medalist II of 1946 was an improved version of the Medalist of 1941. The original was designed as a medium-format, sturdy multipurpose camera using No. 620 roll film. It had a wide-base split image rangefinder, double helix focusing tube, and a complete array of replacement backs, allowing ground glass focusing, film pack, plates, and sheet film as well as an extension back to be used for close-up and macro work. It found use as a military camera and a copy camera, and was used by professionals, advanced amateurs, and photojournalists. It had, arguably, the finest lens ever made for a non-interchangeable lens camera in the 100mm f/3.5 Kodak Ektar.

The Medalist II had some minor control revisions, a coated lens, and a flash synchronization connector with the Kodak Flash Supermatic shutter. The retail price of the Medalist in 1941 was $165, and in 1946 the Medalist II was priced at a lofty $270.

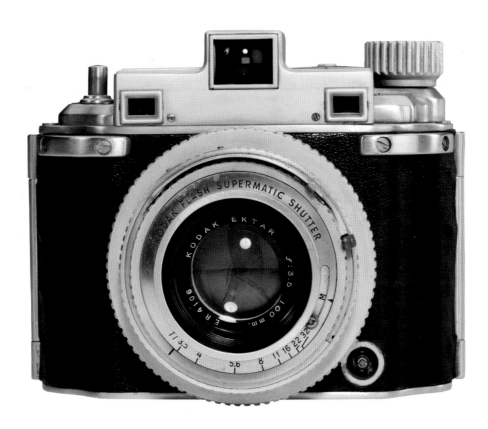

Pacemaker Speed Graphic *ca. 1947*

Graflex, Inc., Rochester, New York.
Gift of Graflex, Inc. 1974:0028:3264.

The Pacemaker Speed Graphic, manufactured by Graflex, Inc., from 1947 to 1970, was the post-war replacement for the legendary Anniversary Speed Graphic. Among the twenty-three improvements advertised were a new focal-plane shutter, tilting front movement, adjustable infinity stops, coated lenses, and a body release. Though available in three sizes, the 4 x 5 became the standard used by photojournalists, advanced amateurs, and artist photographers for decades. The retail price with 5-inch Kodak Ektar lens was $207.

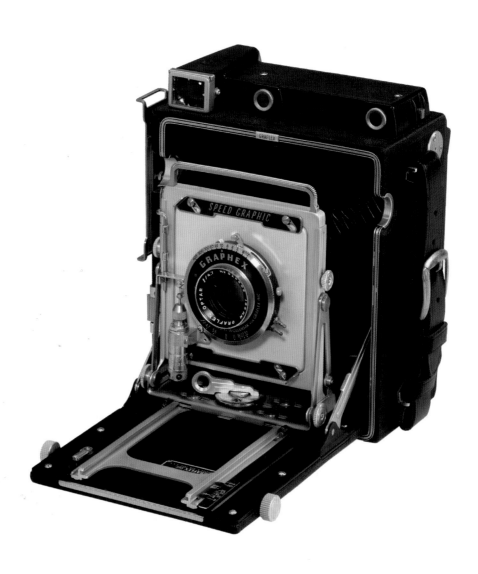

Studio Deardorff *ca. 1950*

L. F. Deardorff & Sons, Chicago, Illinois.
Gift of Eastman Kodak Company. 1978:1371:0056.

People who make a living taking photographs fall into two groups: those who travel to the subject, and those who bring the subject to them. The first group needs equipment that is easy to carry, rugged, and quick to set up, which is why cameras like the Speed Graphic, Leica, and Rolleiflex were favored tools of their trade. The needs of the second group are similar, except for the portability requirement. Studio photographers work in large format and arrange appropriate lighting, backdrops, and props, usually planning everything beforehand. In the past, the large cameras used in studios were heavy enough to require a wheeled platform for support.

Deardorff Portrait Series cameras were heavy, rock-steady, and good for decades of service. Constructed mainly of mahogany, the front and rear standards were supported by strong cast-aluminum brackets. A double rack and pinion smoothly moved the rear standard to focus the image on the ground glass, which had a rotating mount to tilt the image without tilting the entire camera. In addition, both front and rear had vertical and lateral swings to adjust the depth of field and perspective. These movements were quickly made while viewing, thanks to the rear-mounted levers that controlled the front swings. As in most view cameras, lenses and shutters could be easily changed by switching lens boards. This example

wears a coated 305mm f/4.8 Kodak Portrait lens with a No. 5 Universal Synchro Shutter.

While many companies produced good studio cameras, those made by L. F. Deardorff & Sons are to photography what the stringed instruments of Antonio Stradivari are to music. Laben Deardorff began producing his handmade cameras in 1923, and a number of them remain in regular use today. It wasn't unusual for a Deardorff to be used as a money-making tool for a half-century or longer, as one could easily recoup the $1500 to $2000 spent on a portrait outfit.

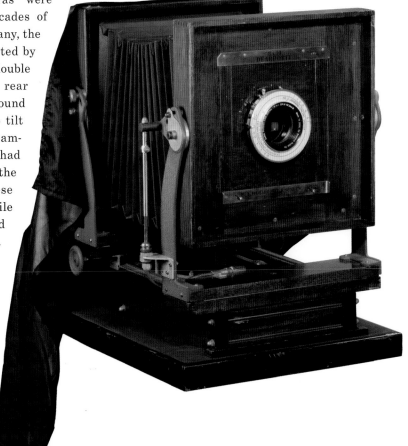

Omega 120 *ca. 1954*

Simmon Brothers, Inc., Long Island City, New York.
Gift of Simmon Brothers, Inc. 1974:0037:0088.

Better known for their Simmon Omega enlargers, Simmon Brothers, Inc., of Long Island City, New York, also made the Omega 120 medium-format professional camera, which produced 2¼ x 2¾-inch images on No. 120 roll film. Its novel feature was an automatic film advance that, with the single action of pulling out and pushing back a lever, advanced the film, counted the exposure, set the shutter, and even changed the bulb in the Repeater-Action flash holder. The retail price in 1954 was $239.50, and with a flash unit was an additional $49.50.

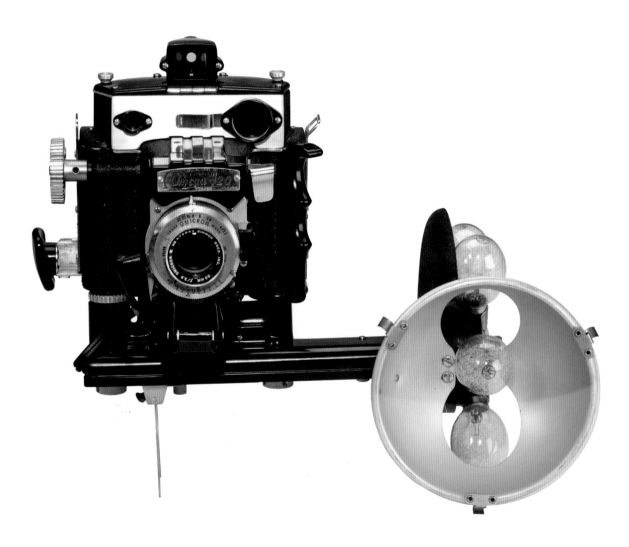

Super Speed Graphic *1959*

Graflex Division of General Precision Equipment Corporation, Rochester, New York.
Gift of Graflex, Inc. 1974:0037:0089.

Introduced in 1959, the Super Speed Graphic was the last of the 4 x 5-inch Speed line of press cameras produced by Graflex. Designed in consultation with industrial designer Peter Muller-Munk, the camera was chock-full of improvements over earlier models. The durable body case was made from extruded aluminum (all other Speed cameras used mahogany) and butt-welded at the bottom joint, then fitted with built-in rangefinder focusing and an electric solenoid shutter release. Front swing was added, giving the Super the full array of front perspective control movements—rise, shift, swing, tilt, and drop bed to accommodate wide-angle lenses—and an advantage over the earlier Pacemaker Speed Graphic. Other improvements included a revolving back, which permitted both horizontal and vertical composition, and a clever combination focusing scale and flash guide number calculator, mounted on the top of the camera for ease of use. Like the Pacemaker, the Super Speed used the Graflok back system, allowing the camera to use standard sheet-film holders or be fitted with numerous accessory backs, including those for roll film, a Grafmatic sheet-film magazine, or Polaroid roll film.

The "Speed" in the camera's name came from the 1/1000-second leaf shutter, making it the fastest leaf shutter of its day (next fastest was Eastman Kodak's Rapid 800). In addition to their stop-action potential, leaf shutters were advantageous in studio use with electronic flash, as they could be synchronized with flash at all shutter speeds. Focal-plane shutters also had 1/1000 second capability, but only synced at slow speeds, usually 1/60 second, depending on the camera model.

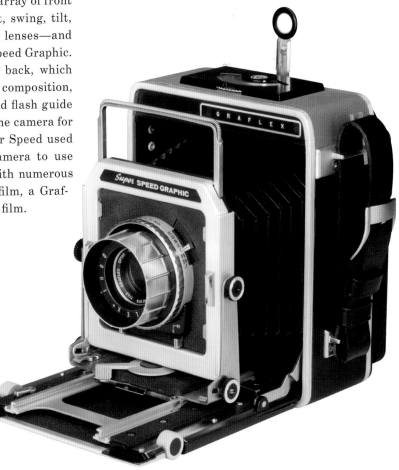

Linhof Color 6.5 x 9 cm *ca. 1960*

Linhof Precision Camera Works, Munich, West Germany.
Gift of James Sibley Watson Jr. 1981:0790:0047.

For those photographers interested in a small, lightweight monorail view camera, the 6.5 x 9-cm Linhof Color was an obvious choice. Not only was it one of the few of its kind ever produced in this size, but the same quality lenses used with its larger and better-known sibling, the 4 x 5-inch Super Technika, could be fitted to the camera without any bellows modification. The Color married the technical lens bench aspects of the monorail camera to the convenience of this smaller size, which could be fitted with a 120 roll-film back. Its swing-back design coupled with full front movements (rise, shift, and swing) made this camera especially desirable for use in the field for architectural or technical photography. Available lenses ranged from 47mm to 360mm. This example is shown with the 120mm f/6.8 Schneider Angulon.

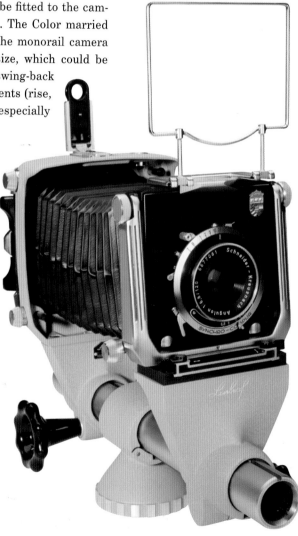

Graflex XL *ca. 1965*

Graflex, Inc. Rochester, New York.
Gift of Graflex, Inc. 1980:0193:0001.

Graflex cameras have been prized as workhorses for photographers since the company's founding in 1887. No press photographer was without his Speed Graphic, his pockets full of film holders and flash bulbs. By the mid-1960s, the company decided to design a new camera to supplement its line of professional equipment. This one would be a true clean-sheet effort, sharing nothing with the traditional Graflex except sturdy construction and versatility.

The result was the Graflex XL, a relatively compact camera built to accept a vast array of lenses and accessories. The XLS (standard) body cost only $96.67, with the XLRF (rangefinder) version listing at $176.68. Available lenses ranged from the 58mm Rodenstock f/5.6 to the 180mm Zeiss Sonnar f/4.8, and included the fast Zeiss f/2.8 Planar and f/3.5 Tessar. Holders for 2¼ x 3¼-inch sheet film; 120, 220, or 70mm roll films; and Polaroid packs were interchangeable. Grip handles with shutter release buttons, various finders, and cases for carrying it all were readily available from Graflex dealers. The XL lenses used Synchro-Compur shutters capable of 1/500-second exposures and flash sync for bulbs or strobes at any speed.

A wide-body version (XLSW) with a 47mm Schneider Super Angulon f/8 lens was offered for specialized use. Graflex kept the XL in production until its parent company abandoned the camera business and the storied Graflex brand in 1973.

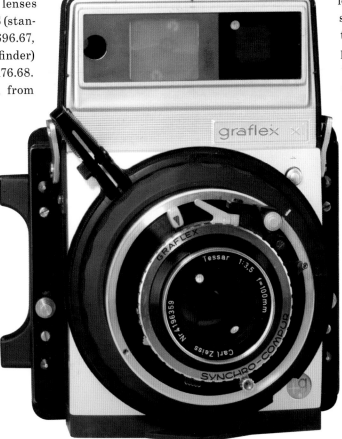

Sinar p2 *ca. 1990*

Sinar AG, Schaffhausen, Switzerland.
Gift of Sinar Bron. 1989:0012:0001.

Commercial photographers routinely deal with demanding customers and impossible deadlines. Any equipment that helps the professional satisfy the fussiest clients is welcomed in the studio. Sinar AG of Schaffhausen, Switzerland, designed the p2 view camera using the same monorail concept as its first cameras from 1951. The standards are mounted on a tube or bar and connected with a bellows. This allows for fast adjustments and a wider range of movements than a baseboard camera. The p2's self-locking movements are micrometer gear-driven for fast, precise adjustment, and asymmetrical for clear focus even during extreme movement. This 4 x 5-inch model, like most Sinars, is of modular design. The price at its 1990 introduction was $6,390, including the metering back. Despite the cost, Sinar cameras are among the most widely used in the commercial photography business.

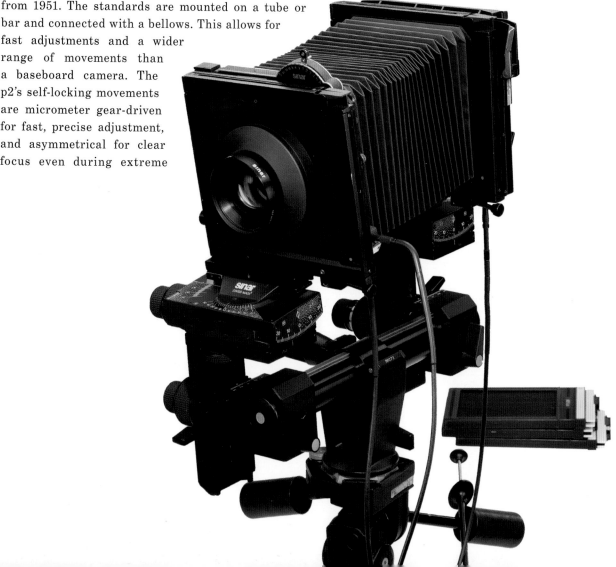

PANORAMIC

Cameras fitted with normal photographic lenses
have a 40 to 50 degree angle of view. To create an
image simulating human vision's 180 x 140 degree angle
of view, one can splice multiple photographs together
or use purpose-built cameras. Purpose-built panoramic
cameras can be categorized into three types: banquet,
short rotation, and long rotation. Banquet cameras are
similar to view cameras but with a wide field aspect
ratio. Short rotation cameras use a swinging lens with
a slit shutter to expose curve-mounted sensitized mate-
rial. Long rotation cameras advance the film past the slit
shutter as the entire camera rotates on its axis.

Cyclographe á foyer variable (FOCUSING MODEL) *1890*

J. Damoizeau, Paris, France.

Gift of Eastman Kodak Company, ex-collection Gabriel Cromer. 1974:0037:2331.

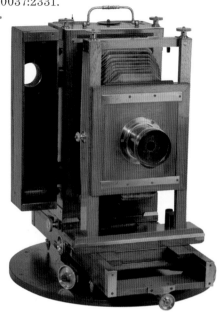

As roll-film technology progressed, so did panoramic photography. Introduced in 1890 by J. Damoizeau of Paris, the Cyclographe á foyer variable had a key-wound, clock-drive motor to turn a brass wheel on the camera's underside that rotated the mahogany and brass camera on its pivot dowel. The drive wheel was geared to the transport to move the nine-inch-wide film over a narrow slit at the same speed, but in the opposite direction. This made a 360-degree sweep possible. A bellows adjusted by a rack and pinion allowed focusing of the Darlot landscape lens to be focused.

Stereo Cyclographe *ca. 1894*

J. Damoizeau, Paris France

Gift of Eastman Kodak Company, ex-collection Gabriel Cromer. 1974:0037:1041

Damoizeau's Stéréo Cyclographe combined two fixed-focus panoramic cameras in one mahogany box. The lenses were mounted eight centimeters apart with a plumb bob indicator between them to help the photographer set the camera level. A single spring-wound clock motor powered both transports for the 9-cm-wide film as well as turning the shaft that rotated the camera on its tripod base. With its 360-degree capability, the Stéréo Cyclographe could make 9 x 80-cm pairs that required a special viewer. These images were generally used for mapping purposes. Like the Cyclographe á foyer fixe on which the Stéréo was based, a compartment on each side stored five rolls of spare film.

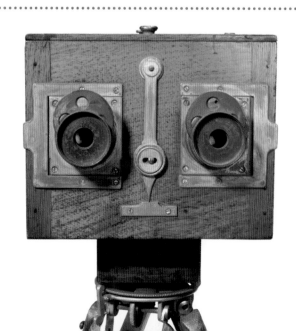

Cyclographe à foyer fixe (FIXED FOCUS) *ca. 1894*

J. Damoizeau, Paris, France.
Gift of Eastman Kodak Company, ex-collection Gabriel Cromer. 1974:0084:0065.

Cameras designed for panoramic pictures used various methods to capture the extra-wide images. Some used a swinging lens that swept light across a stationary length of film. Others used a non-moving, very wide-angle lens on fixed film. And still others, like the Cyclographe manufactured by J. Damoizeau in Paris in 1894, had clock-spring motors that rotated the entire camera at the same time as the nine-cm wide film was moved in the opposite direction across a narrow slit. Built into the bottom of the polished mahogany camera was a nickel-plated turntable, which allowed it to rotate and record the scene. Travel limits could be set to whatever angle the photographer chose. Shutterless, the Cyclographe controlled exposure by the rotational speed and by the three-position aperture disc on the Darlot 130mm f/11 meniscus lens. A folding eye-level finder and a bubble level on the top aided the photographer in composing the photograph. Despite its narrow body, the Cyclographe had doors on both sides, giving access to storage chambers for ten rolls of film.

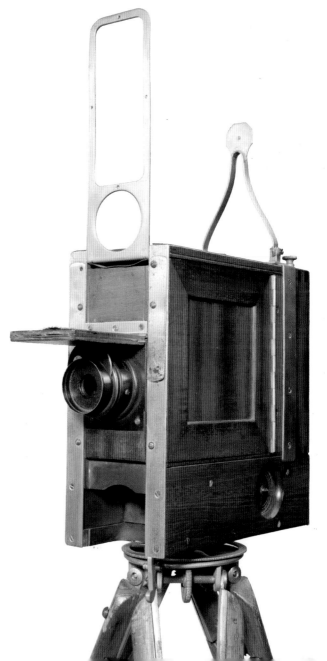

Wonder Panoramic Camera *1890*

Rudolf Stirn, Berlin, Germany.
Gift of the Damon Runyan Fund. 1974:0084:0048.

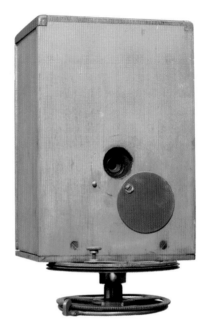

The Wonder Panoramic Camera of 1890, made by Rudolf Stirn in Berlin, Germany, depended on the photographer for its motive power. A string, hanging through a hole in the tripod screw, wound around a pulley inside the wooden box camera. When set up to take a panoramic photo, the user swiveled the metal cap away from the lens to start the exposure. Once the string was pulled, the inside pulley rotated, and through a clockwork mechanism the take-up spool turned and pulled the 3¼-inch wide Eastman film past a one-millimeter-wide slit where it was exposed by the 75mm f/12 lens. The rotation could be set for a full 360-degree sweep, producing an eighteen-inch long negative, or three shorter lengths at ninety-degree intervals. For $30 you got the Wonder, a roll of film, folding tripod, and carrying case.

Al-Vista 4A *ca. 1900*

Multiscope & Film Company, Burlington, Wisconsin.
Gift of Eastman Kodak Company. 2002:0959:0002.

Beginning in 1897, Multiscope & Film Company of Burlington, Wisconsin, was known for its Al-Vista series of panoramic roll-film cameras. The Model 4A was a spring-motor powered, swing-lens design with almost 180 degrees of lens travel. A travel distance control could be set for any of five picture lengths, from four to twelve inches. Typical of the swing-lens panoramics, the Al-Vistas had no mechanical shutter. A metal cap shielded the film from light when the lens was parked for the next picture, and a strip of plush fabric did the same job once the lens completed its sweep. A friction brake on the lens pivot shaft controlled the exposure time. An external adjustment knob increased brake pressure to slow the travel speed. The Al-Vista Model 4A was one of more than a dozen different panoramics in the Multiscope catalog.

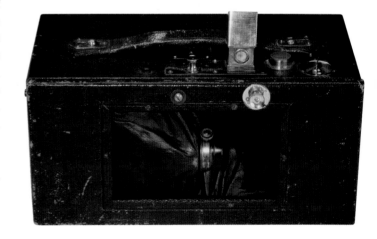

Baby Al-Vista No. 2 *1909*

Multiscope & Film Company, Burlington, Wisconsin.
Gift of Eastman Kodak Company. 1997:2735:0001.

Panoramic photography usually involved toting a large, heavy camera on location. The 1909 Baby Al-Vista No. 2 was a lightweight, scaled-down version of Multiscope & Film Company's popular swinging-lens cameras. The Baby's Rapid Rectilinear lens swept a 160-degree arc across a 6¾-inch length of standard 2¼-inch wide roll film. Exposures were controlled by attaching metal "fans" to the spring-motor shaft extension atop the morocco leather-covered box. Air resistance slowed the sweep speed of the lens assembly, lengthening the exposure time. The larger the fan paddles, the slower the travel. Three fans were included in the Baby's five-dollar price. Instead of the bubble levels found on higher-priced cameras, Baby Al-Vista had a small circular window covering a steel ball bearing set in a shallow depression on the camera top. When the little ball was centered, the camera was level.

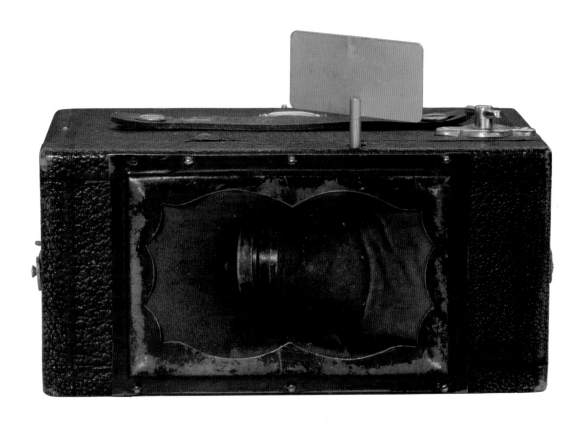

Périphote *ca. 1901*

Lumière Fréres, Paris, France.

Gift of Eastman Kodak Company, ex-collection Gabriel Cromer. 1974:0037:2845.

The Périphote panoramic camera was a variation on the swinging lens-stationary film design in that it took a 360-degree image on 2¾-inch wide film. Built by Lumière Fréres of Paris in 1901, the Périphote was a drum within a drum. A spring-wound clock motor rotated the outer drum; the inner drum held the roll of film and its take-up spool. Attached to the apparatus was a 55mm Jarret lens and a prism that directed the light through a half-millimeter-wide slit aimed at the film. With the spring fully wound and the camera sitting on its base flange, the photographer rotated a small lever to start the process. The film then passed through a slit to the smaller drum's exterior, wrapping completely around it before going back inside for respooling. Once the operation started, the photographer had to walk backwards around the camera as it made its sweep to avoid being photographed.

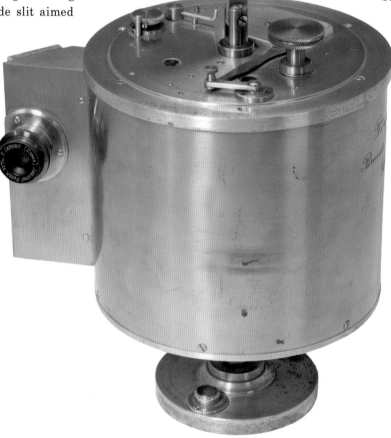

Rundblick *ca. 1907*

Heinrich Ernemann AG, Dresden, Germany. 1974:0037:1497.

Panoramic cameras of the swinging-lens variety or the wide-angle fixed lens type were effective for fields-of-view up to about 120 degrees, but for scenes requiring more than that, only a rotating camera would do. Such cameras were usually powered by wind-up spring motors and necessarily mounted on a sturdy tripod. When making a picture, the camera rotated at a constant speed while the film moved at the same speed in the opposite direction, thanks to the same spring motor. The best-known example of the rotating camera was the Cirkut, introduced in 1904.

Heinrich Ernemann AG, which started building cameras in 1889, introduced the Rundblick (German for "looking around") in 1907. Much more compact than the Cirkut types, though just as heavy, it rotated 360 degrees to make a 12 x 92-cm negative on special roll film. The front-mounted crank wound up the spring, and an indicator pointer allowed the panoramist to vary the rotation angle. As with the swing-lens cameras, the speed of travel controlled what the shutter-speed dial did for conventional cameras, but the Rundblick also had an adjustable slit that functioned as an aperture control. The Ernemann Doppel-Anastigmat 135mm f/5.4 lens had a vertical shift adjustment for perspective correction. Marketed for five years, especially to the military and to artists, the camera was used to photograph landscapes and very large groups of people.

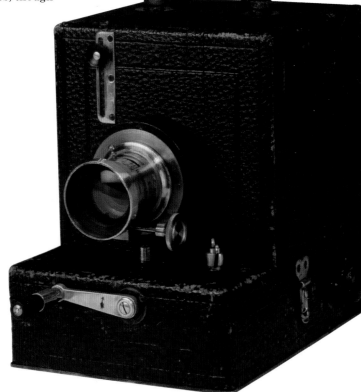

Cirkut Camera No. 10 *ca. 1910*

Century Camera Division, Eastman Kodak Company, Rochester, New York.
Gift of Eastman Kodak Company. 2000:0805:0001.

Produced for nearly fifty years and sold under numerous Rochester-based company nameplates Rochester Panoramic Company, 1904-1905; Century Camera Company, 1905-1907; Century Camera Division, Eastman Kodak Company, 1907-1915; Folmer & Schwing Division, Eastman Kodak Company, 1915-1926; Folmer-Graflex, 1926-1945; and Graflex, Inc., 1947-1949 the No. 10 Cirkut camera was designed to make panoramic photographs up to ten inches tall by twelve feet in length. To accomplish this, a small pinion gear, mounted at the bottom of the camera and driven by a spring-wound motor, rotated the camera on a gear-head tripod. As the camera revolved, the roll film was exposed as it advanced past a narrow slit shutter, creating images, generally group portraits or landscapes, in a manner similar to that of a digital flatbed scanner. In 1916, the list price for the No. 10 Cirkut was $290, including the Series II Turner-Reich Convertible lens and shutter. The illustrated example is a new old-stock camera fitted with the factory original, undrilled lens board. It lacks the bed-mounted focusing scales, which would have been custom matched to a lens and gear set.

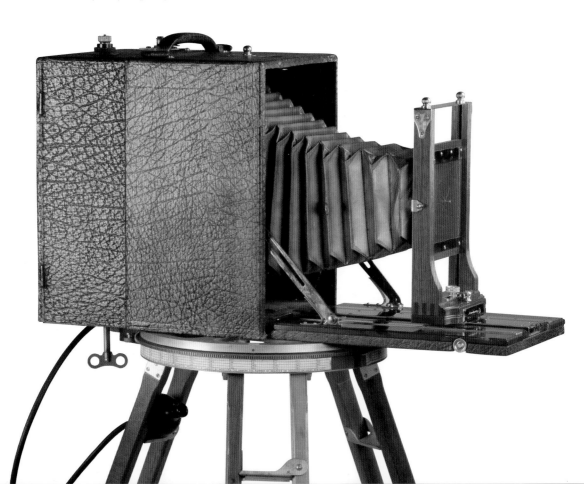

Korona Panoramic View *ca. 1914*

Gundlach-Manhattan Optical Company, Rochester, New York.
Gift of Mrs. Allen E. Kappelman. 1978:1371:0010.

Panoramic cameras didn't come any simpler than the Korona Panoramic View. Instead of relying on gears, springs, and moving parts to shift lens and film, the Gundlach-Manhattan model was basically a view camera that was much wider than it was tall. This type of panoramic camera was fitted with a wide-angle lens that could cover the width, leaving the top and bottom of the image cropped to create the extra-wide prints. There was no need for a curved film plane, clock motor, or any of the other complexities of cameras like the Cirkut. While the Korona didn't have the field of view of the motorized cameras, it was more than adequate for most panoramic work.

The Panoramic View was built in three sizes: 5 x 12 inches, 7 x 17 (pictured here and listed for $50 in 1914), and 8 x 20. Gundlach-Manhattan made its own lenses under the Turner-Reich name, and for this

camera recommended a T-R Anastigmat twelve-inch f/6.8, costing $90 with shutter. At ten pounds, the 7 x 17-inch version of the camera was easily packed for outdoor work, and its elegant cherry and bright-finish metal construction could withstand the rigors of professional duty.

The cropped wide-angle method of making panoramas has been used as recently as the 1990s, when companies such as Kodak and Nikon incorporated retractable masking panels at the film plane of some of their small 35mm and APS point-and-shoot cameras. Printing the cropped negatives on 4 x 10-inch paper allowed anyone with a good eye for composition to create dramatic images.

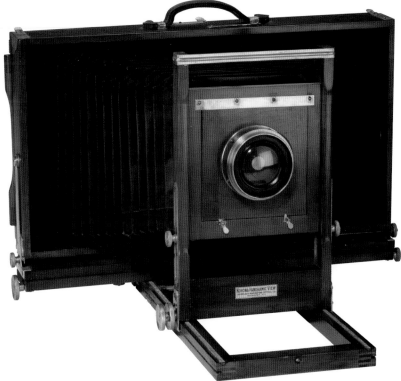

3A Panoram Kodak _1926_

Eastman Kodak Company, Rochester, New York.
Gift of Eastman Kodak Company. 1974:0037:2662.

The 3A Panoram Kodak was basically a box camera for taking pictures of broad landscapes or large groups of people. To expose the long, narrow picture, the spools and rollers were located to hold the film against a curved guide, while the lens was mounted on a pivot, allowing it to swing 120 degrees when the shutter button was pressed. However, instead of a shutter, a flattened, funnel-shaped tube attached to the inside of the lens swept the light across the film. The result was a 3¼ x 10-inch image that allowed everyone to be in the picture. The lens funnel opening was lined with a plush material and parked firmly against a stop covered with the same black fabric, making a light-tight seal. To assist the photographer in holding the camera straight, two bubble levels were located near the viewfinder. The 3A Panoram cost $40 in 1926. The size A122 film was available in either three- or five-exposure rolls.

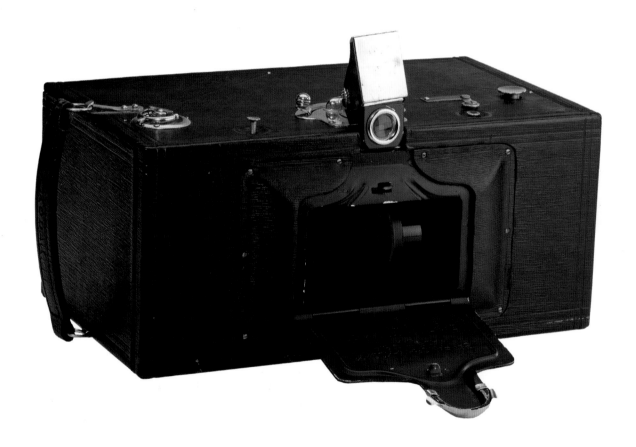

Panon 120 *ca. 1952*

Panon Camera Company, Ltd., Tokyo, Japan. 1974:0028:3055.

Moving-lens panoramic cameras, first available in the late nineteenth century, were fairly simple devices that kept a long piece of film held against a curved guide until the button was pressed and the lens swept the wide image onto the light-sensitive film surface. Advances in the technology overcame some of the shortcomings of the early cameras, and by the 1950s they were smaller, faster, and more accurate. Panon's first wide-angle camera used No. 120 film and a lens mechanism that covered an angle of 140 degrees. Operation was fairly uncomplicated. The bottom plate was removable for changing film, and the entire film holder lifted out to simplify the task. To take a panoramic picture, one had to estimate the distance, although most panoramic subjects were far enough away that the lens focus could be set to infinity. Focusing the Panon's 50mm f/2.8 lens meant turning a tiny ridged knob accessible through the ¾-inch-wide slot in the curved cover, while watching the distance scale barely visible beneath the lens. Setting the aperture required poking a finger into the lens slot and using the small dowels to move the rim to the proper stop.

Next was the shutter speed, although this type of camera had no actual shutter. The speed control actually set the time required for the lens to finish its sweep across the film.

At each extreme of travel, the film holder was masked to prevent light from striking the film when the lens was stopped. When all the adjustments were set, the photographer cocked the "shutter" by pulling the tab on the lens slot until it was locked in place on the other side. Then it was time to compose the scene in the flip-up viewfinder, press the button, and listen to the mechanism operate while the lens revolved to the other leg of the angle. At the slow speed, a solid tripod mount was required, and a pair of bubble levels on the top helped align the camera to the horizon. Panon later designed a 35mm version called the Widelux, which was so much more successful that the big, heavy roll-film Panon was discontinued.

FT-2 *ca. 1958*

Krasnogorsk Mechanical Factory, Krasnogorsk, USSR. 1974:0028:3342.

The FT-2, a 35mm panoramic camera produced from 1958 to 1965, was made by Krasnogorsk Mechanical Factory (KMZ), a suburban Moscow manufacturer known for its Zorki and Zenit cameras. It featured a swing lens covering 120 degrees and produced twelve 24 x 110-mm images on standard 35mm film loaded in special cassettes. A military camera designed to verify artillery fire, the FT-2 was presented at the Brussels World Exhibition of 1958 and put into civilian production to make its manufacture profitable.

Deardorff Precision 8/20 Camera *ca. 1960*

L. F. Deardorff & Sons, Chicago, Illinois.
Gift of Eastman Kodak Company. TD2008:0302:0001.

For forty years, New York's Grand Central Terminal hosted the "World's Largest Photograph," the Kodak Colorama. The backlit transparencies that graced the terminal's east balcony measured eighteen by twenty feet, with a new image mounted every month. For Eastman Kodak Company, these scenes were simply advertisements for its cameras and color film. However, creating these enormous color slides required special equipment and processes, beginning with the camera, an 8 x 20-inch Deardorff Precision. It was almost inevitable that L. F. Deardorff & Sons would be part of the Colorama story. A name synonymous with large-format photography since Laben Deardorff founded his company in the 1920s, the firm's reputation was made with large studio cameras, sturdy workhorses with all the distortion- and perspective-correcting movements needed by commercial photographers. The Precision View was built for large murals, but Kodak's photographers pushed it to extremes undreamed of by its designers. Beautifully constructed of mahogany, cast aluminum, and stainless steel, the Deardorff combined precision with durability. Lenses like the Schneider-Kreuznach Symmar S 360mm f/6.8 could cover the twenty-inch-wide film, so no cropping was needed.

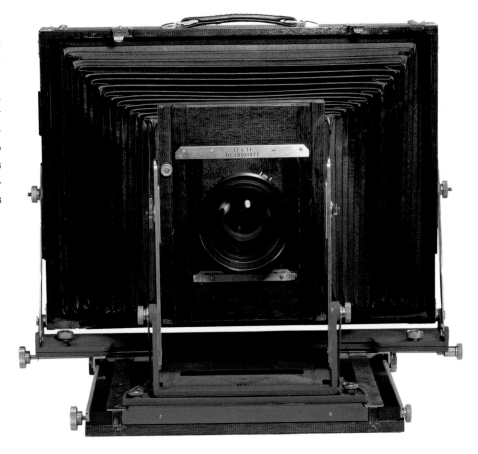

Noblex Pro 06/150 *ca. 1994*

Kamerawerke Noble GmbH, Dresden, East Germany.
Gift of Pro Photo. 1994:0473:0001.

The purpose of a camera is to capture what the eye can see, and the photographer's role includes choosing what portion of a scene to expose. The idea for a camera capable of recording the entire field of a person's view was hatched not long after the first photographs were made, and by 1843 the panoramic camera was a reality. Since then, several methods of taking these spectacular photographs were perfected. One solution is a swinging lens, which begins its cycle at one side of the frame and sweeps across to the opposite side, scanning the image onto a long strip of film. Starting in the late nineteenth century, cameras using this method were made by such companies as Al-Vista and Eastman Kodak, and later by several other firms. There was even a subminiature panoramic that used 16mm film.

One of the latest manufacturers to join the swinging-lens panoramic field is the German firm of Kamerawerke Noble. In 1994, the Dresden company began making high-quality equipment for both 35mm film and the larger 120 roll film. Its Noblex cameras, including this Pro 06/150, are designed for the professional market. Unlike earlier swing-lens designs, which used spring-wound mechanisms to power the action, the Noblex lens is motor-driven. This provides a more precise travel speed to ensure correct exposures. The shutter-speed setting controls the exposure—the slower the movement of the swing, the more

light strikes the film. Once activated, the fixed-focus Tessar lens makes a full clockwise revolution while exposing a 146-degree view on a 50 x 120-mm negative. Six pictures are possible on a roll of 120 film, which is advanced with the manual knob on the top plate. While many of the jobs formerly done with film cameras are now performed by digital models, the panorama photographer can still rely on cameras like the Noblex to make the entire shot in a single wide negative, with no need for software to stitch together a series of images. In some niches of photographic practice, the old ways are still the best.

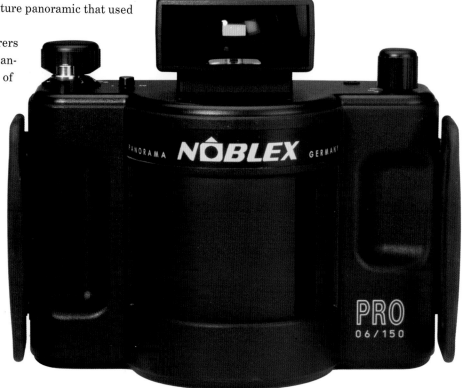

Handmade panoramic camera *1970*

David Avison, Chicago, Illinois.

Gift of the Estate of David Avison. 2004:0653:0002.

This medium-format panoramic camera was handmade by David Avison (1937-2004), one of the most accomplished panorama photographers of our day. Unsatisfied with available panoramic cameras, he used his combined skills as an avid photographer and a Ph.D. in physics to design and build this remarkable camera between 1970 and 1972. A banquet-style panoramic camera, constructed of machined and anodized aluminum with a 75mm Schneider-Kreuznach Super Angulon lens and a detachable film magazine with dark slide, it produced five 6 x 18-cm images on No. 120 roll film. The lens is mounted on a rising/falling front with a parallax-correcting open finder. David Avison taught physics and photography at the university level, and his work is preserved in a number of museum collections, including George Eastman House.

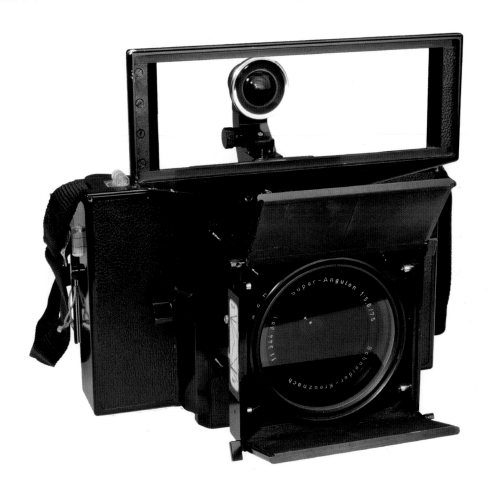

Technorama 617 *ca. 1980*

Linhof Präzisions-Kamera-Werke, Munich, West Germany.
Gift of Linhof. 1980:0045:0001.

Panoramic photography dates back to the 1840s. Over the years, several approaches were engineered to make the wide, sweeping images. Some cameras used a spring-wound clock drive that rotated the entire apparatus as it moved the film along, a process that could cover 360 degrees or more. Others incorporated a swinging lens, which swept light across a long piece of stationary film. Yet a third type, the fixed-lens panoramic, used an extreme wide-angle lens with the film held flat. One benefit of this design was that it had no moving parts, save for the shutter.

The Linhof Technorama 617 was a fixed-lens panoramic camera. Its 617 designation refers to the negative size of 6 x 17 cm. Using either 120- or 220-size roll films, the camera made four or eight shots per roll respectively. The 90mm f/5.6 Schneider-Kreuznach Super Angulon lens could focus as close as five feet from the subject,

although these cameras were seldom used for close-up work. With its minimum aperture of f/45, the Technorama's depth of field could match the field of view. The shutter was capable of 1/500-second exposures. The viewfinder had a bubble level to help frame the long, narrow scenes. Fixed-lens panoramic cameras could easily be handheld, something not practical with the clockwork and swing-lens types. Linhof had been famous for its precision cameras since 1898 when Valentin Linhof made his first aluminum-bodied design. The Technorama 617 was no exception, as it made no compromises in quality. The last years of the Kodak Coloramas at New York's Grand Central Station were made with one of these extremely capable instruments. Professional photographers paid about $4000 for the body alone, because they knew the results would be worth the price.

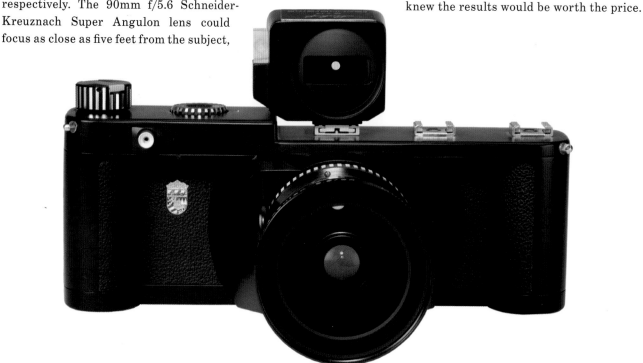

Globuscope *ca. 1981*

Globuscope, Inc., New York, New York.
Gift of Globuscope, Inc. 1981:0061:0001.

Looking more like a science-fiction movie prop than a camera, the 1981 Globuscope 35mm panoramic was developed by the Globus brothers for use in their New York City commercial photography studios. Their successful results led the brothers to have the apparatus manufactured for sale. Despite its futuristic appearance, the Globuscope uses the rotating body and film slit design perfected a century earlier. What Globus did differently was make an extremely compact and simple-to-use device. Removing the oval stainless steel cover makes loading a thirty-six exposure film magazine as easy as with any 35mm camera. Once the dome is back on, the handle is rotated to wind the spring. Like all such cameras, the Globuscope does not have a shutter. Exposures are controlled by aperture setting and selection from two rotation speeds. A brass button on the handle triggers the process. The camera makes two complete 360-degree revolutions, using twelve inches of film for each exposure. The photographer can then print the entire scene or crop it as desired. The camera can also be held by the body, with the handle rotating for dramatic effects with moving subjects.

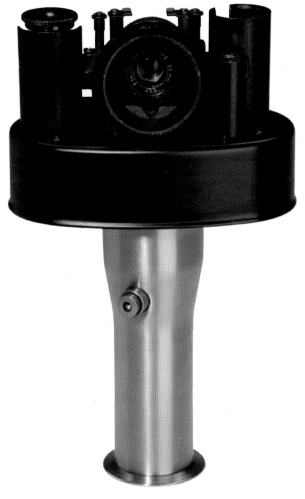

4 x 5 Camera *ca. 1983*

Globuscope, Inc., New York, New York.
Gift of Globuscope, Inc. 1983:2331:0001.

Globus Brothers Studios of New York City was one of the few photography studios in the modern era to have also manufactured cameras. One of the studio's specialties was panoramic imagery, most of which was produced with cameras of the brothers' own design and manufacture. The Globuscope 4 x 5 was a specialty wide-angle view camera designed for interior, scenery, group portraiture, and aerial photography. Its cone-shaped body was made from lightweight, die-stamped stainless steel. The friction-tube-focused, 65mm f/8 Schneider Angulon lens, mounted in a Copal 0 shutter, kept the apparatus small for a 4 x 5-inch camera—about equal to a motor-driven 35mm SLR of the same vintage. This example is fitted with the convenient Globuscope leveler, which, when mounted beneath the camera, was used to square the image, keeping any distortion from the wide-angle lens to a minimum.

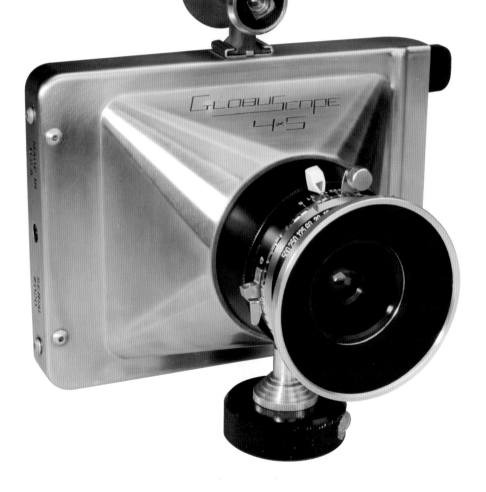

STEREO

During his 1832 investigation into stereoscopic vision, English scientist and inventor Sir Charles Wheatstone (1802-1875) designed a viewer for visually merging two similar drawings into a single three-dimensional image. Soon after the introduction of photography, drawings of this type could be replaced with camera-made images. The stereo camera, like human vision, creates two images of a subject from slightly different viewpoints just a few inches apart. On nineteenth-century cameras the distance varies from 3½ to 4½ inches, depending on camera format, while twentieth-century 35mm roll film cameras use a standard distance of 2½ inches. These "twin" photographs can be accomplished by accurately moving a single-lens camera to create both images, or more commonly, by using a camera fitted with two lenses, both of the same focal length.

Stereo camera (OWNED BY M. B. BRADY STUDIO) *ca. 1860*

John Stock & Company, New York, New York.
Gift of Graflex, Inc. 1974:0028:3542.

John Stock & Company manufactured double-box and stereo cameras in New York City during the 1860s. This camera, a folding-bed stereo model fitted with C. C. Harrison Petzval portrait lenses, made a pair of 4½ x 4¼-inch stereoscopic images on a 4½ x 8½-inch wet plate. After printing, the images were separated, cropped to 3 x 3 inches, and coupled again on standard 3¼ x 6¾-inch stereograph mounts.

Both this and the Nelson Wright double-box camera were found with an assortment of Brady Studio plates in Auburn, New York, hence the Brady Studio association.

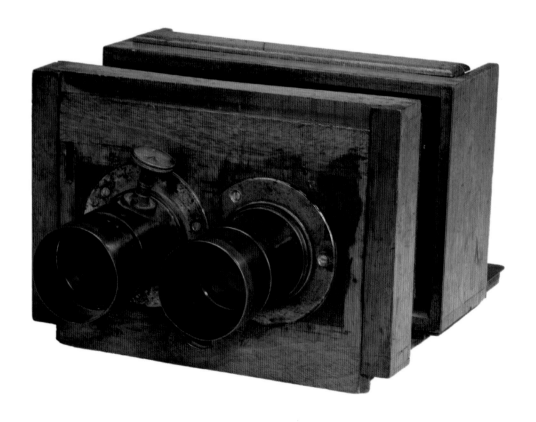

Stereo tail-board camera *ca. 1860*

Unidentified manufacturer, France.
Gift of Eastman Kodak Company, ex-collection Gabriel Cromer. 1974:0037:1000.

Produced by an unknown French manufacturer, this wet-plate stereo camera is fitted with a pair of Derogy Optician Petzval-type portrait lenses that are slotted to accept Waterhouse stops. It is a folding-bed bellows camera with an internal septum to maintain image separation within the negative of 5 x 8 inches, which was the standard size for stereo photography during the nineteenth century. The resulting print would be cropped into two 3 x 3-inch images to be mounted on 3¼ x 6¾-inch stereo cards.

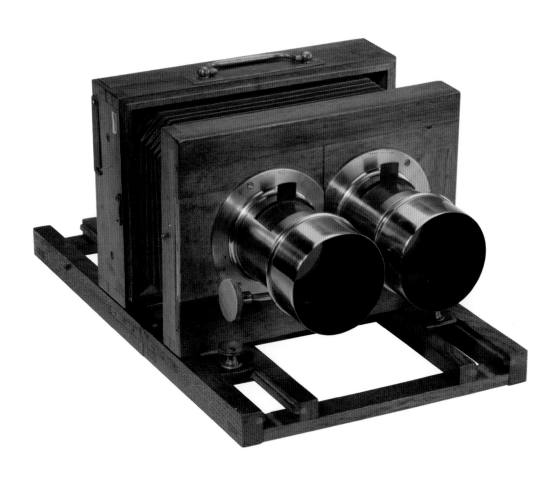

Stereo wet-plate camera with globe lenses *ca. 1860*

Unidentified manufacturer, United States.
Gift of 3M Foundation, ex-collection Louis Walton Sipley. 1977:0112:0001.

Most likely manufactured by one of the New York City camera companies in the early 1860s, this fixed-bed double-box stereo camera is fitted with a pair of Harrison & Schnitzer globe lenses. One of the earliest type of wide-angle lens, the globe lens is named for the shape of its exterior. Using a hinged flap "shutter," the camera exposed stereoscopic images on 5¼ x 8¾-inch wet plates. When printed, the images were separated, cropped to 3 x 3 inches, and paired on standard 3¼ x 6¾-inch stereograph cards.

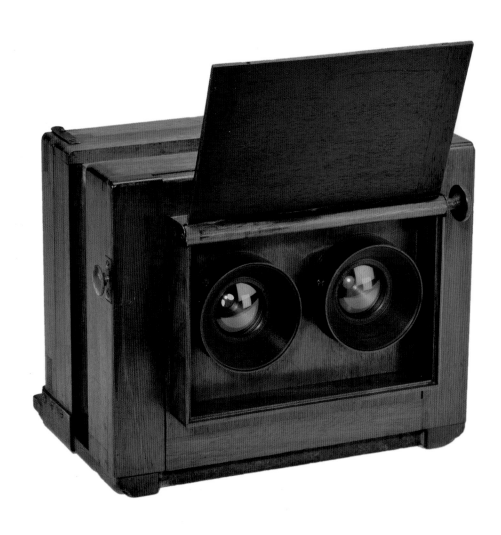

Photo Stereo Binocle *1899*

Optische Anstalt C. P. Goerz, Berlin, Germany.
Gift of Barnet Peck. 1974:0037:2022.

Multitasking personal electronic devices seem to fit more and more into tinier packaging with every consumer electronics show. Cell phones with built-in cameras? Old news! Today, any new gadget trying to elbow its way into the showcases must be capable of fulfilling every need imaginable, from video conferencing to satellite navigation. Yet double-duty devices have been a regular feature of patent applications since the Industrial Revolution. In 1899, Carl P. Goerz's Berlin works began production of the Photo Stereo Binocle. The $108.75 device looked like a pair of pocket binoculars, which indeed it was, but did more than just give birdwatchers a close-up look.

As a binocular, the Photo Stereo Binocle worked the same as any ordinary pair. The viewer would look through the eyepieces and use a ridged focus knob to adjust the telescoping tubes. The difference was that each eyepiece had three lenses mounted on a disc, which was rotated by the fingertip wheels above the lenses. In addition to the binocular eyepieces with a magnification of 3½x were opera-glass lenses that could be rotated into position for a 2½x view, and camera lenses for recording the scene being viewed. If the traveler or opera fan wanted a permanent memento, he'd need only turn the apparatus backwards and, after opening the hinged object lens panel, insert the plate holders into the spaces provided. Next, the eyepiece selectors were rotated to bring the camera lenses into place, and tiny levers between the eyepieces were shifted to set the shutters. Once the dark slides were pulled out from the plate holders, the photographer would raise the Newton finder, compose a scene, and press the shutter release. Each shutter could be tripped independently, allowing for single exposures of a 1¾ x 2-inch plate, or snapped simultaneously to make a stereo pair. After exposure, the dark slides were reinserted and the plates removed for developing. Just as Goerz's advertising stressed that the traveler did not need to buy and tote both camera and field glasses, today's marketers tout the convenience of having a phone with a camera, Internet browser, and an ever-greater number of functions available at the touch of a screen. Surely, Herr Goerz would be impressed.

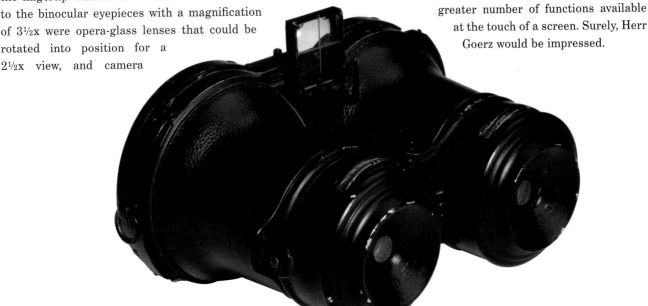

Stéréo-Panoramique Leroy *ca. 1903*

Lucien Leroy, Paris, France.
Gift of Carl W. Steinkamp. 1974:0084:0097.

Photographers wishing to take pictures for three-dimensional viewing bought cameras made specifically for stereo, while those making panoramic shots required another type of specialty camera. In 1903, Lucien Leroy of Paris designed a dual-purpose metal box with two lenses and a septum for making 6 x 6-cm stereo pairs on 6 x 13-cm dry plates, just like so many other stereo cameras of the day. What made the Stéréo-Panoramique notable was its rotating lens mount that allowed the right side lens to be repositioned to the center of the front panel to shoot panoramas. When that lens was moved to the panoramic position, the internal septum pivoted up out of the way. With the left lens capped, the Stéréo-Panoramique was ready to take an eighty-degree view. The matched Krauss Protar lenses were fixed focus with aperture diaphragms that were set individually. The sector shutters operated in unison, regardless of mode. Twin bubble levels on the top helped with handheld shots. The Stéréo-Panoramique Leroy had the typical French machinery look of the period. Buyers needed 315 francs to own one of these versatile instruments.

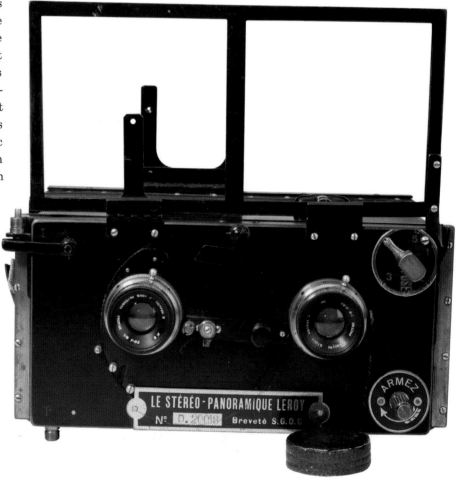

Stereo Graflex *ca. 1903*

Folmer & Schwing Manufacturing Company, New York, New York.
Gift of Dr. Henry Ott. 1983:0836:0006.

U nique among stereo cameras, the Stereo Graflex of 1903 provided stereoscopic viewing on a ground glass by incorporating dual eyepiece magnifiers just as in a stereoscope viewer. The reflex viewing of the Graflex cameras enabled the operator to arrange and study the composition right up to the time of exposure. The image would be seen upright, though still laterally reversed. The minimum focal length was 5 inches and the telescoping front allowed a maximum of nine inches. Designed to use 5 x 7-inch dry plates, this camera sold for $318, including the matched pair of Goerz Celor Series III lenses.

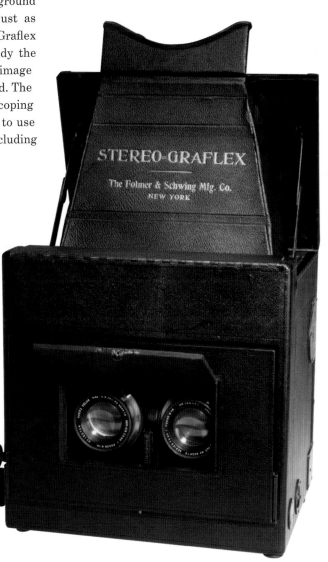

No. 2 Stereo Brownie 1905

Eastman Kodak Company, Rochester, New York.
Gift of Eastman Kodak Company. 1974:0028:3451.

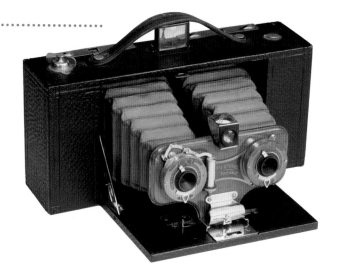

The No. 2 Stereo Brownie, introduced in 1905 by East-man Kodak Company of Rochester, New York, was the only Brownie stereo camera to be made. A twin-bellows folding camera of leather-covered wood construction, it was atypical among stereo cameras in that it had two bellows rather than the customary single bellows with septum. By reducing the manufacturing cost, Kodak made it possible to bring the popular stereo photography to the masses. The camera's retail price was $12.

Telephot Vega Stereoscopic camera 1906

Véga S. A., Geneva, Switzerland.
Gift of Roland Leblanc. 1974:0037:2009.

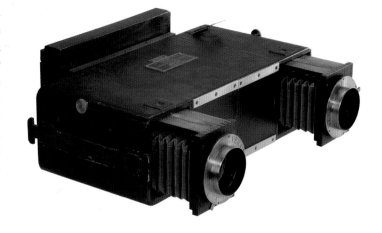

What may look like a 1950s vintage clock radio is actu-ally the Telephot Vega Stereoscopic camera of 1906. Manufactured by Véga S. A. in Geneva, Switzerland, the ingenious lens paths made this telephoto stereo camera special. Using two mirrors in each lens path, it not only shortened the twenty-two-inch focal length to make the camera body smaller, it also crossed the projected images, left lens to right image, so that the images are in the correct position and prints can be made without inversion. The lenses individually rack forward for focus, and the plate holder slides out three inches to further aid in the compactness of the camera. Intended for telephoto photography, the lenses are spaced approximately ten inches apart, more than triple a "normal" interocular distance, for a heightened stereo effect.

Stereo Hawk-Eye Model 4 *ca. 1907*

Eastman Kodak Company, Rochester, New York.
Gift of Eastman Kodak Company. 1974:0037:1295.

The Hawk-Eye line of cameras originated with the Blair Camera Company. Eastman Kodak picked up the brand when it bought the Boston firm in 1899, though the cameras' catchy name wasn't behind the acquisition. Roll film was fast becoming the preferred medium in amateur photography. The convenience of being able to take numerous pictures on a single roll of film drove customers away from plate and sheet-film cameras and their awkward, time-consuming practices. Blair, like Eastman Kodak, had invested big money in roll-film production and controlled patents that would greatly benefit its new owner.

Blair roll films had a paper backing printed with consecutive numbers that could be viewed through a small ruby window on the camera's back. This innovation greatly simplified the tracking of exposures, which previously meant relying on elaborate linkages and external frame counters, or counting the number of turns of the film transport key. When Eastman Kodak became owner of Blair Camera and relocated the entire operation to Rochester, it acquired the ruby window and numbered backings as well as Blair's film-coating expertise and its skilled workforce.

While Kodak continued to manufacture some of the Blair cameras, it also introduced new models such as the Stereo Hawk-Eye No. 4. Made of mahogany and cherry and covered with black leather, the camera had hardware of polished brass or nickel plate. With its matched pair of Bausch & Lomb lens-shutter assemblies, this Model 4 was a $35 camera; if fitted with Zeiss Tessars, the price soared to $98.55. Rolls of No. 2 film, sufficient for six 3½-inch square stereo pairs, were sixty cents. An optional adapter allowed glass plates to be substituted for film.

The Blair name gradually faded as Eastman Kodak absorbed the company, but the Hawk-Eye line lived into the late 1970s (though Kodak changed the spelling to Hawkeye in the 1950s). With such a legacy, a digital Hawkeye may not be out of the question. In fact, Eastman Kodak used "Hawkeye" as the code name for a 1989 digital camera system.

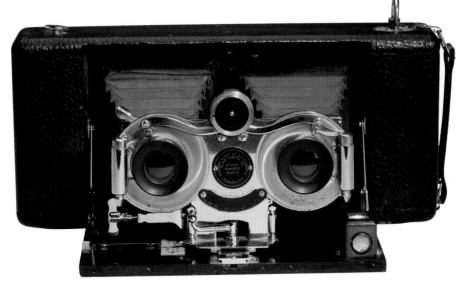

Verascope *ca. 1908*

Jules Richard, Paris, France.
Gift of D. L. Stern. 1974:0037:2297.

Stereo photography became more popular when manufacturers designed miniature cameras for roll film. The Verascope line of small stereo cameras from Jules Richard of Paris was of very rugged and durable all-brass construction, with function more important than style. This Model 6a from 1908 took 45 x 107-mm glass plates or could be fitted with the roll film holder as shown. The entire lens/shutter assembly, which consisted of six-speed Chromonos shutters behind a pair of Zeiss Tessar 55mm f/6.3 lenses, could be moved upward to correct perspective. A reflex finder between the lenses moved up as well to give an accurate view. The bubble level on top of the body was important for aligning the pairs. When new, the Verascope 6a cost $232 and the roll-film holder added another $52.

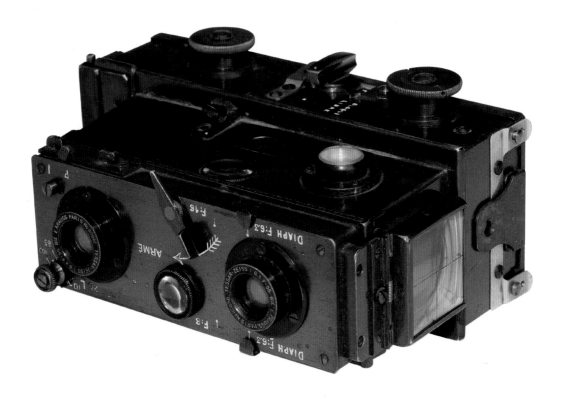

Stereo Block-Notes *ca. 1910*

L. Gaumont & Cie, Paris, France. 1977:0737:0004.

Léon Gaumont, like many other European camera makers, was a precision instrument builder prior to becoming a photographic equipment manufacturer. He entered the trade as a teenager, and after nearly fifteen years, in 1895, bought out his latest employer, Comptoir géneral de photographie. Then, with several partners, including engineer Gustave Eiffel (of iron-tower fame), he formed L. Gaumont & Cie. The firm went on to manufacture equipment for both the still and motion picture markets, using designs that embodied form-follows-function thinking and had the look of the precision tools they were.

The Block-Notes (notepad) series included this stereo camera for glass plates, which made a pair of 39 x 50-mm images on 45 x 107-mm plates. Constructed of heavy-gauge brass, the collapsible design had four locking struts that provided the matched Elge Anastigmat lenses with an extremely rigid platform. Arming the multi-speed guillotine shutter for the next pair of images was handled by sliding the cover over the lenses and back to the open position. The shutter button was located atop the lens board. The lens cover also housed the front crosshairs for the Newton finder, with the rear sight attached to the plateholder structure. Plates could be used individually or in a magazine.

Gaumont did well as a broad line manufacturer and supplier of apparatus from other makers. However, the firm is best known for its contributions to the motion picture industry, as a manufacturer of equipment and especially as a movie production company. Its current corporate entity, Gaumont SA, remains a top European producer and distributor of films.

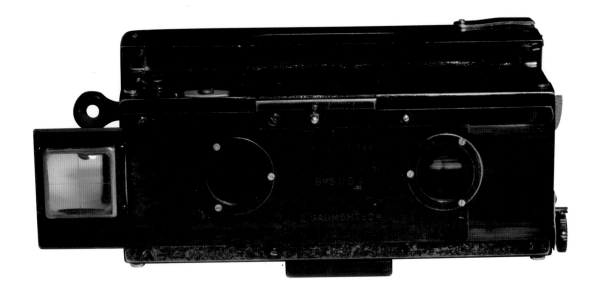

Homéos _1914_

Jules Richard, Paris, France.

Gift of Eastman Kodak Company, ex-collection Gabriel Cromer. 1974:0037:2003.

The Jules Richard firm of Paris was noted for its line of Verascope stereo cameras dating back to the 1890s. Added to the Richard catalog in 1914, the Homéos was the first stereo camera to use perforated 35mm ciné film instead of glass plates or larger film rolls. Taking full advantage of the film's narrowness, the designers created a very compact body. The lenses, either Optis or Krauss 28mm f/4.5, made stereo pairs measuring 19 x 24 mm. A folding Newton finder and bubble level atop the body helped the stereographer compose scenes. A similar finder on the left side of this 1920 model, which had a slide to cover one lens for single-frame non-stereo pictures, was for shooting single-frame horizontal-format pictures with a vertically held camera.

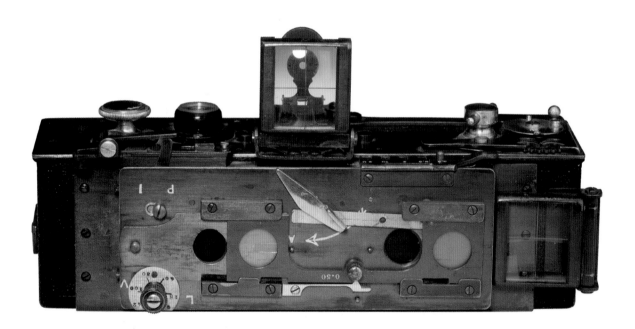

Stereflektoskop *ca. 1915*

Voigtländer & Sohn, Braunschweig, Germany.

Gift of Garfield Merner. 1974:0084:0108.

A dvertised as the smallest stereoscopic reflex camera manufactured, the aluminum-bodied Stereflektoskop was introduced in 1913. The addition of a waist-level, hooded reflex viewer made it an improvement over the earlier Stereofotoskop, which had only an eye-level optical finder. The second finder provided a 3.5-cm square view and included a bubble level. Three Voigtländer Heliar 62mm f/4.5 lenses, with the optical finder in the center, were mounted in a sector shutter with speeds to 1/250 second, variable apertures to f/18, and a rising and falling front. A 1923 revision featured the stereo-Compur shutter. Normally, the Stereflektoskop was pictured as having a twelve-plate, push-pull magazine back for 4-cm square stereo pairs, though a single plate holder was also offered. This particular camera is outfitted with a film-pack holder.

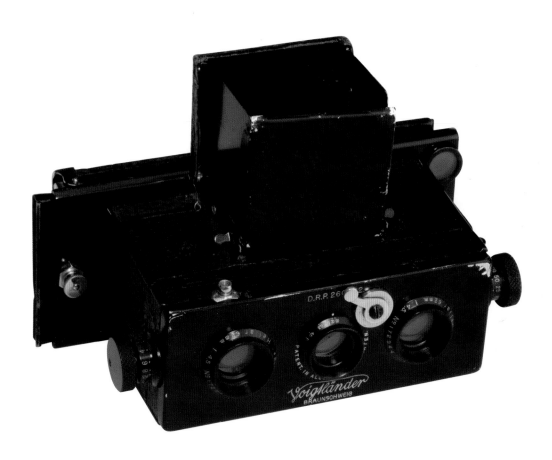

Deckrullo Stereo Tropical *ca. 1921*

Contessa-Nettel AG, Stuttgart, Germany.
Gift of 3M Foundation, ex-collection Louis Walton Sipley. 1977:0415:0128.

The Deckrullo Stereo Tropical, manufactured from 1921 to 1925, was the product of Contessa-Nettel AG, a newly merged concern in Stuttgart, Germany. In 1926, the company was part of a larger merger that formed the new firm Zeiss-Ikon from the firms of Ernemann, Goerz, and Ica. The tropical Deckrullo is a beautiful folding teakwood-bodied stereo plate camera with tan leather bellows and nickel-plated trim. The word "Deckrullo," meaning "covering roller blind," indicates it has a focal-plane shutter, in this case with speeds to 1/2800 second. Available in several sizes, this model 332 is the 10 x 15-cm plate size, with twin f/4.5 Carl Zeiss Jena lenses. An ingenious feature of this camera is the ability to convert from stereo to panoramic images. One of the lenses is mounted in an eccentric flip-over lens board, and with the slightly shifting front standard, that lens can be centered for a panoramic single exposure. At introduction, the retail price in the U.S. was $268.

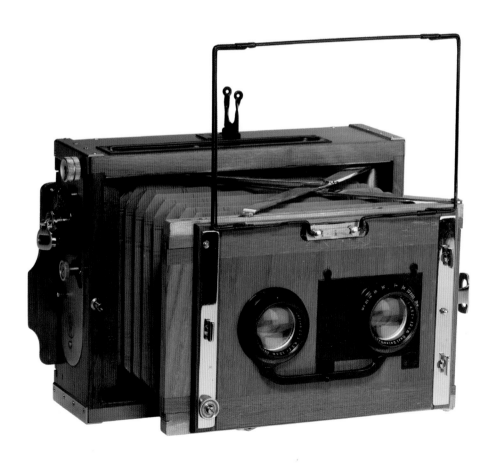

Heidoscop (6 x 13 CM) *ca. 1925*

Franke & Heidecke, Braunschweig, Germany.
Gift of Franke & Heidecke. 1974:0037:2014.

Stereo photography has been in and out of fashion several times since it was invented in the 1840s. Franke & Heidecke of Braunschweig, Germany, began business in 1920, hoping to cash in on the latest upswing in three-dimensional pictures. Their first product strongly resembled a 1913 Voigtländer design by having a reflex viewfinder with its own lens set between the matched pair of taking lenses. The Heidoscop had two Carl Zeiss Jena 7.5cm f/4.5 Tessars focused in unison with the center lens. A ground glass on the top of the black leather-covered body was the same size as the images on the 6 x 13-cm glass plates. Roll film was rapidly gaining on glass plates in popularity, so Franke & Heidecke designed a slide-in holder for 120 film. A later version made exclusively for roll film was sold as the Rolleidescop. The reflex viewer and 6-cm square format were later used for a non-stereo camera that elevated Franke & Heidecke to world fame. That camera was named Rolleiflex.

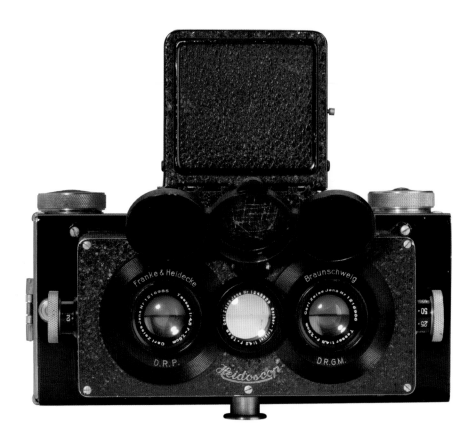

Retina I Stereo *ca. 1935*

Kodak AG, Stuttgart, Germany. 2007:0234:0001.

．．．

Stereo photography, which was perfected not long after the medium's invention, first used individual cameras mounted on a common stand or board. The two cameras were later replaced by a pair of lenses mounted in the same apparatus. Camera bodies needed to be wider than normal to accommodate the side-by-side optics. To maintain costs, most manufacturers of stereo equipment based their designs on regular 2D models. With the rise of miniature cameras, it wasn't long before 3D versions were proposed and evaluated. The French Homéos pioneered the use of 35mm film for stereo pairs in 1914. Fifteen years later, Leitz's Oskar Barnack built a stereo Leica designed to make two 24 x 36-mm images with a single press of the shutter release. The camera never made it past the prototype stage for a number of technical reasons, one being that just one focal-plane shutter served both lenses. The gap in the shutter curtains could sweep across only one frame at a time, and good stereo photos require both pictures to be exposed simultaneously.

The experimental Retina I Stereo solved the problem of simultaneous exposure by using leaf shutters in the lenses, with the releases linked by a connecting rod. The camera used Kodak 35mm daylight-loading cassettes, and, like the Leica, made 24 x 36-mm pairs. Many of the parts used for this test mule came from the Retina I parts bins, though the body was specially made. Two 50mm Xenar lenses and Compur-Rapid shutters were set 2⁹/₁₆ inches apart, and had to be focused individually. Neither the speed nor aperture dials were linked in the prototype, but most certainly would have been had the project continued beyond this trial instrument. Numerous companies would revive the 35mm stereo idea after World War II, but Kodak AG was not among them.

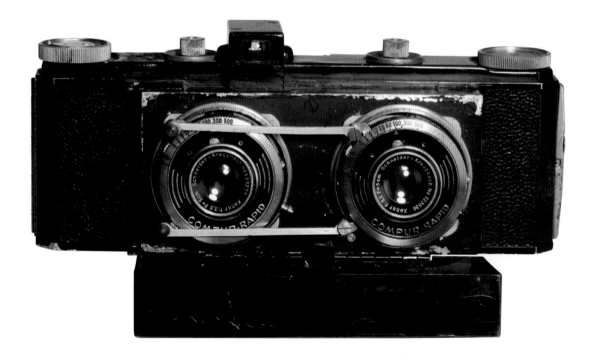

Kirk Stereo Camera *ca. 1942*

Kirk Plastic Company, Los Angeles, California. 1974:0037:2501.

Introduced in 1942, the Kirk Stereo Camera was constructed in an art deco style of brown marbleized "Plastonyx." It had two lenses with "Dual Synchro-Shutters" and a direct vision finder, with the option of a matching battery-powered viewer. Using No. 828 roll film, which allowed for either black-and-white or color (Kodachrome), it produced six 26 x 28-mm stereo slide pairs. The camera and viewer retailed for $29.75 in 1942.

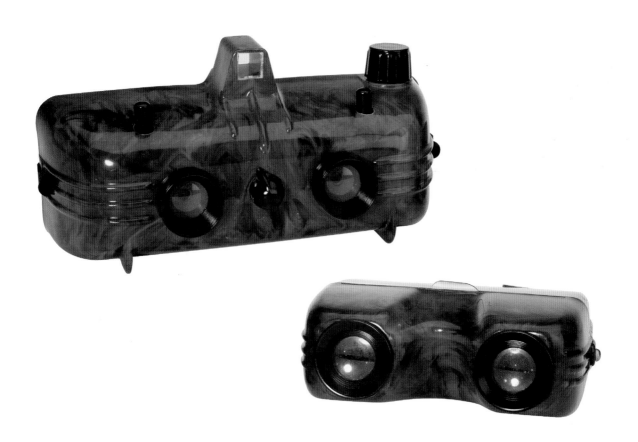

Stereo Realist Model ST41 *ca. 1950*

David White Company, Milwaukee, Wisconsin.
Gift of Dr. Iago Galdston. 1982:1620:0005.

The Stereo Realist Model ST41 was introduced in 1950, early in the 35mm stereo craze, which ran until the mid-1950s. It was a high-quality, attractive, reasonably priced camera that embodied good-quality lenses, rangefinder focus, and a parallax-free central viewing lens. Focus was achieved by moving the film plane, thus assuring perfect lens alignment. It retailed for $162.50 in 1950 and for analog (film) photographers is considered the first choice for stereo photography today.

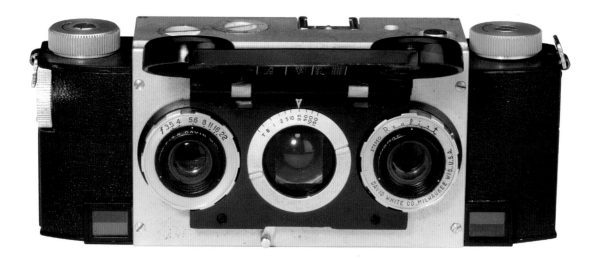

Kodak Stereo (35MM) *ca. 1954*

Eastman Kodak Company, Rochester, New York. 1974:0037:2023.

The Kodak Stereo camera was introduced in 1954. Though Kodak's was not the first of the 35mm stereo cameras, its introduction acknowledged the rebirth of stereo views and the fascination for 3D popularized in the 1950s by Hollywood movies and products such as the Sawyer View-Master. This revived interest, along with a ready availability of supplies, made stereo cameras quite popular. The Kodak Stereo camera had a built-in spirit level, visible in the viewfinder, to assure the proper stereo effect.

The Kodaslide Stereo Viewer was a sturdy, attractive, art deco-inspired Bakelite viewer, available in both battery-powered and line-powered versions. It featured an interocular adjustment, focus, and brightness controls.

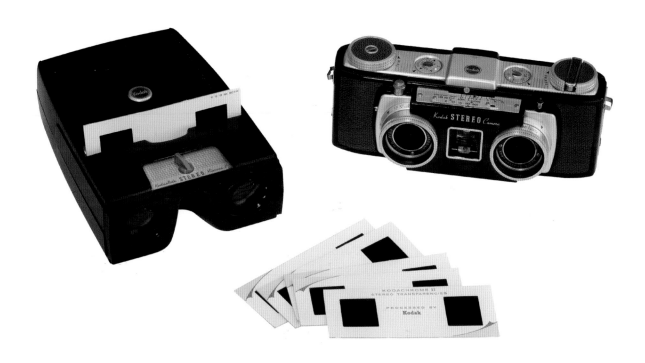

Duplex Super 120 *ca. 1956*

Industria Scientifica Ottica S.R.L. (ISO), Milan, Italy.
Gift of Robert Olden. 1977:0526:0001.

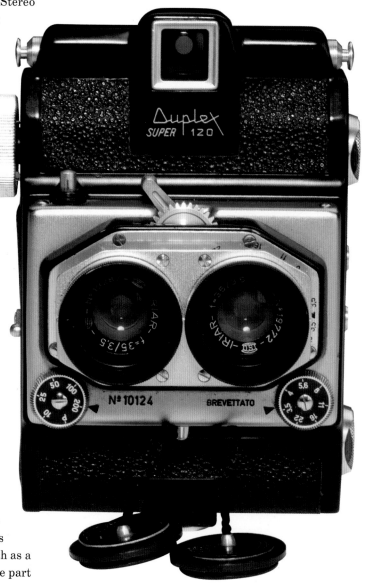

During one of stereo photography's periodic booms beginning with the 1947 introduction of the Stereo Realist camera, ISO of Milan produced the Duplex Super 120 in the mid-1950s. The Super 120 used the same 24 x 25-mm format as the Realist, but on 120 roll film instead of the 35mm film used by most other Realist-format cameras on the market. By spacing two 35mm f/3.5 Iriar lenses 1¼ inches apart, rather than the 2¾ inches others used, the Super 120 made a pair of images on a short strip of vertically loaded film. The linked lenses were focused together by turning the gear-like knob above them. Two shutters were tripped simultaneously by pressing the button on the lens panel, and a pair of tiny dials under the lenses adjusted the shutter speed from 1/10 to 1/200 second and the aperture from f/3.5 to f/22. Scenes were framed using a simple top-mounted finder. Connector cord sockets for flash were located on one side, the advance knob on the other. The body was molded of plastic, with the rear door and front lens panel stamped from steel.

The Duplex name refers to its single-image feature. By covering one lens with the cap, it was possible to expose only one side of the pair. The "Singolo" lever was used when cocking the shutter, which defeated the double-exposure interlock. Switching the cap to the opposite lens allowed the second frame of the pair to be exposed. Single frames and stereo pairs could be mixed on the same roll. ISO priced the Duplex Super 120 at $39, making it a better buy than the 35mm stereo cameras offered by Realist, Kodak, or Revere. Accessories such as a negative cutter, stereo mounts, and a 3-D viewer were part of the Duplex line.

SUBMINIATURE

Almost from their inception, cameras, like clocks, have been made in many sizes. During the nineteenth century, the term "miniature" was applied to cameras smaller than those in common use. In the twentieth century, the word was applied to cameras such as the Leica, whose 24 x 36mm image size on 35mm film came to represent technically advanced photography. Cameras smaller than the Leica were classified as subminiature, and with the introduction of the Minox, took on the allure and intrigue associated with espionage. But not all subminis were used by spies; the majority were used as pocket-sized carry-along cameras for those seeking to always be prepared to capture the next great image.

Miniature Chambre Automatique de Bertsch *ca. 1861*

Adolphe Bertsch, Paris, France.

Gift of Eastman Kodak Company, ex-collection Gabriel Cromer. 1974:0037:0001.

Adolphe Bertsch offered a miniature version of the Chambre Automatique that produced circular images two centimeters in diameter. Housed in a fitted mahogany case, the outfit included the camera, twelve plates, chemistry for sensitizing and processing the wet-plate images, and a loupe for viewing the small images.

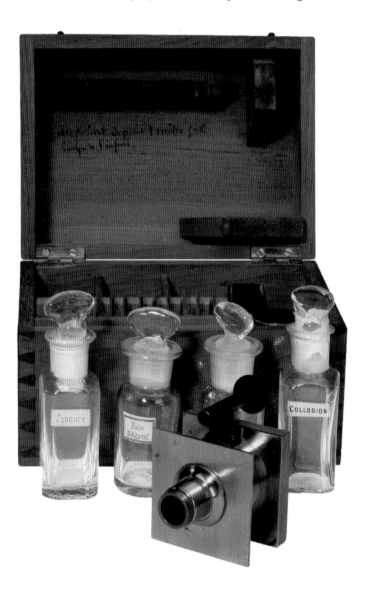

Small view camera *1870*

Jules Reygondaud, Paris, France.
Gift of Eastman Kodak Company. 1974:0037:1683.

Manufactured in 1870 by Jules Reygondaud of Paris, France, this mahogany-bodied small view camera used 8-cm square collodion dry plates, which first appeared in the mid-1860s but were not commonly used as they were slower than the wet version. The camera's style resembles the stand cameras used by professional photographers, but in miniature. It had a rack-and-pinion focusing mechanism but no distance scale, so ground-glass viewing was necessary. The barrel-mounted Reygondaud Rapid Rectilinear lens had provision for Waterhouse stops, which controlled depth of field. However, it contained no shutter and had to be capped and uncapped for exposure.

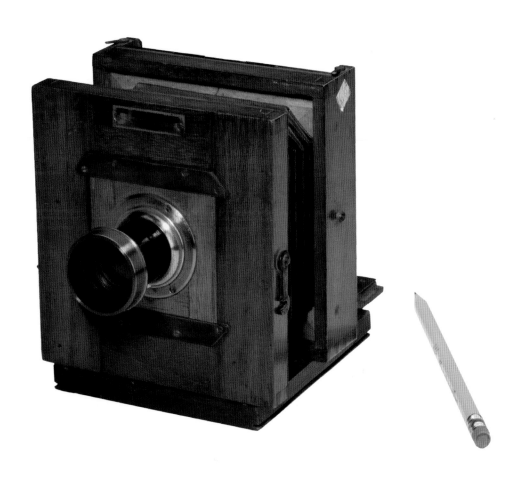

Metal Miniature Camera *ca. 1884*

Marion & Company Ltd., London, England. 1974:0084:0033.

In the 1880s, Marion & Company of London advertised its Metal Miniature Camera at 2⅜ x 2⅞ x 5¾ inches as "easily carried in the pocket," which may have been possible with the clothing styles of the time. The availability of dry plates had simplified photography, and manufacturers responded by designing smaller cameras. The Metal Miniature had a cast brass body and rear door, rack-and-pinion focusing, and a brass shutter operated by gravity when the release lever was pressed. A ground glass was used to focus the 55mm f/5.6 Petzval-type lens, and a tiny knob on the lens barrel operated the diaphragm. Two-inch square dry plates could be developed and printed at home, using the equipment and chemicals included in the £5 10s. outfit packed in a polished walnut case.

Lancaster's Patent Watch Camera *1886*

J. Lancaster & Son, Birmingham, England.
Gift of Eastman Kodak Company. 1974:0084:0040.

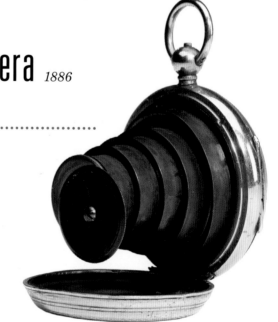

The Lancaster Patent Watch Camera was introduced in 1886 and manufactured by J. Lancaster & Son, Birmingham, England. It was made in men's or ladies' versions to resemble a pocket watch, with a self-erecting design using six spring-loaded tubes to function as a bellows upon opening. The men's version held a 1½ x 2-inch plate, while the smaller ladies' version used a 1 x 1½-inch plate. The original list price was £1 11s. 6d.

Kombi *ca. 1892*

Alfred C. Kemper, Chicago, Illinois.
Gift of Walter D. Marshall. 1974:0084:0064.

The photography boom of the 1890s had many manufacturers eager to meet the demand. Simplification and portability were required by amateurs and encouraged Alfred C. Kemper of Chicago to set up production of his tiny Kombi in 1892. An all-metal box camera roughly the size of a modern 35mm film carton, the Kombi was named for its dual purpose, being both camera and viewer. The roll holder for the 1⅛-inch wide film slipped onto the body and was held in place by friction. Film had to be loaded in the dark, requiring that one be familiar with the holder assembly. The shutter was spring loaded and held with a latch but was not self-capping; a finger had to be kept over the lens while the shutter was cocked. To use the Kombi as a Graphoscope, images were transferred to positive film and a cap on the holder removed. With a positive roll in the holder, the lens was brought to the eye and the film end aimed at a light source, just like a souvenir shop viewer. The Kombi retailed for $3.50, a price that included masks for square and round pictures. Its catalog offered a wide selection of equipment for processing and printing.

Photoret *ca. 1893*

Magic Introduction Company, New York, New York.
Gift of Eastman Kodak Company. 1974:0084:0066.

In the 1890s, almost every man carried a pocket watch. No one then would have looked twice at someone with a watch in his hand. In 1893, inventor Herman Casler was granted a patent on his Photoret camera, a nickel-plated metal device shaped like an ordinary timepiece of the day. For $2.50, the buyer received a sliding lid wooden box containing the camera and a tin of six film discs. Similar to that of the Kodak Disc camera, which would appear nearly a century later, the Photoret disc rotated after each exposure until all frames were complete. Film needed to be loaded and unloaded in the dark. Camera operation was simple. Unlike the later Expo and Ticka watch cameras, the Photoret lens was in the watch body, not the stem. Moving the stem sideways brought a fresh film sector into position, with a counter keeping track. The watch was aimed and the stem depressed to trip the shutter. Despite its tiny lens and 12 x 12-mm negatives, the Photoret's images could be enlarged to snapshot size with good sharpness.

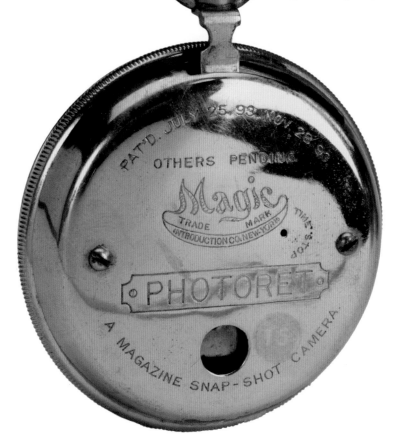

Ne Bougeons Plus *ca. 1895*

L'Office Central de Photographie, Paris, France.
Gift of Eastman Kodak Company, ex-collection Gabriel Cromer. 1995:2631:0001.

Cameras used as advertising pieces are still quite common, with today's examples being mostly of the one-time-use variety emblazoned with various company logos. The concept wasn't unknown in the nineteenth century, as this all-metal canister camera from France shows.

Only two-and-one-half inches high and less than two inches square, the tiny tin was made by the "workshops of the Central Office of Photography," a manufacturer of optical goods in Paris. A simple glass lens was secured in the slip-off lid, as was a sliding metal tab that served as a shutter. The sensitized media of the day were slow enough to allow use of such a crude design. Not that taking pictures was the main purpose of the device. Four sides and the bottom of the can served as ad space for businesses. Vendors of bicycle trailers, pianos, and photographic equipment presumably paid to have their stores touted on these cameras, which were either given away as promotional pieces or sold at fairs for very low prices.

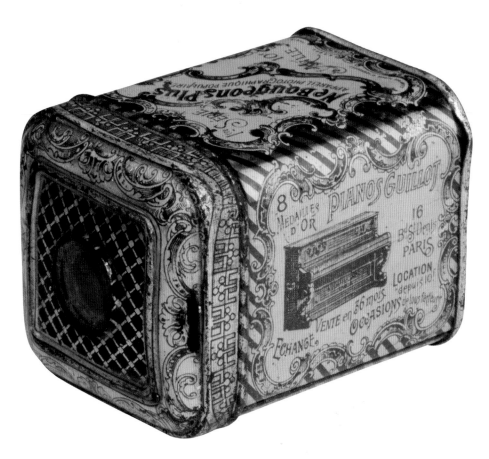

Presto *ca. 1896*

Magic Introduction Company, New York, New York.
Gift of 3M Foundation, ex-collection Louis Walton Sipley. 1977:0085:0011.

Improvements in photographic plates and film allowed camera manufacturers to miniaturize their products. One of the smallest designs was the Presto camera of 1896, made by the Magic Introduction Company of New York. An all-metal construction, the Presto could be used with roll film to take 1¼-inch square pictures, or the roll holder could be removed and a mechanism holding four glass plates substituted. The pillbox body was stamped from brass as was the removable cover, which was held in place by friction. The shutter was dropped by gravity when the button was pressed, and then reset by turning the camera upside down. A rotating disc on the front had three selectable aperture sizes.

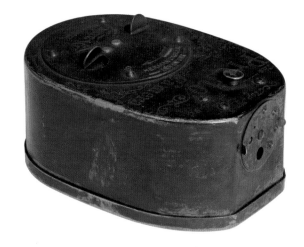

Ticka *ca. 1910*

Houghtons Ltd., London, England.
Gift of Eastman Kodak Company. 1974:0037:0036.

The 1910 Ticka was a milestone in miniaturization made possible by continuous improvement in the quality of roll films. Introduced by Expo Camera of New York, the pocket watch-shaped camera was also licensed to Houghtons Ltd., in London. The watch's winding stem hid a 30mm f/16 meniscus lens that worked through a simple guillotine shutter; the knob served as a lens cap. The dial and hands looked functional but were just for effect, though the hands were positioned to serve as a viewfinder. Sold in special daylight-loading cassettes, the film dropped right into place when the dial face was removed. A winding key on the back advanced the film to the next of its twenty-five exposures. The Ticka sold for under $5 at introduction.

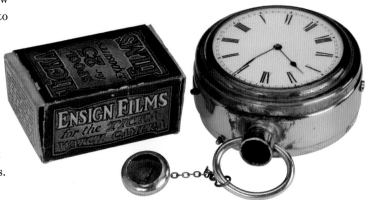

Ensign Midget 55 *ca. 1934*

Houghton-Butcher Ltd., London, England.
Gift of Dr. Rudolf Kingslake. 1993:0525:0001.

The Ensign Midget 55 was "no wider than a sixpence" when folded, according to the London firm's 1935 catalog. The top of the Midget line, the Model 55 designation came from its fifty-five shilling price tag. Featuring an Ensar f/6.3 focusing lens, adjustable aperture, and three-speed shutter, it looked like a child's toy but produced images sharp enough to enlarge on the six-exposure rolls of 35mm wide Ensign E10 film. The designers of the Midget series allowed no wasted space and managed to include a two-position reflex finder, folding eye-level bull's-eye finder, prop stand, and locking struts that held the lens board rigidly in position. Many "vest pocket" folding cameras were available then, but none were smaller than the Houghton-Butcher Ltd. series of Midgets.

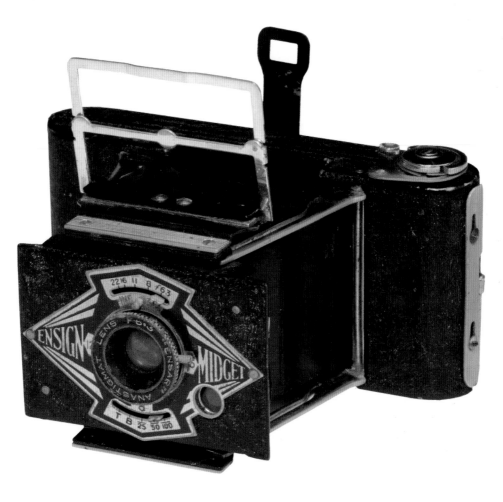

Coronet Midget *ca. 1935*

Coronet Camera Company, Birmingham, England. 1974:0028:3052.

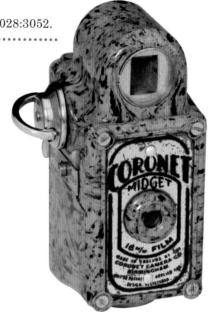

The Coronet Midget, manufactured by Coronet Camera Company, Birmingham, England, in 1935 was advertised as "the world's smallest camera." Also known as "The Tom Thumb of Cameras," it was made of Bakelite in five different colors and weighed just 1¾ ounces. The retail price was $2.50, and a roll of six-exposure 16mm film sold for twenty cents.

Minox (ORIGINAL MODEL) *ca. 1937*

Valsts Electro-Techniska Fabrica, Riga, Latvia.
Gift of Eastman Kodak Company. 1974:0084:0130.

The original Minox, designed as a pocket-sized hiking camera, was destined to become the world famous "spy camera" as seen in the movies. It was designed by Walter Zapp and manufactured in 1937 by Valsts Electro-Techniska Fabrika, in Riga, Latvia. The first of many tiny Minox cameras, it was initially made from stainless steel and later changed to lighter aluminum. Though the camera had all the usual controls, its main feature was that it was made instantly ready by merely pulling the sliding inner case out, which simultaneously exposed the viewfinder, advanced the film, and set the shutter. Later versions of the camera kept up with advancing technology by adding innovations such as parallax correction, electronic flash, and auto exposure. The original retail price in 1937 was $79.

Sola *1937*

A. Schatz & Söhne AG, Triberg, Germany.
Gift of Jerry Friedman. 2004:0979:0001.

Schatz & Söhne of Triberg, Germany, designed and built clocks from its founding by August Schatz in 1881 until its closing in 1985. Its specialty was the four-hundred-day clock. The horologist's expertise for precision proved valuable when the firm decided to enter the camera market in the 1930s. Introduced in 1937, the palm-sized Sola immediately became the most sophisticated submini-ature camera available. The 16mm jewel had features that, until then, were found only on German 35mm and medium-format roll-film apparatus. A nine-speed focal-plane shutter made good use of three interchangeable Schneider-Kreuznach lenses—Xenon f/2, Kinoplan f/3, and Tele-Xenar f/5.6—that were part of the Sola pack-age. The metal cassettes were reloadable in a darkroom and held enough unperforated 16mm film for twenty-four 13 x 18-mm negatives.

A Sola shooter could click off those twenty-four frames in about as many seconds, thanks to the spring motor-powered film advance. The wind-up key was located on the bottom of the horseshoe-shaped body, next to the frame counter. An entire roll moved through the camera with a single winding, just as the Schatz clocks ran for more than a year with the same input. The Sola viewfinder could be used as a reflex type when sighted from above or at eye level. Rotating it to the side allowed use of a folding sports finder. The shutter button had a sliding lock that prevented the user from accidentally pressing the release and wasting film.

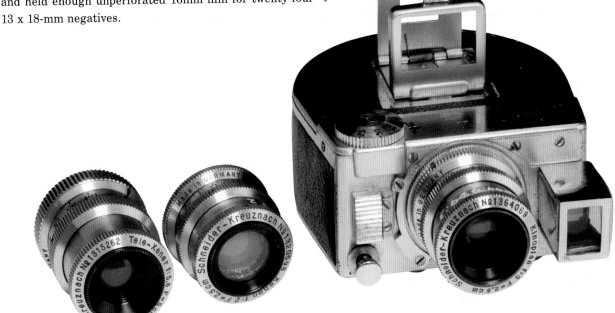

Малютка (Malutka) *ca. 1938*

State Optical-Mechanical Works (GOMZ), Leningrad, USSR.
Gift of Jerry Friedman. 2006:0263:0002.

The 1934 SIDA was a cast-metal, 35mm roll-film camera first made in Berlin, Germany. It proved to be very popular, and soon was also manufactured in England, France, Italy, Czechoslovakia, and Poland, using either metal or plastic for the body material. All variants of these little cameras were very simple, with a single-element lens and one-speed shutter. What looks like a tripod socket on the bottom is actually an attachment for a wrist strap. By the late 1930s, a Soviet copy of the German camera appeared as the Liliput, made by GOMZ (State Optical-Mechanical Works) in Leningrad. Molded of Bakelite in several different colors, the Liliput was far from the first Soviet-era camera to be based on a design that originated in Germany.

Shortly after GOMZ put its copy of the SIDA in domestic camera stores, an improved version was offered. Functionally identical to the Liliput, the Malutka (Little One)

had a more attractive shape, and metal sliding locks that secured the back, in place of the troublesome friction snap of the original SIDA design. Molded into the body was a simple optical finder, located between the film winder and the notched rotating disc that served as an exposure counter. This last feature eliminated the red plastic window used on the Liliput and all SIDA cameras. Production of both the Liliput and Malutka ceased in 1940, after the USSR entered World War II. The SIDA resumed manufacture in 1948, when Fritz Kaftanski, the camera's designer, opened a factory in France.

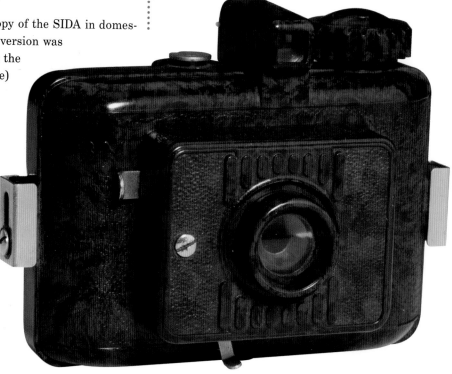

Compass *ca. 1938*

Jaeger LeCoultre & Cie, Switzerland. 1974:0028:3309.

. .

The Compass camera was manufactured by Jaeger LeCoultre & Cie, Switzerland, for Compass Cameras Limited, London, in 1937. It had a precision, fully machined aluminum body that produced 24 x 36-mm images on glass plates, sheet film, or 35mm roll film. No. 828 roll film also could be used with an available back. The compact camera possessed advanced features such as a coupled range-finder, extinction meter, right-angle viewer, ground glass focusing, and interchangeable backs. The retail price in 1937 was £30.

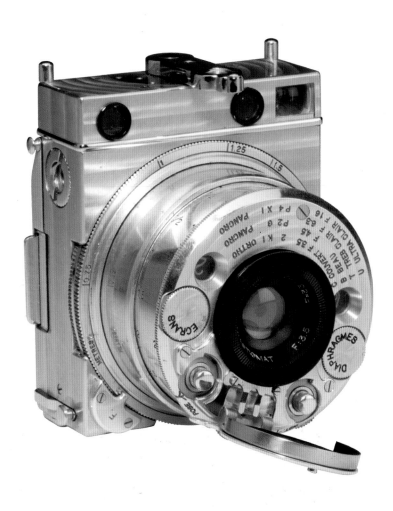

Biflex 35 *ca. 1948*

E. Schmid, Feinmechanische Konstructions-Werkstatte, Urdorf, Switzerland.
Gift of Jerry Friedman.

The term *subminiature* refers to image size, which does not necessarily relate to the exterior dimensions of the camera taking those little pictures. The Biflex 35 shot 11 x 11-mm images, but did so on perforated 35mm film in a camera not much smaller than the Signet 35, which made standard-sized *miniature,* or full-frame, negatives. And with its thick-walled cast body and a shutter-lens-control housing machined from solid brass, the Swiss-made camera surely weighed more than the Kodak model. A standard 35mm cassette supplied film to the Biflex, with a reloadable take-up cassette on the other end. To pack as many as two hundred of the tiny frames on a 36-exposure roll, the user had to shoot the first one hundred pictures, remove the bottom plate, and turn the film and cassettes upside down. The second one hundred exposures were then made on the same roll, resulting in two rows of images.

All of the Biflex 35's control setting dials were on the front of the camera, near the Meyer Görlitz Trioplan 20mm f/2.8 lens. The shutter had seven very smooth-operating speeds, and the aperture knob rotated a sector with five Waterhouse stops. The camera did not need a rangefinder, as it had a fixed-focus lens. Although the viewfinder looked odd with a 1/16-inch diameter window, it was more than adequate for composing a scene. The $25 Biflex had no provision for flash, no tripod socket, and no "T" or "B" setting for the shutter. What it did have was a complete complement of accessories available for cutting and mounting slides to view with the Biflex projector. The slides required special mounts that measured just under one inch square. The Biflex 35 was discontinued after a few years on the market, due to poor sales. Competition in the form of cameras no larger than a Biflex 35 were being introduced, and they took half-frame (18 x 24-mm) or full-frame (24 x 36-mm) pictures that made much better prints and slides.

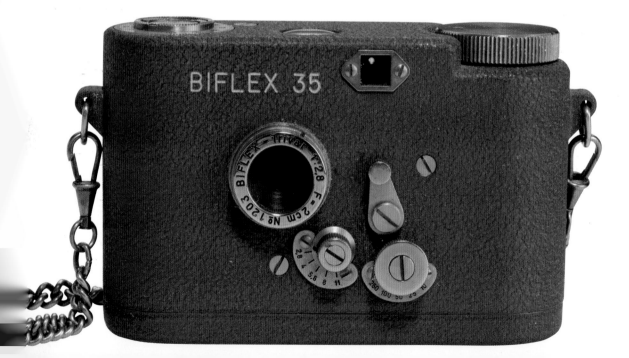

Sakura Petal (OCTAGONAL MODEL) *ca. 1948*

Sakura Seiki Company, Tokyo, Japan.
Gift of C. A. Vander. 1978:0642:0002.

The Sakura Petal, manufactured in 1948 by the Sakura Seiki Company of Japan, was a subminiature camera just over one inch in diameter. It made six exposures, each about ⅛-inch in diameter, on a round piece of film about one inch across. The octagon-shaped body shown here was rarer than the earlier round body.

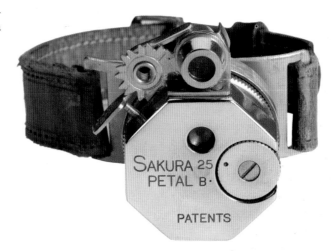

Tone *ca. 1948*

Toyo Seiki Kogaku, Tokyo, Japan.
Gift of Harry G. Morse. 1981:2297:0033.

Small enough to hide in your hand, the little Tone of 1948 was a cut above the cheap novelty cameras produced in enormous quantities in post-war Japan. Manufactured by Toyo Seiki Kogaku in Tokyo, the Tone used the same "midget" size film for 14 x 14-mm negatives, but it was made of higher quality materials and had features the cheaper cameras lacked, such as both eye-level and waist-level viewfinders. The lens was adjustable for focus, and the shutter could be set at whichever of its three speeds suited the occasion.

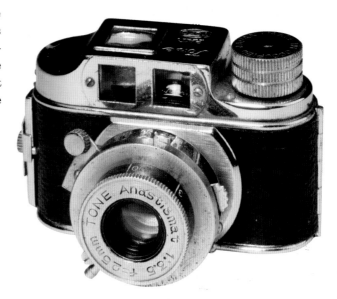

Rapitake *ca. 1948*

Raymond R. LaRose & Son, Culver City, California.
Gift of Judith Sealander. 2008:0360:0005.

The post-World War II demand for new consumer products gave a big boost to creative designers in many industries, and helped launch unusual products like the Rapitake camera. Raymond R. LaRose designed two miniature cameras of similar concept: the Micro 16, a tiny 16mm made by the Whittaker firm, and the Rapitake, manufactured in LaRose's own facility in Culver City. Both cameras had die-cast metal bodies with a hinged metal door for film chamber access. They also shared a shutter actuator/film-advance mechanism operated by a plunger-style button on the side.

The 35mm Rapitake was much larger than LaRose's 16mm design, but still very compact when compared to competitors' offerings. Using standard film in Agfa Rapid Cassettes, the camera exposed each 18 x 24-mm half-frame through the fixed-focus, 35mm f/7.5 lens with a single-speed 1/50 second shutter. Three Waterhouse stops selected with a ridged thumbwheel made allowances for light conditions. An exposure counter next to the viewfinder kept track of film usage. The camera could be easily held in either the vertical or horizontal position while sighting through the finder. Its lens was color-corrected to make use of the latest films, and the shutter was synchronized for flash, which was secured in place by the connector plug. Despite innovation and stylishness, the Rapitake failed to attract enough buyers to support the LaRose enterprise, which quickly faded into history.

Mikroma *1949*

Meopta, Prerov, Czechoslovakia.
Gift of Jerry Friedman. 2009:0278:0001.

In much the same way that the availability of cheap lengths of 35mm ciné film gave rise to cameras that made use of the 35mm format, 16mm movie film spawned the design of many subminiature cameras. The Czech firm of Meopta entered the "spy camera" market in 1949 with the Mikroma. A heavy, rugged piece of equipment, the Mikroma was no toy. Construction was all-metal, the Mirar 20mm f/3.5 lens was fast and sharp, and the control lever on the top rear actuated the shutter when pushed to the left, and advanced the film while it cocked the shutter when pushed to the right. This example, made for the Czech police, has a four-speed (plus Bulb) shutter and a top-mounted shutter button. Film was loaded into special Meopta cassettes for the 11 x 14-mm negatives, and depending on the length of the strip, could produce as many as sixty exposures per loading. The viewfinder was built into the top of the camera, with the police model having an additional waist-level finder on the front. Interest in subminiature photography led to the development of many 16mm cameras of varying quality, and the Mikroma was considered one of the better ones. A solid feel and reliable operation, as well as the addition of a stereo version, kept sales going until the 1960s. The fact that the Mikroma looked like a real camera, only smaller, set it apart from its competition.

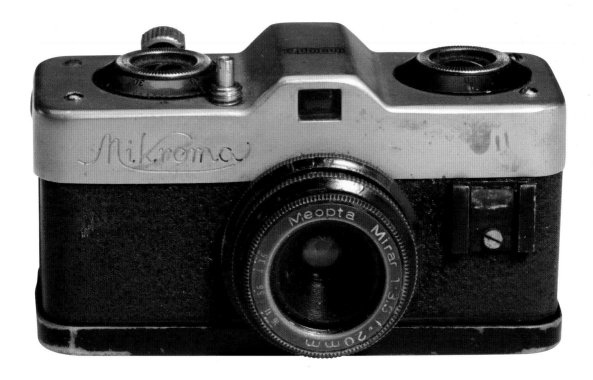

SUBMINIATURE CAMERAS
Jerry Friedman

The equipment may be tiny, but the subminiature family of cameras is amazingly large and varied. These small film cameras were most popular from the 1950s to the 1980s. In a period when other cameras grew increasingly larger, many people enjoyed being able to carry a pocket-sized apparatus that could capture that special picture anytime, anywhere.

By definition, subminiatures make an image smaller than the standard 24 x 36 mm of the negative from 35mm cameras, which are in a class of equipment known as miniature. Historically, three of the smaller formats have been most important. All used film that was originally intended for movie cameras, usually packaged in special cassettes. The smallest, the 8 x 11-mm image of the Minox camera, was about the size of a pinky fingernail. Introduced in 1933, the tiny camera used readily-available 9.5mm ciné film. From its first days, the Minox was considered the ultimate spy camera, and has been featured in many books, movies, and television programs.

The second image size of importance was the 10 x 14-mm format, made on 16mm ciné film by such cameras as the Minolta 16, the Mamiya 16, the Mec, and many others. These cameras are considerably larger and generally less expensive than a Minox. 16mm ciné film was very readily available and its 140 sq. mm-negative compared favorably to the 88 sq. mm of the Minox, producing technically superior photographs.

The half frame was the third and most popular subminiature image size, and most important historically. The 18 x 24-mm image, which is half the size of the image produced by a 35mm camera, predates 35mm still photography. Originally known as the single frame, it was the standard size for an individual image on a reel of 35mm movie film.

Half-frame cameras, best exemplified by the Olympus Pen series of equipment, were just a little bigger than many 16mm cameras, and smaller than some like the GaMi, yet produced a much larger 432 sq. mm-image. This is more than three times larger than the image of a standard 16mm camera and about five times the size of the Minox image. Most important, half-frame cameras could use the standard 35mm film that was widely available and could be processed by any pharmacy.

Even within these general categories, several cameras innovated in order to make the most use out of small film sizes. The Rollei 16 produced a negative which was 12 x 17 mm, or 194 sq. mm, nearly forty percent larger than the standard image of a 16mm camera. Similarly, the Swiss Tessina camera used 35mm film to make an image 17 x 23 mm in size, or 391 sq. mm. While this image is smaller than the

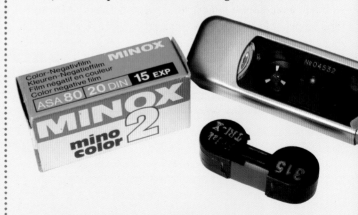

Minox (original model), ca. 1937. Valsts Electro-Techniska Fabrica, Riga, Latvia. Gift of Eastman Kodak Company. 1974:0084:0130.

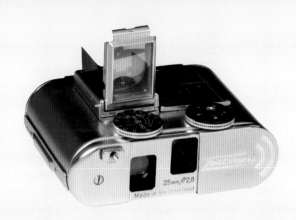

Tessina 35, ca. 1960. Concava SA, Lugano, Switzerland. 1978:0763:0001.

standard half frame made by the Pen camera, the Tessina was a truly compact camera, about one-third smaller than the Pen and half the size of most 16mm subminiatures. In terms of total volume, the Tessina was actually only a little larger than a Minox but made a negative about four times larger on more convenient film. Hence, for many enthusiasts, the Tessina remains the ideal subminiature, as it combined a very small camera size with a large image size.

Some subminiature cameras were truly tiny and took several amusing forms, such as cigarette lighters, fountain pens, binoculars, and even small transistor radios with built-in cameras. Even smaller cameras were built into wristwatches. One Italian designer created a series of fully-featured ring cameras capable of producing six decent-sized photos from a round piece of film just one-half inch in diameter. Some ring cameras from Poland produced acceptable images from teeny 3-mm slices of film.

Despite the great fun factor offered by subminiature cameras, and the real photographic capabilities of the best half-frame cameras, several factors limited their popularity.

Olympus Pen, ca. 1959. Olympus Optical Company, Ltd., Tokyo, Japan. Gift of Jerry Friedman. 2008:0364:0001.

Most required special ciné film in special cassettes. Finding adequate commercial film processing was often difficult, certainly more so than for 35mm film. During the 1960s, the increasing popularity of color film and transparencies hurt the sales of small cameras. While the negative from a quality subminiature could produce a great black-and-white enlargement, good color enlargements demanded a much larger negative. The growing popularity of color photos and transparencies only made the limitations of subminiatures that much more apparent. Most recently, the advent of incredibly tiny digital cameras, capable of far better pictures than their analog counterparts, has further contributed to declining popular interest in subminiatures.

And yet enthusiasts continue to use subminiature cameras. Many have become accomplished darkroom magicians, often capable of turning a tiny Minox negative into beautiful 11 x 14-inch enlargements. Dedicated users have created custom enlargers with specially-corrected lenses, capable of producing amazing results. Such enlargements demand precise, often bizarre darkroom techniques as well as special films and chemistry. For some, this represents far too much work. For others, this is precisely why subminiature cameras remain such fun.

Jerry Friedman is a retired history professor from Kent State University and a collector of subminiature cameras.

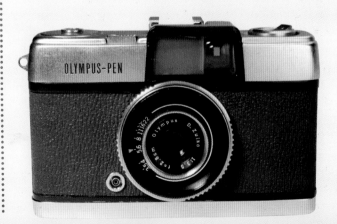

Linex *ca. 1954*

Linex Corporation, Division of Lionel Manufacturing Corporation, New York, New York.
Gift of Eastman Kodak Company. 1999:1009:0001.

The 1950s saw a resurgence of stereo still cameras owing to the popularity of the Sawyer View-Master and what has come to be known as the "Golden Era of 3-D" in Hollywood. One of many models was the Linex stereo camera, introduced in 1952 by the Linex Corporation, a division of the Lionel Corporation, which was a leading manufacturer of toy trains. The seed of Lionel's entrance into the camera business was planted in 1949, when its head, Lionel Cowen, received a gift of a Stereo Realist camera prior to his Hawaiian vacation. By the time he returned to the mainland, he was convinced that there was a profitable market for a much cheaper version of the Realist and put his toy train engineers on the project. The Cowen family's photographic roots go back even earlier, to 1899. Cowen's father, Joshua Lionel Cohen (later changed to Cowen), was the inventor of a patented device that ignited photographic flash powder. This was followed by a U.S. Navy contract to produce mine fuses. The proceeds were used to found the Lionel Corporation.

With the help of a respected designer, August Stellpflug, the Lionel engineers came up with a stereo camera design consisting of a sturdy die-cast alloy body with some molded nylon parts, weighing about one pound. The lenses were of a 30mm fixed-focus design with adjustable apertures of f/6 or f/8, mounted in a single shutter of a fixed 1/50 second. The 16mm unperforated Ansco color transparency film was supplied in a factory-loaded magazine. After returning the film for processing in the supplied shipping box, the user received two strips of transparencies, each with four stereo pairs. The strips were then assembled into clear viewing frames for use in the Linex viewer. The boxed outfit, including camera, viewer, plaid cloth carrying case, batteries, and processing mailing box was priced at $44.50 at introduction, meeting its goal of offering a stereo camera at far less than the competition. A flash attachment was offered at $6.50 extra.

Cowen's market estimate of $40 million per year was wildly optimistic. The Linex managed to manufacture only 85,000 cameras over the two-year production span, with only about 67,000 sold at retail, and the rest being severely discounted. Most likely the camera fell out of favor with the public due to its proprietary film and processing system, as with so many camera systems that tried to capture the consumables business along with their camera sales. The Linex went out of production in 1956.

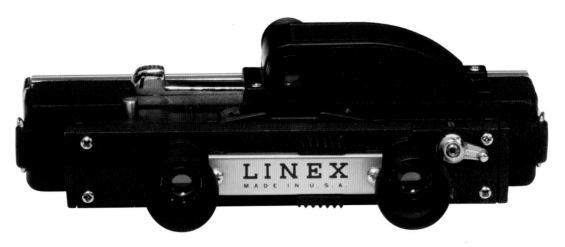

Stylophot *ca. 1955*

Secam Corporation, Paris, France. 1974:0028:3311.

··

The public's fascination with espionage during World War II continued through the Cold War years and undoubtedly boosted sales of subminiature or "spy" cameras. Some, like the Minox, were costly, high-quality instruments, but most were sold as inexpensive trinkets. Secam of Paris offered the Stylophot in 1955, with its bloated fountain-pen shape and $14.95 price tag placing it firmly in the novelty market. The pocket clip did come in handy for carrying the plastic-bodied Stylophot. Special cassettes held perforated 16mm ciné film for eighteen pictures in either noir or couleur (black-and-white or color). Operation was very simple. The film was advanced and the shutter cocked, then a chrome slide called the "transport plate" was pulled out. The tiny fixed-focus 27mm f/6.3 coated lens fed light to the film through one of the two stops, and a ridged metal thumb tab actuated the 1/50-second shutter for each 10 x 10-mm image.

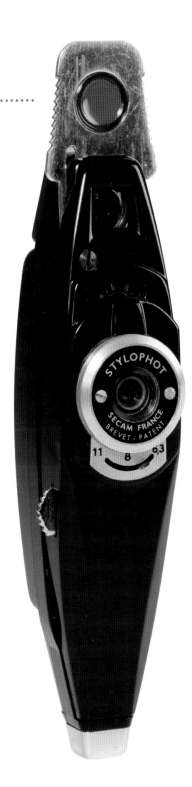

Golden Ricoh 16 *1957*

Riken Optical Industries, Ltd., Tokyo, Japan.
Gift of James Sibley Watson Jr. 1981:0790:0043.

Riken touted its Golden Ricoh 16 as "the most modern subminiature in the world" when it debuted in 1957. While that claim is debatable, the Golden was certainly one of the most attractive of the many tiny 16mm cameras of its day. The gold-colored metal parts contrasting the black leather-grain covering was an homage to the luxus cameras favored by the well-heeled prior to World War II. The Golden Ricoh had many features of a 1950s 35mm camera, but was small enough to hide in one's palm. It used 16mm film in special cassettes that could be reloaded. Like most subminiature cameras, this one had a supply and a take-up cassette, but unlike its competitors, the two pieces were connected by a metal bracket that made loading and removal easier.

The controls of the Golden Ricoh were much the same as those on larger cameras, including a single-stroke film advance lever, an automatic exposure counter, and top-mounted release button. A knob for selecting one of three (plus Bulb) shutter speeds was on the top next to the PC socket. The aperture setting was made by rotating a ring on the 25mm f/3.5 Riken fixed-focus lens. A lens cap no bigger than a bus token protected the glass when not in use. The thread-mount lens could be interchanged with a 40mm f/5.6 telephoto, which, unlike the normal lens, had focus adjustment. A cable release could be threaded into the shutter button, and the camera mounted on a tripod using the socket on the side. The Golden Ricoh 16 was priced at $39.95 for the camera with leather field case. For an additional $20, you got a complete outfit, including a slide viewer, all in a metal jewel case. The heyday of subminiature cameras continued through the 1960s, but came to an end when Kodak announced its Pocket Instamatic in 1972.

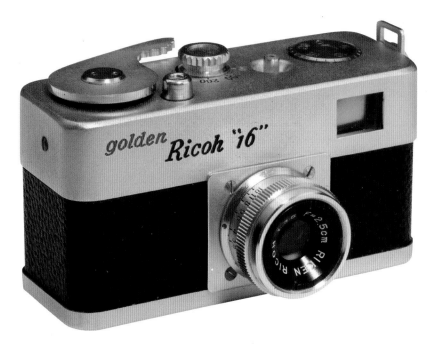

Darling-16 *ca. 1957*

Shincho Seiki Co. Ltd., Japan.
Gift of Jerry Friedman. 2004:0955:0002.

A subminiature camera can be pigeon-holed into one of three quality-based categories. At the highest level are the expensive, precision-built "spy" cameras like the Minox, Goerz Minicord, or Galileo Gami. At the opposite end are the cheap novelties such as the Hit series, Whittaker Pixie, or Univex Minute 16. Shincho Seiki's Darling-16 sat firmly on the middle ground. It was better built than the toy-like cameras, but lacked many of the features of the premium brands. The matte-black finish of the plastic body and metal ends contrasted well with the bright metal lens and controls. A large viewfinder made it easy to compose shots after cocking the single-speed shutter. Normally held in the vertical position for the 10 x 12-mm negatives, it could also be held sideways for landscape-format pictures.

The Darling-16 didn't have a focusing lens, but had a choice of three apertures, set by a tiny knob on the front panel or by turning a lens ring on later

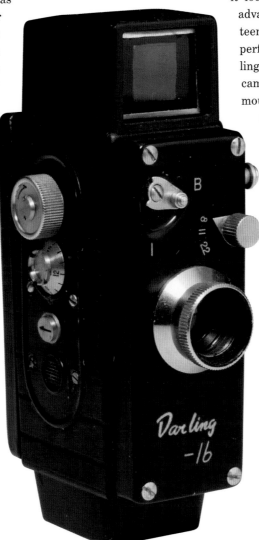

versions. The improved models also had a synchronized shutter and a socket for flash. The film advance knob on the side was linked to an exposure counter, and the knob turned only enough to advance to the next frame before it locked. A slide button unlocked the advance once your shot was made. Sixteen-millimeter film, with or without perforations, could be loaded in the Darling's metal cassettes. The base of the camera had a threaded hole for tripod mounting or to secure it in its box on a short length of ¼-20 thread. The Darling-16 sold for $9.95 in 1957, and film for the little camera was fifty cents per twelve-exposure roll. The camera was also produced as a promotional item, inscribed with the alternate brand "Albert, Fifth Avenue, New York," a clothing store.

Minicord *ca. 1951*
Minicord III *ca. 1958*

Optische Anstalt C. P. Goerz, Vienna, Austria. 1974:0028:3298.

..

Subminiature, or "spy" cameras using 16mm film ranged from cheap novelties to serious instruments—the Minicords were among the latter. Advertisements showed it next to a cigarette pack to highlight its compact dimensions. Any standard 16mm ciné film could be used for the camera's 10-mm square images. The Minicord was a twin-lens reflex design, but unlike most TLRs, had a prism, so the subject appeared right side up in the finder. The Minicord was not styled to look like a toy version of a 35mm camera, but instead designed to take advantage of its diminutive size by positioning the controls for one-handed operation. With the camera nestled between the thumb and forefinger, one's index fingertip could easily focus the 25mm, f/2 Helgor lens as the shot was lined up in the viewfinder. With the second finger, both the release button for the six-speed focal-plane shutter and the film advance trigger could be actuated. A folding rest for the ring finger helped steady the Minicord, leaving one hand free to turn pages or arrange objects, saving valuable time. An automatic frame counter displayed when the fortieth picture had been taken, meaning that the removable magazine needed reloading.

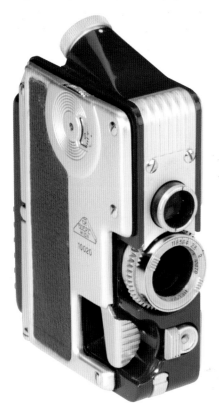

The Minicord's six-element lens focused as close as twelve inches, making it ideal for photographing documents and other espionage tasks. Provisions for mounting a tripod and a remote release cable added to its versatility. Minicord film cassettes were available empty or preloaded, and could be refilled in a darkroom. Changing cassettes was made faster by the quick-change magazine. Other features such as diopter adjustment on the viewfinder, depth-of-field scale, strap lugs, and leather field case help justify the camera's $149.50 price.

The Minicord stayed in production into the 1960s with few changes. The Minicord III, appearing in 1958, added a flash sync and some minor cosmetic changes. The Goerz Minicord is still highly regarded by collectors and users of subminiature cameras.

Frica *ca. 1960*

J. Frennet, Brussels, Belgium.
Gift of Jerry Friedman. 2004:0960:0002.

Subminiature photography gained in popularity in the 1950s and 1960s when major players like Minolta, Mamiya, and Rollei built tiny cameras for 16mm film. Other, less-known makers joined in with slick products such as the Minicord, Edixa, and Meca. These were sophisticated designs, with quality optics, exposure controls, and accurate shutters. The days of the simple novelty subminiatures, typified by the toy-like Japanese Hit series, were largely over.

The Belgian firm of J. Frennet had experience in the design and manufacture of cameras, mostly of the large-format plate and sheet-film variety. In 1960, Frennet contracted with a Spanish shop to produce a new subminiature camera that it named the Frica. Measuring only 2¼ x 1⅝ x ⅞ inches, the camera was a throwback to an earlier design era and wasn't competitive in any respect other than style. Even though Bakelite had largely fallen out of favor with camera makers, Frennet chose it for the little Frica. Compared to other subminiatures of the day, it was a simple piece, with a striking half-round form and art deco styling. Reminiscent of a pill box, it opened the same way, by pulling the friction-fit top from the base. The little shooter didn't take 16mm films, but used 9.5mm Pathé ciné stock in special Bakelite cassettes to make images that were 14 mm long. Once the strip of film was in place on the take-up cassette and the two halves rejoined, the film was advanced with a bottom-mounted winder. Also located on the bottom were the shutter release and Instant-Time selector. The Frica's lens was a simple affair, held in place by a wire snap-ring. A pop-up viewfinder resided on the top side. Unfortunately for Frennet, that was the extent of the Frica's features, and the camera quickly exited the marketplace.

Tessina 35 *ca. 1960*

Concava SA, Lugano, Switzerland. 1978:0763:0001.

··

The Tessina 35, introduced in 1960 as the "world's smallest and lightest 35mm camera," is a side-by-side twin-lens reflex 35mm camera about the size of an iPod. The viewing lens reflects up to the waist level, or spy, finder, and the taking lens reflects down to the film, which is spring motor-driven across the bottom of the camera.

Accessories include a pentaprism finder, high-magnification finder, right-angle finder, and a wrist strap that allows the camera to be worn like a wristwatch. Despite all the "spy" features, this is not a toy; it's a fine piece of Swiss workmanship, offering all the features of a subminiature with the convenience of 35mm film.

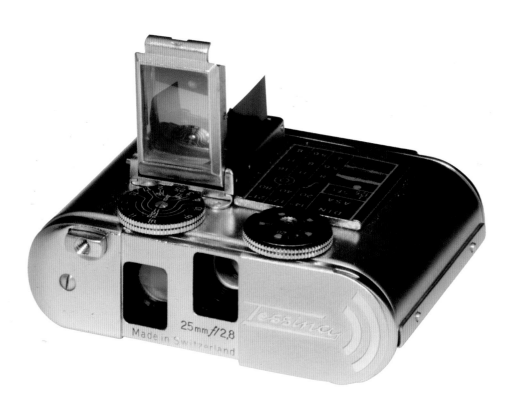

F21 Button Camera *ca. 1960*

KMZ, Krasnogorsk, USSR.
Gift of Jerry Friedman. 2006:0265:0006.

Made in the Krasnogorsk (KMZ) factory from the 1960s through the 1980s, the F21 Button Camera was used by the Soviet KGB for espionage purposes. In appearance, it resembled a miniature version of Otto Berning's Robot camera, featuring a similar top-wind spring-motor film advance, though no viewfinder. It produced 19 x 24-mm images on 21mm unperforated roll film. In use, the camera was disguised in a jacket with the lens protruding through the buttonhole. The lens was covered by a four-hole button, complete with what appeared to be thread; during exposures, the button split in half, allowing the picture to be made.

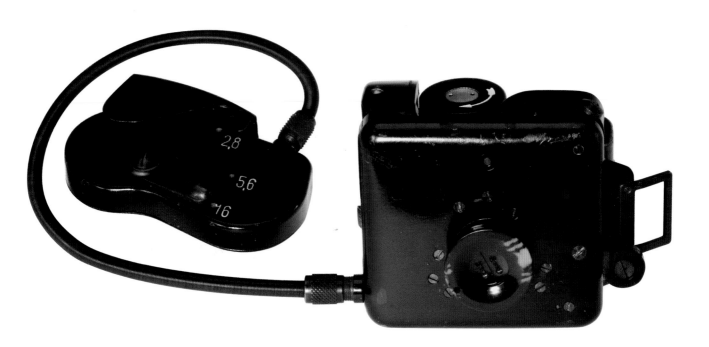

Stereo Mikroma II *ca. 1961*

Meopta, Prague, Czechoslovakia. 1974:0037:2989.

· ·

Introduced in 1961, the Stereo Mikroma II was a revised version of the Stereo Mikroma, having added automatic shutter cocking with film advance. Both models originated as a stretch of the original Microma 16mm subminiature, which used single perforated 16mm film. The stereo versions produced twenty-two horizontal stereo pairs, 13 x 12 mm in size, from a roll of film. The cameras were available in black, brown, and green, and accessories included ever-ready cases, viewers, film cutters, and close-up attachments.

The manufacturer was founded in Czechoslovakia as Optikotechna around 1938, and became Meopta after World War II. Today Meopta is a major optical supplier worldwide.

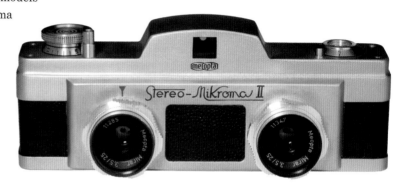

Pocket Instamatic 20 *ca. 1972*

Eastman Kodak Company, Rochester, New York.
Gift of Eastman Kodak Company. 1974:0028:3049.

· ·

In 1972, Eastman Kodak Company of Rochester, New York, introduced a new film format and a line of cameras to use it. The film was the 110 size, using 16mm roll film with paper backing in a drop-in cartridge, similar to the 126 cartridge. The new cameras were small enough to slip into a shirt pocket and were named Pocket Instamatic 20, 30, 40, 50, and 60. Available films included black-and-white, a new finer grain color print emulsion, and two color slide films. The retail price of the Pocket 20 was $27.95.

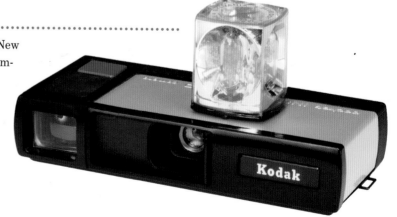

Ektralite 10 *ca. 1978*

Eastman Kodak Company, Rochester, New York.
Gift of Eastman Kodak Company. 2003:1111:0019.

Eastman Kodak Company introduced the subminiature Pocket Instamatic camera line in 1972, with the easy-loading 110 film cartridge design adapted from the original 126 Instamatics. To add to the versatility of the line, Kodak offered the Ektralite 10, which had a built-in electronic strobe flash. Powered by a pair of AA-size batteries, the flash had to be switched on by the user whenever there was insufficient illumination for available light photography. A simple fixed-focus 25mm f/25 lens was protected by a sliding cover interlocked with the shutter button. A complete Ektralite 10 outfit, boxed with camera, booklet, strap, a roll of Kodacolor VR 200, and even batteries, listed for $39.95 in 1978.

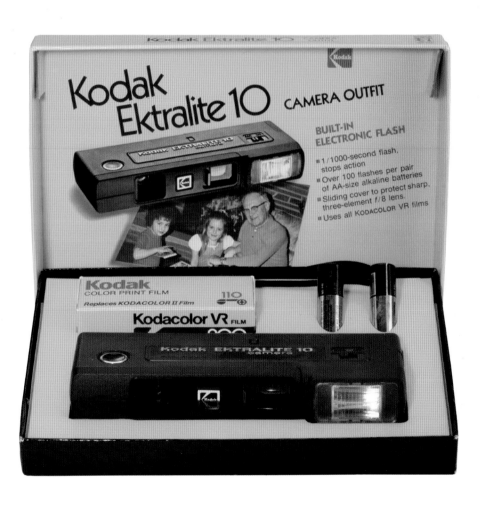

Kodak Disc 4000 *ca. 1982*

Eastman Kodak Company, Rochester, New York.
Gift of Eastman Kodak Company. 1982:1002:0001.

The Kodak Disc camera was designed to replace the enormously popular and profitable Instamatic designs that had been Eastman Kodak Company's mainstay for twenty years. Foolproof photography had made Kodak the world's largest photographic company, and the company's engineering teams were determined to retain its top position. Everything on the camera was automatic; exposure, flash settings, and film advance required no input from the user and were powered by a ten-year lithium battery. The fifteen-exposure disc film cassette made the thin, pocket-size body possible but also presented many manufacturing challenges. New film and precision-ground glass lenses were necessary to produce good snapshots from a negative about one-third the size of the Pocket Instamatic images. The entire system of cameras, film, and processing/printing machinery, plus the facilities to successfully produce them, could only have been accomplished by Kodak, but in less than five years it was all abandoned in the wake of the compact point-and-shoot 35mm cameras the public preferred.

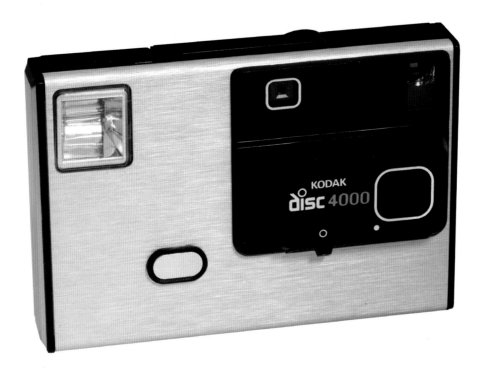

Courrèges Disc camera *1983*

Minolta Camera Company, Osaka, Japan.
Gift of James L. Conlin. 1986:0562:0001.

André Courrèges is best known as a fashion designer, famous for his bold colors and geometric shapes, and for inventing the miniskirt (although this is disputed by some fashion historians). In 1983, he applied his talent to Minolta Disc cameras. Rolled out by Kodak a year earlier, the Disc film system was still a fresh idea, and Minolta wanted something to showcase its versions of the new format. The André Courrèges (labeled "ac") cameras were dressed-up versions of standard models and, like all Disc cameras, featured automatic exposure and flash, power winder, and a thin body made for pockets. The Disc film made fifteen color negatives 8.2 x 10.6 mm in size, which was sufficient for standard prints.

The Minolta ac 101 shared a design with Minolta's Disc-5 camera, and was available in pink, blue, or yellow pastel, with bright chrome cladding. Its front was decorated with matching wavy bands as well as the designer's "ac" logo and family name in chrome. A sliding cover, which also served as the power switch, protected both lens and viewfinder when the camera was not in use. The ac 301, also styled by Courrèges, was based on the Minolta Disc-7 and had all the features of the ac 101. Additional features included a close-up lens that allowed shots from as little as 1⅝ inches from the subject, a self-timer, a mirrored cover on the lens for self-portraits, an electronically controlled shutter, and a tripod mount. The décor of the ac 301 differed from that of the ac 101, consisting of a repeat pattern of very small "ac" logos on the front panel. While designer cameras were nothing new when the Minolta Courrèges hit the market, earlier collaborations had involved industrial designers the likes of Teague or Loewy, not someone from a French house of haute couture.

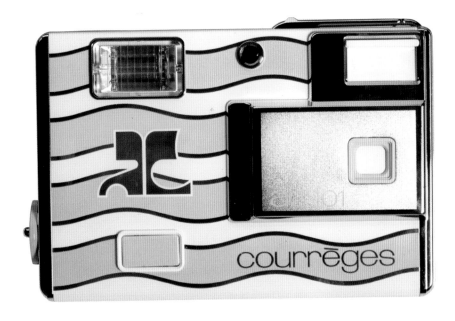

GF 84 Ring camera *ca. 1994*

Gianpaolo Ferro, Buttrio, Italy.
Gift of Jerry Friedman. 2004:0964:0001.

Hidden cameras have been used by photographers for various reasons almost since the beginning. Sometimes it's to capture a candid image without the subject being aware of the camera's presence. Other uses are for sneaking pictures where photography is forbidden, such as detective or undercover spy work. Hiding the camera is easier if it's made to look like something besides a camera. Making it smaller gives the designers more options for disguising it. Cameras have been hidden inside fake cigarette packs, matchboxes, wrist watches, and even rings worn on the finger. The ring camera presents a big challenge to the engineer, for it requires a watchmaker's skill to package a lens and shutter, film holder, and the various controls for exposures into an apparatus small enough to slip on a finger.

Several attempts at ring cameras have been made over the years, one of the most recent being the GF 84 made by Italian craftsman Gianpaolo Ferro. It is rather doubtful anyone could wear one of these and not be noticed, but perhaps that's the point of owning it. The GF 84 used special 23 mm-diameter discs of film to make six 4.5 x 6-mm images from the 10mm f/2 lens. The film disc had to be loaded and unloaded in a darkroom. Rotating the top ring allowed a choice of five aperture stops, while the middle ring set the focus distance, and the lowest ring indexed for each exposure. Setting the shutter speed required turning the slotted head of the release button located on the side, using the screwdriver that was part of the finder attachment supplied with the camera. The instruction booklet packed with each GF ring camera claimed the little negatives could be enlarged thirty times in size, which would make a 5 x 7-inch print. Ferro made only thirty-two of the black GF 84 models, and the entire production of ring cameras since his first in 1981 amounted to only 107 units.

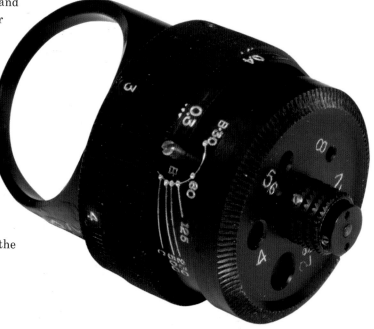

TOY

As photography evolved, manufacturers recognized that children were an untapped source of profitability. By producing cameras that appealed to youth while also being affordable to their parents, companies could hook the young snapshooters and make them photographers for life.

Driving the boom in the production of toy cameras was Eastman Kodak Company's introduction of the Instamatic 126 plastic film cartridge (1963) and the 110 film cartridge (1972). These provided a cost-effective and efficient solution to one of the most expensive components of a camera: the light-tight film transport and indexing system. Not only were cartridges easy for little hands to manage, but they also made it economically more attractive for toy manufacturers to produce low-end, point-and-shoot cameras that could be mass marketed, especially to children.

No. 2 Eclipse Outfit *1888*

E. I. Horsman, New York, New York.
Gift of Daniel C. Miller. 1985:1182:0002.

Edward Imeson Horsman of New York City was a retailer and wholesaler who sold many kinds of toys, games, and sporting goods through his stores and catalogs. Today, his company is best remembered for the dolls it imported from Germany. Around 1887, E. I. Horsman began selling its own Eclipse line of cameras, which, with their basic construction and inexpensive price tags, were marketed to amateurs, including children. Unlike most of the firm's products, these were advertised as manufactured by Horsman.

Introduced in 1888, the No. 2 Eclipse was a simple, lightweight dry-plate camera constructed of polished cherry wood with a fragile leatherette bellows. Since it had no shutter, making an exposure meant uncapping and recapping the lens. Instructions indicated that an average subject in bright sun required five to eight seconds of exposure, while a subject of lesser illumination might need seven to ten seconds. Interior views would take much longer, perhaps as long as one to two hours. The No. 2 Eclipse was sold as part of a complete photographic outfit, which consisted of the camera, a "Rapid Wide Angle Lens," a plate holder, a printing frame, a ruby lamp candle, instructions for making a darkroom lamp, and carrying case. In addition, it would have included materials for

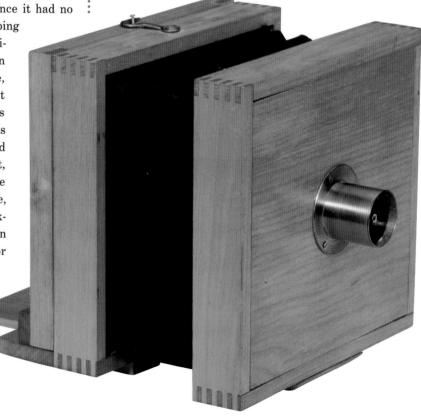

exposing, developing, and mounting images, such as dry plates, two Japanned iron trays, developing solutions, toning solutions, printing paper, and card mounts. The entire outfit, including tripod, retailed for $5 in 1888. Apparently photographic goods were a worthwhile part of the Horsman inventory, as one of the firm's 1892 advertisements claimed "the most complete line of cameras and lenses to be found in New York." The same ad, which pictured an Eclipse outfit, also stated, "Kodak Cameras A Specialty."

Student Camera No. 1 *ca. 1888*

Student Camera Company, New York, New York. 1974:0028:3459.

Manufactured by the Student Camera Company of New York City, the Student Camera No. 1 was probably introduced around 1888, based on a reference to the paper negative film of the competition in their brochure. Aimed at students, as the name implies, it was very inexpensive, retailing at just $2.50 for the complete outfit. Included was a small wooden box camera that exposed single glass plates held in place by tacks, plus all the necessary chemicals and supplies to get started. The original model made images of 2 x 3 inches; the No. 2 produced slightly larger images. It offered a choice of apertures, but there was no actual shutter. Instead, the exposure was controlled by the user's fingertip.

Ensign Mickey Mouse *ca. 1935*

Houghtons Ltd., London, England.
Gift of Eastman Kodak Company. 1990:0458:0003.

The worldwide popularity of Mickey Mouse quickly led to the licensing of his image from Walt Disney by numerous companies looking to cash in on the character's fame. The first photographic manufacturer to market a Mickey Mouse camera was Ensign, Ltd., of London, in 1934 (established in 1930, Ensign, Ltd., was the distributor of Houghtons Ltd. products). It was a simple box camera constructed mainly of wood and covered with a geometric-patterned black material. Six-exposure rolls of special Mickey Mouse M10 film could be sent to the local chemist for developing and printing, or done at home with the Mickey Mouse Developing Dish and Printing Outfit.

Donald Duck *ca. 1946*

Herbert George Company, Chicago, Illinois.
Gift of Eastman Kodak Company. 1990:0458:0004.

The Donald Duck camera was introduced in 1946 by the Herbert George Company of Chicago, Illinois. Formed by Herbert Weil and George Israel, the firm produced inexpensive plastic cameras for more than fifteen years before being sold and renamed the Imperial Camera Corporation. The first design patented by George Israel, the Donald Duck camera was originally made in olive drab plastic but was soon switched to black. Its rear shows figures of Donald and his nephews Huey, Dewey, and Louie in relief.

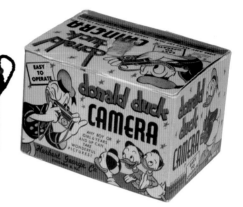

Roy Rogers and Trigger *ca. 1951*

Herbert George Company, Chicago, Illinois. 1974:0028:3339.

Manufactured in 1951 by the Herbert George Company of Chicago, the Roy Rogers and Trigger camera had a front plate depicting Roy mounted on a rearing Trigger. The otherwise standard Herbert George "Imperial" black Bakelite camera produced twelve images on No. 620 roll film. Issued at a price of $3.99, it was one of the many memorabilia items made for fans of the "King of the Cowboys" and remains a popular collectible today.

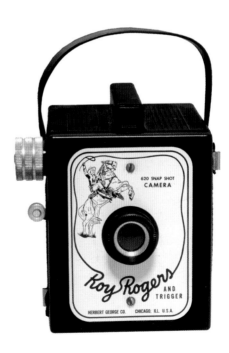

Diana *ca. 1965*

Great Wall Plastic Factory, Kowloon, Hong Kong.
Gift of Eastman Kodak Company. 2001:0120:0001.

When the Great Wall Plastic Factory in Hong Kong began producing Diana cameras in the early 1960s, no one could imagine that this flimsy novelty would one day be revered by an avid cult of art photographers. Intended as little more than a toy, the Diana was molded entirely of thin, low-grade plastic, including the single-element lens. Sold for $1 or less, these featherweights were popped out in huge numbers by several factories, mostly identical in appearance but branded with more than one hundred different names. Regardless of the label, each camera took sixteen 4-cm square images on a roll of 120 film. Many were handed out as premiums at gas stations or sales conventions, only to end up at the bottom of toy boxes or in landfills. It's not that these cameras were difficult to operate. The only controls were the shutter release and two sharp-edged metal tabs to set the aperture and select Instant or Bulb shutter action. Those tabs were rough on the fingers, and with the dawn of the Kodak Instamatic, which spelled the end for many makers of cheap cameras, the Diana line ended in the 1970s.

The entire enterprise would have been long forgotten but for the quality deficiencies of the body and lens, both of sloppily molded plastic. No two lenses were alike. Every one produced distorted images, blurred areas, and unpredictable color saturation. The body and rear cover rarely sealed well enough to keep out light, causing some of the picture to look washed out or smudged. All were reason enough to discard the thing and invest in a decent camera, yet hobbyists began exhibiting their Diana pictures. Suddenly, those drawbacks became assets. Demand for the former giveaways began climbing, and asking prices hit the hundred-dollar-plus mark. As the Diana supplies dwindled, new cameras were marketed with carefully engineered flaws that mimicked the old Hong Kong classics. Now there are smartphone applications that imitate toy cameras, and it may be only a matter of time before digital cameras have a "Diana" setting on them.

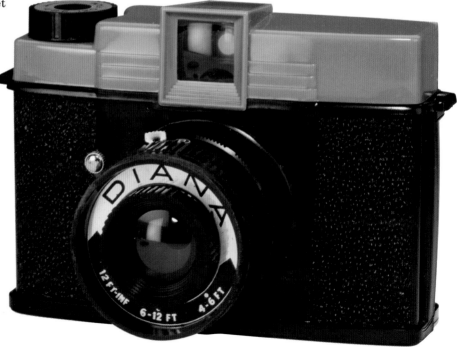

Kookie Kamera *ca. 1968*

Ideal Toy Corporation, Hollis, New York.
Gift of Andrew H. Eskind. 1974:0028:3534.

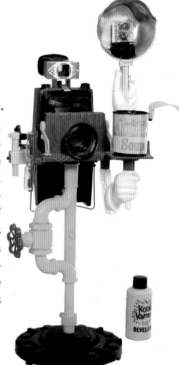

From its manhole cover base to saucepan flash cube holder, Ideal Toy Corporation's Kookie Kamera was a wonder of whimsy. This 1968 toy was a real working camera that made direct-positive pictures on rolls of sensitized paper in plastic "Kookie Kassettes." The lens housing was modeled after an empty soup can, which distorted the image and could be rotated to alter the effect. The photographer sighted the subject through the bloodshot-eye viewfinder and then pressed the shutterbug to make the exposure. After snapping the picture, the "cranker" knob advanced the paper into the developer tank under the camera and a push-pull slide actuated a cutoff blade. A swiveling egg timer told the user when three minutes had elapsed, so the print could be removed and rinsed in water. "A ridiculous thing from . . . Ideal" was printed on the box, but in the course of having fun with their Kookie Kameras, kids absorbed some valuable knowledge about photography.

Charlie Tuna *ca. 1970*

Whitehouse Products Inc., Brooklyn, New York. 2004:0298:0001.

The Charlie Tuna camera was modeled from the popular cartoon character in the Starkist Tuna TV commercials of the 1970s. Charlie's dream was to be selected by Starkist for cooking and canning, but while he always tried to demonstrate his "good taste," Starkist wanted tuna that would taste good. This large camera could be awkward to carry, but it was easy to use. Instamatic 126 film cartridges were simply dropped in place; the lens was hidden in Charlie's wide smiling mouth, and his hat served as the flash cube socket. Whitehouse Products produced the Charlie Tuna in Brooklyn, New York, where they had been building less colorful cameras since the 1940s.

Mick-A-Matic *ca. 1971*

Child Guidance Products, Bronx, New York. 1974:0028:3059.

The Mick-A-Matic was more than a toy. Produced in 1971 by Child Guidance Products in New York, it was a functional camera that used drop-in 126 Instamatic film cartridges. The lens was in Mickey Mouse's nose, and his right ear served as the shutter release. A flash attachment could be mounted between the ears.

The shape of the Mick-A-Matic made it attractive to children, though somewhat difficult for their small hands to operate. The camera was sold mostly in toy departments. Well-known artist/photographer Betty Hahn (b. 1940) employed a Mick-A-Matic to create a popular series of flower images in the 1970s.

Bugs Bunny *ca. 1978*

Helm Toy Corporation, New York, New York.
Gift of F. S. Spira. 1982:0501:0001.

The Bugs Bunny was one of several cartoon character cameras made by Helm Toy Corporation of New York City in the 1970s. Helm's simple plastic box design for the ubiquitous Instamatic 126 film cartridge made it possible to use different style front covers for a variety of characters. The Bugs Bunny front showed the cwazy wabbit reclining over the lens, his elbow resting on a sign that read, "EH DOC SMILE!" While sold as toys, these cameras introduced many children to the fun of photography and made them photographers for life.

TOY CAMERAS
Therese Mulligan

T he words "toy camera" may con-
jure up a child's plaything, but
for many adult camera enthusiasts
and professionals it opened up new
creative doors to thinking about and
making photographs. Mass-produced
as novelties, toy cameras are decep-
tively simple devices. Plastic-molded
bodies, simplified shutter and aper-
ture settings, and plastic or glass
lenses pronounce an elementary
appearance and ease of use. Similarly
unsophisticated are these modest
devices' photographic results. Light
leaks, erratic color saturation, and
lens distortion with a blurred field
of vision all contribute to snapshot
images with unpredictable but evoca-
tive pictorial affectations. Rather
than dismiss these qualities as dis-
reputable, amateur and professional
photographers mounted a loosely
organized campaign in the 1960s to
raise the prospect of the toy camera
as an alternative to the complexity,
refinement, and high cost of the pre-
vailing camera market. At the center
of this counter-camera movement
was the Diana, first marketed in 1965
by the Great Wall Plastic Factory in
Hong Kong as a corporate premium

Ensign Mickey Mouse, ca. 1935. Houghtons Ltd.,
London, England. Gift of Eastman Kodak Com-
pany. 2001:0120:0001.

or as an inexpensive take-away sold
at gas stations, drug stores, and
newly evolving discount stores.

The Diana gathered a photographic
following with a cult-like fascination
for its low-tech manual handling,
120-size roll film with medium-format
square negative, and idiosyncratic
pictorial characteristics that elic-
ited blurred, dream-like images. It
famously was the subject of exhibi-
tions, including *The Diana Show* at
the Friends of Photography in 1980,
and influential publications such
as artist Nancy Rexroth's portfolio
The Snapshot in the 1974 issue of
the journal *Aperture*. The Diana was
initially short-lived; its production
ended in the early 1970s. However,
its distinctive attributes ubiqui-
tously embodied and popularized by
its direct descendents, the Chinese-
produced Holga and Russian-made
LOMO, has prompted a reappearance
of the Diana in recent years.

The Diana and its lineage epito-
mize one varietal strain in the vast
realm of the toy camera market.
More predominant are plastic devices
molded into a mind-boggling cast
of commercial characters drawn

from popular culture. Perhaps the most iconic cartoon character appearing as a revered toy camera is Disney's Mickey Mouse. From his cinematic debut as Steamboat Willie in 1928, Mickey became a magnet for photographic manufacturers seeking to capitalize on his celebrity. The London-based company Ensign Limited marketed the first Mickey Mouse camera in 1934. A simple box

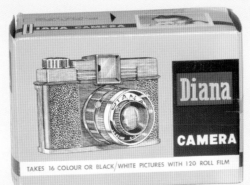
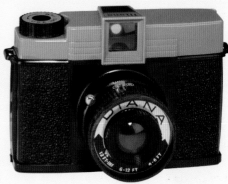

camera, it employed a six-exposure roll of specially named Mickey Mouse M10 film. Film processing and printing could be accomplished with the company's exclusive Mickey Mouse Developing Dish and Printing Outfit. The popularity of the iconic cartoon figure continued unabated in photography through the twentieth century. To the delight of Disney enthusiasts of all ages, powerhouses like Eastman Kodak and Fujifilm turned out a bevy of Mickey-inspired products. In 1971, Child Guidance Products introduced the Mick-A-Matic, a plastic camera uniquely fashioned to resemble Mickey's face. The camera found a keen audience not only among children but also art photographers, who with it produced snapshot pictures similar in look to those realized by the Diana.

By the 1990s, toy cameras were highly desired collectibles. The George Eastman House accumulated these devices in great quantity as representatives of the camera's varied and rich history. Along with better-known toy cameras, such as Charlie Tuna, Bugs Bunny, Spider Man, Snoopy, and the 1998 Photo Mission Action Man, the collection contains uncommon products. Among the more unusual are Ideal Toy's 1968 Kookie Kamera, a Rube Goldberg-like wonder that encompassed image capture and print processing all in one device, and the comical Taz Instant Camera, produced in 1999 by the Polaroid Corporation in the waning years of its film-based camera technology. The collection also points to the toy camera's antecedents. Manufactured in 1888, the Student Camera

Diana, ca.1965. Great Wall Plastic Factory, Kowloon, Hong Kong. Gift of Eastman Kodak Company. 2001:0120:0001.

No. 1 and the Eclipse were entry-level, inexpensive cameras marketed to youthful amateur photographers. But neither was as successful as Eastman Kodak's first Brownie, launched in 1900 for $1. Named after cartoon characters popularized by children's author Palmer Cox, the Brownie's low-tech, low-cost properties proved revolutionary to the rise of snapshot photography. It also remains the leitmotif of camera manufacturing and embedded product marketing directed to children and adolescents.

The transition from film-based to digital camera technology did not sound a death knell for the toy camera. The Holga, LOMO, and the re-introduced Diana are sought-after products with a nostalgic flair readily available at museum and photography stores, and at retail outlets, including the youthfully chic Urban Outfitters. In the digital realm, "apps" like Camera Bag and Hipstamatic produce a simulacrum, or visual imitation, of the look of a toy camera photograph, replete with soft focus, light flares, and a dreamlike ambience.

Therese Mulligan, Ph.D., Chair, School of Photographic Arts and Sciences, Rochester Institute of Technology

Snoopy-Matic ca. 1982

Helm Toy Corporation, New York, New York.
Gift of F. S. Spira. 1982:0501:0002.

The Snoopy-Matic was the high point of the novelty camera fad made possible by the popular Instamatic 126 film cartridge. Helm Toy Corporation of New York produced this all-plastic doghouse design in 1982, along with other cartoon character-based cameras. Snoopy's door functioned as the lens, with the two windows serving as viewfinder and shutter button. Flash cubes could be snapped onto the chimney for low-light situations. Despite their whimsical styling, many of these odd-shaped novelties delivered decent-quality pictures.

Spider-Man ca. 1982

Vanity Fair Industries, Melville, New York.
Gift of F. S. Spira. 1982:0501:0003.

Produced by Vanity Fair Industries of Melville, New York, the Spider-Man camera was one of several cameras that used the same style plastic bodies. By molding in various colors and applying different decals, the cameras were marketed under the names of many cartoon characters and superheroes. The Spider-Man, like most novelty cameras of the 1960s and 1970s, used Instamatic 126 film cartridges, ideal for children. The built-in handle, large shutter button, and thumb-lever film advance made it easy to use. Flash cubes could be used for indoor pictures. A lens housing with a simulated knurled ring and a stepped-up ramp for the flash mount gave it a shape just like the cameras Mom and Dad used.

Panda 110 *ca. 1985*

Kiddie Camera, Taiwan.

Gift of Eastman Kodak Company. 2003:0263:0001.

Building and maintaining a customer base is a challenge for any business, and with photography the secret has long been to start them young. Eastman Kodak introduced the $1 Brownie in 1900, and gave free box cameras to twelve-year-olds in 1930, in both cases hoping to gain lifelong photographers from among its many young customers. Toy-like cameras are another way to attract future shutterbugs. This Panda Bear Camera is one of a series of "character head" designs found on toy aisles in the 1980s. Made in various Taiwanese factories, they were available as dogs, bears, clowns, and even Santa Claus.

Despite their whimsical appearance, these cameras were real and made actual pictures. The nose on the character's face was made of soft material and served as a lens cover. To take photos, the disc-shaped back cover was removed and a 110 film cartridge dropped in place. With the cover replaced, the ridged winding wheel below one of the eyes was turned until the film stopped for the first exposure. With the nose removed and safely stored in the budding paparazzo's pocket, the shot was framed through the viewfinder and the oblong button near the critter's ear pressed. While it's not easy to take devices like these seriously, there's no denying the excitement of picking up the first packet of one's own pictures from the photofinisher, even if the quality isn't suitable for framing.

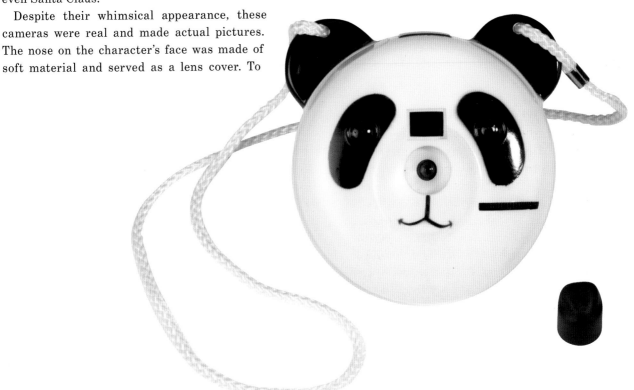

Photo Mission Action Man _ca. 1998_

Hasbro, Pawtucket, Rhode Island.
Gift of Jerry Friedman. 2004:0989:0001.

Cameras disguised as toys were easy to design around the Instamatic 110 film cartridge. Hasbro of Pawtucket, Rhode Island, offered one in 1998 as part of their Action Man series, based on a popular children's TV show. The all-plastic twelve-inch-tall hero, packaged as Photo Mission Action Man, had a video camcorder on his shoulder. Inside his torso was a working 110 still camera that shot through the lens in his chest armor. A button near his right shoulder blade tripped the shutter and captured whatever image was framed by the viewfinder atop the shoulder camcorder. Film was loaded by removing a panel on his back and advanced with the ridged thumbwheel on the belt. The film pack was oriented vertically, as were the pictures.

Taz instant camera _ca. 1999_

Polaroid Corporation, Cambridge, Massachusetts. 1999:1031:0001.

The 1990s was a tumultuous decade for the photographic industry, especially Polaroid Corporation in Cambridge, Massachusetts. The groundbreaking technology of the 1972 SX-70 had matured to the point where it was relegated to cameras marketed to children. Polaroid's 1999 Taz was a special version of its OneStep 600, molded in brown and tan plastic. The flip-up Tazmanian Devil head housed the electronic flash and opened to reveal the fixed-focus lens and Taz teeth decals, while a Looney Tunes logo served as the shutter release button. Polaroid made special film for the camera, sheets pre-printed with Taz and other Looney Tunes characters in the border, but it could also use normal ten-exposure Polaroid 600 Instant film packs. Cartoon-character-themed cameras were once common items in toy departments, but Taz was one of the last to be made. And "Th-th-th-that's all, folks!"

SPECIALTY

The camera's ability to produce documents that accurately record events makes it an essential research tool. But sometimes a standard off-the-shelf camera just won't do. Inhospitable conditions; specialized industrial, military, or scientific purposes; or tight, enclosed spaces can all require a custom-built camera in order to achieve the required image. Manufacturers such as Eastman Kodak, Graflex, Hasselblad, Nikon, and others have produced specialty cameras to meet specific needs, sometimes as a one-off, other times in a small-scale production. Over time, many of the specially conceived features become incorporated into common, work-a-day cameras.

Racetrack camera (OWNED BY EADWEARD MUYBRIDGE) *ca. 1884*

Scovill Manufacturing Company (attrib.), New York, New York.
Gift of George E. Nitzsche. 1978:1371:0047.

During the 1870s, Eadweard Muybridge worked with Leland Stanford, the California governor and railroad baron who founded Stanford University, to prove that a trotting horse briefly (very briefly) had all four hooves in the air. At Stanford's farm in Palo Alto, Muybridge constructed a fifty-foot shed with a painted backdrop marked with vertical, numbered lines to measure intervals of space. Opposite the backdrop, he placed twelve cameras (including the one shown here), each equipped with electro-mechanical trip-shutter and 1/1000 exposure—high-speed photographic technology of his own design. Pulling a two-wheeled sulky, Stanford's horse raced past the twelve cameras, tripping them in sequence as the iron rim of the sulky wheel contacted wires stretched across his path and closed an electrical circuit to trip the shutter. Muybridge not only proved that the horse's four feet did, indeed, leave the ground at the same time, he also found his niche—motion photography.

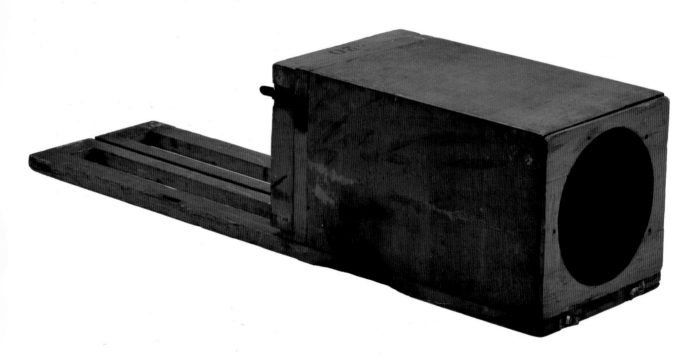

Ives Krōmskōp Triple Camera *ca. 1899*

F. E. Ives, Philadelphia, Pennsylvania.
Gift of Raymond O. Blanchard. 1977:0037:1043.

Ives Krōmskōp Monocular Viewer *ca. 1899*

F. E. Ives, Philadelphia, Pennsylvania.
Gift of 3M Foundation, ex-collection Louis Walton Sipley. 1977:0415:0217.

Ives Krōmskōp Night Illuminator *ca. 1899*

F. E. Ives, Philadelphia, Pennsylvania.
Gift of 3M Foundation, ex-collection Louis Walton Sipley. 1977:0415: 0375.

The Ives Krōmskōp system consisted of a paired apparatus for the capture and viewing of still images in full color. Offered in both monocular and stereoscopic versions, it was an additive color system developed and patented in the late 1890s by Frederic Eugene Ives (1856-1937) of Philadelphia, a prolific inventor and perfecter of the inventions of others with more than seventy patents to his name, including those for the practical printing of pictures in newspapers and magazines.

The Ives Krōmskōp Triple Camera simultaneously made three color-separation records of the scene behind red, green, and blue filters. A set of positive transparencies from these records, when viewed in perfect mechanical alignment through filters of the same colors, reproduced the colors of the original scene. The camera used a single 2½ x 8-inch glass plate, exposing the three 2¼ x 2½-inch images side by side. Positives made from these negatives were strung together with cloth tapes so that an image set, or Krōmgram, could be laid over the step-like structure of the Krōmskōp viewer. Looking into the viewing lens revealed a magnified full-color image. For times when daylight was not available for the viewer, a night illuminator was provided.

On the outside, the camera was a simple mahogany box with brass-mounted lens, sliding-plate shutter, and brass carrying handle. Inside, the camera's prisms deflected light to the left and right for the red and green exposures.

Undeflected light passed straight back to make the blue exposure. Adjustable masks balanced the light for the individual records according to the sensitivity of the plate being used. The ivorene label above the lens shows September 5, 1899, as the patent date. The lower label lists seven patents on the system from 1890 to 1899.

The Krōmskōp Monocular Viewer was a brass-bound mahogany box with a brass-mounted viewing lens and an adjustable reflector. Each step was capped by a colored filter, which was, in descending order, red, blue, and green. The Krōmgram's cloth strips, acting as hinges, allowed the three images to be arranged on the steps in the proper sequence.

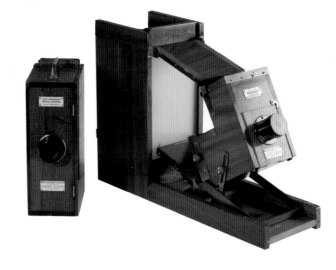

Hicro Color Camera *ca. 1915*

Hess-Ives Corporation, Philadelphia, Pennsylvania.
Gift of Eastman Kodak Company. 1974:0037:1011.

The Hicro camera was introduced around 1915 by the Hess-Ives Corporation of Philadelphia, through the combined efforts of Henry Hess as financial backer and Frederic Eugene Ives, the noted inventor of imaging processes. It was an attempt to simplify the making of a set of color separation negatives, which were the required starting point for many early color processes, including those for magazine and newspaper reproduction. Three negatives were made, one each recording the red, green, or blue content of the scene.

The Hicro camera was a 3¼ x 4¼-inch box camera requiring a special plate holder containing three glass plates. A lever dropped the plate for the blue record to the floor of the camera, while the other two plates remained in the holder to record the green and red content of the scene. A beam splitter was swung into position to direct some of the exposing light to the blue plate. Tilting the camera put all plates back in the holder. With the aid of Ives's darkroom expertise,

skilled photographers were able to make charming portraits with soft gradations of color, but the complexities of the camera and the printing process stood in the way of mass acceptance.

The camera was available with fixed- or adjustable-focus lenses priced at $25 and $38 respectively; it was manufactured under contract by the Hawk-Eye Works of Eastman Kodak Company.

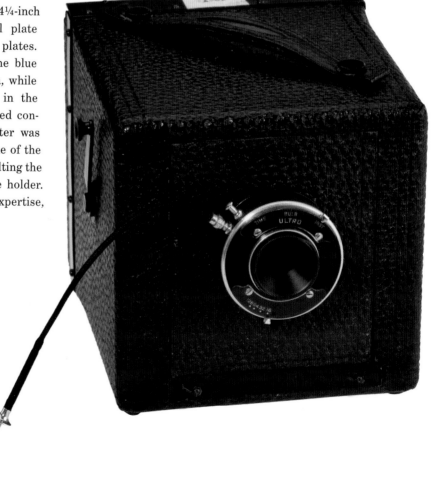

Tri-Color Camera (OWNED BY NICKOLAS MURAY) *ca. 1925*

Jos-Pe Farbenphoto GmbH, Hamburg, Germany.
Gift of 3M Foundation, ex-collection Louis Walton Sipley. 1978:1472:0003.

The Tri-Color Camera was introduced in 1925 by Jos-Pe Farbenphoto GmbH, Hamburg, Germany. The company name was derived from the name of one of the owners, Josef Peter Welker. This nineteen-pound, all-metal camera produced three black-and-white negatives simultaneously, each recording one of the three additive primary colors. Two internal beam splitters directed the image to three separate 9 x 12-cm plate holders, each containing either a red, green, or blue filter. Matrices made from these negatives could be printed in succession with the complementary subtractive primary dyes, cyan, magenta, and yellow respectively. This produced a single-layer full-color print. The negatives could also be used to make photoengraved plates for magazine and newspaper printing.

This camera was owned and used by the famed Hungarian-born American photographer Nickolas Muray (1892-1965), a respected celebrity portrait photographer and pioneer in color advertising photography. His Jos-Pe had a huge, 210mm Steinheil Cassar f/3 lens in a compound shutter.

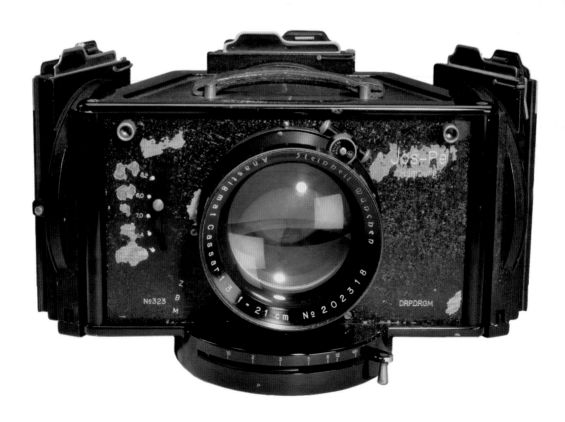

Spektaretta *ca. 1939*

Optikotechna, Prague, Czechoslovakia. 1974:0037:2797.

Before color film was perfected and readily available, the three-color method served as a reliable and reasonably simple way to make color pictures. It worked by making three identical images on ordinary black-and-white film through color filters, one for each primary color. Camera designers came up with different ways of making the simultaneous exposures, based on one of two methods. Some approaches used three lenses, while others, like the Spektaretta, used one lens and a prism to split and triple the image. Either way, after the negatives were developed, each image was projected and printed, using the same filter color through which it was shot, in an alignment that produced a single, full-color picture.

Somewhat resembling a movie camera, the Spektaretta, made by Optikotechna in Prague, Czechoslovakia, was one of the smallest three-color cameras produced, due in part to its being built around 35mm film. Loading the camera required weaving the film strip though slots and over rollers to properly position it behind each filter. The fast 70mm f/2.9 Spektar lens could focus from one meter to infinity, in a shutter with a top speed of 1/250 second. There was a parallax correction feature in the flip-up viewfinder, which was located between the winding knobs. Also on the camera's top was the frame counter and a fingertip lever to trip the shutter. Underneath was a telescopic sight adjustable for focus, as well as a diopter. With each snap of the Compur shutter, the prism sent the same image to expose three 24 x 24-mm sections of the film. The Spektaretta was ready to sell in 1939, but the combination of war and the increasing popularity of color films worked against any chance of success for the camera. Made in very small numbers and for only a short time, it soon disappeared from the market.

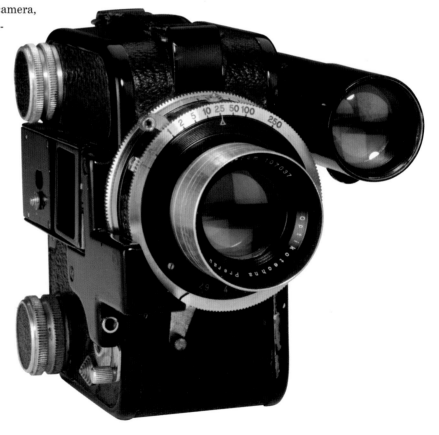

Sunshine *1947*

Ottico Meccanica Italiana, Rome, Italy.
Gift of Fred Spira. 1985:0781:0001.

Before the introduction of Agfacolor and Kodachrome films in the 1930s, color photographs were made by a number of processes, including the three-color method. This nineteenth-century system worked by making three identical exposures, each through a different colored filter, on standard black-and-white film. After processing, the images were projected simultaneously through the same filters and aligned on the screen to create a single full-color picture. Special cameras and projectors were required, but not special films. Most color films, on the other hand, were used in ordinary cameras. Consequently, the camera-friendly films from Eastman Kodak and Agfa made other color processes obsolete. But that didn't stop O.M.I., an Italian manufacturer, from announcing the Sunshine camera in 1947.

The Sunshine used 35mm black-and-white ciné film in a small all-metal body finished with gray crackle paint. The three small lenses arranged in a triangle used a single shutter to make three 8 x 11-mm images of the same scene.

Each lens was filtered with a different color: red, green, or blue. The pictures could be viewed through the same lenses, by loading the developed film into the camera that was then attached to the matching projector. Because the same filters used to take the pictures were in place when the film was projected, the viewers saw an accurate color image on the screen. Very few of the Sunshine camera and projector outfits sold. The postwar supply of color film for use in existing cameras proved too much of an obstacle for O.M.I., and production ceased after only a few months.

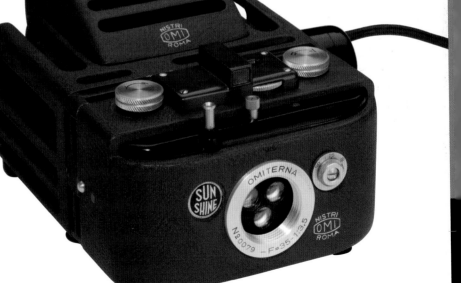

Eastman Gun Camera *ca. 1915*

Eastman Kodak Company, Rochester, New York.
Gift of Eastman Kodak Company. 1994:1486:0001.

The Eastman Gun Camera, designed by John A. Robertson, was produced from 1915 to 1920 by Eastman Kodak Company, Rochester, New York. A training device, the gun camera was used to practice shooting, using photographs as ersatz bullets. Prior to this invention, army airmen trained with live ammunition, shooting at kites, pennants, or balloons that were towed by other planes, endangering both pilots and planes. The camera, similar in style and weight to the Lewis machine gun that gunners fired in the field, allowed for much safer training. It shot a 4.5 x 6-cm image of the target with a superimposed crosshair of the bullet's location on No. 120 roll film. In effect, it was a forerunner of a training process now done with computer simulation.

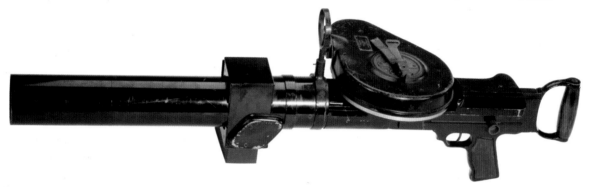

Williamson Aeroplane Camera *ca. 1915*

Williamson Manufacturing Company Ltd., London, England.
Gift of Eastman Kodak Company. 1992:0140:0001.

Designed for aerial reconnaissance photography around 1915, the Williamson Aeroplane Camera produced 4 x 5-inch images on roll film, exposed in either single or continuous mode. Its cloth curtain shutter, which had to be manually set when the film was loaded, used different speeds of 1/25, 1/50, and 1/100 second. The camera was attached to the aircraft's belly with thumbscrews located on the top of the apparatus. Winds blowing through the aluminum propeller located on the camera's front provided ample power for both shutter and film advance.

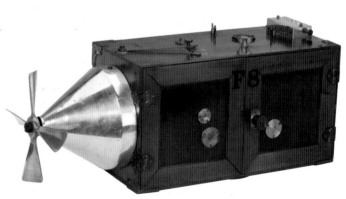

Signal Corps PH-324 (Kodak 35) *ca. 1942*

Eastman Kodak Company, Rochester, New York.
Gift of Eastman Kodak Company. 2010:0066:0003.

Sub-Periscope camera (Kodak 35) *ca. 1942*

Eastman Kodak Company, Rochester, New York.
Gift of Eastman Kodak Company. 1974:0037:0150.

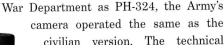

Always looking to make use of new technologies, military forces quickly recognized the tactical advantages of photography. While civilian cameras straight off the shelf sometimes served adequately, more often supply contracts called for specifications tailored to specialized needs. The popular Kodak 35 camera, sold in large numbers after its introduction in 1938, is a typical example of a standard product being modified for military use. Eastman Kodak's first American-made 35mm camera, the Kodak 35 (top) was a rugged, reliable device even before being adapted for World War II service. The original lacked a rangefinder but did have a focusing lens and multi-speed shutter. The molded plastic body had top and bottom plates stamped from steel. A 50mm Kodak Anastigmat f/5.6 lens on the early models was replaced by a faster f/4.5 lens when higher-speed films became available. On the top of each camera were a folding viewfinder, winding and rewind knobs, and an exposure counter.

When Uncle Sam came calling, Kodak outfitted the 35 for the U.S. Army Signal Corps by painting the body olive drab, and all the metal parts flat black. Known to the War Department as PH-324, the Army's camera operated the same as the civilian version. The technical manual, however, had a page not found in the user guide supplied to civilian customers. Instructions on how to destroy the camera gave a soldier the choice of smashing it with a variety of heavy tools, cutting it up, or burning it. In any case, the object was to not leave the enemy anything useful.

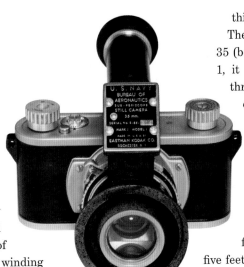

The Navy had its own specialized Kodak 35 (bottom). Known as the Mark 1 Model 1, it was designed to take photographs through a submarine's periscope. It differed from the standard camera by having a special prism finder that allowed viewing through the camera's fixed-focus lens. A flange for quickly mounting the camera to the sub's periscope was part of the viewer assembly. The camera could be used "topside," but wasn't able to focus on anything closer than thirty-five feet, which limited its usefulness. Unlike the Army, the Navy provided no information on how to demolish the camera. The fact that it wouldn't float was probably sufficient to keep it from enemy hands.

Combat Graphic 45 (WITH INLAID MOTHER-OF-PEARL) *ca. 1942*

Folmer Graflex Corporation, Rochester, New York.
Gift of Graflex, Inc. 1974:0037:2454.

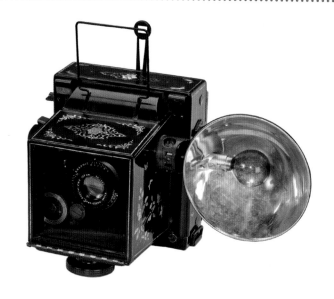

The Combat Graphic 45 was introduced in 1942 by Folmer Graflex Corporation, Rochester, New York, for use by the U.S. armed forces in World War II. It was an all-wood 4 x 5 camera, olive drab in color. Built to afford simplicity and sturdiness, it did not have the customary bellows, instead using a solid cone front construction, and it had a pop-up spring-loaded wire frame as a finder. The traditional focal-plane shutter had a fixed spring tension with only four speeds. The camera was offered to qualified members of the public in limited quantities in late 1944 as the Graphic 45 camera. The particular camera shown here was a one-of-a-kind that had been customized in mother-of-pearl inlay by a South Korean artisan for a war photographer. The retail price of the public version was $174.

Eastman Matchbox Camera *1945*

Eastman Kodak Company, Rochester, New York.
Gift of Eastman Kodak Company. 2001:0636:0002.

Named for its size, the Eastman Matchbox Camera (also known as Camera "X") was small enough that the sleeve of a standard European matchbox could slip over it as a disguise while the lens peered discreetly through a side panel. A true spy camera, it was designed when the American intelligence agency the OSS (Office of Strategic Services) approached Kodak for a small photographic instrument to be used in occupied

Europe by American and European agents and resistance members. The top-secret project shipped 500 units in early 1944, with another 500 in 1945. Using 16mm film in cassettes to produce thirty half-inch square images, the Matchbox also had a stand with a close-up lens for document copying. Patented in February 1945, the camera discontinued production just months later with the war's end.

70mm Combat Graphic *ca. 1953*

Graflex, Inc., Rochester, New York. 1981:2813:0002.

Introduced in 1953 by Graflex, Inc., of Rochester, New York, the 70mm Combat Graphic fulfilled a long-standing goal of the U.S. Army Signal Corps Lab. Since World War II, the Signal Corps had worked to develop a camera specifically for military needs. After specifications were released to camera manufacturers, Graflex assigned Hubert Nerwin, formerly of Zeiss Ikon, to the task. Following several prototypes, his result was a large, rugged, spring motor-driven rangefinder camera that produced 5.5 x 7-cm images on 70mm roll film and shot ten frames in six seconds. The civilian version, called the Graphic 70, appeared in the 1955 Graflex catalog. Available in a limited quantity, it retailed for $1,850 with an Ektar f/2.8 lens.

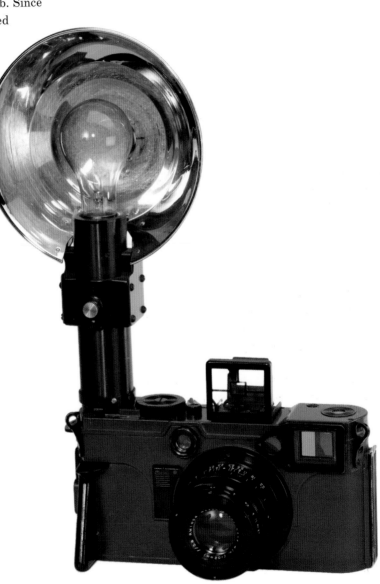

Ansco Autoset *ca. 1961*

Ansco, Binghamton, New York.
Gift of Eastman Kodak Company. 2008:0301:0001.

Manufactured in 1961 by Minolta for Ansco of Binghamton, New York, the Autoset is best known as the hand camera used by John Glenn on Friendship 7, the first U.S. manned space mission to orbit the Earth. To produce an apparatus suitable for outer space, NASA purchased several cameras, including the 35mm Autoset, from a local drug store and made numerous modifications to the Autoset, including milled components for reduced payload weight and a coat of black paint. Now oriented upside down for left-hand operation (as Glenn's right hand was needed to fly the spacecraft), the customized camera was fitted with an auxiliary viewfinder as well as a large film advance lever and a pistol grip that accommodated handling by space-gloved hands. For a few years after the successful flight, Ansco advertised the Autoset as the "first handheld camera used in outer space by an astronaut." Later U.S. manned space missions used special cameras supplied by Hasselblad and Nippon Kogaku (Nikon).

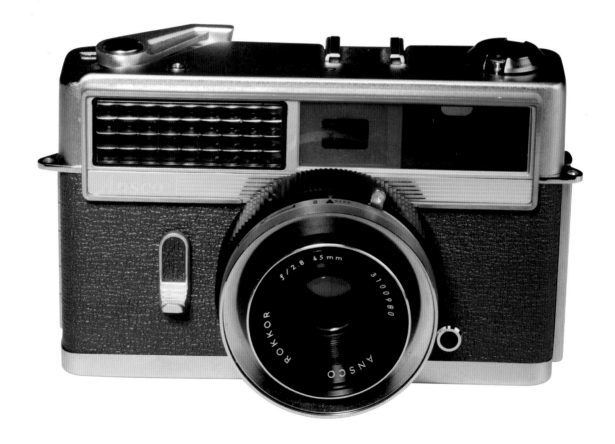

Lunar Orbiter camera payload *1967*

Eastman Kodak Company, Rochester, New York.
Gift of Frank Marussich. 1981:0795:0001.

In the early 1960s, NASA began to develop a Lunar Orbiter Program that would photographically map both sides of the moon to aid in site selection for the planned manned lunar landings of the Apollo space program. After compiling specifications, the agency solicited design proposals from aerospace firms, ultimately awarding the contract to Boeing, with Eastman Kodak Company and RCA being major subcontractors. While Boeing built the mission vehicle, Kodak's contribution to the project was a photographic subsystem that included a 65mm film media for image capture, two lenses, onboard film processing that used the Kodak Bimat process to eliminate the use of "wet" chemicals in the development, and a scanner and video system.

Once the photographs were taken, the film was processed and electronically scanned, and the negative images were transmitted as analog video to ground receiving stations back on Earth. They were then written back to film and shipped to Kodak in Rochester, New York, for final reconstruction. A total of eight subsystems were built by Kodak, five of which made one-way trips aboard Orbiter spacecraft in 1966 and 1967. During the five missions, the many images made provided a wealth of knowledge to NASA scientists.

The apparatus shown here was originally unfinished, as it wasn't needed for the program. It was acquired at government auction by Rochester's Genesee Tool and Die Corporation, completed, and donated to George Eastman House.

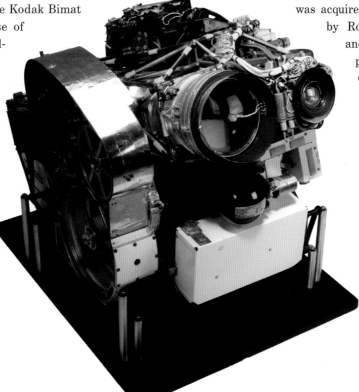

PHOTOGRAPHY IN SPACE
Peter Schultz

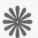

The astronomer Arago predicted in 1839 that the daguerreotype would provide an accurate, objective, and permanent record of the Moon and stars. Cameras in space represent the culmination of his prediction—Arago didn't realize that mankind would actually visit these places either in person or vicariously through images sent back by spacecraft.

Comparison of the Archimedes region of the Moon from pre-photography to today. At left is a map by Lohrman (1828), just prior to the invention of the daguerreotype. The middle image is a Woodburytype from a photograph of a sculpted plaster model of the Moon based on telescopic observations (Nasymth and Carpenter, 1874). The image at right is a modern telescopic view of the same region. This area is also shown in the Apollo 15 landing site photograph (see page 414). In 1839, Arago predicted that photography would allow accurate maps and renderings to be created, and this comparison illustrates his point. Map and images from the collection of Peter and Barbara Schultz.

The role of photography in exploring space, whether in 1850 or in the twenty-first century, goes beyond providing an image of a new world. These images inspire the public and prompt curiosity in non-specialists. Astrophotography stimulated, if not initiated, new disciplines, such as astrophysics (through the spectrograph of a star), planetary geology (through images of new planetary landscapes), and fluid mechanics (through images that froze motion in time). The first stereo images of the Moon were exhibited in 1851 at the Crystal Palace Exhibition in London, and they created a sensation. Viewing the Moon was no longer restricted to scientists with telescopes; it could be marveled at within the confines of one's living room through a parlor stereoscope or a book. Engineers, geologists, and amateurs were introduced to landscapes of a world other than Earth. Today the web supplies us with nearly real-time images not only of the Moon but of Mars and beyond.

Should we call digital imaging photography? True, it is a different process, but so were the various chemically based processes that captured a permanent image in the nineteenth century (e.g., salt prints, daguerreotypes, cyanotypes, wet plates, dry plates). Historical and digital processes all capture a latent image that is revealed when processed (chemically) or electronically recompiled (digitally). The distinction in nomenclature is further blurred when a digital image is printed, since the process involves chemistry as well as electronics. For all intents and purposes, we call any captured image a photograph. This applies even to a digital image that has been reconstructed to show wavelengths beyond the visible light spectrum.

One school argues that digital images are just a subset of "remote sensing," but in fact, the use of the resultant image, whether wet, dry, or digital, remains the same. When an image is used to assess precise light levels (photometry), wavelength color (e.g., spectra), or relative color (e.g., spectral ratios) in a scene, then perhaps the remote-sensing label is appropriate. But a photographic image provides something else: it records features that can be mapped, measured, compared, and interpreted. Today there are sixteen facilities across the world (known as Regional Planetary Image Facilities) designed to retain photographic collections with supporting materials (e.g., maps and data records) and managed by in-residence experts. Scientists, educators, and students use planetary photographs housed in these collections to discover new places and understand the processes that shape planets.

Work area at the Northeast Planetary Data Center at Brown University. This is one of sixteen Regional Planetary Image Facilities worldwide where photographs and maps are used to interpret, map, and compare the surface features on the various solid-surface planets. The image of the large crater in the foreground is from the Magellan mission to Venus and was constructed from radar data. Other maps and photographs are from the Viking mission to Mars. Photograph courtesy of Brown University.

Lewis M. Rutherfurd, Stereo view of the Moon, 1864. The Moon rotates on its axis at a constant rate, but its elliptical orbit results in slightly different speeds. As a result the Moon appears to wobble left and right, as above (libration in longitude). This is enough to allow the construction of a stereoscopic view from photographs taken at different times. Such images were highly popular in the nineteenth century, introducing the Moon into parlors as well as into the imaginations of non-astronomers. Glass stereo transparency from the collection of Peter and Barbara Schultz.

A scientist can easily be lost in contemplating the process of how an image was made. This is like studying a window rather than the scene on the other side. So, a distinction must be made between interpreting the image and interpreting the objects *within* the image. Even though computers can be used to enhance detail, create quantitative data, and even produce a map, we still need prints. An enlarged photographic print allows one to look at features both synoptically and in great detail. In viewing a print, one's focus is on understanding the feature within the photograph, not the algorithms required to create it.

Like a great painting, a great planetary photograph keeps the viewer coming back, whether for inspiration or to gain new insights. Planetary photographs endure, providing the singular record of a scene at one specific moment in time. Some scenes will never change. Some scenes will never be visited again, at least in a lifetime. Photographs from the Apollo mission era are still used and valued for scientific research more than forty years later.

What forms do planetary photographs take? They mirror those we see every day: black-and-whites, colors, stereo views, and panoramas. They are used for a variety of purposes. For example, the Apollo missions (Apollos 15, 16, and 17) carried a panoramic camera that operated in the same way that the earliest panoramic cameras did: the lens pivoted on its axis as the film moved past a slit (*see* Al-Vista 4A). In the mid-1970s, the Viking cameras (as well as the Pathfinders in the 1990s and the Rovers in 2005) took sweeping, panoramic views of the surface of Mars using CCD detectors. Photographs made on the planet's surface revealed a completely different view than those made from the satellites above.

Apollo 17 Astronaut Ronald Evans on a spacewalk to retrieve a film canister from the SIM bay of the Apollo Command Module before returning to Earth in late 1972. Before digital imaging was widely used in space, the film that produced the high-resolution images required for mapping the Moon had to be returned to Earth for processing.

Panoramic view from the surface of Mars taken by the Mars Viking 1 Lander Camera on July 23, 1976. This is the first photograph from the surface of another world outside the Earth-Moon system. The Viking camera used a slowly rotating slit that created noodles of digital data (rather than film) that could be reconstructed into a panoramic view. This view is actually constructed from pans on different days.

Photograph of the Apollo 15 landing site taken with a panoramic camera aboard the Apollo 15 Command Module. This is the same area shown in the modern telescopic view of the Archimedes region of the moon, but rotated right (see page 412). As the panoramic lens swings to either side from a point just below the camera, the photographic field covers more area. As a result, the image widens at either end. Scientists and engineers used special viewers to scroll the films over different portions of the lunar surface. Such maps and photographs are still being used to make geologic maps and to interpret the processes that have shaped the surface. Image is NASA Apollo Panoramic Photographic 15-9377.

What do scientists do with photographs of planetary surfaces? They use them to tell time, map history, create topographic maps, assess future missions, explore processes, and place other types of data in context. Relative time is determined through examining the number of impact craters that have accumulated since a surface was formed and through superposing one image over another. Geologic maps are created through identifying the relationships between different terrains and processes. Topographic maps are created from stereo views (photogrammetry), or from comparing changes in brightness related to slopes and elevation (photoclinometry). Future missions require an understanding of the character of and processes affecting the surface, especially for landing site selection, a safety as well as scientific concern. Surface processes include the formation or erosion of craters, eruption of lavas, creation of mountains (even instantly by an enormous impact), and evidence of natural agents (e.g., water, whether flowing, frozen, or evaporating). Finally, photographs are needed to understand where other data (compositional, gravitational, or magnetic anomalies) fit into either the geologic history of a surface or the processes that are modifying it.

Photographs of outer space also play an important role in inspiration. The spectacular landscapes of Mars, stunning rings of Saturn, or ever-changing surface of Io spark students' imaginations. Waking up in the morning and seeing a photograph of an unknown world tacked on the wall gives purpose to a child struggling with a difficult math class or to an adult striving to understand where he or she lives in space. The printed photograph is and always has been a beacon for the curious.

Prof. Peter H. Schultz, Ph.D., Director of the Northeast Planetary Data Center, Department of Geological Sciences, Brown University

Color image of the Hebes Chasma region on Mars (top) that was part of a stereo pair of images that allowed reconstruction of a high-definition three-dimensional view (bottom). This image was taken by the High Resolution Stereo Camera on ESA's Mars Express Orbiter. Such reconstructions reveal details about the geologic history of Mars.

Hasselblad Electric Camera (HEC) *ca. 1969*

Victor Hasselblad AB, Göteborg, Sweden.
Gift of Victor Hasselblad AB. 1974:0028:3081.

The first Hasselblad camera used in space was a 500C carried onboard Mercury Sigma 7, which flew October 3, 1962. A standard off-the-shelf model, it was purchased at a Houston camera store by astronaut Walter Schirra (1923-2007) and modified slightly by NASA, with the leather panels removed and the camera body painted black to reduce reflections. That mission's high-quality photographs prompted NASA to contract Hasselblad to build special models for the space program. Since then, Hasselblad cameras have served on virtually every NASA manned flight.

The Hasselblad Electric Camera (HEC), a modified version of the Hasselblad EL/70, first flew on Apollo 8 in December 1968 and was used for the remainder of the Apollo Program, including the moon landing missions, as well as the Skylab and space shuttle missions of the early 1980s. It is worth noting that all the cameras used on moon landings were left there. Due to weight concerns at the lunar takeoff, only the film magazines returned to Earth.

The example shown here did not travel into space. It was donated personally by Dr. Victor Hasselblad to the George Eastman House Technology Collection in March 1972.

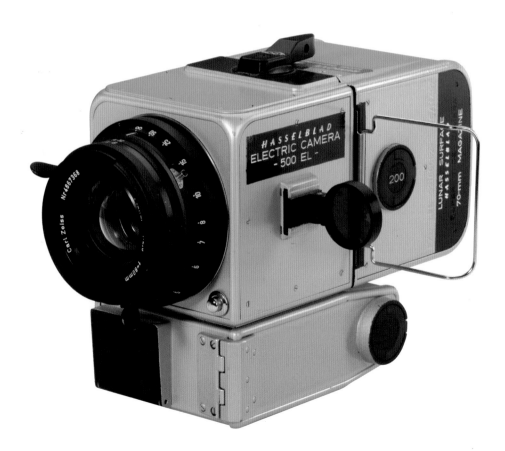

Téléphot-Véga *ca. 1900*

Véga SA, Geneva, Switzerland. 1974:0037:2810.

Today's photographers give little thought to how easily they can remove a camera lens and replace it with a telephoto, or move a control on their camera and greatly magnify the image of a faraway subject. Nineteenth-century photographers didn't have that luxury. Only by moving closer to their subject were they able to create a larger image on their sensitized plates. This posed a major problem for wildlife and naturalist work, which required pictures of creatures in the wild, undisturbed by camera-wielding intruders. Large diameter, long focal-length optics were an established part of astronomy, but adapting this technology to photography presented engineers with great challenges. Not until the 1890s did a workable telephoto lens become available.

The problem of accommodating a forty-inch lens in a camera that didn't require a pack animal to tote it was successfully addressed by the Swiss firm of Véga SA. The solution was to use a mirror to "fold" the light path linking the lens to the 7⅛ x 9½-inch film plate, which immediately reduced the length of the camera by half. When combined with a hide-away upper portion, the result was an instrument of reasonable size, considering what it could do.

Preparing the Téléphot-Véga for duty was not unlike setting up a weekend camper. Raising the front and rear panels tightened the bag they were attached to, and locking the struts kept it all in place and aligned.

The lens board and bellows were adjusted for focus by the familiar rack-and-pinion method. Folded flat against the lower body was the wire frame finder, ready to swing out when needed. Setting, adjusting, and tripping the optional roller-blind shutter was all handled by controls on the body of the Thornton-Pickard unit. Basic operation was the same as with any other camera of the day. The difference was that with the Téléphot-Véga, the focused-on subject was much farther from the photographer than it would have been with an ordinary camera—perhaps an important distinction when recording the behavior of a tiger in its native habitat.

Naturalists' Graflex *1907*

Folmer & Schwing Division of Eastman Kodak Company, Rochester, New York.
Gift of David Fischgrund. 1990:0011:0001.

Designed especially for naturalists' work—photographing birds and wild animals with long-focus or telephoto lenses—the Naturalists' Graflex was manufactured by the Folmer & Schwing Division of Eastman Kodak Company of Rochester, New York, from 1907 to 1921. It was similar to many of the Graflex cameras of the period, with the exception of its very long extension front that accommodated lenses up to twenty-six inches in focal length. Features included a spring back to hold individual plates or film packs, a focal-plane shutter curtain, and a large reflex viewing hood that was contoured to the photographer's face. From the second year of production, the viewing hood was hinged so it could be rotated upward. The Naturalists' Graflex was available only in the 4 x 5-inch size and the retail price, without lens, was $190.

Little Bertha *ca. 1941*

Graflex, Inc., Rochester, New York. 1974:0028:3537.

Long lenses are used for photographing objects to which the photographer cannot get physically close, such as sporting events or animals in the wild. The Little Bertha, like its predecessor, the Naturalists' Graflex, was designed for such purposes. Also like the Naturalists', Little Bertha was based on a production Graflex model, in this case, a 4 x 5 RB Graflex Super D. Modifications were added to the camera base to support the 30-inch (and forty-pound!) f/8 lens. To allow for fast focusing, a chain-drive system, complete with three adjustable focus points, was added to the side of the camera. For example, when shooting baseball, it could be focused on the different bases. This camera was used in the 1940s at the Chicago Sun Times, probably for stadium sports photography.

Zoomar lens *ca. 1959*

Zoomar, Inc., Glen Cove, New York.

Gift of Eastman Kodak Company. 1991:2644:1-2.

Introduced in 1959 by Zoomar, Inc., of Glen Cove, New York, the Zoomar lens was billed as the "world's first and only zoom lens for single-lens reflex cameras." The first version issued was the 36mm to 82mm f/2.8. When used with the Voigtländer Bessamatic, one of the first 35mm SLR cameras with a coupled light meter, it offered fully automatic, pre-set operation. As became standard with most lenses, the focusing was done with the lens wide open, then automatically stopped down to the pre-set aperture when the shutter was tripped.

In 1959 the retail price for the Zoomar lens was $298 for the Voigtländer version and $318 for a version to fit other SLR cameras with focal-plane shutters. That same year, the Voigtländer Bessamatic sold for $220.

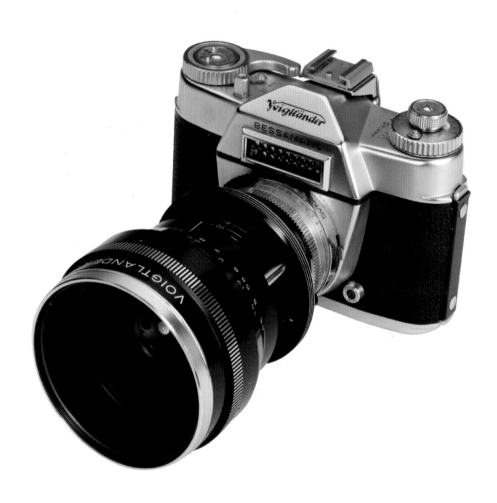

Questar 3½-inch CAT (catadioptric) lens *ca. 1962*

Questar Corporation, New Hope, Pennsylvania.
Gift of Questar Corporation. 1978:1525:0001.

The 1954 introduction of the Questar Astronomical telescope was the culmination of an eight-year project to apply Soviet optical engineer Dmitri Maksutov's catadioptric design to a commercial product. The result was a 3½-inch telescope of seven-foot focal length reduced to an eight-inch-long tube. For amateur astronomers who didn't have room to set up a telescope or wanted to pack one along to get away from city lights, the Questar was a wish granted. For $995, delivered from the New Hope, Pennsylvania, plant, the stargazer received a handmade, fitted leather case with the Questar 'scope and everything needed to explore the night skies, including a synchronous clock drive. Questar chose Nikon cameras for telescopic photography because of their smooth working shutters and interchangeable finders, then added a mirror lock-up to eliminate a source of vibration. The Questar Nikon body was priced at $250. The camera-telescope combination also could be used for earthbound photography. Wildlife close-ups and other extreme long-distance shots were now possible. With extension tubes and two Barlow lenses, the effective focal length was 450 inches.

Hill Cloud Camera *ca. 1923*

R. & J. Beck, Ltd., London, England.
Gift of Ralph Steiner. 1974:0037:2840.

The Hill Cloud Camera of 1923 was manufactured by R. & J. Beck, Ltd., of London. Designed by Robin Hill, it was intended to photograph the entire sky on a 3¼ x 4¼-inch plate. The polished mahogany body measures 5¾ inches square by 1⅝ inches deep and is used horizontally, with the lens pointed up and fixed for correct focus. Hill's design covered a field of 180 degrees, making it the earliest "fisheye" or "sky" lens. The camera has three apertures and three orange/red filters to enhance contrast and differentiate between cloud types. When used in pairs for stereoscopic viewing, it was possible to estimate the relative altitudes of clouds. The camera could also be used to project a negative back to a normal perspective.

Eastman Wide-Angle View *ca. 1931*

Kodak Ltd., Harrow, England.
Gift of Eastman Kodak Company. 1993:0210:0002.

Introduced in 1931 by Kodak Ltd., Eastman Kodak Company's British subsidiary, the Eastman Wide-Angle View was designed to photograph interiors and other areas with tight access. A simple box design, the full-plate-sized camera has no means of focusing since the wide-angle f/18 Zeiss Protar lens provides enough depth of field to make it unnecessary. There is no viewfinder as the image is composed directly on the ground glass. The lens board can also be mounted backwards, with the front element facing the film, and used for extreme close-up copy work.

Hasselblad SWC *ca. 1969*

Victor Hasselblad AB, Göteborg, Sweden.
Gift of Victor Hasselblad AB. 1974:0028:3079.

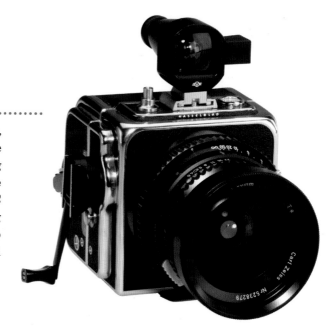

Manufactured by Victor Hasselblad AB of Sweden, the Hasselblad SWC is a wide-angle version of the venerable Hasselblad 500C. A short non-reflex viewing body immediately identifies it as a "Super Wide," a line that began with the SWA. Second in the series, the SWC of 1959 incorporated the film advance and shutter cocking in a single crank and moved the shutter release to the top of the body. The example shown here has a black anodized Biogon lens barrel that indicates a manufacture date of post-1969. The retail price, with 38mm Biogon lens and viewer, was $700.

Fisheye-Nikkor 6mm f/2.8 lens *ca. 1975*

Nippon Kogaku K. K., Tokyo, Japan.
Gift of Ehrenreich Photo-Optical Industries (EPOI), Inc. 1981:1037:0001.

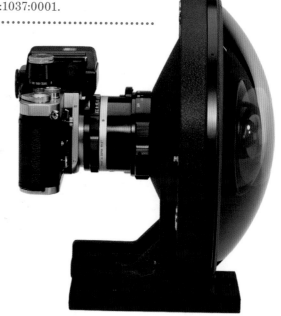

Introduced in 1972, the 6mm f/2.8 fisheye Nikkor lens was intended for meteorological and astronomical research. A 220-degree picture angle also made it ideal for use in industrial photography to shoot images of objects in tight spaces, such as the interior of pipes or cylinder walls. Weighing in at eleven and a half pounds and measuring nearly ten inches in diameter, the lens was by no means a small one. It produced a round, 23-mm diameter image in the center of a standard 35mm roll film. The dramatic fisheye effect—an extreme wide angle with enormous depth of field—was adopted by advertising and commercial photographers to create attention-grabbing images.

Plaubel 69W Proshift *1982*

Plaubel Feinmechanik und Optik GmbH, Frankfurt, West Germany.
Gift of Plaubel USA. 1983:0579:0001.

The Plaubel name dates back to 1903, when the German company entered the camera business. Best known for its line of Makina folding cameras, the firm also manufactured some unique designs for specialized work. When the 69W Proshift came on the scene in 1982, it was marketed to professionals. The camera could use No. 220 as well as the more common 120 roll films to make its 6 x 9-cm format negatives. The very capable Schneider-Kreuznach Super Angulon 47mm f/5.6 lens working through a Copal ten-speed shutter wasn't what distinguished the Proshift from other 6 x 9 cameras. It was its lens board shift feature, for correcting perspective distortions, that got the buyer's attention. While common in large-format view cameras, shift capability was seldom seen in the handheld medium-format market. For assignments like architectural pictures, it

was essential to be able to shift the lens to correct perspective. Lens movement was controlled by a thumb-lever locking nut and an L-shaped slot. When the shooter moved the lens, the viewfinder went with it, taking the guesswork out of the set-up. The finder also had a parallax adjustment for close work. The body shape of the Proshift was unusual in that the right side curved toward the front, while the left grip extended rearward. It may have looked strange at first, but this design made handheld use easier. The large shutter button on the right grip was perfectly located, as was the film advance lever. These cameras still find work, even in the age of digital photography. Perspective corrections can be made in photo-editing software, but many people think old school methods work just fine.

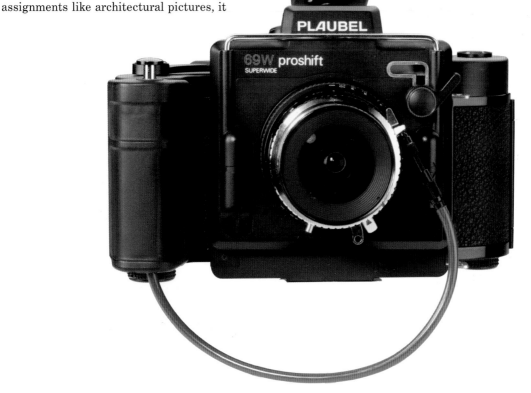

Mako Shark *1957*

Healthways, Inc., Los Angeles, California. 2008:0554:0002.

Dick Klein found fame as the brains behind Healthways, Inc., of Los Angeles, a supplier of diving equipment, and for trademarking the name SCUBA, the acronym for Self-Contained Underwater Breathing Apparatus, coined by the U.S. Navy for his line of underwater air supplies. Underwater photography was a popular activity with divers, so Healthways soon had a special camera in its catalog. The Mako Shark appeared in 1957 priced at $19.95, much less than the typical submersible cameras of the day. Healthways was able to keep costs low by basing the Mako Shark on an existing mass-produced design, the Kodak Brownie Hawkeye Flash Model. Inside the Mako Shark's round plastic body was the front half of the Brownie, containing the lens, shutter, and film transport. A spring-loaded release button and a winding knob on the Mako Shark's front housing connected to the corresponding parts of the Kodak. For a few dollars more, a diver could buy the Mako Shark with external connectors for flash, activated by being wired to the Brownie's flash connections.

The entire rear portion of the Mako Shark was removed by unscrewing it like a pickle jar lid. With the back opened, the roll of 620 film could be loaded or removed. Each roll was sufficient for twelve 2¼-inch square negatives. With the back of the housing replaced and tightly secured, you were ready for your dive. The camera was rated to a maximum depth of one hundred feet. A molded handle and a big crosshair finder made shooting easy, as did the large bright red shutter button. What wasn't easy was keeping track of the exposure count through the red plastic window on the back side. Divers would compensate for this by remembering the number of turns required to bring the next frame of film into place.

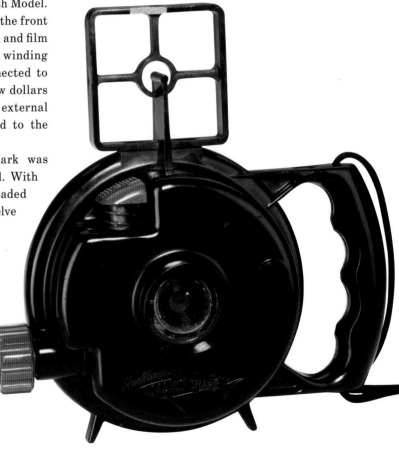

Calypso *ca. 1960*

Spirotechnique, Levallois-Perret, France.
Gift of John and Zarnaz Arlia. 2006:0251:0001-2.

Nikonos *ca. 1963*

Nippon Kogaku K. K., Tokyo, Japan.
Gift of Ehrenreich Photo-Optical Industries (EPOI), Inc. 1974:0028:3164.

The first commercial camera produced specifically for amphibious photography, the Calypso (left) was designed for Jacques-Yves Cousteau and manufactured by Spirotechnique of Levallois-Perret, France, in 1960. Its O-ring-sealed body was watertight without need of external housing, yet the same size as a normal 35mm camera. Tested to 200 feet, it was also tropicalized and protected against corrosion, sand, and mud. The covering is a gray imitation sealskin. The design was later sold to Nikon and evolved into the Nikonos line of cameras (right).

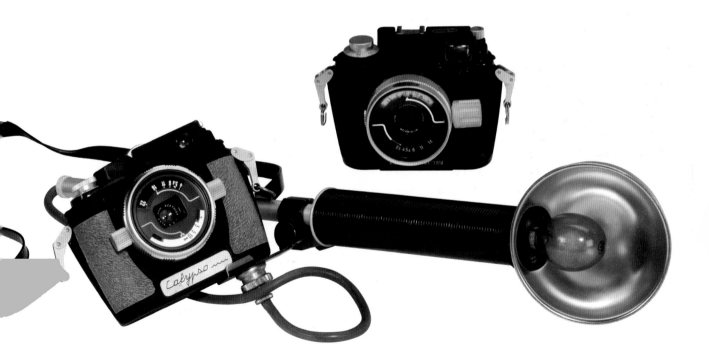

Nikonos IV-A *ca. 1980*

Nippon Kogaku K. K., Tokyo, Japan.
Gift of Nikon, Inc. 1981:3208:0027.

The Nikonos IV-A of 1980, manufactured by Nippon Kogaku of Tokyo, was the first updated version of the amphibious line of cameras originally designed by Spirotechnique as the Calypso camera for Jacques-Yves Cousteau. The Nikonos IV-A featured an automatic aperture priority exposure system with an electronic shutter, a hinged film back, and O-ring seals, waterproof to 160 feet. Its new die-cast body was more rugged looking, used a textured rubber covering, and featured a hinged back for ease of loading. The series' final model appeared in 1984 as the Nikonos V, with a new bright orange covering on the body.

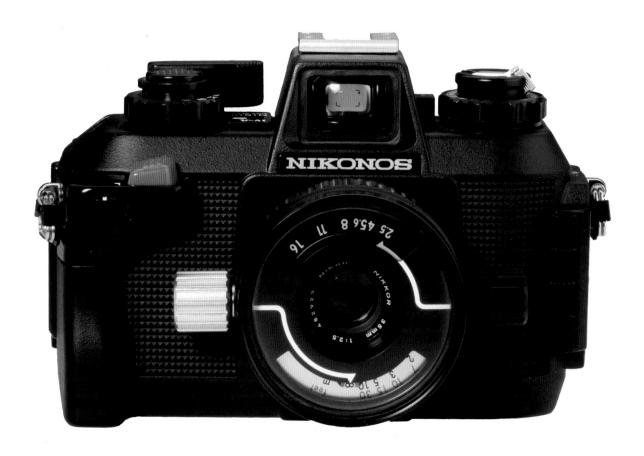

Disc Snapper 500 *ca. 1985*

Alfon (Tung Tai Industries), Taiwan. 2010:0066:0002.

The challenges of underwater photography pose some engineering problems for camera designers. The obvious one of keeping water away from the film and the internal parts of the camera and lenses requires seals that do not leak. Also important is the need to protect against the water pressure that can compromise camera bodies. The most common design approaches provide two basic options to underwater photographers: purpose-built cameras, or waterproof housings for standard equipment. When it comes to specially designed cameras, a professional photographer would likely buy one that is a clean-sheet effort capable of deep-water photography, while the amateur might choose from "sport" models that are adaptations of standard cameras and adequate only for work in shallow water. The second option of waterproof housing means one must acquire what is essentially a clear plastic box with a special cover gasket, and control levers and buttons for operating an off-the-shelf camera.

The Alfon Disc Snapper 500, made by Alfon, Taiwan, was in many ways typical of aftermarket underwater housings, though it had some unique features. It was designed to be used with Eastman Kodak's 1982 Disc camera, which had many features that made it ideal for use in submarine work. Most important was that all functions were automatic, making it a true point-and-shoot product. Once the camera was sealed inside the housing, taking shots was done with a button mechanism that would press the shutter release on the front of the camera. Focus, flash, and film advance were all handled by the camera and powered by the long-life lithium battery. The clear housing of the Snapper 500 was molded of strong polycarbonate, with the cover plate, which also served as the handle, sealed by an o-ring stretched over the rectangular shape. The cover-handle assembly was secured by a pair of swinging latches that held it tightly in place but required no tools to remove the camera. Atop the housing was a large crosshair sight that was easy to see through diving masks. A soft grip on the right side helped the diver hold the unit steady. While other underwater housings were made for the Disc cameras, they lacked the Disc Snapper 500's style and ergonomics. The weakest link in the product was not the housing, but actually the Disc camera's tiny negatives, which were barely good enough for standard-size prints.

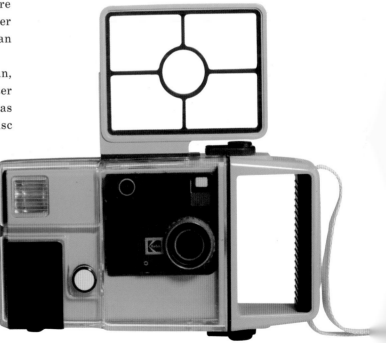

Tom Thumb Camera Radio *ca. 1948*

Automatic Radio Manufacturing Company, Inc., Boston, Massachusetts. 1978:1657:0001.

The Tom Thumb Camera Radio, a two-for-one product of Automatic Radio Manufacturing of Boston, Massachusetts, combined an AM radio with a Flex-Master twin-lens reflex camera. The earliest example of a portable electronic device (PED) in the George Eastman House collection, this hybridization had a radio dial on one face and camera lenses above a speaker on the opposite one. Its upright design, reminiscent of a console-style radio, was built around a camera from the Spencer Company of Chicago. Even with its neck strap, the camera, which was mounted on a hinged panel that swung down for access for film loading and advance, would be rather inconvenient to use. Measuring 9½ x 4½ x 4½ inches, with

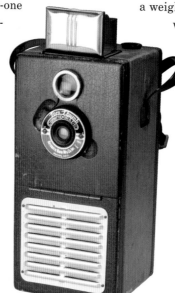

a weight of about five pounds, the Tom Thumb was not very small by today's circuit-board standards. Adding to its bulk was the need to house pre-transistor vacuum tubes for sound amplification and three batteries for power, which occupied the space behind the speaker. Whether used as camera or radio, one suspects that, as is the case with many multi-tasking devices, neither component worked as well as it might in a stand-alone appliance.

G.E.C. Transistomatic Radio Camera *1964*

General Electric Company Ltd., London, England.
Gift of Eastman Kodak Company. 1990:0458:0005.

A marriage of radio and camera, the Transistomatic Radio Camera united a Kodak Limited Instamatic 100 camera within a General Electric Company Ltd. radio with AM, short wave, and long wave capabilities. The camera was slightly wider than the standard model to accommodate a storage compartment for spare AG-1 flash bulbs. Removing the lens bezel allowed the camera to be separated from the radio, a procedure necessary to

access the two AA batteries that powered the flash. This early portable electronic device necessarily took a much more literal approach to integrated components than today's PEDs.

IN-CAMERA PROCESSING

Though pioneering inventors including Niépce, Daguerre, and Talbot had earlier considered how to sensitize, expose, and develop photographs within a camera, the Dubroni of 1864 is regarded as being the first camera system to do so successfully. Research into making the process feasible continued in ensuing years. In the late 1890s, street photographers equipped with ferrotype button cameras that used manufactured emulsions provided customers with souvenir portraits in just a few minutes. Shortly after World War II, Edwin Land, inspired by his daughter's wish to instantly see her photograph, introduced the Polaroid camera and film. And most recently, in 1975, Steven J. Sasson of Eastman Kodak Company devised an in-camera system to convert the image recorded on a solid-state imager to numeric values, and then store the digital image file on a separate memory device.

Appareil Dubroni No. 1 *ca. 1864*

Maison Dubroni, Paris, France.
Gift of Eastman Kodak Company, ex-collection Gabriel Cromer. 1974:0037:0002.

Appareil Dubroni No. 2 *ca. 1864*

Maison Dubroni, Paris, France.
Gift of Eastman Kodak Company, ex-collection Gabriel Cromer. 1974:0037:2280.

The idea of developing an image in the same apparatus in which it was exposed, usually described as in-camera processing, dates back to the early days of photography. The first of its kind to sell in quantity was the Dubroni, an anagram of the family name of G. J. Bourdin, the Frenchman who patented the camera in December 1864. Sold as a kit (below), it included everything necessary to produce images in-camera.

The apparatus consisted of a small box camera, with a glass or ceramic container fitted inside. A glass plate was coated with iodized collodion and loaded into the camera. Silver nitrate was then introduced with a pipette onto the plate through a hole at the top of the camera, which sensitized the plate. After exposure, the plate was left in the camera and

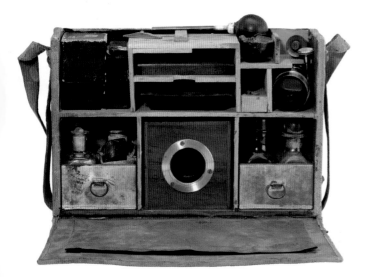

Nodark tintype camera *ca. 1899*

Popular Photograph Company, New York, New York. 1974:0037:1762.

The magazine ads boasted "A Finished Picture in a Minute," but this wasn't the 1948 Polaroid introduction. It was 1899 and the camera was called Nodark, a hardwood-bodied box built to use metal dry plates, popularly known as tintypes. Nodark outfits were sold by Popular Photograph Company in New York for $6, delivered. What you got for your money was a camera with a meniscus 5-inch f/10 lens, two finders, and a non-automatic shutter. The slow media of the day required exposures too long for a simple snap shutter. The tintypist had to keep both camera and subject still while the shutter was open. Inside the box was a darkroom-loaded wooden magazine with twenty-six 2½ x 3½-inch plates in individual slots. A bright, plated knob on the side was turned to advance the next fresh plate into position as a knob pointer tracked the remaining plates. When the narrow dark slide was pulled out, the exposed tintype dropped from the magazine into a developing tank or storage box slipped onto the bottom side. Chemicals included in the outfit developed the plates individually or in batches.

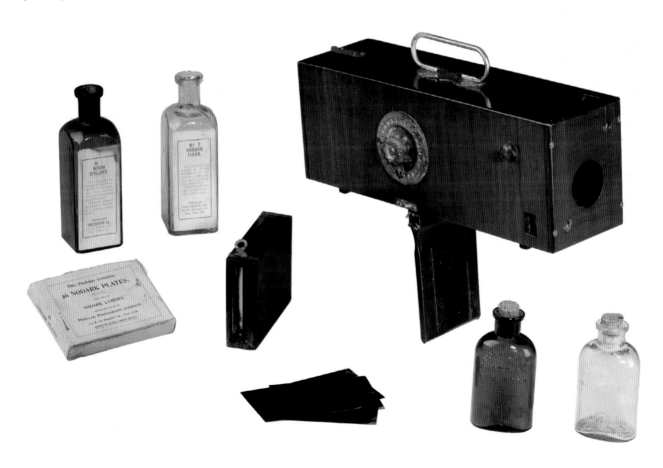

Wonder Automatic Cannon Photo Button Machine *ca. 1910*

Chicago Ferrotype Company, Chicago, Illinois. 2000:0413:0001.

Earning a living as a portrait photographer usually involved a considerable investment for equipment, supplies, and studio. Additional money had to be spent on advertising your services. In 1910, the Chicago Ferrotype Company offered an alternative. For $30, they would deliver the Wonder Automatic Cannon Photo Button Machine and enough supplies for you to start business immediately. The idea was to set up the four-pound Wonder Cannon in busy public areas and offer passers-by a metal button with their picture on it for five cents. One hundred one-inch diameter sensitized blanks could be loaded into the nickel-plated brass cannon's breech in daylight. When the subject was centered in the sights, the photographer squeezed the rubber bulb to operate the shutter. The exposed buttons didn't have to be removed for developing. A quick push-pull of the "bolt" dropped the button into a tank of developer, and thirty seconds later it could be removed, rinsed, and popped into a pinback frame. All this for a nickel.

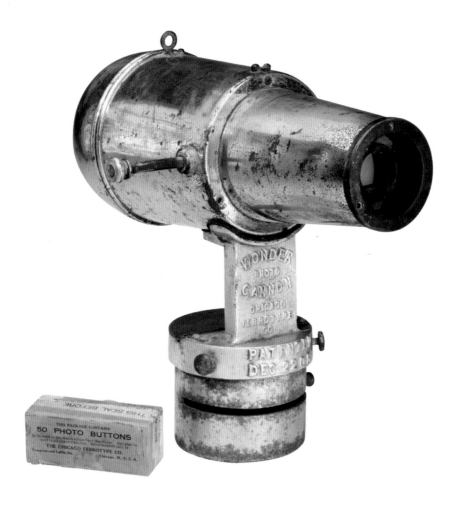

Räderkanone *ca. 1912*

Romain Talbot, GmbH, Berlin, Germany.
Gift of Kodak Pathé. 1988:0099:0001.

A button portrait camera was a familiar sight at tourist attractions, carnivals, and other gatherings where souvenirs were sold. The Räderkanone of 1912 was made by Romain Talbot GmbH of Berlin for concessionaire use and could deliver your portrait on a one-inch-diameter metal button in a minute. Made mostly of polished hardwood, it was styled like a field gun, right down to its brass wheels. More than fifteen inches in length, the camera was loaded from the rear with a tube full of tintype blanks. Using the scope atop the barrel, the vendor centered the customer's face in the circle. A spring-loaded plunger moved the blanks forward to be exposed by the f/4 lens when the shutter at the muzzle end was tripped. A push of the transfer plate dropped the exposed button into the tank of developer beneath the barrel. When the photographer retrieved the developed button and finished washing it, the customer handed over a five-cent piece and walked away happy.

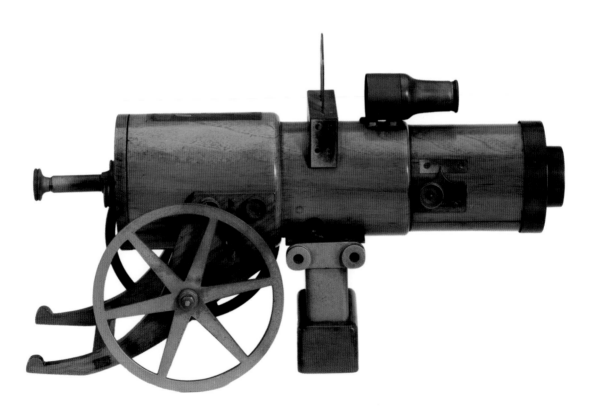

Teddy Camera *ca. 1924*

Teddy Camera Company, Newark, New Jersey.
Gift of Eastman Kodak Company. 1990:0458:0007.

Long before Edwin Land's 1947 Polaroid camera made it look so easy, there were many attempts at cameras that processed their own prints after exposures were made. In 1924, the Teddy Camera Company of Newark, New Jersey, added their $2 answer to that list. Tin-can technology made the low price possible, but like most tries at "instant" cameras, this one required extra work both before and after the shot. The Teddy Model "A" didn't use film. Exposures were made on a sensitized card that was transferred to the developing tank hanging from the underside. To do this in darkness, the user had to slip a hand through the flannel sleeve on the back cover. Teddy sold a combined developing and fixing solution, Del-Fix, that was poured into the removal tank. Handheld photos were seldom possible with a Teddy because of the long exposure times needed for the direct-positive prints.

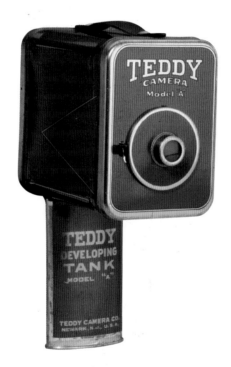

Maton _1930_

Multipose Portable Cameras Ltd., Paris, France.
Gift of Eastman Kodak Company. 1990:0458:0008.

Introduced by Multipose Portable Cameras Ltd. of Paris in 1930, the Maton was a novel box camera. The brown, Bakelite body was very precisely molded, with all panels having an engraved texture. Its unusual grip resembled a set of brass knuckles, with a thumb socket for steadying the camera during exposure. Equipped with a long H. Roussel Trylor 85mm f/4.5 lens in a Gitzo shutter, the camera had two reflecting brilliant finders for both vertical and horizontal exposures, and two dial readouts indicating the number of exposures made and those remaining. A turn of the crank handle released the shutter, advanced the exposure, and set the counters.

The Maton's most unusual feature, daylight processing, made it a popular item among street photographers. Instead of using film, the camera took up to twenty-four 24 x 30-mm images on direct positive 35mm paper. This meant that photographic prints could be produced on the spot, without an intermediate negative. Once the roll of sensitized paper was exposed, it was placed in a special holder and passed through four containers of developing chemicals, processing a strip of sepia-toned positives in about ten minutes. During exposure, a prism in the camera corrected the reversed image. The 1930 retail price was 850 francs, with an additional 85 francs for the processing apparatus.

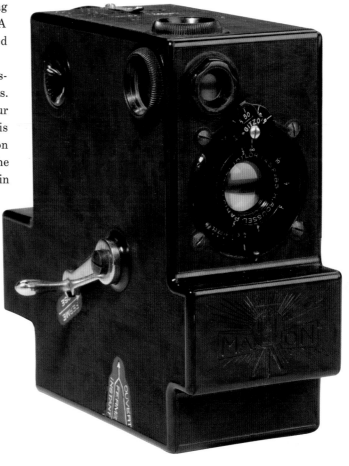

Land Camera Model 95 *ca. 1948*

Polaroid Corporation, Cambridge, Massachusetts. 1974:0028:3137.

In February 1947, inventor Dr. Edwin H. Land (1909-1991) demonstrated the Polaroid Land Camera, the world's first instant camera. It went into production in 1948 and became an immediate success. The first Polaroid camera, the model 95, used roll film and produced finished 3¼ x 4¼-inch prints in just sixty seconds. After exposing the image, the photographer pulled a tab, which caused the roll of negative film to join with the print paper as they were drawn through rollers. At the same time, the rollers spread developer evenly across the interface surface to process the print.

Over time, film improvements meant that a film pack replaced the roll film and allowed for the print to develop outside the camera, letting the user immediately take another picture. Faster film required only ten seconds to the finished black-and-white print, and color film was added. Camera advances included sonar auto focusing, and a later model, the SX-70, was a folding SLR. The retail price for the original Model 95 was $89.75.

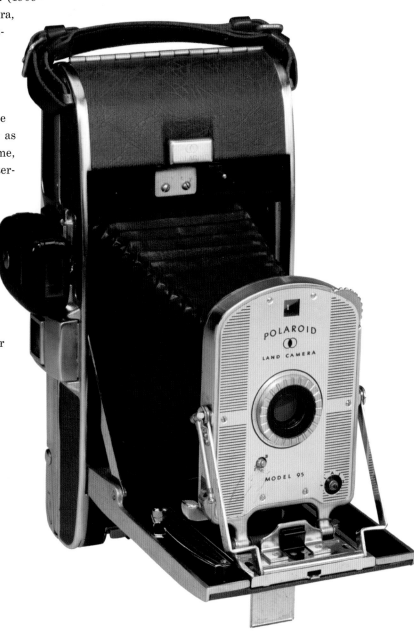

Speed-O-Matic *ca. 1948*

Speed-O-Matic Corporation, Boston, Massachusetts.
Gift of Eastman Kodak Company. 1991:0977:0007.

The Speed-O-Matic camera was introduced in 1948 by the Speed-O-Matic Corporation of Boston, Massachusetts. It was an interesting, if not successful, "instant" camera producing 2 x 3-inch images on direct positive paper. The black Bakelite body had an extinction meter that allowed the photographer to select one of five apertures. A sliding rod on the back transferred the exposed image to a holder that was mounted to the developing tank, where a mono-bath developed the images. In 1950 the camera was redesigned by the Dover Film Corporation to use traditional No. 620 film.

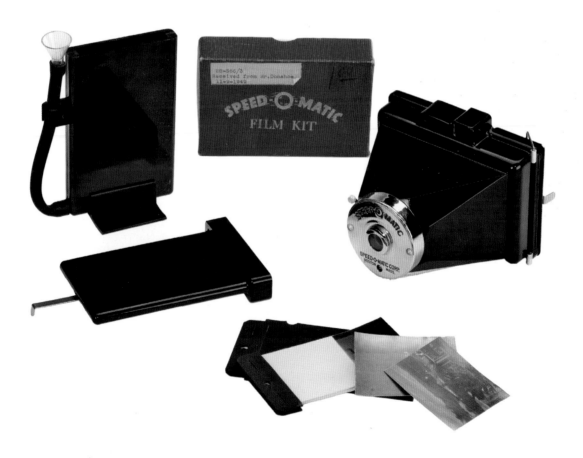

Момент (Moment) *ca. 1952*

GOMZ, Leningrad, USSR. 2005:0277:0001.

Introduced in 1952 by GOMZ in Leningrad, USSR, the Момент (Moment) camera was a copy of the Polaroid 95. Though an impressive-looking camera, with metal body covered in brown leather with bright trim, the instant film of GOMZ's own manufacture was a persistent problem. Production halted after a few thousand units.

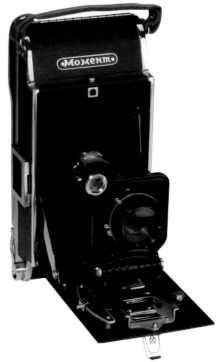

Swinger Model 20 Land Camera *ca. 1965*

Polaroid Corporation, Cambridge, Massachusetts.
Gift of Eastman Kodak Company. 1996:0473:0001.

Polaroid's Swinger, introduced with great fanfare in 1965, was heavily advertised on television. Aimed at the teen market, the all-plastic Swinger was Polaroid's entry-level instant camera. Pinching the shutter button let the user know whether there was enough available light. If "YES" appeared in the viewfinder, you were ready. "NO" meant you had to pop in a flash bulb first. Once the button was pressed, all you had to do was pull a tab to start the developing proces—which took place outside the camera—wait sixty seconds, and peel the finished picture free.

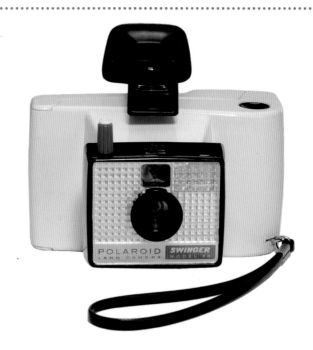

SX-70 Land Camera *ca. 1972*

Polaroid Corporation, Cambridge, Massachusetts.
Gift of Eastman Kodak Company. 1999:0140:0001.

Polaroid's SX-70 Land Camera made its spectacular debut in 1972, even showing up on the cover of LIFE magazine. The futuristic look and fresh technology was a startling break from any previous Polaroid product. When opened, it resembled no other camera, and when folded for carrying, didn't look like a camera at all. The film itself was an extraordinary piece of design. You simply unwrapped the flat pack and slipped it into the camera base. Each pack had its own battery that powered the print eject motor, electronics, and flashbar. The viewfinder was large and bright, making it easy to focus down to ten and one-half inches.

The real fun began when you pressed the shutter button. It did the rest! Almost immediately, the distinctive SX-70 print ejection motor's song heralded the arrival of an exposed print from the front of the camera. An image began to appear on the blank white sheet and a minute later was fully developed, whether you held it in the light or put it in your pocket. Photographers had no peel-off waste or chemical goop to deal with because everything was contained in the print and activated when the whirring motor squeezed it through a pair of rollers on its way out. All this was available for a list price of $180. Later versions of the camera had sonar autofocus. The SX-70's technology migrated to new lower-priced Polaroids as well as into some non-photo-graphic products.

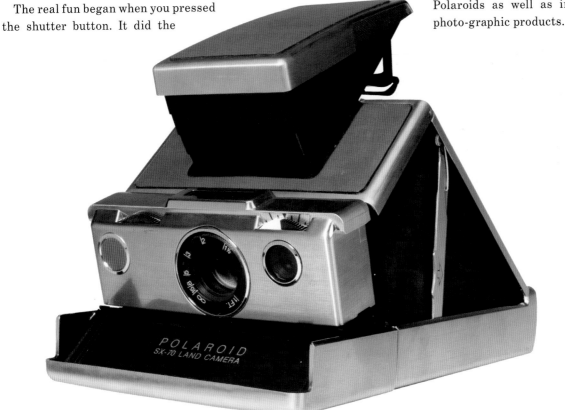

Sasson digital camera *1975*

Eastman Kodak Company, Rochester, New York.
Gift of Eastman Kodak Company. TD2008:0303:0001.

In a 1977 report titled "A Hand Held Electronic Still Camera and Its Playback Unit," Eastman Kodak Company electrical engineer Steven J. Sasson predicted new digital technologies might "substantially impact the way pictures will be taken in the future." How right he was! Sasson was the first Kodak employee assigned to the momentous task of building a complete camera using an electronic sensor, known as a charge-coupled device or CCD, to capture optical information and digitally store the captured images. Primitive by today's standards, the CCD provided to Sasson by Fairchild Semiconductor realized 0.01 megapixels and black-and-white optical information. Undaunted, Sasson incorporated the CCD with Kodak movie camera parts, other commercially available components, and circuitry of his own design to create the world's original digital camera in 1975. His resulting camera weighed more than eight pounds and measured the size of a toaster. The unwieldy camera required twenty-three seconds to record

an image to a cassette tape and another twenty-three seconds for the image to be read from the tape to a stand-alone playback unit for display on a TV screen. With this groundbreaking innovation, Sasson helped to introduce digital technology in camera and photography systems and claim for Eastman Kodak Company its first digital camera patent in 1978.

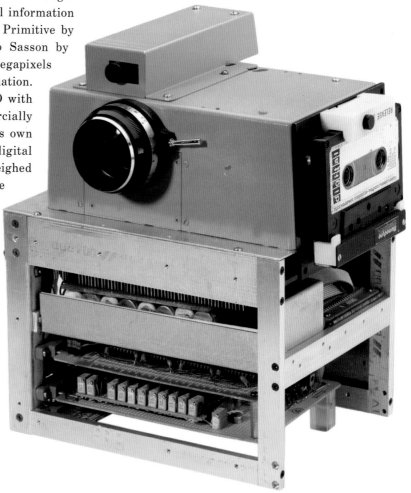

Kodak Handle Instant Camera *ca. 1977*

Eastman Kodak Company, Rochester, New York.
Gift of Eastman Kodak Company. 1981:2812:0006.

Introduced in 1977, the Kodak Handle Instant Camera was a solid body, direct light path, inexpensive instant camera, named for the large handle molded into its body. Instead of folding bellows or mirrors, it used a long snout for direct path imaging. It also used a folding crank handle for picture ejection. A popular premium version of the Handle was manufactured for Coca-Cola as the Happy Times camera. The Handle retailed for $39.95 at introduction.

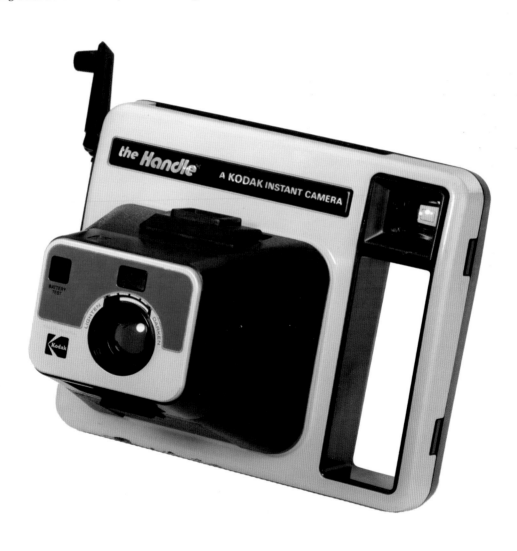

Sony Mavica MVC-5000 *ca. 1989*

Sony Corporation Ltd., Tokyo, Japan.
Gift of Rochester Institute of Technology. 2006:0113:0001.

Photojournalism has always been driven by pressure to decrease the time lag of getting images to press. Generally, any new technology that helps to cut the gap is put to good use. Yet, in some parts of the world, the latest technology may not be the way to go. A current example is the use of video phone cameras in reporting from remote areas of Afghanistan. Sony began experimenting with Mavica (magnetic video camera) in the early 1980s and eventually produced the MVC-5000 still video camera in 1989. By that time, its two-chip 500 raster-line TV resolution was far from the cutting edge. Still, when used in conjunction with the Sony DIH 2000 (digital image handler), the Mavica MVC-5000 could transmit analog still color images over telephone lines. Shortly after the camera's introduction, the television network CNN used a Mavica to avoid Chinese censors and deliver images of the Tiananmen Square student protests. The news value of the subject matter more than compensated for the poor technical quality of the images. This example was used by Reuters during the first Gulf War.

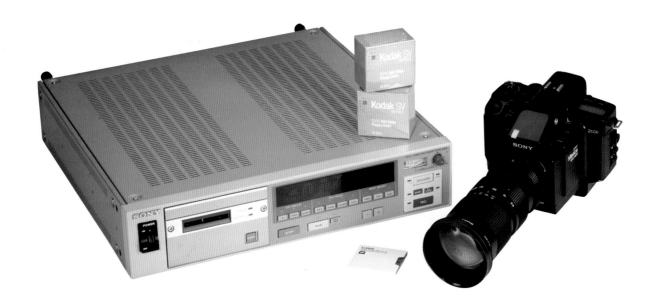

Canon Xap Shot *ca. 1990*

Canon, Inc., Tokyo, Japan.
Gift of Canon USA, Inc. 1989:1161:0001.

The Canon Xap Shot of 1990, manufactured by Canon, Inc., of Tokyo, is best thought of as a video camera that used small discs instead of video tape. Before the advent of digital photography, this analog still video camera was capable of storing fifty individually erasable images on removable 2 x 2-inch video discs. Images were viewed by connecting an AC coupling device from the camera's video output to a television's video input. As with any NTSC video image, Xap Shot photos could be digitized and imported into a PC via a video capture device. Image quality, while adequate for some applications, was not equal to that produced by modern digital cameras.

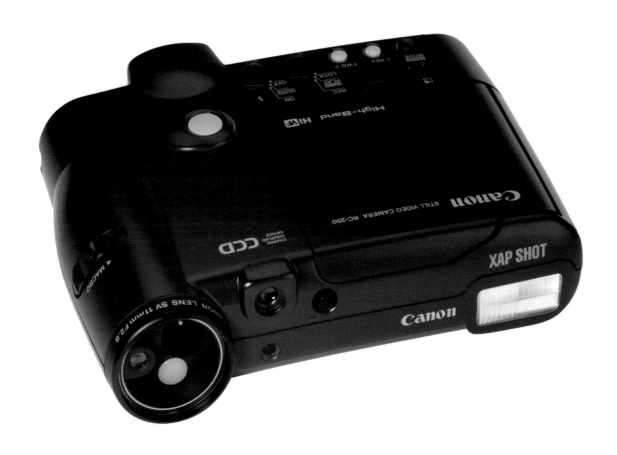

Dycam Model I _ca. 1991_

Dycam Inc., Chatsworth, California.
Gift of Rochester Institute of Technology. 2006:0106:0001.

The Dycam Model I is considered the world's first completely digital consumer camera; prior "digital camera" offerings were, in fact, still video cameras. Introduced in 1991, the Dycam could attach to a PC or Macintosh and produced black-and-white photos at 320 x 240 resolution; thirty-two compressed images could be stored on 1 MB RAM. It worked similarly to the Canon Xap Shot except that the digitizing hardware was in the camera itself. Also marketed as the Logitech Foto-Man, the Dycam Model I retailed at $995.

Kodak DCS _ca. 1991_

Eastman Kodak Company, Rochester, New York.
Gift of Eastman Kodak Company. 2001:0106:1-3.

Introduced by Eastman Kodak Company in 1991, the Digital Camera System was the earliest commercially available professional system of its kind. The first model was the DCS, which consisted of a camera and separate digital storage unit (DSU). A standard Nikon F3 body with a Kodak-designed charge-coupled device (CCD) back and a power winder, the camera was the first digital SLR (DSLR). In operation, light reaching the CCD was converted to charge packets, which were then electronically measured and converted into numeric values. These digital values were exported from the camera body via a connecting cable to the DSU, a battery-powered, 200-MB recorder that stored about 150 uncompressed or 600 compressed images. Virtually all of today's digital cameras work in this manner.

Leaf Digital Camera Back *1991*

Leaf Systems, Inc., Southborough, Massachusetts.
Gift of Rochester Institute of Technology. 2006:0105:0003.

Leaf Systems, Inc., of Southborough, Massachusetts, introduced the Digital Camera Back (DCB) in 1991, making it the first medium-format professional digital camera back. The square format (2048 x 2048), four megapixel back nicknamed "The Brick," due to its shape and fifteen-pound weight, had no onboard memory for image storage. Instead, it had to be tethered to a computer with a SCSI cable, allowing for both viewing and image transfer. This arrangement meant that using the system anywhere other than in a studio setting would be quite difficult. Like all digital cameras of the era, the Leaf was fitted with a monochrome (black and white) CCD sensor. Color images were produced by three sequential exposures through a tri-color (red, green, and blue) motorized filter wheel mounted in front of the lens. The three-color separation images were then assembled into full-color images by the tethered Apple Quadra computer, which was tricked out with Leaf's proprietary hardware and software. The back was rated at ISO

300 for black-and-white imaging, and ISO 25 for color. It could be fitted to the Hasselblad 500 EL and 553 ELX series and to Mamiya RZ67 medium-format film cameras, allowing these popular analog studio cameras to join the digital age. All this digital imaging wizardry did not come cheaply: "The Brick" sold for about $50,000, which did not include the Apple Quadra computer. Leaf also produced versions fitting the Cambo and Sinar 4 x 5-inch studio view cameras.

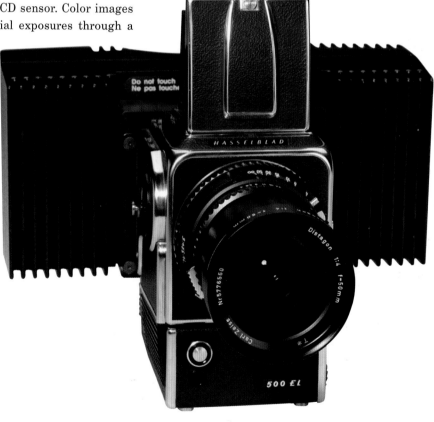

DIGITAL PHOTOGRAPHY
Steve J. Sasson

Digital photography began to displace chemically based film photography in the latter part of the twentieth century. In the 1980s, the technology in astrophotography was developed to capture images using solid-state sensors instead of photographic plates. Professional photographers began to migrate to digital in the early 1990s, followed by the consumer in the latter part of that decade. As of the first decade in the twenty-first century, this technological transition is, for all practical purposes, complete. This relatively rapid displacement of film was driven by the evolution of several technologies that offered the picture taker many new options for the capture, display, and storage of images. Inside a digital camera, the captured light from the scene is converted into a two-dimensional charge pattern on the surface of a silicon device. Like the film that it replaces, this solid-state imager is exposed to the light from the scene for a short period of time as the shutter in the camera is momentarily opened. But unlike film, these solid-state devices cannot hold the light-induced charge pattern for very long and therefore have to "read out" this pattern of charges in an organized way before the charges begin to dissipate. This is where the "digital" in digital camera comes in. Each one of these light-induced elements (called "pixels") that represent the spots that make up the total image is converted into a number by something called an "analog-to-digital converter." This allows the light pattern to be represented by a series of numbers that can be stored indefinitely in another silicon chip device called a "digital memory chip." It is this memory chip that fulfills the other property of film—the storage of the image until it is to be viewed. Because viewing is electronic, it can be

Image sensor from Kodak DCS, ca. 1991. Eastman Kodak Company, Rochester, New York. Gift of Eastman Kodak Company. 2001:0106:0001.

done immediately after the image is captured on the camera's or cell phone's digital display, or it can be done using a computer and its monitor.

This digital approach to photography was rapidly developed as an alternative to film not because it produced better images. In fact, in the early years, digital images were not as good as those produced using film. It was developed because it provided the picture taker with many new options. Since no film is consumed in taking a picture, there is no real cost to grabbing an impulsive shot. Image collections can be filtered in the camera by removing unwanted ones with the push of a button. Images in electronic (digital) form can be shared with anyone in any location with access to the Internet. Also,

with the parallel development of thermal and inkjet color printing in the 1990s, hard copy prints could conveniently be made from a computer or even directly from the camera by using a wireless connection rather than by giving them to a photofinisher for processing. Computer manipulation of the image itself provides the photographer the opportunity to improve and/or easily modify the image to better meet its intended application.

That is not to say that this approach has no drawbacks. As mentioned, the early digital cameras were restricted in the number of pixels available to them. In addition, each pixel is dedicated to collecting only one of the three colors of the visible spectrum by the use of a color filter array superimposed on the surface of the sensor. This can result in imaging anomalies that don't occur when film is used. This problem has improved as the number of pixels per sensor has increased and as imaging processing algorithms to improve color have been developed. Issues remain around image storage and the eventual obsolescence of the formats of those images. A negative taken one hundred years ago can still be easily viewed simply by looking at it. Will we be able to say the same for the images currently stored

on our computers when they are attempted to be viewed a century from now? Clearly the ability to manipulate images on a computer is a two-edged sword, for at what point is an "improved" image not an accurate version of what was actually captured by the camera?

All technological advances come with caveats, and digital photography is no exception. However, the fact that more pictures are being taken and shared today than ever before by professionals and consumers alike is a testament to the success of this stage in the evolution of photography.

Steven J. Sasson is the retired director of Project Management and Competitive Intelligence IP Transactions and Standards for Eastman Kodak Company, Rochester, NY. He is currently a consultant for Eastman Kodak Company.

Nikon D70s with back removed showing circuit board, ca. 2005. Nikon, Inc., Tokyo, Japan. 2011:0036:0001.

Kodak DCS 200 *1992*

Eastman Kodak Company, Rochester, New York.
Gift of Eastman Kodak Company. 1998:1440:0001.

Following the model of its earlier DCS camera, East-man Kodak added a CCD digital imaging system to a Nikon camera body, this time the N8008, creating the DCS 200. Unlike the earlier camera, the 200 was fitted with a built-in 80-MB hard drive, for image storage of up to fifty 1.5 megapixel images. The drive and the circuitry to run it were located in a housing beneath the camera, much like the battery-powered motor-drive units used on film cameras of the day, making the 200 a completely self-contained unit. Freed from the tethered, backpack image-storage unit of the earlier DCS, photographers could use the 200 in the same manner as the standard N8008.

Kodak kept all the features and controls of the analog Nikon, except the film-rewind knob, which was replaced with four soft-touch buttons for controlling the digital system. Marked as ISO, Mode, Drive, and Memory, the controls were similar to those used on most of today's digital SLR cameras. The viewfinder was masked to match the smaller size of the image sensor, which was about one-third that of standard 35mm film cameras. A total of 3,240 DCS 200 units were made during its two-year run. They were available in configurations for either mono or RGB color 8-bit images, with the mono-imager exposure index rated at ISO 100 to 800, and the RGB at ISO 50 to 400.

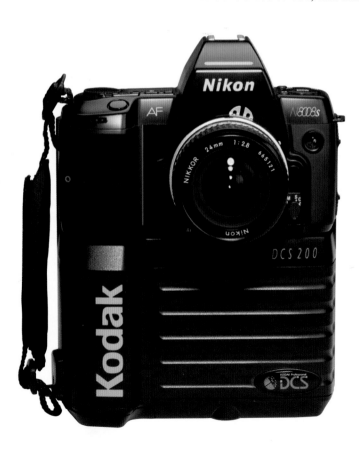

Kodak DC40 *ca. 1995*

Eastman Kodak Company, Rochester, New York.
Gift of Eastman Kodak Company. 1998:1440:0003.

In 1995, Eastman Kodak Company introduced the Kodak DC40 digital camera, their branded version of the Apple QuickTake 100, which Kodak had manufactured for Apple Computer the previous year. Although both cameras used the same Kodak sensor (model KAF-0400), they differed in detail. The Apple produced images of 640 x 480 pixels with one megabyte of internal storage memory, while the Kodak produced images of 512 x 768 pixels with four megabytes of internal storage memory. Both cameras were significant to the new digital photography industry.

Removable storage cards and LCD viewing screens were still in the future, but these cameras produced color images and retailed for just under $1,000, a milestone at the time.

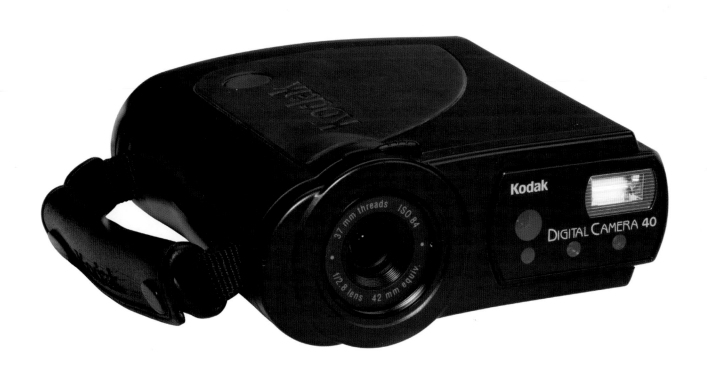

Kodak DC210 *1997*

Eastman Kodak Company, Rochester, New York.
Gift of Eastman Kodak Company. 2004:0720:0002.

Introduced in late 1997, the Kodak DC210 was a pioneering one-megapixel digital camera with the popular characteristics of a snapshot camera. Its attractive body design boasted the reliability and ease of handling of a traditional point-and-shoot camera, and its picture quality rivaled that of traditional analog snapshot cameras. The

DC210 incorporated features now familiar in manufactured digital cameras: a color LCD image viewing screen, first introduced with the 1995 Casio QV-10; easy-to-use operator interface controls, including a thumbwheel for selecting operational modes; and a removable memory card image storage system.

EFS-1 *ca. 2001*

Silicon Film Technologies, Inc., Irvine, California.
Courtesy of Thomas Kelly. L2010:0028:000

When news broke in 1998 about a device that promised to convert your single-lens reflex film camera into a true digital model, it got loads of attention. And why not? It was comforting to know that an electronic film system would keep the analog extension of your eyes and hands from reassignment as a doorstop, especially considering what you had spent on it. With an EFS-1 the user would be able to shoot digital yet switch back to regular film any time, offering the best of both worlds. However, technical and financial problems—inducing a change of the manufacturer's name, from Imagek to Silicon Film Technologies—plagued the venture, and the conversion kit wasn't publicly demonstrated until 2001.

As designed, the EFS-1 consisted of three parts, beginning with the (e)film cartridge that dropped into the camera with less fuss than loading fresh Kodachrome. Pictures captured by the sensor were stored by the electronics in the (e)film's cylinder, which had its own battery. The insert could be popped out any time and set in the clamshell (e)port carrier, which was then inserted into the (e)box storage module. There, the files were quickly downloaded to a removable memory card, which would then be used to copy the files into the computer for e-mailing or printing. Silicon Film claimed a 1.3 MP resolution for the wonder product, and set a target price of $699, batteries included.

Alas, the dream of a digital makeover proved illusory. From the beginning, many had labeled the EFS-1 as "vaporware," predicting that it would never be released. Apparently, the obstacles were too much to overcome. On the technical side, almost every brand and model of camera would need its own unique insert or some sort of adjustment feature. Along with the drawbacks of limited capacities of storage, battery, and sensor size, any dust on the sensor degraded the pictures. The financial problems may have been even greater. In the three years between the announcement and the demonstration nearly everything had changed. Regrettably, the EFS-1 was a boomer product, though not in the usual sense. Instead of being a favorite of those born during the post-World War II generation, it was an offspring of the dot-com boom, that time when merely prefixing an "e" before a product's name often meant being able to attract great buzz and large investor checks. But by 2001 the dot-com bubble had burst, and Wall Street wasn't eager to steer more money to struggling start-ups, regardless of previous hype. To make matters worse, digital SLRs were in the spotlight, and their prices were falling as image resolution kept climbing. In September 2001, Silicon Film's principal backer cut off its financing. The company was forced to suspend operations and never released the EFS-1, though the next year it announced two advanced EFS products that also failed to reach market.

Kodak EasyShare System *ca. 2001*

Eastman Kodak Company, Rochester, New York.
Gift of Eastman Kodak Company. 2006:0344:0018.

In a bid to simplify digital photography, in 2001 Eastman Kodak Company of Rochester, New York, introduced its EasyShare System, a combination of the DX3600 digital camera and Kodak Camera Dock. Prior to EasyShare, digital photography often was seen as being only for the computer-savvy, not an entirely unrealistic perception since the set-up required an end-user to install software and add peripherals, the sort of things that instill dread in many non-techies. EasyShare was meant to be the new Brownie, a system that removed all complexities from digital photography. The photographer had only to connect the dock to a computer via a USB cable. After that, the system was ready to print and share images. Once the camera was placed in the dock, picture transfer was handled by simply pressing the dock's only button, located at the end of a large yellow arrow. With that button, George Eastman's more than century-old advertising slogan, "You press the button, we do the rest," entered the digital age.

Kodak mc³ *ca. 2001*

Eastman Kodak Company, Rochester, New York.
Gift of Eastman Kodak Company. 2006:0344:0023.

To appeal to the youth market, in 2001 Eastman Kodak Company introduced the mc³, a portable, multifunction digital appliance. A sort of digital Swiss Army knife, it consisted of still and video cameras, an MP3 player, and a Digital Juke Box software package, and it was just the ticket to share images, music, and videos with your Internet friends. On the tech-side, it was the first camera to incorporate Kodak's CMOS battery-saving image sensor. The mc³ listed for $299, including the 64-MB compact flash memory card. An additional $24.95 bought the USB dock, which connected to a PC or Mac and made sharing even easier.

Dimage X *ca. 2002*

Minolta Company Ltd., Osaka, Japan. 2004:0297:0001.

The digital camera market follows the same rules that have governed the photographic hardware arena since the Brownie's day: for a product to stand out and attract paying customers, it must have fresh design and new features. Minolta of Osaka, Japan, met the challenge in 2002 with their Dimage X, a two-megapixel mite measuring 3¼ x 2¾ x ¾ inches and featuring a 3x optical zoom lens. Minolta accomplished this feat by placing a ninety-degree prism behind the front element and vertically mounting the seven-element power zoom assembly. The result was a shirt-pocket camera without the usual body thickness required for a zoom. The Dimage X had the usual built-in flash, LCD screen, and video recorder found in most digitals, but its rugged metal body and ultra-compact size set the $399 camera apart from the crowd, at least for a while.

CAMERA PHONES
Todd Gustavson

Introduced in November 2000 and considered to be the first commercially available cell phone fitted with a built-in digital camera, Sharp Corporation's J-SH04 produced 110,000-pixel (0.1 megapixel), 256-color images that can only be called tiny by 2011 standards. Released by J-Phone, a subsidiary of SoftBank Mobile, the J-SH04 was originally available only in Japan. Cell phone camera technology did not hit the U.S. market until 2004. However, since then, camera phones have become practically ubiquitous, with the camera component being included as a "giveaway" feature on just about every mobile phone sold, making a potential photographer of virtually every cell phone user. In 2008, worldwide use of camera phones was estimated at close to two billion, which makes for a lot of mobile snapshooters. With the revenues generated by such sales numbers, the industry has significantly advanced image-making technology, though the geographical distribution of improvements has been uneven. While camera phones sold in Europe and Japan generate images of up to fourteen megapixels, those available in the United States typically produce only two- to five-megapixel images. In the U.S., it's the add-on

Nokia camera phone ca. 2003
Nokia, Helsinki, Finland.
Gift of Nokia. 2003:0811:0001.

applications, such as the iPhone's Hipstamatic, which simulates images taken by old-time plastic cameras, that generate the greatest hype, not the megapixel counts. The question may be when, and not if, camera phones will replace stand-alone amateur digital cameras.

What today seems a commonplace accessory, especially among teens and twenty-somethings, was revolutionary at the turn of the twenty-first century. Introduced in 2002, the Nokia 7650 was one of the first commercial cell phones with an integrated digital camera available in the U.S. It was billed as the "mobile phone that lets you show what you mean." As of this writing, today's multi-interface devices can include not only a wireless phone and camera with up to 10 MP of resolution, but text messaging, web browsing, and support for viewing e-mail attachments, watching videos, and listening to downloadable music—a menu of options that are changing so fast it will undoubtedly be out of date before publication. By comparison, this Nokia 7650 produced an image of just 300 kilopixels (0.3 MP) using an onboard memory of 1 MB to store up to fifty-five basic-level images.

Motorola's E815 of 2005 was a web-enabled clamshell flip phone, featuring a 1.3-megapixel camera with a 4x digital zoom. Images were composed on the 1⅜ x 1⅞-inch LCD viewing screen, and were stored either on an internal memory or on optional 256 MB plug-in Micro SD cards. It was capable of sending and receiving multimedia messages containing both text and images.

The first version of the iPhone was introduced by Steve Jobs at the January 9, 2007, MacWorld convention. It was a smartphone touchscreen PED (personal electronic device), supplied with Apple's iTunes and Safari web browser, and a fixed-focus two-megapixel camera. At $499 for the 4 GB version and $599 for 8 GB, the phone was not cheap. Even so, with the numerous mobile applications available at the App store (currently estimated at more than 250,000) and from third-party developers (now practically a cottage industry), the iPhone soon became one of the hottest consumer products to hit the market in years. Apple has continued to both update the line and lower the price: the 2008 3G with 8 GB sells for $199, and the 16 GB version for $299. The iPhone 3GS of 2009 added a 3 MB still camera and digital video, and of course more speed.

Motorola E815 ca. 2005 Motorola Corporation, Schaumberg, Illinois. Anonymous gift. 2011:0044:0001.

iPhone 3G ca. 2008 Apple Computer, Inc., Cupertino, California. Gift of Ryan Donahue. 2011:0045:0001.

June 2010 brought us the restyled iPhone 4G, with its 5 MB camera, and no doubt Apple will continue to offer innovative improvements in coming years.

Kodak EasyShare DX6490 *ca. 2004*

Eastman Kodak Company, Rochester, New York.
Gift of Eastman Kodak Company. 2004:0296:0001.

When Eastman Kodak Company introduced the DX6490 zoom digital camera in 2003, their goal was to provide professional quality features in a four-megapixel consumer digital camera with a high-quality optical zoom lens, advanced photographic controls, and an SLR-like body. The DX6490 was the first to unite a professional quality Schneider-Kreuznach Variogon 10x optical zoom lens with an f/2.8 to f/3.7 maximum aperture; a new Kodak Color Science image processing sensor; and low-light precision autofocusing, all packaged with the popular EasyShare system. With a press of the camera's red "Share" button, the user could immediately select printing, e-mailing, and marking as favorite options for each picture. On-camera sharing was made simple with a 2.2-inch LCD screen. The retail price for the camera was $499.

Kodak Pro 14n *ca. 2004*

Eastman Kodak Company, Rochester, New York.
Gift of Eastman Kodak Company. 2004:0300:0001.

The Kodak Pro 14n digital camera was the world's first Nikon-mount digital camera to use a full-frame 35mm (24 x 36 mm) CMOS sensor, producing 13.89 megapixel resolution. Announced at Photokina in September 2002, its high resolution and low price took the world by surprise. Though assumed to have been built on a production Nikon N80 camera, it actually had a body made especially for Kodak in a magnesium alloy with a unique vertical format shutter release. The release price was $4,995.

In 2004, the same camera was upgraded with a new imager and improvements in power management and noise performance. This improved model was called the DCS Pro SLR/n; an upgrade package for the 14n was offered at $1,495.

Epson R-D1 *2004*

Seiko Epson Corporation, Tokyo, Japan.
Gift of Seiko Epson Corporation. 2006:0415:0001.

At Photokina 2004, the biennial trade fair held in Cologne, Germany, Seiko Epson Corporation of Tokyo introduced the Epson R-D1, the world's first digital rangefinder camera. In terms of styling and handling, it was a traditional camera, suggestive of the classic Leica M cameras introduced in 1954. It accepted most M-mount Leica lenses and used analog controls for focus, shutter speed, and lens aperture. On the camera's top plate was a status gauge that somewhat resembled a chronograph watch and displayed information about the current image settings, such as image quality, number of remaining exposures, available battery power, and white balance setting.

Kodak EasyShare One *2006*

Eastman Kodak Company, Rochester, New York.
Gift of Eastman Kodak Company. 2006:0344:0020.

The Kodak EasyShare One was introduced in 2005 as the world's first wireless consumer digital camera with the ability to e-mail images directly from the camera. In addition to WiFi capability, it had an articulated three-inch LCD display screen and 3x optical zoom, and it allowed online browsing of photo albums at the Kodak EasyShare Gallery. Initially offered with four megapixels of resolution at $599, it was soon joined by a six-megapixel version.

Leica M8 *2007*

Leica Camera AG, Solms, Germany.
Gift of Leica Camera AG. 2007:0351:0001.

In 2007, the Leica M8 was awarded "Camera of the Year" by the editors of American Photo magazine. Introduced in 2006 at Photokina, the camera world's largest trade fair in Cologne, Germany, the M8 advanced Leica's fortunes in a crowded digital photography market. Drawing its incomparable design from the company's celebrated M-series rangefinders, the gold standard for professional and amateur photographers alike, the ten-megapixel camera uses the Eastman Kodak Company KAK-10500 image sensor, designed especially for Leica.

Company founder Ernst Leitz began manufacturing high-quality and high-performance 35mm handheld cameras in 1925. Their impact on the development of aspiring photographic genres such as photojournalism and fine art photography was monumental. In 1954, the company introduced the now legendary M3, a camera still considered the benchmark of 35mm rangefinders. Its current model descendants, the MP and M7, long-time favorites and immediate antecedents to the digital M8, remain in production today.

In 1998, the Leica Camera Group embarked on digital camera production with the award winning S1, its first high-end, scanning back digital camera. The M8 is the manufacturer's latest in a line of triumphs in the digital camera field. Now known as Leica Camera AG, based in Solms, Germany, the company owes its success in the rapidly evolving and highly competitive field of digital camera technology to Dr. Andreas Kaufmann, who became sole owner in 2006. Kaufmann's energy and vision have propelled Leica to new heights in both innovative production and the marketplace.

ACKNOWLEDGEMENTS

Many friends and colleagues assisted in the preparation of this book. To those who provided thoughtful essays, Anthony Bannon, Rolf Fricke, Jerome Friedman, Therese Mulligan, Mark Osterman, Steven J. Sasson, Peter Schultz, Martin J. Scott, and Robert Shanebrook, I offer my sincerest appreciation.

For contributing research and writing the didactic captions, I thank Frank Calandra, Kathy Connor, and Joseph Constantino. Greg Drake and Ann Stevens brought a critical eye to editing the text, and Barbara Puorro Galasso creatively photographed the cameras. I am greatly indebted to these individuals for giving their talent, time, and energy to this project.

I would also like to extend my thanks to the camera industry, in particular, Eastman Kodak Company for their generous assistance with information, and Leica Camera AG for providing historical photographs used to illustrate key passages in this book.

This publication would not have been realized without the support of Sterling Publishing Company. I especially thank Pam Horn and Ashley Muir Bruhn for their invaluable assistance and collegial spirit throughout the book's production.

Todd Gustavson
Curator, Technology Collection

GEORGE EASTMAN HOUSE MISSION STATEMENT

George Eastman House, an independent nonprofit museum, is an educational institution that tells the story of photography and motion pictures—media that have changed and continue to change our perception of the world. We:

- Collect and preserve objects that are of significance to photography, motion pictures, and the life of George Eastman.

- Build information resources to provide the means for both scholarly research and recreational inquiry.

- Keep and care for images, literature, and technology to tell the story of photography and the motion picture in history and in culture.

- Care for George Eastman's house, gardens, and archives, maintaining them for public enjoyment and as a memorial to his contribution to our lives and our times.

- We do these things to inspire discovery and learning—supporting the education of a regional, national, and international audience.

INDEX
OF CAMERA
NAMES

GENERAL INDEX